THE PHOTOGRAPHERS OF ISLANDS OF HOPE

W.D. Addison

J. David Andrews

Diane Biggs

Robert Boudreau

Susan Buck

Paul Chivers

Paul Clifford

John DeVisser

Mary W. Ferguson

Janet Foster

John Foster

Dan Gibson

Peter Griffith

Leo Heyens

James Hodgins

Samuel Kolber

P.S.G. Kor

Rolf Kraiker

Janis Kraulis

Lori Labatt

Sonia Labatt

M. Patricia Langer

Bruce Litteljohn

Sandy MacDonald

Robert McCaw

Courtney Milne

Mark Moldaver

Chris Motherwell

Freeman Patterson

Bruce Petersen

William D. Reynolds

John Riley

Michael Runtz

Richard M. Simpson

Karl Sommerer

Don Standfield

John Stradiotto

Peter van Rhijn

Paul von Baich

Brenda Walton

Allen Woodliffe

Maria Zorn

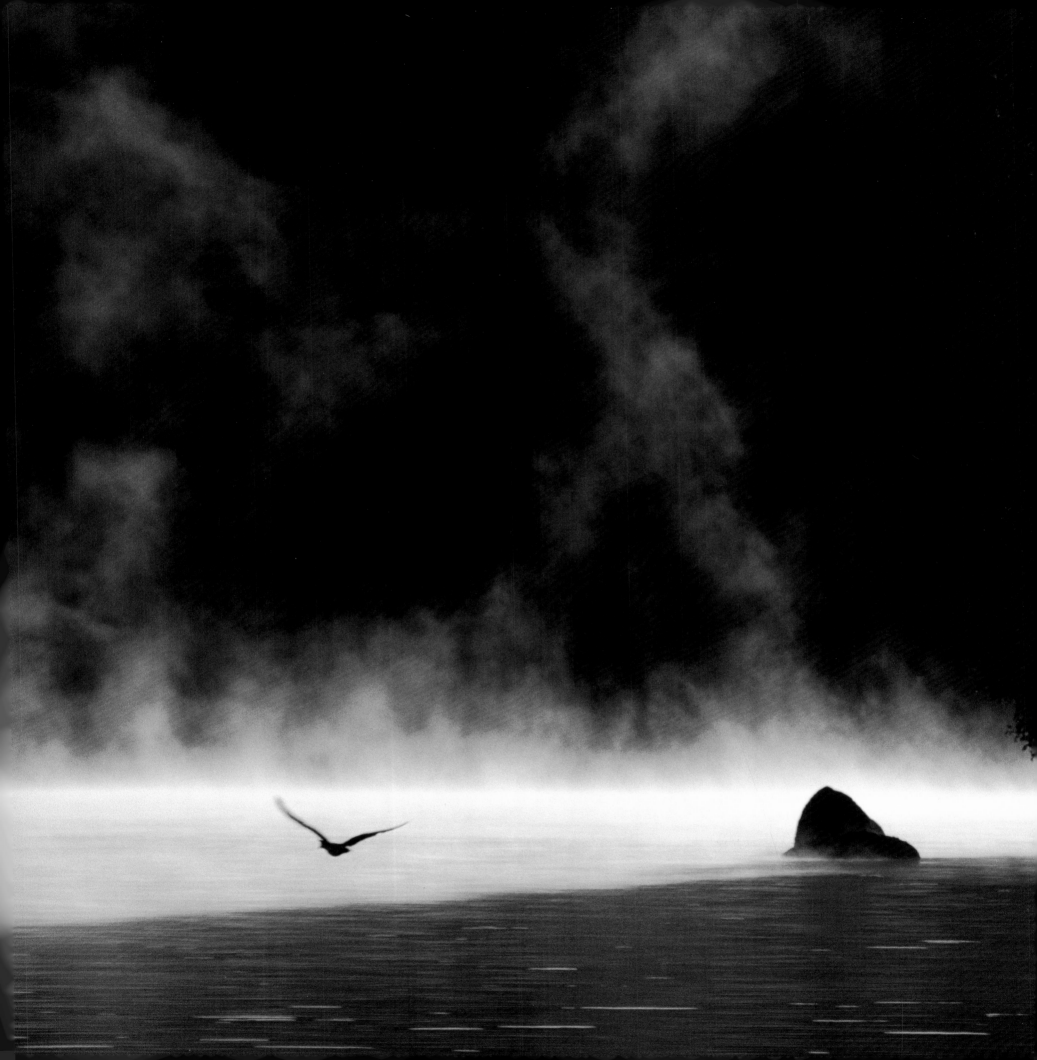

THIS BOOK IS DEDICATED
TO THE MEMORY OF:

C. Brian Cragg
Charlie Ericksen
Bill Mason
James W. McLean
Douglas H. Pimlott
Warner Troyer
Shan Walshe

Their spirits live on in the wilderness
areas they sought to protect.

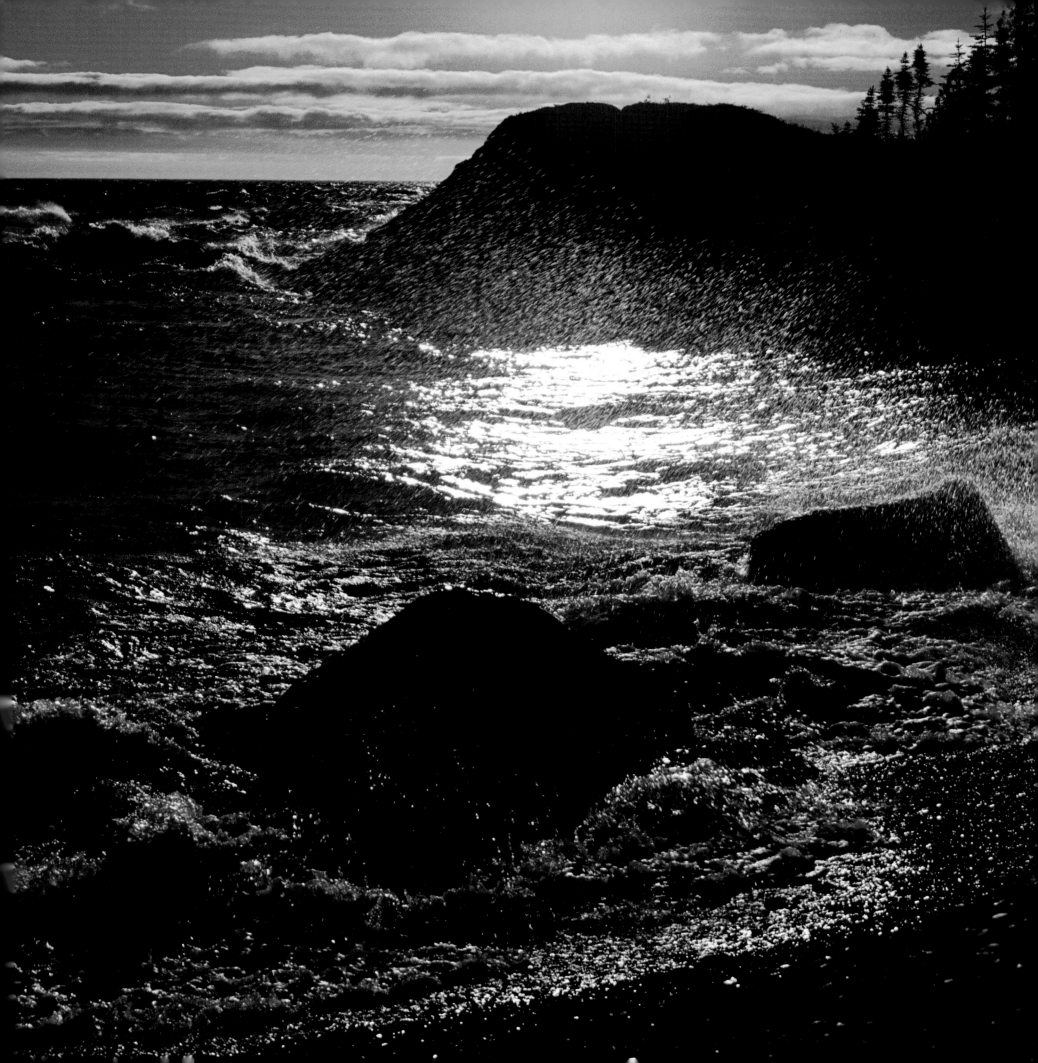

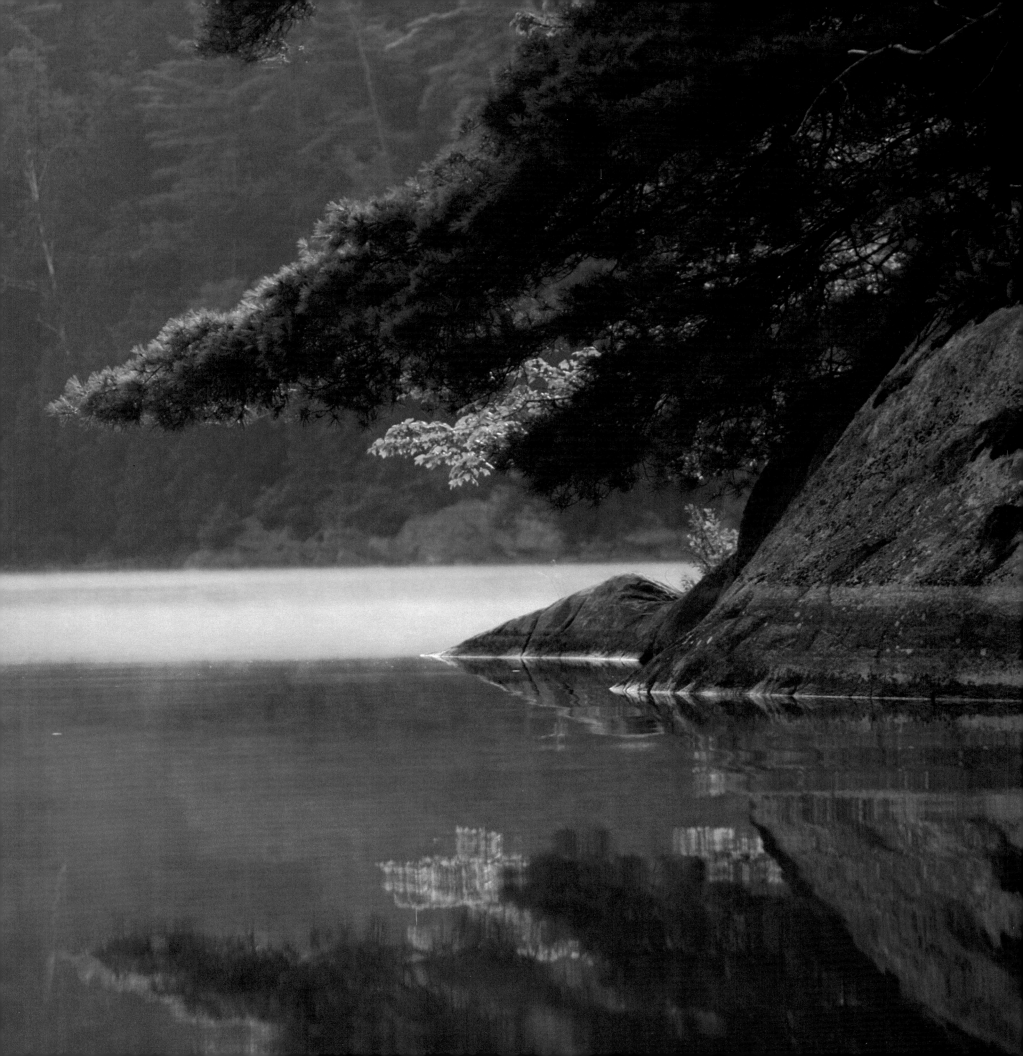

Ontario's Parks and Wilderness

ISLANDS OF HOPE

EDITED BY LORI LABATT & BRUCE LITTELJOHN FOR THE WILDLANDS LEAGUE

FIREFLY BOOKS

A Firefly Book

Canadian Cataloguing in Publication Data
Main entry under title:

Islands of Hope

ISBN 1-895565-10-3

1. Provincial parks and reserves—Ontario
2. Wilderness areas—Ontario—Recreational use

I. Labatt, Lori
II. Litteljohn, Bruce

FC3063.I75 1992 363.6'8'09713 092-C93685-7

F1057.I75 1992

DESIGN: V. JOHN LEE
CARTOGRAPHY: JAMES LOATES
TYPESETTING: V. JOHN LEE/ATTIC TYPESETTING
COLOUR SEPARATION: GRAPHIC FILM STUDIO INC.
PRINTED AND BOUND IN CANADA BY FRIESEN PRINTERS

Published for the Wildlands League by

FIREFLY BOOKS LTD.,
250 Sparks Avenue,
Willowdale, Ontario M2H 2S4

Henderson Book Series No.17

Henderson Book Series honours the kind and generous donation of Mrs. Arthur T. Henderson which made this series possible. The Canadian Parks and Wilderness Society gratefully acknowledges Mrs. Henderson's support of the Society's efforts to promote public awareness of the value of Canada's park and wilderness areas.

PAGE ONE / MISTY LAKE, ALGONQUIN PROV. PARK
LORI LABATT

PAGE THREE / MICHIPICOTEN ISLAND PROV. PARK
BRUCE LITTELJOHN

PAGE FOUR / BLACKSTONE HARBOUR PROV. PARK
BRUCE LITTELJOHN

PAGE SEVEN / SABLE ISLAND NATURE RESERVE, LAKE OF THE WOODS
BRUCE LITTELJOHN

PAGE EIGHT / HAWTHORN AND SCOURING RUSH ON NATURE TRAIL
M. PATRICIA LANGER

PAGE TEN / BLUE CHUTE, FRENCH RIVER WATERWAY PARK
SUSAN BUCK

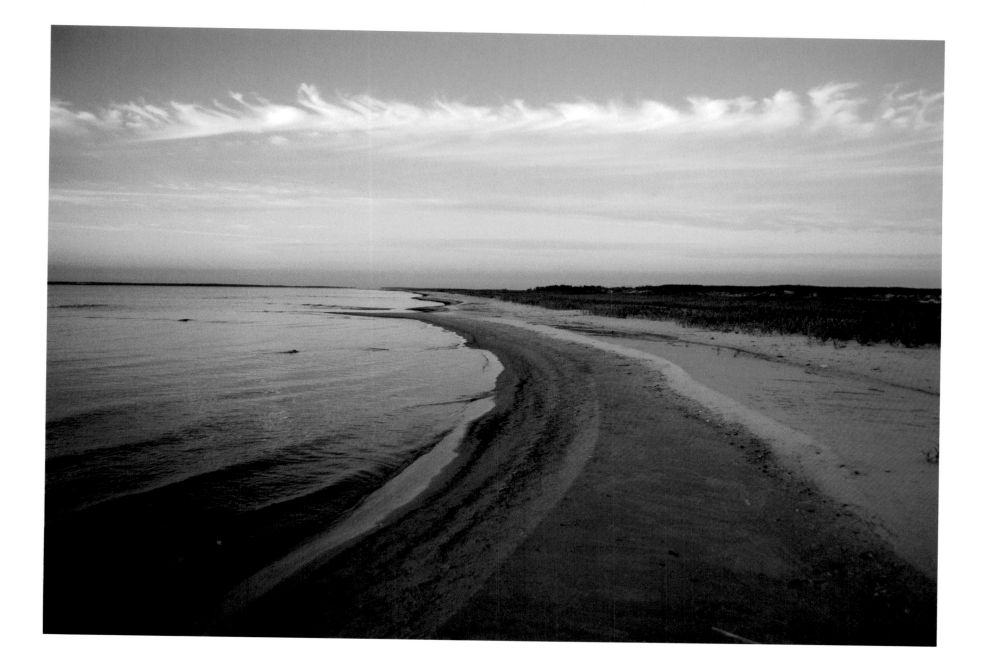

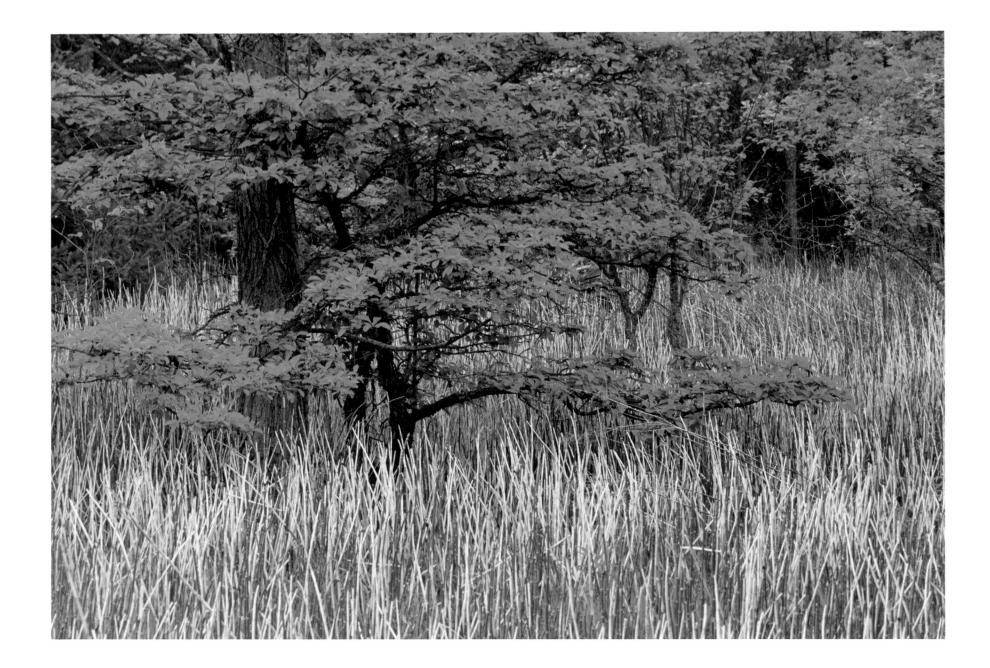

The Wildlands League thanks the following SPONSORS and FRIENDS who share our concern for a healthy and varied environment. Their generous support has made this project possible.

THE SPONSORS

J. P. BICKELL FOUNDATION
(National Trust Company, Trustees)

CANADEX RESOURCES LIMITED

CANADIAN ENVIRONMENTAL EDUCATION FOUNDATION

CONSUMERS GAS

DOW CHEMICAL CANADA INC.

GLEN W. DAVIS

HALLMARK CARDS CANADA

LAIDLAW FOUNDATION

THE LANG FAMILY

LEVER BROTHERS INC.

THE ONTARIO HERITAGE FOUNDATION
(An Agency of the Ministry of Culture and Communications)

ONTARIO MINISTRY OF NATURAL RESOURCES

ONTARIO MINISTRY OF NORTHERN DEVELOPMENT AND MINES

ROGERS COMMUNICATIONS INC.

ROOTS NATURAL FOOTWEAR

SUN PAC FOODS LIMITED

TRIMARK FINANCIAL CORPORATION

WHEATLEY, MACPHERSON, DALEY & SUGAR, BARRISTERS AND SOLICITORS

WORLD WILDLIFE FUND CANADA

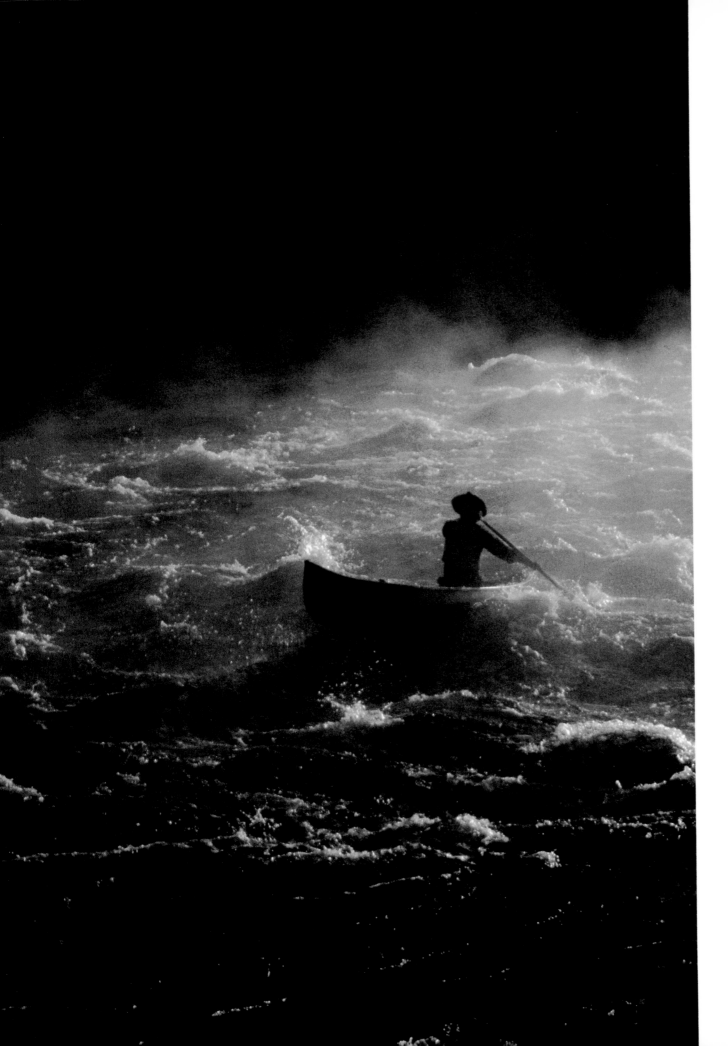

THE FRIENDS

FOREWORD

As we approach the 21st century, the destruction of nature has become a matter of tremendous concern. Environmental protection is now seen as a first priority by governments worldwide.

In Ontario, our provincial parks assume a vital role in preserving our natural diversity and overall environmental health. It is, therefore, fitting that we should celebrate the centenary of our parks system in 1993, while continuing our efforts to expand and protect natural areas.

Both the Government of Ontario and private conservation groups like the Wildlands League are commended for their ongoing commitment to protect what remains of wild nature and to educate people as to its importance. *Islands of Hope* is yet another expression of that commitment.

The Honourable Henry N. R. Jackman
Lieutenant-Governor of Ontario

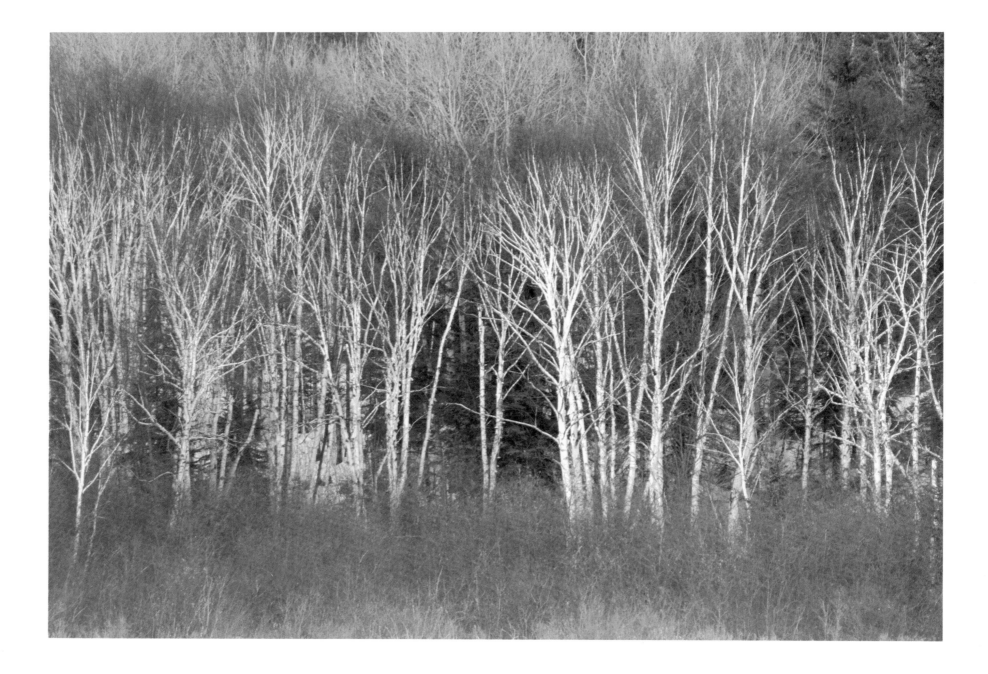

Contents

BIRCHES, CALEDON
CHRIS MOTHERWELL

SOUTH OF OPEONGO, ALGONQUIN PROV. PARK
ROBERT McCAW

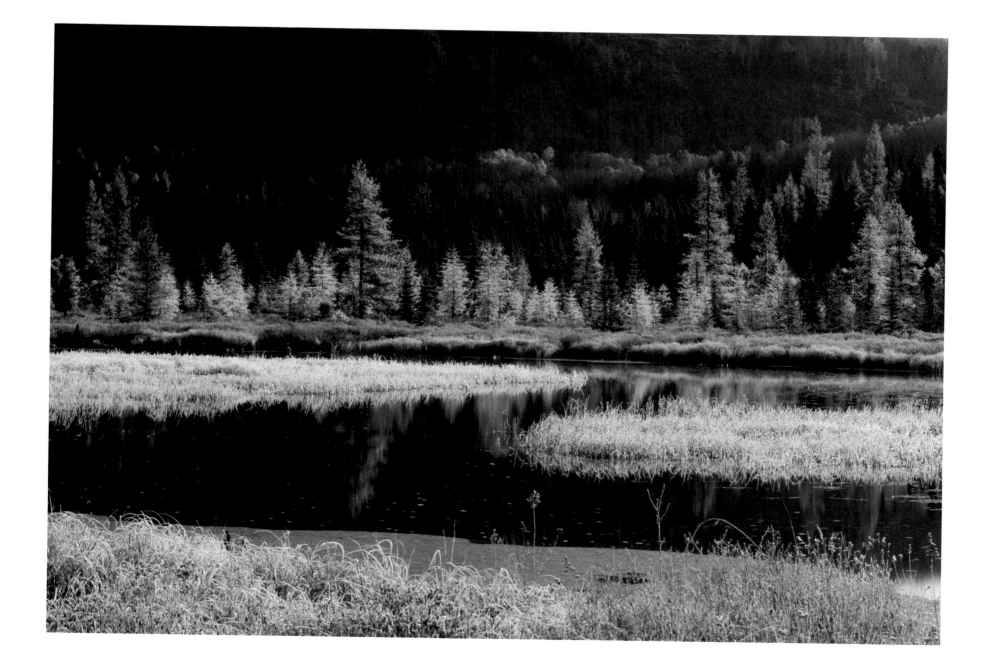

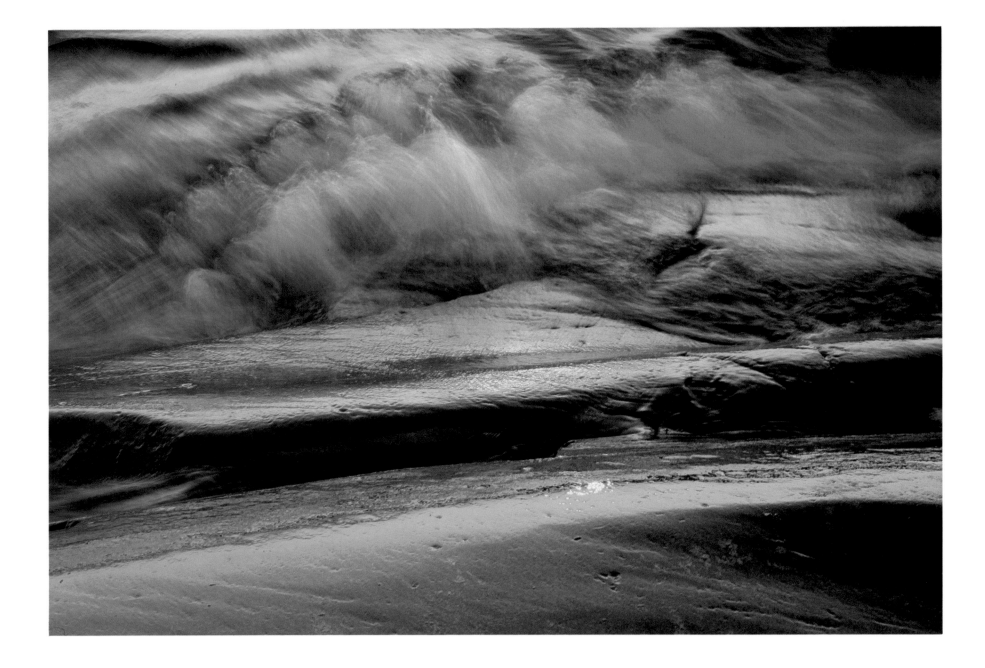

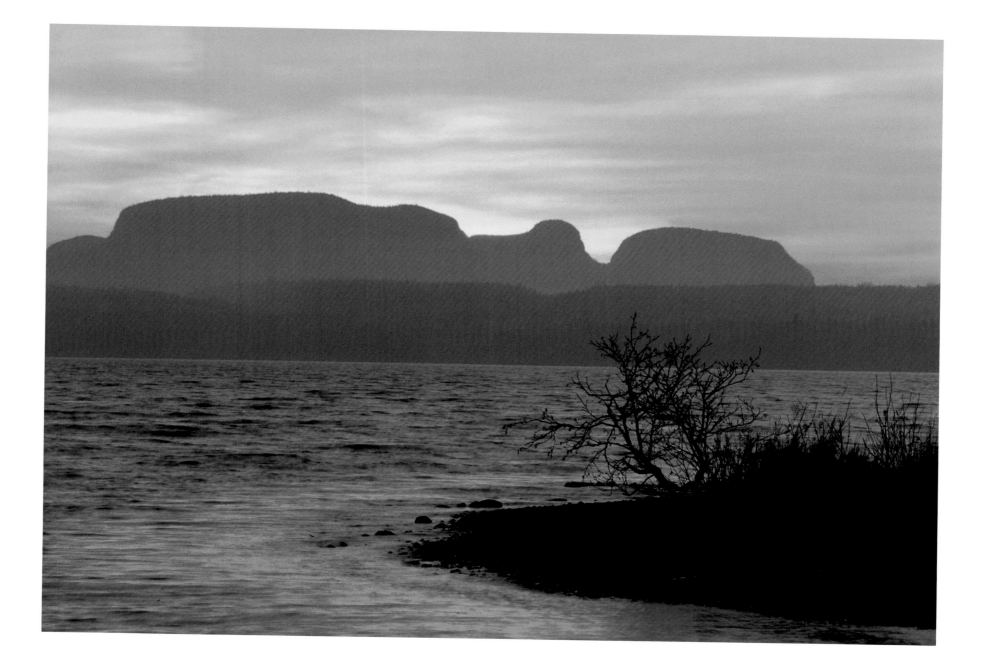

LEFT / NEYS PROV. PARK
SANDY MacDONALD

ABOVE / SLEEPING GIANT,
LAKE SUPERIOR
BRUCE PETERSEN

ONTARIO PROVINCIAL PARKS

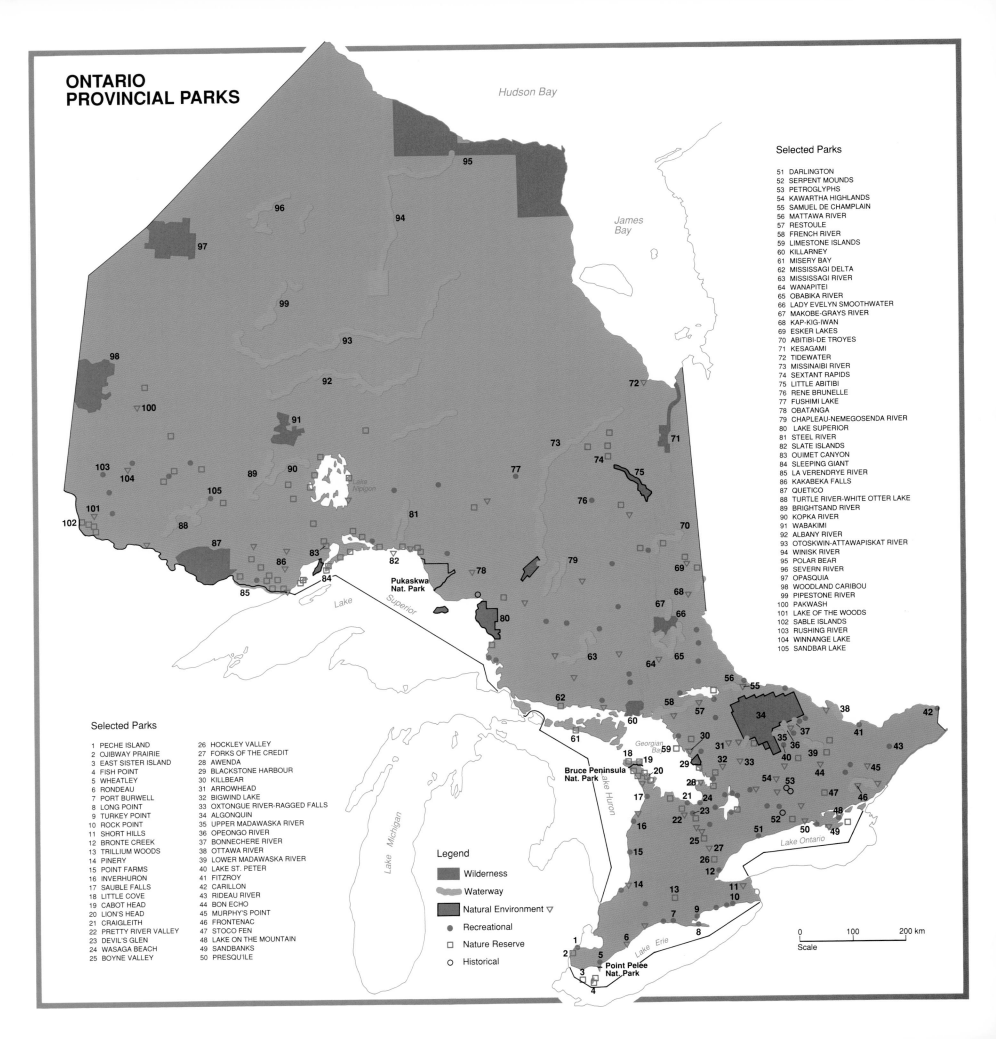

Hudson Bay

James Bay

Lake Nipigon

Pukaskwa Nat. Park

Lake Superior

Bruce Peninsula Nat. Park

Georgian Bay

Lake Huron

Lake Michigan

Lake Ontario

Lake Erie

Point Pelee Nat. Park

Selected Parks

51	DARLINGTON
52	SERPENT MOUNDS
53	PETROGLYPHS
54	KAWARTHA HIGHLANDS
55	SAMUEL DE CHAMPLAIN
56	MATTAWA RIVER
57	RESTOULE
58	FRENCH RIVER
59	LIMESTONE ISLANDS
60	KILLARNEY
61	MISERY BAY
62	MISSISSAGI DELTA
63	MISSISSAGI RIVER
64	WANAPITEI
65	OBABIKA RIVER
66	LADY EVELYN SMOOTHWATER
67	MAKOBE-GRAYS RIVER
68	KAP-KIG-IWAN
69	ESKER LAKES
70	ABITIBI-DE TROYES
71	KESAGAMI
72	TIDEWATER
73	MISSINAIBI RIVER
74	SEXTANT RAPIDS
75	LITTLE ABITIBI
76	RENE BRUNELLE
77	FUSHIMI LAKE
78	OBATANGA
79	CHAPLEAU-NEMEGOSENDA RIVER
80	LAKE SUPERIOR
81	STEEL RIVER
82	SLATE ISLANDS
83	OUIMET CANYON
84	SLEEPING GIANT
85	LA VERENDRYE RIVER
86	KAKABEKA FALLS
87	QUETICO
88	TURTLE RIVER-WHITE OTTER LAKE
89	BRIGHTSAND RIVER
90	KOPKA RIVER
91	WABAKIMI
92	ALBANY RIVER
93	OTOSKWIN-ATTAWAPISKAT RIVER
94	WINISK RIVER
95	POLAR BEAR
96	SEVERN RIVER
97	OPASQUIA
98	WOODLAND CARIBOU
99	PIPESTONE RIVER
100	PAKWASH
101	LAKE OF THE WOODS
102	SABLE ISLANDS
103	RUSHING RIVER
104	WINNANGE LAKE
105	SANDBAR LAKE

Selected Parks

1	PECHE ISLAND	26	HOCKLEY VALLEY
2	OJIBWAY PRAIRIE	27	FORKS OF THE CREDIT
3	EAST SISTER ISLAND	28	AWENDA
4	FISH POINT	29	BLACKSTONE HARBOUR
5	WHEATLEY	30	KILLBEAR
6	RONDEAU	31	ARROWHEAD
7	PORT BURWELL	32	BIGWIND LAKE
8	LONG POINT	33	OXTONGUE RIVER-RAGGED FALLS
9	TURKEY POINT	34	ALGONQUIN
10	ROCK POINT	35	UPPER MADAWASKA RIVER
11	SHORT HILLS	36	OPEONGO RIVER
12	BRONTE CREEK	37	BONNECHERE RIVER
13	TRILLIUM WOODS	38	OTTAWA RIVER
14	PINERY	39	LOWER MADAWASKA RIVER
15	POINT FARMS	40	LAKE ST. PETER
16	INVERHURON	41	FITZROY
17	SAUBLE FALLS	42	CARILLON
18	LITTLE COVE	43	RIDEAU RIVER
19	CABOT HEAD	44	BON ECHO
20	LION'S HEAD	45	MURPHY'S POINT
21	CRAIGLEITH	46	FRONTENAC
22	PRETTY RIVER VALLEY	47	STOCO FEN
23	DEVIL'S GLEN	48	LAKE ON THE MOUNTAIN
24	WASAGA BEACH	49	SANDBANKS
25	BOYNE VALLEY	50	PRESQU'ILE

Legend

▨	Wilderness
〰	Waterway
▨ ▽	Natural Environment
●	Recreational
▢	Nature Reserve
○	Historical

0 100 200 km
Scale

Introduction

Lori Labatt and Bruce Litteljohn

Already home to Algonkian and Iroquoian native people, Ontario was first visited by European newcomers early in the seventeenth century. These newcomers viewed the wilderness as a challenge: an enemy to be conquered, and a source of wealth to be exploited. As their numbers swelled and their economic system penetrated deeper and deeper into the area, fur-bearing animals, forests, minerals, and soils were rapidly turned into commodities, and wilderness steadily diminished. Not until about the turn of the twentieth century was there any appreciable concern about this process, any conservationist questioning of the myth of unlimited abundance. Those early expressions of concern led, in part, to the establishment of Algonquin Park in 1893.

Much has changed since then. Informed people no longer accept the notion of unlimited abundance. They see instead the rapid destruction of nature in the face of exploding populations, pollutants, and the insatiable appetites of consumer societies. Their perception, however, is by no means universal, for many continue to view nature simply as a pool of resources for employment, the generation of goods and wealth, and recreational pleasure.

One can only wish that back in 1893 there had been a widespread land ethic — a general humility that saw humans as but one element among others of equal value in the natural order, and a serious attempt at restrained and sustainable development. Had that been the case, we would not now have to struggle to protect remnants of nature in the form of parks and resist resource extraction within their boundaries. Even as we celebrate the centenary of our parks, we should realize that they are often under siege. Our society has yet to recognize that parks should exist first and foremost as sanctuaries for non-human forms of life and for the physical landscape that surrounds and sustains them.

The attitudes and actions of Ontarians in the past have made it imperative that those who care for nature must strive to protect it. A measure of their success is the system of 261 provincial parks administered by the Ontario Ministry of Natural Resources, as well as several important parks ceded to the national government by the province. Taken together, they provide considerable protection to many — but not all — of our natural regions. Compared to many political jurisdictions, we have done well; and we owe a debt of thanks to many, both within and outside of government, who have worked hard to bring us this far.

The Provincial Parks and Natural Heritage Policy Branch of the Ministry of Natural Resources is the primary voice within the Government of Ontario for the protection of natural areas. To its credit, it has done much to extend services and interpretive information to a growing number of park users, despite severe fiscal restraints. More important, it has identified many natural areas that deserve protection and has devised mechanisms to provide that protection. Part of our centenary celebration should therefore include strong support for the Provincial Parks and Natural Heritage Policy Branch.

We have made this book to celebrate in words and photographs what has been achieved by our parks system. We wish to emphasize that system's great significance especially from the ecological/environmental perspective. Yet we wish as well to draw attention to the importance of natural areas not yet protected, and we consequently include some photographs of areas outside of parks to remind us how universal is the nature we would appreciate and safeguard. At the same time we intend this book to provoke thought and encourage action to make our system of protected areas better and more comprehensive. This is not a guidebook to the parks and their recreational opportunities: other publications serve that purpose. In our view it is more important to understand how our parks system has evolved and to relate that evolution to the ways we view nature. Such knowledge may move more Ontarians to see that steps must be taken now to protect more of the natural world and even —

especially in crowded southern Ontario—to attempt to reconstitute natural ecosystems.

Our writers are many and various: civil servants, youngsters, native people, journalists, poets, ecologists, and environmentalists. Often they simply rejoice in the beauty and fascination of nature. But sometimes they raise questions: How can we increase protection of Great Lakes shorelines? Why is the system of nature reserves not more comprehensive? Should there be a major marine park on Lake Superior? Does park status *really* give sanctuary to plants and animals? Are parks too often treated like any other tract of Crown land? Do waterway parks actually provide the degree of protection rivers need? The answers to these questions are important and sometimes disconcerting. They suggest that we must do a great deal, and very quickly, if our endangered spaces and species are to be spared.

We invite you to celebrate with us what has been accomplished, but also to consider the role of parks—our "islands of hope"—in a province, a nation, a world where unprecedented pressures militate against the beauty, diversity, and fundamental importance of nature. We ask you to recognize that we are dealing with islands—circumscribed and often very small. To acknowledge how limited they are is not to detract from their importance or to question the need to value, protect, and expand our parks system. However, parks will not by themselves ensure a healthy natural environment: that will require broad-scale changes in our attitudes and actions. Our parks are perhaps most important as symbols of our intention to provide sanctuary for other living things. To this degree they are islands of *hope*—beacons leading us toward a deeper appreciation of nature and greater determination to protect it.

As Ontarians celebrate the centenary of provincial parks, the Wildlands League (a chapter of the Canadian Parks and Wilderness Society) celebrates as well. It is twenty-five years since we came into being as the Algonquin Wildlands League and began our work to preserve and protect wilderness. We are pleased and proud that our successes are in part responsible for the natural integrity of some of the remarkable places about to be revealed.

HISTORY AND ATTITUDES

Ontario's Provincial Parks, 1893–1993: "We make progress in jumps"

Gerald Killan

As recently as 1954, Ontarians wishing to visit a provincial park had surprisingly few destinations from which to choose. A mere four parks beckoned to the north—Algonquin, Lake Superior, Sibley (today Sleeping Giant), and Quetico. Four others hugged the shorelines of the southern Great Lakes—Presqu'ile on Lake Ontario, Long Point and Rondeau on Lake Erie, and Ipperwash on Lake Huron. By contrast, today's Ontarians enjoy access to an impressive system of 261 provincial parks: eight Wilderness, twenty-nine Waterway, sixty-three Natural Environment, eighty-three Nature Reserve, seventy-four Recreation, and four Historical. This system, which represents not only the province's great diversity of landforms and plant and animal life but also many outstanding recreational landscapes, is one of the world's best.

Ontario's provincial parks system evolved rapidly over the past forty years in response to a variety of social, economic, and cultural pressures. Woven through these decades of flux and adaptation, however, are elements of continuous evolution which span the century from the establishment of Algonquin Park (1893) to the

FRENCH RIVER WATERWAY PARK
ROLF KRAIKER

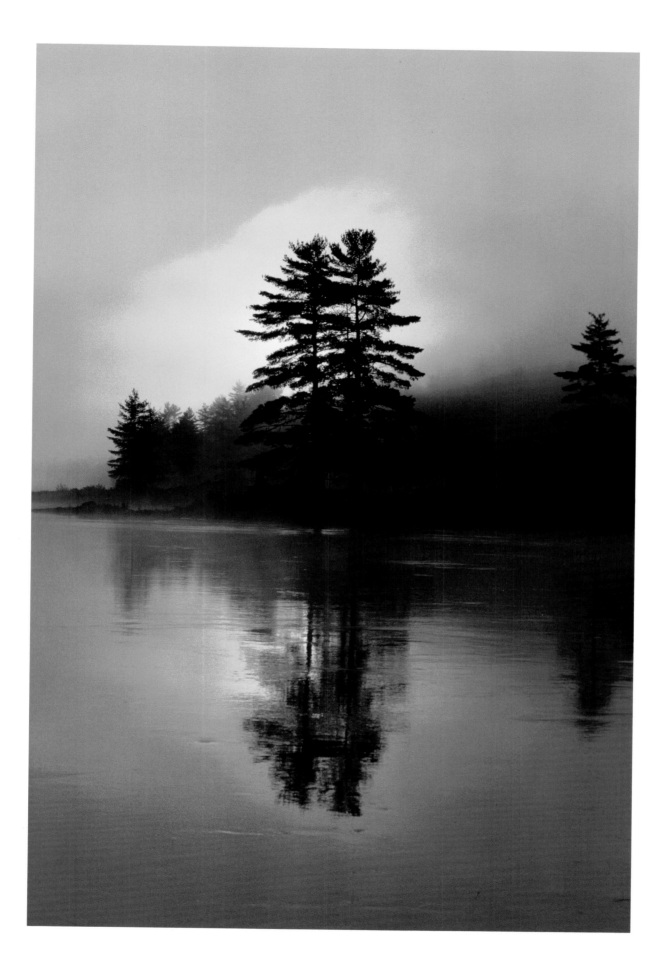

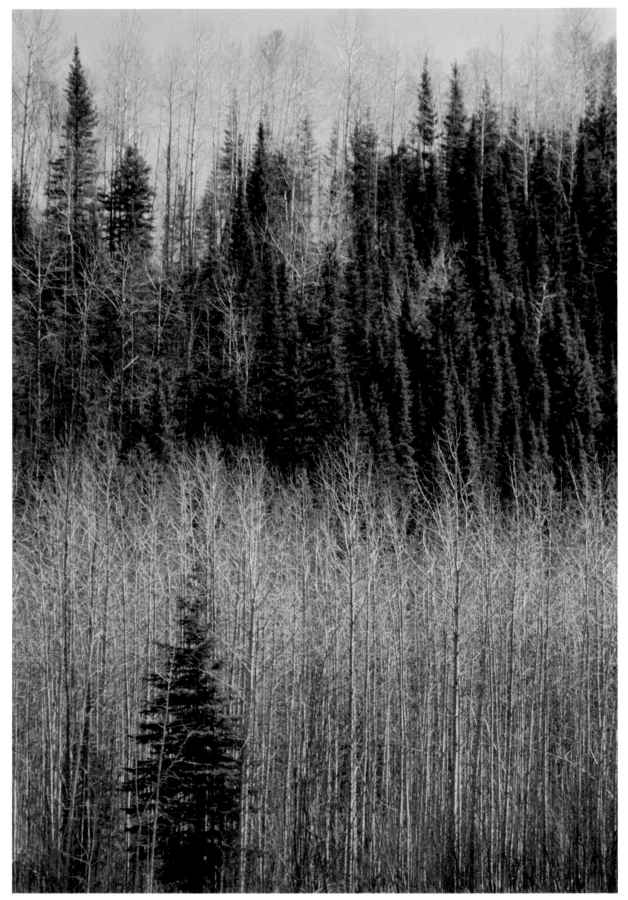

*LEFT / ALONG THE
WHITEFISH RIVER
BRUCE PETERSEN*

*RIGHT / LOWER FRENCH
RIVER WATERWAY PARK
LORI LABATT*

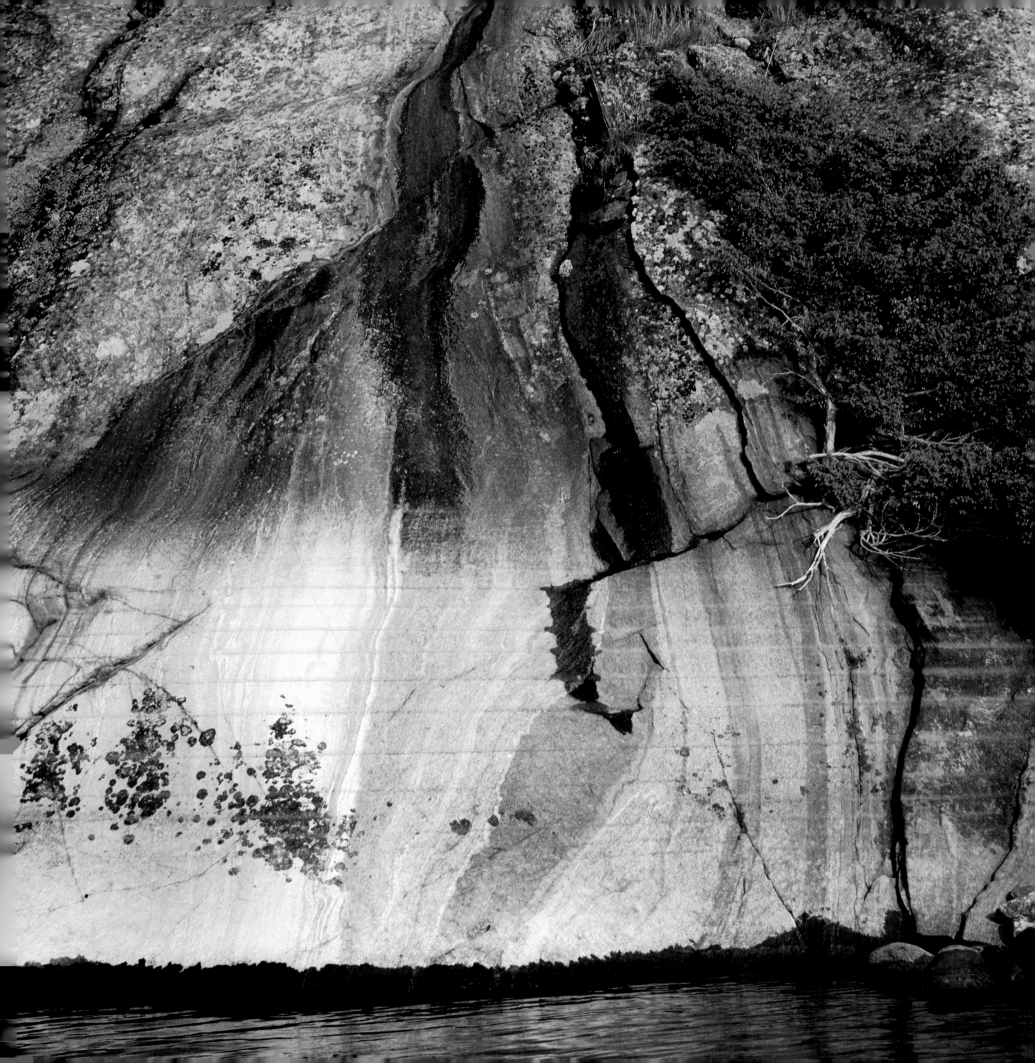

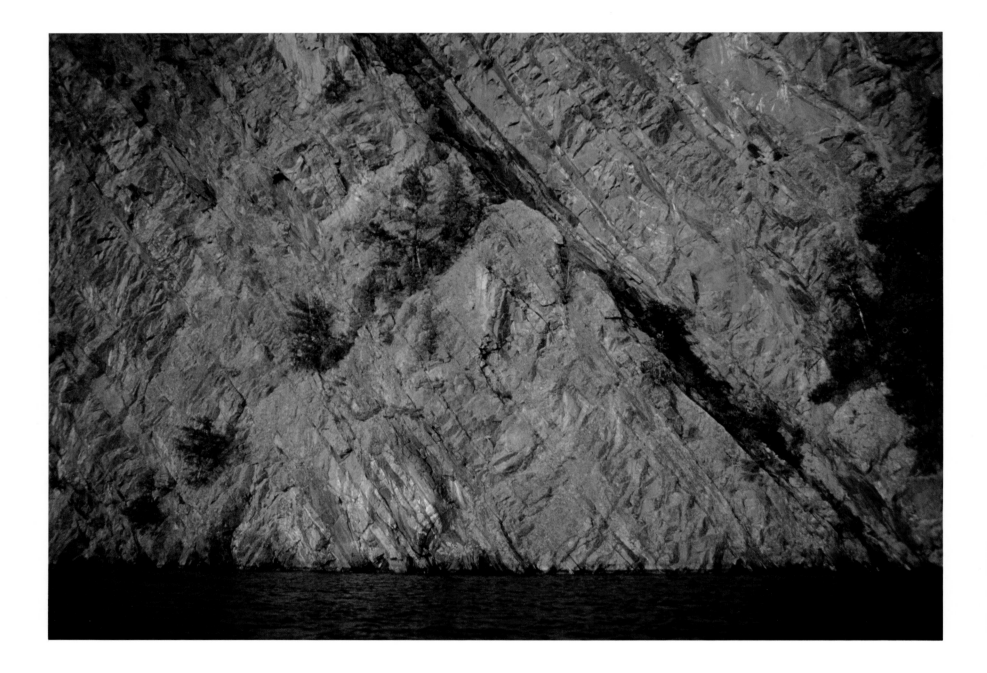

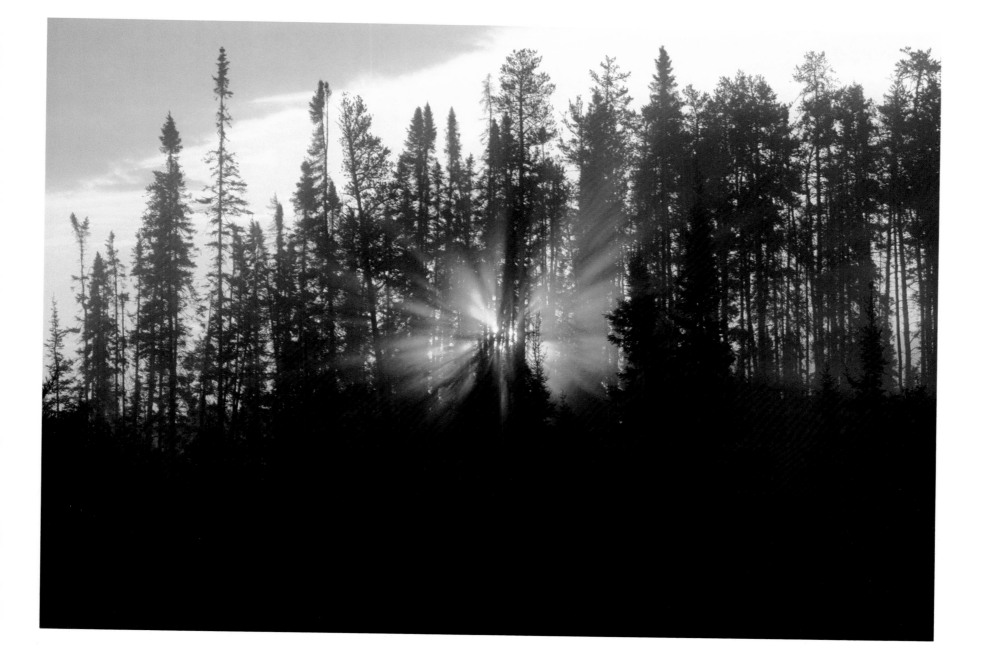

LEFT / MAZINAW ROCK, BON
ECHO PROV. PARK
BRUCE LITTELJOHN

ABOVE / NEAR WHITE RIVER
KARL SOMMERER

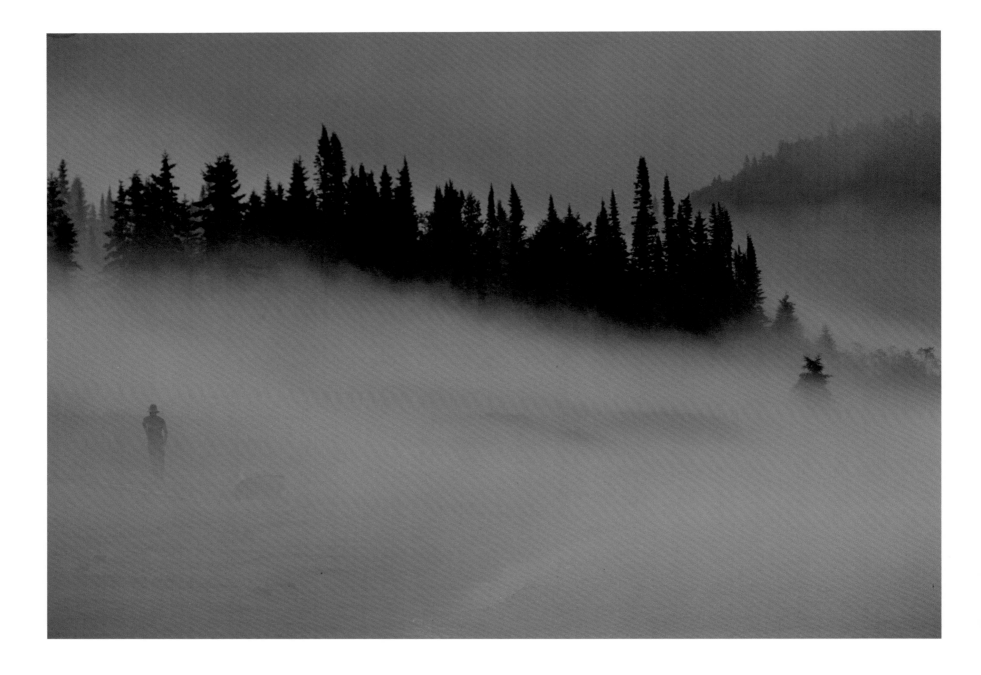

present. For instance, the rationale for creating parks has not fundamentally changed. Present policy declares that provincial parks are created to meet protection, recreation, heritage appreciation, and tourism objectives. Late-nineteenth-century conservationists could have subscribed to such a statement. Similar objectives were embedded in Alexander Kirkwood's 1886 pamphlet calling for the establishment of "Algonkin Forest and Park" and the 1894 petitions of the Kent County–Chatham residents requesting that Rondeau Peninsula be designated a provincial park. Differences are ones of degree, not kind.

Beyond the persistence of the basic rationale for setting aside parkland, the cast of players in the provincial parks story also reflects historical continuity. The groups now dominating centre stage in the competition to shape park policy are similar to the original conservationists, naturalists, hunters and anglers, recreationists, and industrial interests behind the creation and management of our first parks. And now, as then, in the midst of the incessant jostling for influence among the various park users and interests, can be found the government officials — the civil servants and politicians — who must strike a policy balance palatable to the principal players in the cast.

The relationship between continuity and change is a convenient lens through which to view the parks story. During the twentieth century, Ontario has undergone massive urban, industrial, demographic, and cultural transformations. As our society evolved, so, too, did the climate of opinion on such matters as out-door recreation, natural areas protection, the environment, and the uses of forests. These changes in attitude altered the balance of influence among the competing groups using the parks and required occasional revisions in the emphasis given to the different aims of parks policy. Frank A. MacDougall, the "flying superintendent" of Algonquin Park during the 1930s, and later Deputy Minister of Lands and Forests (1941–66), put it this way: "The world is changing daily," he wrote in 1965, "and we have to change . . . at intervals close enough that we catch up with changes. We are like the tortoise and the hare — in reverse — the hare being us [the park managers] to dart ahead and catch up. We make progress in jumps."

What follows, then, is a selective, reflective survey of a century of provincial park development in Ontario, with emphasis on those periods when societal pressures prompted the government to make revisions in policy, or as MacDougall put it, to "make progress in jumps".

THE DOCTRINE OF UTILITY AND PROFIT

Beginning in the mid-1960s, people trained in the social and natural sciences, as well as environmental and recreational planning, began to demand that our provincial parks be acquired, classified, and managed according to sophisticated system planning and policy frameworks. This was a dramatic change in approach from earlier practices in which parks were selected and managed in a planning and policy vacuum, through a process of creative ad-hoccery, and usually in response to immediate local needs and political pressures. Before 1954, each of our first eight parks had been established without reference to the others; nobody had yet conceived building a system of different types of parks and protected natural areas which represented the spectrum of provincially significant natural, cultural, and recreational environments or which provided equitable levels of camping, day use, and wilderness recreational opportunities for all Ontario residents.

The creation of our first provincial parks was due to the influence of the first conservation movement, which emerged in the last two decades of the nineteenth century. That movement arose in reaction to intensifying urban and industrial growth and the resulting exploitation and destruction of Ontario's natural, scenic, and recreational resources.

The main ideology of early conservationism has been variously described by historians as "the gospel of efficiency", "the doctrine of usefulness", or the "wise use" conservation impulse. Those who held these ideas, like the renowned Gifford Pinchot of the United States Forestry Bureau, emphasized the judicious and scientific management of natural and recreational resources to prevent depletion and destruction. A second but much less powerful current of thinking also ran through conservationist ranks — the so-called "doctrine of unselfishness", represented in the United

States by John Muir and the Sierra Club. Conservationists of this persuasion, usually the members of the early local naturalist groups in Ontario, were more idealistic, less mindful of questions of utility and economics, and more concerned with preserving scenic, wilderness, and wildlife resources for aesthetic, transcendental, and scientific reasons. In the beginning, these two currents in the conservation stream converged in Ontario to their mutual benefit, for both represented a sharp contrast to the prevailing mentality towards nature as an unlimited storehouse to be exploited at will.

The pressures which led to the creation of the first eight parks primarily reflected utilitarian rather than preservationist thinking. Algonquin Park, for instance, was mainly set aside to provide watershed protection. Forest cover was to be maintained on the height of land in the Nipissing District to ensure adequate water flow downstream for lumbering, power development, and manufacturing. Settlers, considered to be the main threat to the forests, were banned from the park area. The Ottawa Valley timber men, on the other hand, were allowed access, as conservationists of the day did not think the establishment of Algonquin involved a choice between water and wood. "The timber need not be permitted to rot down," explained Alexander Kirkwood. "The mature trees can be cut in due season to allow the next in size a chance for growth." In this way, "utility and profit will be combined: the forest will be of great benefit as a producer of timber, and will add to the provincial revenue."

Game protection ran a close second to watershed protection as a reason for the park. In setting aside Algonquin, the government of Oliver Mowat was partly reacting to the report of the McCallum Royal Commission on Fish and Game (1892), which had documented a wildlife crisis of massive proportions in southern Ontario. "On all sides, from every quarter," the commissioners had reported, "has been heard the same sickening tales of merciless, ruthless, and remorseless slaughter." If it continued, they claimed, hunters and anglers would be denied their recreation, and the tourist and outdoor recreation supply industries would lose their clientele. The government assumed that

Algonquin Park, as a wildlife reserve where hunting and trapping would be prohibited, would serve as a breeding ground to restock surrounding areas with game and fur-bearing animals.

Briefly, one can identify similar "wise use" or utilitarian considerations behind the creation of all the early parks. Recreation, tourism, and harbour protection shaped the decision to establish Rondeau in 1894. Nineteen years later, in 1913, the government set aside Quetico for game and forest protection. The promotion of auto tourism and recreation lay behind Presqu'ile in 1922, Ipperwash in 1938, and both Lake Superior and Sibley in 1944, the last two parks being situated on the proposed route of the Trans-Canada Highway.

Utilitarianism conditioned most aspects of park management policy for half a century. The results were not always conducive to the protection of scenic and natural values. In Algonquin and Quetico timber operators frequently logged the shorelines of canoe routes and left unsightly slash for all to see. In the spring, they dammed outlets to lakes to facilitate log driving and sometimes maintained the high water level into the summer, a practice which created an ugly fringe of dead and fallen trees along kilometres of shoreline. During the 1920s, as the number of tourists increased in both Algonquin and Quetico parks, the Department of Lands and Forests tightened the reins on the timber operators. New licences bristled with restrictive clauses and fines were levied against transgressors. Still, government officials never questioned the assumption that commercial logging belonged in parks. "A too frequent emphasizing of the health, wildlife and recreative factors submerges the importance of the commercial factor," asserted Deputy Minister Walter Cain in 1924.

The utilitarian line of thinking also shaped park wildlife management policies as inventive officials thought up new ways to generate revenues. The first superintendent of Rondeau, Isaac Gardiner (1894–1913), constructed an aviary in 1896 and be–gan a program of raising game birds. This involved purchasing, selling, and bartering eggs, as well as selling adult birds. The aviary operation influenced other aspects of wildlife policy, since Gardiner tried to eliminate game bird predators — hawks, owls,

weasels, skunks, and foxes — by poisoning and trapping. Ironically, while waging war on these predators, Gardiner, in an effort to increase park visitation and revenues, encouraged gun clubs to locate in Rondeau where only small parties had previously hunted.

Meanwhile, superintendent George Bartlett of Algonquin convinced his superiors that "surplus" beaver could generate "a large and lasting revenue", and from 1910 to 1920 park rangers trapped beaver and other fur-bearing species for sale on the fur market. In 1913, Bartlett also began shipping live beaver and mink to fur farmers in Ontario, Prince Edward Island, and the United States. Then, abruptly in 1920, the Drury government terminated the program. Evidently, poaching had increased to embarrassing levels, as trappers in surrounding regions, angered by the competition posed by the rangers in what was supposed to be a wildlife sanctuary, increasingly engaged in illicit operations within the park.

Besides timber and wildlife, the recreational side of provincial park operations also came under the influence of the doctrine of "utility and profit". Isaac Gardiner of Rondeau assiduously worked throughout his tenure to develop his domain as an elaborate tourist resort with tidy, shaded picnic areas, manicured and stately forested areas, tame wildlife, concessions and recreational facilities which included a pavilion, and cottage subdivisions. Gardiner and his successor, George Goldworthy, also wanted a park hotel to accommodate several hundred guests, but the government, not wishing to compete with established resort hotels in nearby Erieau, repeatedly rejected this suggestion. In 1911, Gardiner also endeavoured to encourage auto tourism by constructing a circular scenic parkway through what he described as "the centre and best timbered portion" of the park. At the same time, George Bartlett of Algonquin was overseeing the beginning of developments which would turn his park into a tourist mecca for an affluent middle-class clientele. The first cottage leases were issued in 1905; hotel and youth camp leases came three years later.

The tendency to promote recreation and tourism revenues in the provincial parks intensified in the mid-1920s, an era of stringent government austerity. The province ran deficits from 1918 to 1927, when the end of Prohibition produced a surge of new liquor revenues. During the austerity years, superintendents were ordered to cut back capital and operating expenditures, and to dream up ways of augmenting revenues. John Millar of Algonquin bubbled over with recommendations to open his park to a wide range of commercial activities. In 1922, he began the practice of having the rangers produce maple syrup for sale to tourists. He also proposed that licences be sold to those wishing to graze livestock in the park, to operate canoe liveries and riding stables, and to extract gravel and sphagnum moss. He also recommended licensing pedlars, egg collectors, and taxidermists and establishing "retail stores of every description" including a pool hall and bowling alley. Even the revenue-hungry Department of Lands and Forests found most of these suggestions unacceptable.

One of the main revenue production strategies adopted by the department in the mid-1920s involved promoting recreation and tourism in parks, with special emphasis on attracting leaseholders. From 1923 to 1928, two new lodges, four youth camps, and dozens of cottages appeared in Algonquin. The number of cottages in Rondeau rose from sixty in 1921 to 268 in 1931. Perhaps the most insidious consequence of this policy was the tendency to manage and develop the parks to suit the interests of the leaseholders. In 1922, for example, the Rondeau cottagers succeeded in obtaining major street improvements in their subdivisions, the introduction of hydroelectricity, an ice-house, and a gasoline pump operated by one of their own on the right-of-way in front of his cottage.

Nowhere was the temptation to operate and develop parks as the private preserves of the leaseholders more powerful than at Long Point and Presqu'ile, which were both administered by commissions often appointed from the ranks of the leaseholders themselves. Required to balance their budgets annually, the commissioners aggressively promoted cottage development and strove to meet the needs of the leaseholders, whose annual rents provided the bulk of the operating revenues. At Long Point various commissions pursued cottage development with a singlemindedness that defied the conservationist intent of the Park Act. After the Second World War, so little land remained for public use — there were 550

cottages in 1949 — that the original Long Point Park had to be abandoned and a new park relocated on adjacent property.

The social composition of the cottage communities in the parks also reflected how restricted these ostensibly public areas became. Beginning in the 1920s and lasting to the mid-1940s, the cottage associations controlled access to their numbers often on the basis of race, colour, and creed. The original by-laws of the Long Point Association banned the rental of cottages to Jews "or for that matter any others, who for any reason, either political or religious, would be unable to unite in the general idea of a congenial gathering for the summer months". At Rondeau, the association forbade members to rent to non-whites and non-Christians. Little wonder that black residents of Kent County rarely used the park's beaches and congregated instead across the bay at Shrewsbury.

CROSS-CURRENTS IN CONSERVATION

Despite the good intentions of government officials, park policies based on "utility and profit" inexorably led to environmental and scenic degradation. During the late 1920s and 1930s, two new groups — the Quetico–Superior Council and the Federation of Ontario Naturalists — challenged the utilitarian paradigm and jostled the conservationist old guard for a larger place in the park sun. These organizations took the position that wilderness and representative natural areas should be treasured for recreational and aesthetic reasons and preserved for scientific and educational considerations.

The Minnesota-based Quetico–Superior Council (QSC), was established to protect the recreational and wilderness values of the vast lake-spangled Rainy Lake watershed in both Minnesota and Ontario. Formed in 1928, the QSC set out to thwart the plans of timber baron Edward Backus, who wanted to construct a series of dams along the international border from Fort Frances to the east side of Quetico Park. If completed, the dams would have raised water levels on the border lakes between Quetico Provincial Park and the Superior National Forest by as much as 24 m. The damage to the scenic and natural values of the area, renowned for its wilderness canoeing, would have been incalculable.

The QSC was not rooted in the preservationist tradition; its members acknowledged that logging would remain the economic destiny of the Rainy Lake region. What they demanded was a reworking of the wise-use equation to give primacy to the recreational and scenic values along the waterways of Quetico–Superior. They wanted all shorelines reserved and protected from logging, flooding, and other forms of exploitation by means of a formal treaty between Canada and the United States. In large part because of the efforts of the QSC, the Backus scheme was thwarted, and by 1941 shoreline reservations had been placed on all canoe routes in Quetico Park and adjacent sections of the Superior National Forest. The proposal for a treaty, however, got nowhere. Officials in both Ontario and Minnesota were adamantly opposed to turning over administrative control of the watershed to their respective federal governments. Still, there was a happy outcome to the treaty question. In 1960, after thirty-three years of lobbying, the QSC and its Canadian counterpart (the Canadian Quetico–Superior Committee formed in 1949, and reconstituted as the Quetico Foundation in 1954) arranged a diplomatic exchange of letters between the United States and Ontario governments to protect the primitive conditions of Quetico Provincial Park and the Boundary Waters Canoe Area.

Unlike the QSC, the Federation of Ontario Naturalists (established in 1931) emerged out of the preservationist side of conservationism — a tradition which had been informed in recent decades by the new science of ecology. In its second publication, *Sanctuaries and the Preservation of Wild Life in Ontario* (1934), the FON questioned the excessive emphasis that governments placed on utilitarianism. "The need for nature preservation does not depend only on the economic value of the natural life usually considered worthy of conservation," the federation asserted. There were also compelling scientific and educational reasons for creating a system of nature sanctuaries in provincial parks and on Crown land for the "preservation of representative samples of the natural conditions, including the plants and animals," characteristic of the province.

In calling for a nature reserve system, *Sanctuaries* stands out as a landmark document in Ontario conservation history and was

decades ahead of its time. It also signalled that the two currents in the conservation stream – the utilitarian and the preservationist – which had flowed together when it came to park issues, had finally veered apart.

In 1938, the issue of logging in Algonquin Park served to bring the two ideologies coursing back towards one another to create turbulent cross-currents in the conservation stream. When the Depression eased in the mid-1930s, timber operators in Algonquin expanded their woods operations (fourteen licence holders employing some 1,500 men were active in the bush during 1934–35). At the same time, the number of recreationists swelled dramatically with the opening of Highway 60, built following the closure of the Canadian National Railway line in 1933. As recreationists and naturalists became aware of the destructive logging practices, the FON orchestrated a public protest and called for a ban on all logging in the park.

The idea of prohibiting logging in Algonquin was anathema to most government foresters, who by inclination and training were rooted in traditional "wise use" conservationist thinking. All the same, the FON arguments did not fall entirely on deaf ears. The naturalists found an ally in the person of the park superintendent, Frank A. MacDougall, who over the course of the 1930s had been gradually amending park policy in favour of scientific research as a basis for resource management, scenic and wildlife protection, recreation, and visitor education. MacDougall drew inspiration from many sources, but his general policies reflected the philosophy of multiple land use as practised by the United States Forest Service. For MacDougall, multiple use meant that wherever a clash occurred between recreationist and logger, scenic protection and recreational values should become the primary variables in management policy. Accordingly, in 1939, he responded to the protest over logging practices in Algonquin by instituting a standard shoreline reserve policy on all canoe routes and portages in the park. Shortly after becoming deputy minister in 1941, MacDougall heard the entreaties of the QSC and extended the same standard shoreline protection policy to Quetico.

Significantly, MacDougall also made the preservation of natural areas as well as scientific research part of his multiple use model in Algonquin. In 1940, for example, he established an important precedent by setting aside two small areas of pine forest as nature reserves. Four years later, as deputy minister, he designated a 7,770-ha "wilderness area" in Algonquin for wildlife and silvicultural research. All in all, MacDougall's multiple use approach was innovative and progressive for the times. By embracing both utilitarian and preservationist positions, MacDougall struck a new balance in park management policy which lasted until the environmentalist upsurge in the 1960s.

THE GREAT RUSH TO GET OUTDOORS
Following the Second World War, rapid population growth, urbanization, a rising standard of living, increased levels of leisure time, more personal mobility, tourism, and an increasingly younger, more educated population all combined to sustain thirty years of explosive growth in outdoor recreation in Ontario and a concomitant demand for parkland. Initially, Frank MacDougall and his foresters underestimated the dramatic socio-economic and attitude changes at work and, instead of intensifying their efforts to meet the outdoor recreation challenge, attempted to rid themselves of responsibility for providing parkland in the southern districts of the province. In 1949, the Department of Lands and Forests transferred the commission parks at Long Point and Presqu'isle to the Department of Municipal Affairs. Three years later, an amendment to the Provincial Parks Act placed Rondeau and Ipperwash under the same department (although the amendment was never proclaimed because of administrative obstacles and public opposition).

As it happened, the foresters failed to disentangle themselves from the southern recreation parks. The public demand for more parkland with beaches, picnic and camping facilities, and protected natural areas, all within a few hours' motoring distance of the major urban centres, could not be denied. In addition, MacDougall and his foresters gained a better appreciation of the role other lands and forests agencies were playing in the outdoor recreation field after the regional foresters toured the American state park systems in

1953. Subsequently, Ontario's Department of Lands and Forests officials reversed their decision to concentrate solely on operating the large northern parks. At last, in 1954, the government of Premier Leslie Frost acknowledged the great rush to get outdoors by creating the Division of Parks within the Department of Lands and Forests. Its mandate was to develop, as rapidly as possible, a network of provincial parks around the shorelines of the southern Great Lakes and at regular intervals along the major tourism highways. By 1960, the number of provincial parks had expanded to seventy-two; a decade later there were 108 in operation.

The demand for parkland seemed to be insatiable. Year after year, Ontarians flocked to provincial parks in numbers beyond all expectations. Over the five-year period from 1957 to 1961, overall visitation increased 300 per cent to 6.2 million users, while the number of campers alone skyrocketed to over 862,500, a staggering 995 per cent increase. Interior users in Algonquin tripled from 10,600 in 1958 to 32,800 in 1961. A decade later, in 1970, some 12 million people used the 108 operating provincial parks. And still there remained a shortage of parkland, especially in southern Ontario.

The massive expansion of the provincial park system, driven as it was by the recreation imperative, shifted the balance between the various user groups and forced a rethinking of management policies. The Department of Lands and Forests faced a dilemma: how to accommodate the resource extractors in the midst of hordes of recreationists, while at the same time advancing protectionist objectives?

In the attempt to meet this challenge, various policies were cobbled together including the 1954 "back to nature" strategy involving the phasing out of the leaseholders in the original eight parks, and the decision in 1956 to ban prospecting, staking, and mining in all parks. As for logging, in 1961 the Parks and Timber branches agreed upon guidelines which involved a general application of the kinds of timber management practices introduced thirty years earlier by Frank MacDougall in Algonquin Park. In theory, at least, the guidelines protected waterways and portages, public use areas, scenic vistas, and nature reserves from the loggers.

Unfortunately, these and other initiatives failed to produce the desired balance and harmony in the parks system. By the mid-1960s, the tremendous visitor pressure on existing parkland had created a recreation/preservation imbalance and had generated an almost overwhelming set of management problems—overused campgrounds, environmental degradation, rowdyism, crowded and littered canoe routes, and heightened tensions between hunters and naturalists, motorboat anglers and wilderness trippers, loggers and environmentalists.

Almost from the outset of the parks expansion program, conservationist groups looked to the government for an official parks policy as a way of resolving conflicts and preventing new ones. During the late 1950s, the Conservation Council of Ontario, the FON, and the Quetico Foundation deplored the way park management decisions were being made by bureaucratic or political whim and without the slightest hint of public consultation. They protested vehemently in 1958 when the Minister of Lands and Forests opened to the public four logging roads to the perimeter of Algonquin Park, and again in 1959 when Deputy Minister MacDougall decided to set aside some 2,200 ha of Algonquin for the construction of a radio observatory by the National Research Council of Canada.

The conservationists were frustrated that the Ontario Parks Integration Board seemed incapable of developing a general parks policy. The board, composed of cabinet ministers, had been established in 1956 to coordinate the acquisition, development, and management policies of the various parks agencies in the province. Eventually, the FON stepped into the breach and issued an "Outline of a Basis for a Parks Policy for Ontario" (1958), a document which denounced the dominance of recreation and utilitarianism in existing provincial park policies and demanded that more consideration be given to the protection of natural areas. To that end, the FON urged that logging, trapping, and sport hunting be banned from parks, as well as any other activities detrimental to ecological values and nature appreciation. Most important, however, the document urged the province to set aside a representative system of nature reserves by following the lead of the British Nature Conservancy in this regard.

SHORELINE NEAR PINERY PROV. PARK, LAKE HURON
FREEMAN PATTERSON, MASTERFILE

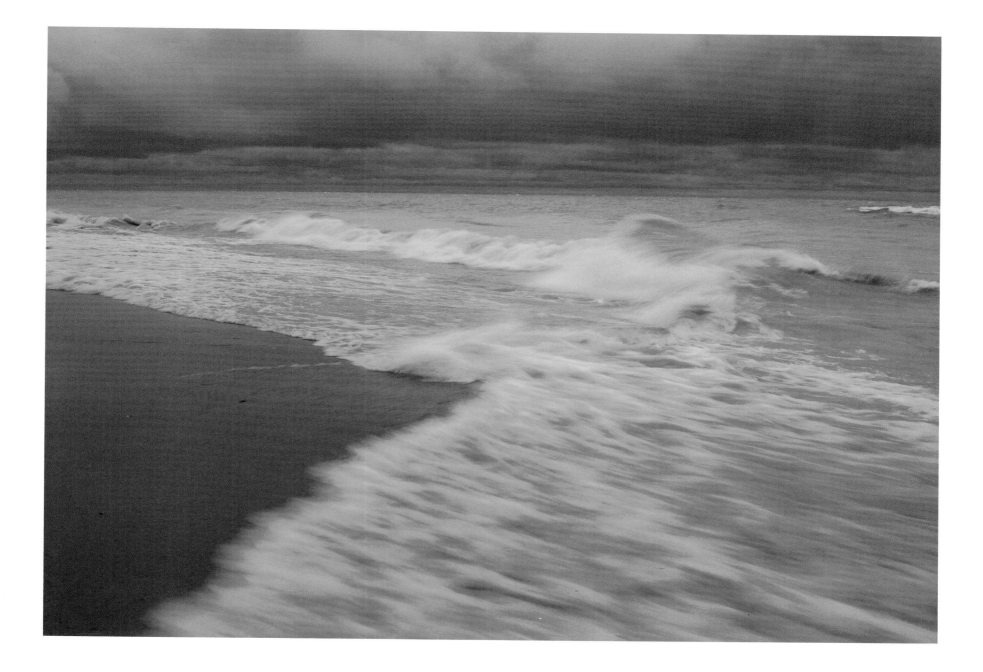

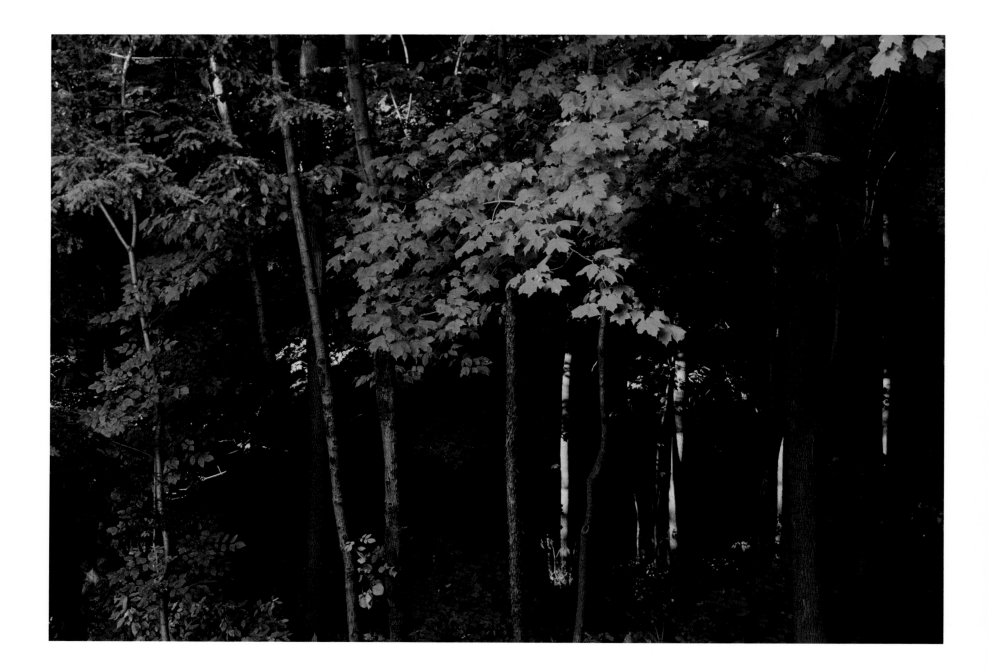

ABOVE / SUGAR MAPLES, BRONTE CREEK PROV. PARK
LORI LABATT

RIGHT / LOON AND CHICKS, KILLARNEY PROV. PARK
LORI LABATT

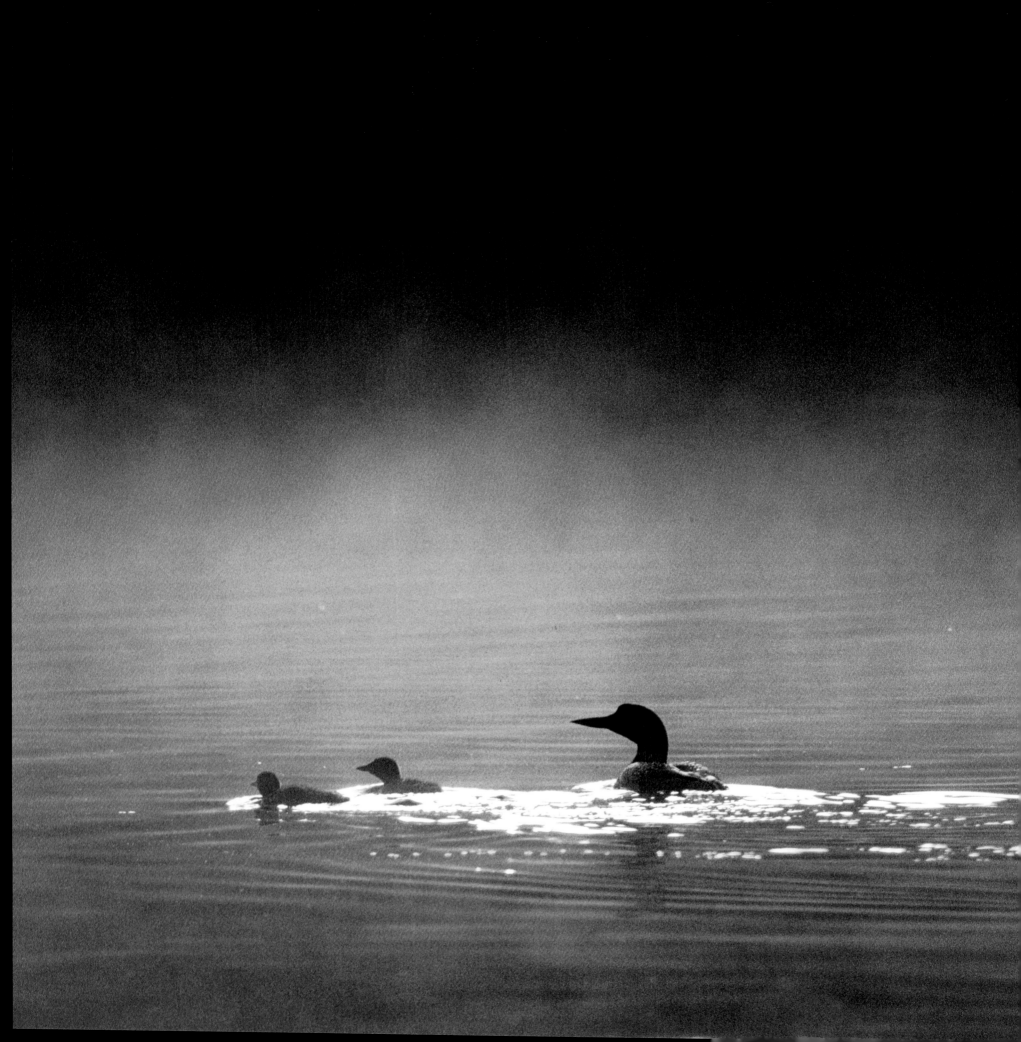

Sensitive to the FON criticisms, the Frost government responded by introducing the Wilderness Areas Act (1959), which provided the first legislative recognition for the nature reserve concept in Ontario (albeit under the misnomer Wilderness Area). The legislation also provided for the protection of historical sites. Alas, the act contained a major deficiency. In deference to the mining interests, who feared that vast tracts of Crown land would be removed from resource exploitation, the government restricted full protection to those Wilderness Areas under 260 ha (640 acres) in size, and made larger ones subject to "development and utilization". Despite this flaw, it is noteworthy that the act did provide a mechanism by which protection was afforded to many important sites which eventually became parks. Petroglyphs Historical Park, Michipicoten Historical Park, Polar Bear Wilderness Park, Pukaskwa National Park, and the Bat Cave, Gibson River, Matawatchan, Montreal River, and Porphyry Islands Nature Reserves all were initially protected under the Wilderness Areas Act.

During the early 1960s a growing number of conservationists and government officials concluded that to resolve the management problems besetting provincial parks, a classification scheme had to be entrenched as an integral component of parks policy. No one park, they realized, could be all things to all people. Instead, different types of parks should be established for different user groups and should be managed to achieve specific objectives.

Ideally, classification of parks held the promise of replacing conflict and confusion with harmony and balance throughout the parks system. The American Outdoor Recreation Resources Review Commission (ORRRC), appointed by Congress in 1958 to ascertain the nation's outdoor recreation needs to the year 2000, was especially influential in developing a wider appreciation of parks classification across North America. In its final report, *Outdoor Recreation for America* (1962), the commission issued a standard parks classification framework destined to influence park agencies in both the United States and Canada. The Canadian Federal–Provincial Parks Conference (in which Ontario park officials participated) took the cue from the ORRRC and developed a standard classification framework of its own by 1965.

Following the reorganization and expansion of the Ontario Parks Branch in 1965, the new planning section headed by James Keenan consulted widely both within and outside the Department of Lands and Forests before introducing a provincial park classification and zoning system based on the Federal–Provincial Parks Conference model. The scheme received government approval in 1967. Henceforth, new and old provincial parks were classified into five categories: Natural Environment, Nature Reserve, Primitive, Recreation, and Wild River. That same year, again following a path blazed by the ORRRC, the Federal–Provincial Parks Conference initiated the Canada Outdoor Recreation Demand Study, while Ontario launched the companion Tourism and Outdoor Recreation Planning Study. From 1967 through the mid-1970s, these programs undertook the outdoor recreation supply inventories and leisure behaviour surveys essential for determining how many of each class of park Ontario required, where, when, and why.

Meanwhile, during 1967–68, under the impetus of the new classification policy, the Parks Branch conducted inventories of the province's rivers and set aside sections of the Mattawa and Winisk as the first Wild River parks. In 1967, the Robarts government also abandoned the longstanding practice of requiring municipalities and conservation authorities in counties along the southern portion of the Niagara Escarpment to assume all responsibility for providing recreational parkland. That policy had left the heavily urbanized counties of Lincoln, Welland, Brant, and Wentworth without any provincial parks and their residents without adequate outdoor recreational opportunities. Belatedly, Premier John P. Robarts recognized the need to preserve the recreational and natural values of the Niagara Escarpment; he commissioned Leonard Gertler to conduct a study to delineate areas worthy of protection for their recreational and environmental values and to recommend how they might be preserved.

Preservationists were also delighted by the designation in April 1968 of Ontario's first Primitive Park – Polar Bear, consisting of 18,000 km². In Canada at the time, only Wood Buffalo

National Park could claim to be larger. The FON also applauded the conversion of five Wilderness Areas to Nature Reserve status, the creation of two new reserves (Trillium Woods and Wauba-shene Beaches), and the appointment of a special advisory committee to plan the Nature Reserve system.

As one park announcement followed another during 1967–68, it seemed that all was roses in the provincial parks garden. In fact, nothing could have been further from the truth. The euphoria over the classification policy and the new park initiatives turned out to be short-lived, a lull before the storms ahead.

ENVIRONMENTALIST IMPACT

The 1967 parks policy came to a standstill over the issue of creating Primitive parks. With the exception of Polar Bear, which was located above the tree line and in an area of low mineral potential, timber and mining interests rejected proposals for new Primitive parks and opposed the idea of reclassifying large Natural Environment parks. Industry viewed Primitive parks as a colossal waste of potentially valuable natural resources and an extravagant amenity for a handful of recreationists and naturalists. In rejecting the preservationist concept of parks, the industrial interests evoked the principle of multiple use, which, ironically, had first been introduced by Frank MacDougall in the 1930s to accommodate the preservationist position. For its part, the Robarts government upheld the doctrine of utility and profit and classified Algonquin and Quetico, Killarney and Lake Superior as Natural Environment parks where commercial logging was permitted.

The problem with all of this was that forestry practices had undergone a massive transformation since the Second World War. The teamster, winter camp, and spring river drive had been replaced by a highly mechanized and automated year-round operation. Technological advances in equipment in the form of chain saws, wheeled tractors, and skidders allowed for the harvesting of trees previously considered uneconomical. The scream of chain saws and the roar of engines now reverberated through the bush. Worse still for wilderness users, the forest industry required permanent road systems through formerly inaccessible areas to accommodate the massive trucks now required to haul the logs to the mills. Modern mechanized logging had become far more damaging to the environment than earlier methods.

The question of logging and the classification of the large Natural Environment parks became the focus of public controversy as two new organizations stepped forward to join the FON in championing the cause of natural areas protection. The National and Provincial Parks Association of Canada (today the Canadian Parks and Wilderness Society), established in 1963, became a force to be reckoned with, especially after Gavin Henderson assumed the executive director's position in 1965. Then, in June 1968, the Algonquin Wildlands League (AWL) sprang into prominence under the leadership of such worthies as Douglas Pimlott, Abbott Conway, Walter Gray, and Patrick Hardy. With the formation of the AWL, the stage was set for a showdown between wilderness preservationists and loggers over the future of Ontario's large provincial parks.

The quickening preservationist impulse in Ontario was part of a larger and growing phenomenon sweeping North America—the environmental movement. The new environmentalists were ecologically aware and concerned about issues related to "quality of life", "environmental protection", the fundamental question of human survival on a planet under siege from air and water pollution, and the awesome effects of urban, industrial, and technological developments which threatened the last vestiges of wilderness everywhere. In such a world, the environmentalists concluded, the preservation of natural areas had become an urgent priority. This understanding of the importance of their cause steeled the AWL members against their critics. League members drew inspiration from the literature and accomplishments of their counterparts to the south who were rapidly developing a national wilderness system following the passage by Congress of the Wilderness Act in 1964.

From 1968 to 1974, the AWL and its allies earned themselves a lasting place in Ontario conservation history by generating, for the first time, widespread public support for wilderness preservation. Indeed, the AWL succeeded in making the management of the

province's large parks a litmus test of the Robarts and Davis governments' commitment to environmentalism. People from all political camps, regions, social strata, age groups, and genders responded to the AWL's clarion call. These were the Ontarians who had been part of the post-war outdoor recreation boom, who treasured their parks and natural areas, and who feared the threat of air and water pollution. They believed that parks and wilderness were essential to a healthy quality of life, that forests were to be valued less as tree farms than amenities to be enjoyed (albeit vicariously by many people) and protected and managed for their recreational and scientific values.

By 1974, the wilderness preservation movement had made impressive gains. Logging had been banned in Killarney and Quetico, and both parks had been designated Primitive, in 1971 and 1973 respectively. Further, in 1971, the new premier, William Davis, just prior to his first election in October, signed an agreement with Ottawa to create Ontario's first large National Park at Pukaskwa on Lake Superior. The agreement brought to a conclusion the Ontario phase of a project begun by the Canadian Audubon Society in 1962 to convince each province to create a new national park as a way of commemorating Canada's Centennial. In the past, Ontario governments had rejected proposals for national parks because of an unwillingness to transfer large tracts of Crown land to federal authority with the resulting loss of resource revenues. Moreover, provincial officials who were wedded to the multiple use approach also recoiled in disgust at the preservationist emphasis in the revised 1965 national park policy. It required the political impact of the wilderness preservationist movement, in combination with Premier Davis's pre-election jitters, to dissolve the province's objections to a new National Park at Pukaskwa.

In addition to these gains for wilderness protection, the environmentalist forces had succeeded by 1974 in entrenching public consultation as part of the provincial park master planning process. The government even appointed a Provincial Park Advisory Council to serve as a watchdog over the system and to seek public input on significant policy matters.

The environmentalists also learned the limits of their influence in these years. When faced with a choice beween employment and wilderness protection, the Davis government decreed that both Algonquin and Lake Superior would remain Natural Environment parks. To this day both parks continue to be the domain of the timber workers and the "multiple use" anomalies within the system. Still, the preservationists could take some comfort in the fact that they had forced the DLF in 1971 to introduce a policy excluding timber licences from all other parks. Henceforth, parks were to be operated as Crown Management Units; if logging was deemed necessary, the cutting would be carried out by private companies as a department project and each operation would have as its main purpose managing the forest for environmental values.

Apart from the reclassification battles from 1968 to 1974, the environmentalists also prodded the Robarts and Davis governments to address the shortage of parkland in southern Ontario. Parks were especially scarce in the province's urban and industrial heartland, the so-called "Golden Horseshoe" from Oshawa to St. Catharines, home to nearly two-thirds of the provincial population. Environmentalists maintained that the government had a responsibility to preserve in provincial parks the unique and representative physical, biological, and cultural features of areas such as the Niagara Escarpment, the Great Lakes shoreline, and the Oak Ridges Moraine, and could not ignore that responsibility simply because these areas fell within the jurisdiction of municipalities or conservation authorities. Echoing these arguments, the New Democratic Party under Stephen Lewis asked why there were only six provincial parks within a 80-km radius of Metropolitan Toronto. To the NDP, the fact that most provincial parks were inaccessible to the less affluent, less educated, and less mobile city-bound residents smacked of class bias and social inequity. Back of this debate was the sharpened realization among the politicians that a lack of outdoor recreation programs had been identified as a factor in the summer riots which had swept some dozen American cities during 1967, and that the U.S. National Park Service and several states had introduced near-urban park initiatives to address this problem.

Such was the general context out of which emerged several special parkland acquisition funding initiatives during the 1970s. In 1971, the Davis cabinet unveiled a near-urban park initiative of its own, beginning with the showcase Bronte Provincial Park between Toronto and Hamilton, located on both the Queen Elizabeth Way and the Go-Transit line. Before the near-urban park idea foundered on the shoals of constraints and inflation in the late 1970s, the government announced that three more sites — Short Hills near St. Catharines, Peche Island located at the mouth of the Detroit River near Windsor, and Komoka near London — would be be acquired and developed as near-urban parks.

The Niagara Escarpment program also received substantial special funding after the release of Leonard Gertler's *Niagara Escarpment Study, Conservation and Recreation Report* in 1968. Following the general principles set out by Gertler, the Division of Parks alone spent over $13 million from 1972 to 1977 to acquire properties of natural and recreational significance. Meanwhile, the government began the excruciatingly complex and lengthy land use planning required to conserve the 5,200-km^2 escarpment area, a process which culminated in 1985 with cabinet approval of the Niagara Escarpment Plan. By that time, a chain of provincial parks — six Natural Environment, seven Nature Reserve, and three Recreation — had been established from Short Hills in the south to Cypress Lake and Fathom Five (the latter Canada's first underwater park) at the top of the Bruce Peninsula.

Finally, at Wasaga Beach, special funding was provided to expand the 14 km of linear beach park. A mere 121 ha in size in 1968, Wasaga was an administrator's nightmare. On peak summer days, automobiles clogged the beach to the water's edge. Planners recognized, however, that this one park possessed enormous recreational potential, especially if the cars could be banned from the shoreline. Five million people, or 70 per cent of the provincial population, lived within a two-hour drive of Wasaga. The residents of Toronto and region were particularly dependent on Wasaga for beach opportunities in a provincial park setting. Accordingly, the province added an extensive 1,194-ha dunes area to the park, and purchased at great expense dozens of lakeside cottage

properties to provide for off-beach parking lots. The automobile was removed from the shoreline in 1973.

After 1975, the special funding for Wasaga, the Niagara Escarpment, and near-urban parks gradually dried up. Parkland acquisition came to a virtual halt. Inflation, slow economic growth, and severe budgetary constraints played havoc with parks programming generally. Such conditions led to unwelcome innovations. As a case in point, in 1976 the Davis government introduced park privatization, the controversial practice of contracting out to private entrepreneurs the operation of small Recreation-class provincial parks. In these difficult times, the Parks Branch (reorganized as the Division of Parks in the new Ministry of Natural Resources in 1972) wisely made a virtue out of fiscal necessity and turned its energies and limited resources to matters of park policy and system planning.

"THE GOSPEL RELATING TO PARKS" AND . . . SLUP!
During the years when wilderness preservationists and special park funding commanded the public's attention, the Parks Division and the regional offices of the MNR underwent profound changes in both the quality and quantity of their personnel. Of particular significance, parks planning became professionalized with the addition of specialists from a wide spectrum of disciplines. By the late 1970s, these new administrators had introduced park master and system planning programs which put Ontario at the creative forefront of North American park agencies. The highlight of their efforts occurred in 1978 with the approval by the Davis cabinet of an official parks policy and the completion of the so-called "blue book", the *Ontario Provincial Parks Planning and Management Policies* manual.

The "blue book", referred to by many as "the gospel relating to parks", was of extraordinary importance and sophistication. Based on a decade of scientific and recreation research and analysis, it provided answers to a host of complex questions: What were the goals and objectives of Ontario's provincial park system? How many of each class of park did Ontario need? Where should these parks be located and why? What activities should be

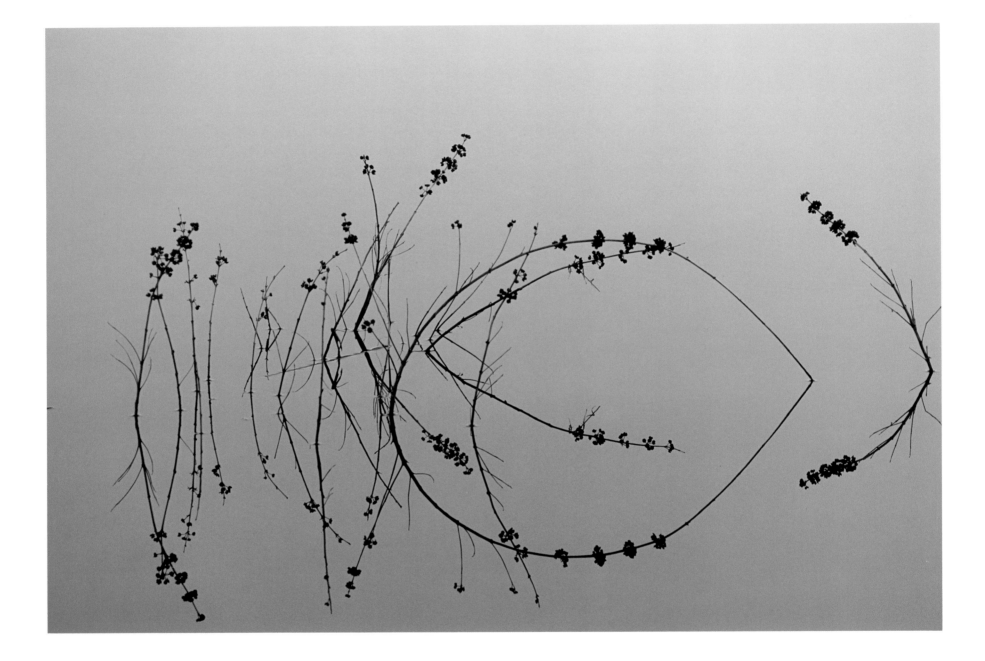

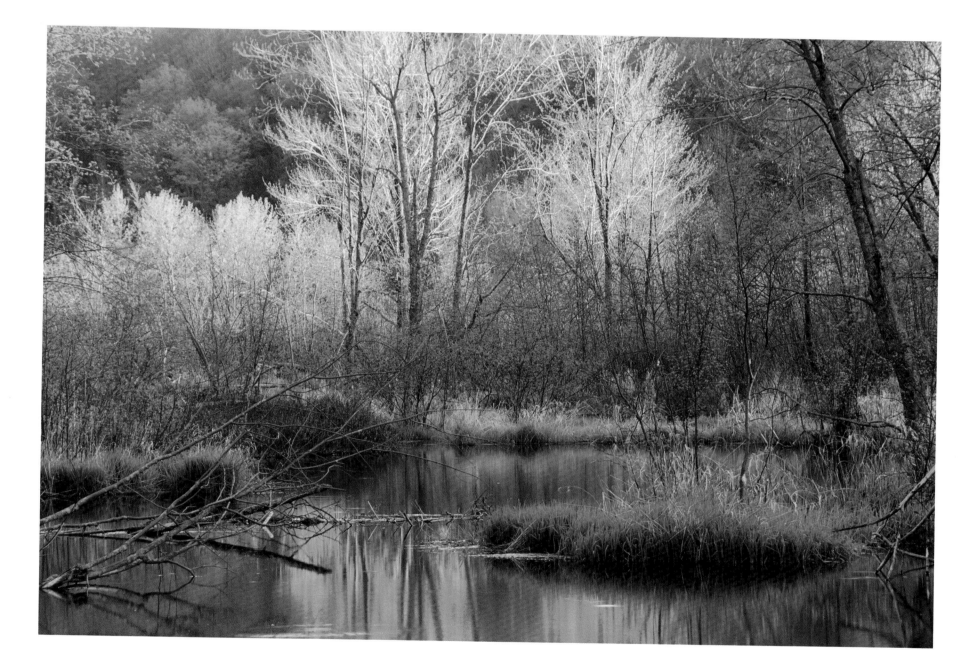

LEFT / PRESQU'ILE PROV. PARK
ROBERT BOUDREAU

ABOVE / SPRING MARSH,
LAKE MINDEMOYA,
MANITOULIN ISLAND
M. PATRICIA LANGER

permitted/prohibited in each class of park and zone? The new policy also broadened out the 1967 classification framework by adding Historical Parks to the system, while revising two other park classes. Primitive Parks became Wilderness Parks, and the Wild River designation metamorphosed into a Waterway Parks class to encompass the full spectrum of water routes capable of providing quality recreational experiences.

Possessed of a clear idea of what the optimum Ontario parks system should look like, regional parks officials undertook the earth and life science inventories and field surveys necessary to identify the actual sites required to meet the "blue book" targets prescribed for each class of park. This painstaking work came to fruition in early 1981 with the completion of parks system plans for each of the MNR's eight administrative regions. These documents identified 245 candidate provincial parks which the planners deemed necessary to achieve policy objectives. The sig–nificance of these documents and the policy frameworks upon which they rested can scarcely be exaggerated. They provided a powerful, indeed an irresistible rationale for expanding the parks system. As it happened, these plans and policies set the agenda for the park advocacy groups and inspired them to extraordinary action during the 1980s. By decade's end, the politicians had been compelled to double the provincial parks system and to manage it according to "the gospel relating to parks".

This scenario began to unfold in 1981 when the MNR at-tempted to dovetail the regional park system plans into the broader Strategic Land Use Planning (SLUP) program, a remark-ably ambitious attempt to sort out the future uses of Ontario's vast Crown land base. At this juncture, the 245 candidate parks had to be assessed against the land and water requirements of other minis-try programs and the needs of all users of Crown land resources. Predictably, in every MNR district, especially in northern Ontario, commercial and industrial interests, fishing and hunting groups, and some native peoples assumed an anti-parks posture. Most were agitated about the seven candidate Wilderness Parks and the 151 candidate Nature Reserves, in which resource extraction would be prohibited. The lines were drawn for an epic struggle

over parks and wilderness in Ontario, a struggle which would dominate the SLUP process.

It was 1982 that proved to be the most telling year in the provincial parks story. Across Ontario, in 141 district open house meetings and seven Minister's forums, the opposing forces of environmentalism and utilitarianism turned out in force to register their views for or against wilderness. A coalition of eight environ-mentalist groups, which included provincial organizations such as the AWL and the FON, as well as new regional alliances such as Parks For Tomorrow in northwest Ontario and Environment North based in Sudbury, successfully organized local action committees and workshops to alert the public as to what was at stake in SLUP. The environmentalists faced a formidable and well-financed anti-parks coalition made up of such groups as the Ontario Forest Industries Association, the Ontario Trappers Association, the Prospectors and Developers Association, and the Ontario Fed-eration of Anglers and Hunters (the last a highly regarded conser-vationist organization which had resolved to oppose any new provincial park in which hunting was prohibited). At the centre of this conflict stood Alan Pope, the new Minister of Natural Resources, who was determined to bring SLUP to a swift and suc-cessful conclusion.

The smoke of combat cleared on June 2, 1983, when Alan Pope revealed the government's historic decision on the provincial parks system. The cabinet, he announced, had placed five new Wilderness Parks into regulations — Woodland Caribou and Opasquia abutting the Manitoba border, Wabakimi to the north-west of Lake Nipigon, Lady Evelyn–Smoothwater in Temagami, and Kesagami at the tip of James Bay. Although there was to be no Wilderness Park for southern Ontario, Pope revealed that as an alternative, negotiations were under way for the establishment of a National Park on the Bruce Peninsula. Another 149 new provin-cial parks of all classes would also be established as soon as possi-ble. In one fell swoop, then, the Davis government had created a provincial wilderness system and had committed itself to more than doubling the number of provincial parks.

Environmentalists quickly learned that a heavy price had

been exacted for the historic gains made that day. Drastic cutbacks had been made in the size of many parks, and ninety candidate parks had been discarded altogether, seventy-six of which had been potential Nature Reserves. There was some consolation in the fact that the MNR intended to protect these and other significant natural areas outside the parks system through the new Areas of Natural and Scientific Interest (ANSI) and private stewardship programs in partnership with the Ontario Heritage Foundation and the Natural Heritage League.

Even more disconcerting than the loss of the ninety candidate parks was Pope's declaration that the government intended to discard the protectionist essence of the "blue book" in the 155 new parks. Mining, hunting, trapping, and commercial tourism would be permitted in park classes and zones where they had been previously prohibited. Mineral exploration would be allowed in forty-eight of the new parks including all Wilderness Parks. Sport hunting and trapping would be permitted in all Wilderness Parks and thirty-eight Nature Reserves. Existing commercial tourism operations would be permitted to continue in almost all the proposed parks. Essentially, with the exception of logging, there was little to distinguish the range of uses permitted in parks and on Crown land generally. All of these policy revisions compromised the concept of a park classification system based on the principle of establishing distinct park classes and zones to achieve different objectives and to meet the conflicting needs of different user groups.

Fortuitously, the unexpected collapse of Ontario's forty-two-year Tory dynasty in 1985 and the assumption to power of a minority Liberal government headed by David Peterson provided an occasion for the review of parks policy. Within a year, the Liberals began to reshape parks policy by terminating "privatization" or whole-park contracting and by signing an agreement in principle with Ottawa to create Bruce Peninsula National Park, which encompassed Cypress Lake and Fathom Five provincial parks. As for the "non-conforming" uses permitted by Alan Pope in the post-1983 parks, that issue caused the Liberals considerable soul-searching. After nearly two years of internal cabinet debate, the

government announced on May 17, 1988, that Alan Pope's non-conforming uses (with the exception of commercial tourism) would be terminated and "blue book" managagement policies reinstated throughout the parks system.

Those who subscribed to the multiple use philosophy were incensed. *Toronto Star* sportswriter John Kerr deplored the fact that "yuppies", "tree-huggers and bunny-patters", all possessed of a "warped view of nature", had infected the thinking of the Liberal cabinet. The policy shift, he lamented, "marks a move away from conservation . . . toward total protectionism". Actually, there was slight chance of total protectionism prevailing in the Ontario parks system. Trade-offs and flexibility rather than protectionist rigidity were the hallmarks of the 1988 Liberal parks policy. Hunting and commercial tourism — activities considered exploitive by environmentalists — were permissible in selected Historical, Natural Environment, Recreation, and Waterway parks. Sport hunting was already being accommodated in sixty-six parks throughout the system. Status Indians were allowed to continue their traditional activities including hunting, trapping, and wild rice harvesting in all classes of parks located within their treaty areas.

Most significantly, considerations of "utility and profit" also influenced the ostensibly protectionist Wilderness Parks policy. In an extension of the tourism and marketing initiatives ordered by cabinet directive in 1979 and pursued through the 1980s by the Parks and Recreational Areas Branch (the new name for the Parks Division since 1979), the Peterson government substantially revised "blue book" policy to permit existing commercial tourism operations to remain in Wilderness Parks and to allow some fly-in operations and the use of motorboats. Status Indians located within treaty areas who owned and operated hunt camps in Wilderness Parks were allowed to remain and their guests permitted to hunt within park boundaries. These were hardly prescriptions typical of a policy of total protectionism!

To be sure, the multiple use exponents were correct in arguing that the 1988 policy represented a shift away from wise use conservation in the direction of protectionism. Frank MacDougall would have viewed it as one of those progressive leaps forward that

governments periodically make in response to changing social pressures. In making this shift, however, the Peterson administration had not forsaken the doctrine of utility and profit. Witness the tourism and marketing strategies pursued with enthusiasm by government officials who now describe provincial parks as "products" to be "packaged" and "promoted" through paid ad campaigns and customized marketing plans. Note, too, the blatant 1988 trade-off between "non-conforming use" and logging in Temagami. At the very same press conference that the Peterson government announced its decision on the non-conforming uses issue, it also declared that it would push ahead with the construction of the Red Squirrel Road Extension without an environmental hearing in order to give the logging companies immediate access to the "old-growth" Temagami pine forests to the south of Lady Evelyn–Smoothwater Wilderness Park. The outcome of that unfortunate decision was an ongoing political brouhaha over wilderness protection which surprised the government and led to substantial concessions' being made during 1989–90 to both the environmentalists and the Teme-Augama Anishnabai Indians who claim Temagami as their ancestral homeland.

One certainty emerges out of this brief survey of provincial park development in Ontario. The balance struck between the protectionist, recreational, and commercial interests in the 1988 parks policy is only a temporary state of affairs. In due course, some combination of economic, social, and political factors will occasion a reworking of the parks policy equation.

As a case in point, the election in September 1990 of Ontario's first New Democratic Party government under Premier Bob Rae introduced a political catalyst for change. Acting swiftly to deal with longstanding native land claims, the new government made a dramatic policy decision for Algonquin Provincial Park in January 1991. The Minister of Natural Resources, C.J. (Bud) Wildman, issued an order allowing members of the Algonquin Golden Lake First Nation to hunt and fish virtually without restriction, and to travel by motorized vehicle in the park, pending the settlement of the band's land claim. While sympathetic to the historic rights of native peoples, some environmentalists

questioned the wisdom of this decision, arguing that it violated Algonquin Park's status as a wildlife sanctuary and represented a serious setback for natural areas protection generally. To what extent the Algonquin precedent will influence the management of other parks where similar native land claims are outstanding remains to be seen.

No one can predict what the decade of the 1990s holds for Ontario's provincial park system. As in the past, recession and worsening deficits may give rise to constraints, program cutbacks, and new revenue-generating commercial tourism schemes. By the same token, there is reason to be hopeful that protectionism may be given added weight in the park policy balance. Since the late 1980s public support for environmentalism has been surging, a condition which can only benefit the parks and wilderness movement. Furthermore, the Rae government is committed to environmental reform. The premier himself, as Opposition leader, joined the Temagami Wilderness Society's blockade of the Red Squirrel Road construction and was arrested for his trouble.

Environmentalist groups have also taken initiatives which will likely have significant political consequences. On September 6, 1989, the World Wildlife Fund Canada and the Canadian Parks and Wilderness Society launched a national campaign entitled "Endangered Spaces", which included the issuance of the Canadian Wilderness Charter. The objective of the campaign is to promote the preservation of Canada's natural diversity and to encourage all federal and provincial park agencies to complete their park systems by the year 2000. Among other things, the Canadian Wilderness Charter calls for 12 per cent of the nation's land and waters to be set aside as wilderness, a goal recommended in *Our Common Future*, the so-called Brundtland Report, issued by the World Commission on Environment and Development. If successful, the "Endangered Spaces" campaign will assist Ontario's newly renamed Parks and Natural Heritage Policy Branch (1990) to complete the implementation of the provincial parks system plan. The province has yet to meet some 15–20 per cent of the parks and protected areas targets as set out in the "blue book".

Significantly, the Ministry of Natural Resources has

developed a new corporate "Direction '90s" strategy which may advance the protectionist side of parks policy. The "Direction '90s" document represents a philosophical watershed for the ministry insofar as it acknowledges the need for "changes and new directions" in resource management and endorses the concept of sustainable development as advanced in *Our Common Future*. If this corporate strategy is to succeed, the provincial parks system must

serve as the protectionist cornerstone of the ministry's sustainable development approach.

But enough is enough. Suffice it to say that all of these considerations bode well for the future. At the very least, they should give environmentalists and park advocates some grounds for optimism as they celebrate the centennial of Ontario's Provincial Parks.

Ontario Parks: Islands of Hope

Ron Reid

Outside the hall, the temperature was —40°C. The dark ranks of spruce echoed with the snaps of deep frost pushing deeper. For us southerners, the village of Armstrong in midwinter seemed very far north indeed.

But inside the steel-clad community centre, the atmosphere was steaming. Most of the town was there—an assortment of loggers, tourist operators, local natives—people who draw their living from this northern landscape, who view the resources of the surrounding Crown land as legitimately theirs. They came to air their views on a proposed wilderness park on part of that Crown land. We came too, a small handful of us, to talk about the value of setting aside some of the wilderness as a park.

The to-and-fro of lively debate surged through the hall for hours that night—sometimes laced with bitterness about the role of the "townhouse environmentalists" from the south, sometimes touching on the special affection that northerners feel for their chosen lifestyle, often dwelling on fears that a park would stifle the economic future of the town. We listened, and responded as best we could, and put forward our own case to

justify the preservation of this particular corner of wilderness.

Did we persuade anyone? I'm not sure. Eventually, the provincial government did approve part of the park we sought, in the form of Wabakimi Provincial Park. That night in Armstrong may not have been a turning point towards that decision, but it was a critical part of the process. In Armstrong and dozens of other communities affected by park proposals, facing squarely the clash of competing values is a prerequisite to preservation.

For the most part, local people are able to put their priorities on the line without hesitation—jobs, economic expansion, local autonomy to make their own decisions. "Show us" they say "how the values you attach to parks will outweigh those needs. Tell us why we need parks so badly that you are willing to threaten our livelihoods."

Strictly in local terms, that can be an impossible task. Parks attract visitors, and those visitors bring dollars and jobs to nearby communities. But in the short term at least, the numbers involved are unlikely to match the glowing projections put forward by local timber operators, mine speculators, or hunting and fishing

boosters. For the folks who make their living from the wilderness, who spend their spare time hunting or snowmobiling or fishing in the wild country, parks are just one more unwelcome intrusion. In their eyes, parks are playgrounds for rich city people, regarded in much the same light as a landfill site for city garbage would be.

Facing a hostile crowd who question the very foundations of parks philosophy can be an unsettling experience for any parks advocate. In one way, it can act as a spur to battle on, in the recognition that nowhere in Ontario is wild country safe from competing land uses. No longer can we rely on benign neglect to preserve the wilderness values of the north. Only formal designation as parkland or some other protected status can ensure a future without exploitation.

In another way, the challenges from local communities can and should make parks advocates sit back and contemplate their motives. Is the cause worth the costs? In a planet racked by environmental crises, from toxic chemicals to loss of rainforests to global climate change, how do Ontario parks fit in? Is the creation of another park a mere sop to our collective conscience, a futile gesture in the face of the real environmental problems? Are we motivated only by the cynical need to appear to be doing something positive for the environment?

How you answer those questions has a lot to do with how you view the world and humanity's place within it. If you believe that humankind has dominion, that all nature was put here as resources for our profit and pleasure, then parks perhaps are just frills. If you are persuaded that the world's environmental ills can be solved solely by the judicious application of more technology, then setting aside protected natural areas is of little or no benefit.

Such views are founded on the assumption that we humans are masters in our own house, that we have no need of nature other than as raw material for our endeavours.

But a growing chorus of dissent is labelling this world view as dangerously arrogant. Humans are, after all, but one species among billions of living things. Those other species are important not only for their potential usefulness to humankind, but also as integral parts of the complex global system that sustains all life.

While humans have become the dominant species, we still have a cardinal responsibility to share our whole planet with all other living creatures, plant and animal, that evolved here.

For this breed of conservationist, parks are an essential part of strategies to bring the world back from the brink of ecological collapse. Parks serve as refuges for species under threat, as benchmarks for environmental research, as classrooms for an increasingly urban population to learn about natural systems firsthand. They become windows onto the overlapping webs of life that make up natural ecosystems.

All this may at first strike northerners as pretty thin gruel. But even in places like Armstrong, or perhaps especially there, people can see that the landscape around them is being drastically altered by our industrial society. Clearcutting of forests, hydroelectric dams on rivers, new roads and cottages, added hunting pressure on wildlife — all are familiar factors in the wilderness frontier of Ontario's north as well as farther south.

Yet we understand little about the future effects of these changes. Will a second-growth forest produce as much wood as the original? How will wildlife or fish populations respond to the pressure of extra consumers? Are disturbed ecosystems more vulnerable to stresses such as acid rain or global warming?

Our mismanagement of natural resources will have profound effects on their future sustainability and profound effects on the economic future of resource-based communities. But when things go wrong, where will we turn to search for solutions? Most likely, I suggest, to natural ecosystem functions, where we have the best chance of sorting out how our "managed" ecosystems are misfunctioning. This benchmark role of wilderness parks could be seen as a sort of ecological insurance policy, not just for urbanites but for the single-industry towns that depend on the "spoils of nature" for their existence.

To be prudent, we should set aside a full range of protected areas to represent all the different kinds of ecosystems in Ontario. We should make sure that each sample is large enough to function normally as a natural ecosystem, to protect even the large predators that need extensive tracts of habitat. The World Commission on

NYM LAKE, NEAR QUETICO PROV. PARK
JOHN STRADIOTTO

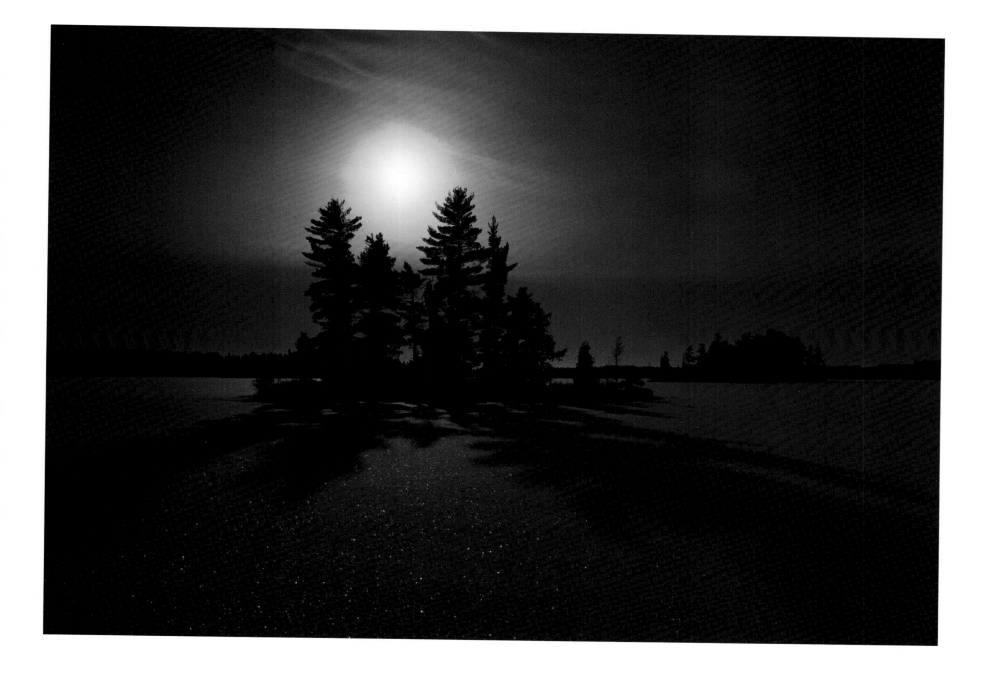

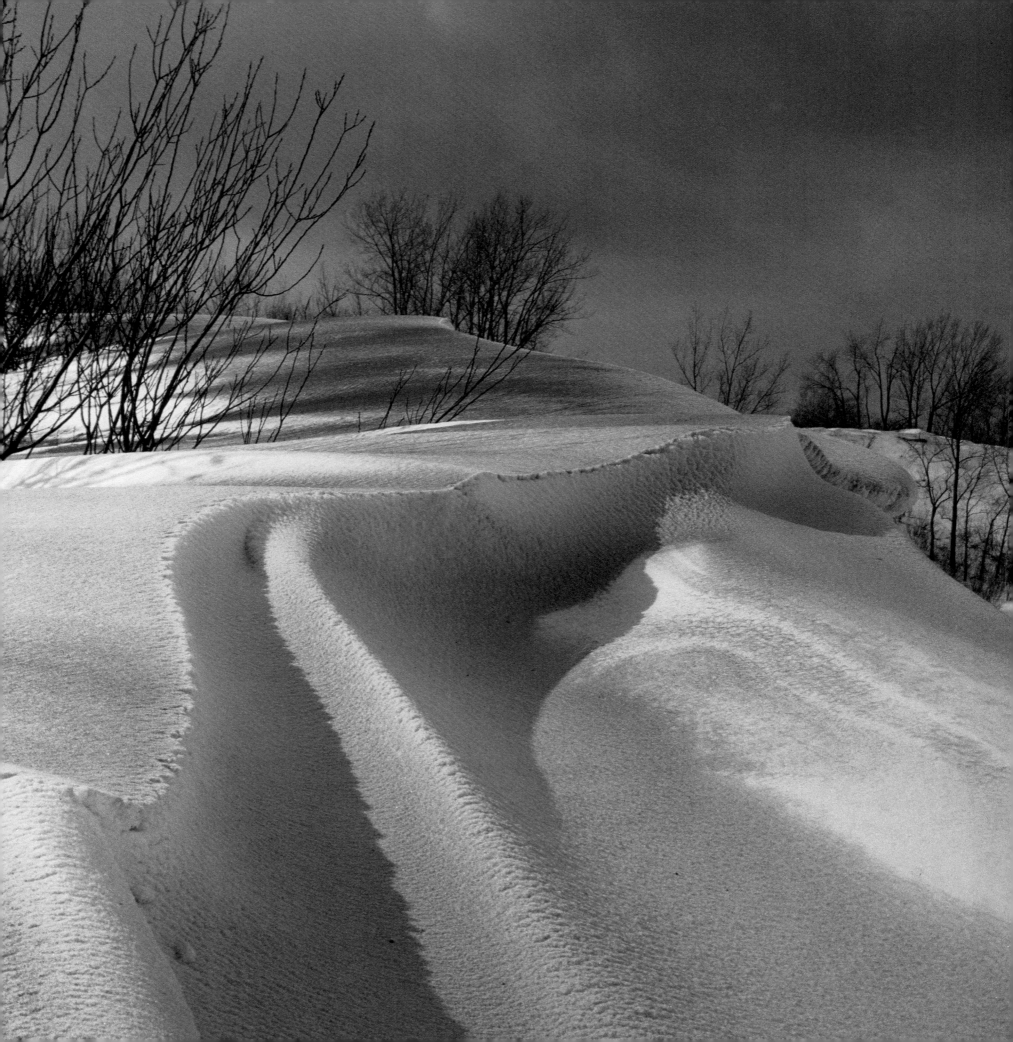

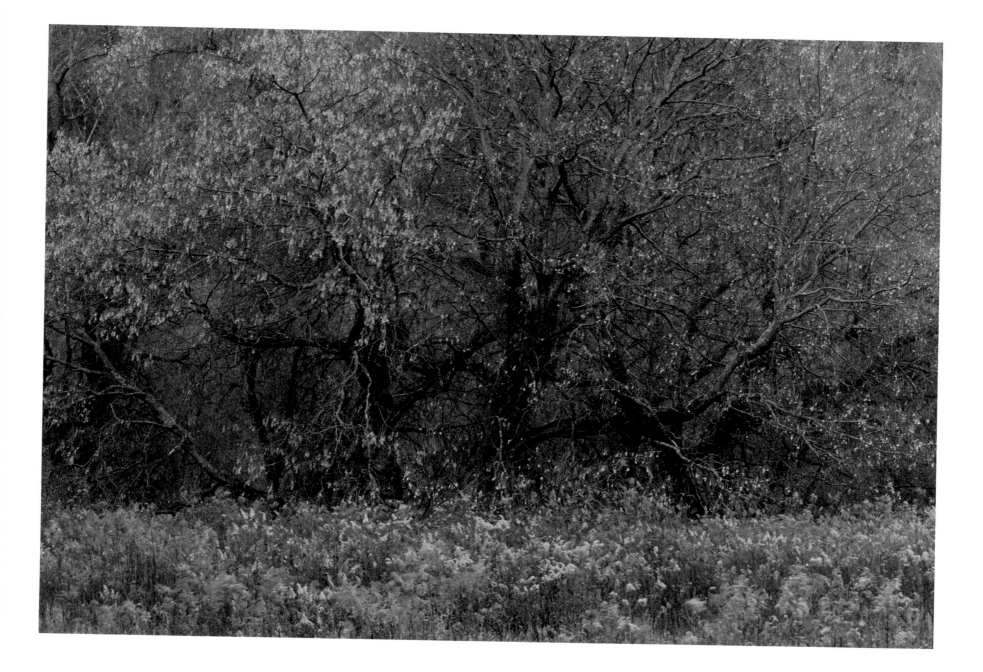

LEFT / SANDBANKS PROV. PARK
BRUCE LITTELJOHN

ABOVE / ASH–LEAVED MAPLE,
ROUGE RIVER VALLEY PROV. PARK
M. PATRICIA LANGER

Environment and Development suggests a target of 12 per cent of a country's area under protection. In Ontario, we now have 2.2 per cent of our land base fully protected, with another 4 per cent reserved as parkland but only partially protected from exploitive uses.

Less than two centuries ago, the timber barons first cast their eyes on the seemingly endless forests of white and red pine from the Ottawa Valley to Georgian Bay. Today, we have no significant areas of mature pine forest remaining. The forests of Algonquin are routinely logged; on the northern fringes of the pine belt in Temagami, loggers and preservationists are battling over the few last scraps of big pine.

Across most of southern Ontario, we have lost the opportunity to protect all the elements of natural ecosystems. None of the protected sandpits of Lake Erie — for example, Long Point, Rondeau, Pelee — are large enough to sustain wolves or other large predators. As a result, deer populations have multiplied unchecked, and young trees and other plants have been severely overbrowsed. Managers must now intervene to control deer numbers to allow the rest of the ecosystem to function more normally. Having such problems does not mean that these parks have no natural value — far from it. But their value as ecological benchmarks is clearly limited.

Parks can serve human self-interest in other ways as well. One of the most important is through the preservation of the incredible array of genetic diversity that characterizes natural areas. Even a small Ontario park contains at least 4,500 kinds of plants, a hundred or more species of bird life, a few dozen mammals, a smattering of reptiles and amphibians, and an uncounted array of insects, fungi, nematodes, and other forms of life. Within single species, there is a genetic variation across the expanse of Ontario. A yellow birch coping with winter frost at the northern edge of its range has a significantly different package of genetic materials from that of a yellow birch of the south struggling against the oppressive heat of the summer.

That genetic diversity is a cornucopia of potential usefulness to humankind. All of our food crops, and nearly half of our medicines, originated from the wild. Wild species continue to yield new discoveries and to provide new genetic material to rescue domesticated strains threatened by disease. The species involved need not be spectacular: the common May apple is contributing to cancer research, armadillos are useful in the study of leprosy, newly discovered solid bacteria may yield a whole new range of antibiotics.

Yet again and again we become so blinded by the immediate, by a few more years of supplying big pine to the mills, that we fail to give any heed to protecting our planet's genetic storehouse. The ecologist Norman Myers estimates that we have intensively investigated the economic value of only 1 per cent of all species. Among the other 99 per cent, the unknown 99 per cent, there are certain to be many species of service to humankind.

We now render extinct more than one of those species per day. By the turn of the century, we will likely be exterminating one species per hour. And we are doing so not only by shooting or polluting or spraying, but by destroying the habitats that provide life support for all species. That's where parks and other protected ares should be playing a pivotal role, to temper the genetic carnage wrought by our common folly.

The loss of species means more than just the loss of future food and drugs. It also means the progressive weakening of the global ecosystem that sustains us all. Sometimes, when my friends have been waxing enthusiastic about their fancy supercharged computers and all the marvellous things they can do, I can't help thinking about the maples on the ridge. As the yellowing leaves swirl down, or the bare branches rattle before the winter storm, or the buds swell again in spring, I reflect how much more complex, how much more marvellous, are the workings of a single tree than any computer.

Here we have an organism that can respond unerringly to the subtle cues of its environment, that can suffer extreme adversities of weather in the rhythm of the seasons, that can create its own energy source from sunlight and soil, that can propagate its own kind, and that even recycles its own body back into the soil to nourish future generations. The maple does not stand alone — its

branches provide food and shelter for the vireo that sings praises in its own crown; its shade brings forth the trillium among its fallen leaves. Even so, without the lowly earthworm and the other hidden creatures of the soil to recycle nutrients, the mighty maple would not stand for long.

It is this complexity, magnified a million times over, that forms the foundation of the global ecosystem. And despite the technological ingenuity of our own species, our survival is still chained to that natural order. We exist within a web of life so richly interwoven that mere humans can't even identify all the parts, much less fathom how they connect. But without a second thought, we pluck out random strands of that web, as species after species disappears into the abyss.

My friends would shudder at the thought of abusing their computers in such a cavalier manner. Yet we persist in treating our planetary ecosystem as a grab bag of stray parts rather than a smoothly functioning whole.

By offering protection to representative pieces of habitat, to collectives of species, parks go at least a little way to correcting this suicidal attitude. Parks that incorporate larger systems — wilderness areas and waterway corridors like the Missinaibi — are obviously of greatest value. But even small Nature Reserve zones have an important place if they protect parts of the ecosystem not well represented elsewhere. By safeguarding the bits and pieces of our genetic heritage, all parks become islands of hope in a sea of environmental despair.

Parks and other protected areas have another role in the conservation of natural systems — what might be called the teaching role. I don't mean teaching in a formal sense, on nature walks or in evening slide shows, although those certainly have their place. Rather, I mean teaching through experiencing, through allowing the ancient bonds between people and landscape to grow again.

It has become conventional wisdom among parks advocates that one of the most effective ways to "sell" people on the merits of a park area is to entice them to visit, to actually experience the tranquillity of the wilderness setting. In fact, many of the staunchest defenders of wilderness areas are recreational users who visit them often, who form a sense of attachment, a bonding, to their chosen landscape.

But beyond the specific, parks can imbue their urban visitors with at least a primitive understanding of the richness, the beauty, and the wonder of natural systems functioning naturally. Such understanding, such sympathy for the natural order of things, is desperately needed to stem the tide of reckless destruction in the 90 per cent of the landscape that will never be parkland. Park visitors may come seeking recreation, in all its varied forms. If we are wise, they should leave carrying an appreciation of how natural systems operate, and how that understanding might be applied to managed landscapes as well.

We face a great risk as more and more of our population become massed in urban centres, bereft of contact with natural settings. Their opportunities to get to know the varied facets of nature become ever more limited. And you cannot miss what you have never known. How often have you felt a pang of loss over the fate of the passenger pigeon? Probably never. Yet for my great-grandfather, breaking land among the maples and beeches of southern Bruce County, the throngs of pigeons that darkened the sun must have been a sight of great wonder. For my grandfather, the last of the passenger pigeons was a distant childhood memory. For my father, they were the stuff of legends, passed down with the generations. For me, they are simply another story, no more real than the tales of extinct auks or mastodons.

How, then, can we expect the modern urbanite, living in a cocoon of artificiality, to lament the loss of wild nature or to fight for its preservation? A child who has never peered through clear waters at the antics of a crayfish, or breathed in the fresh scent of a pine woods, has little cause to be an understanding friend of nature.

However rich in dollars, too many urban dwellers are ecological paupers. Despite all the bustle, their surroundings have become gradually less diverse, more homogenized in content and form. The grey concrete that surrounds them has crept into their souls. And without the opportunity to experience the rich tapestry of wild surroundings, they haven't even realized their loss.

The antidote is generous exposure to natural environments. And the emphasis must be on environments — total living systems — rather than just bits and pieces caged in zoos. That lonely young moose, listlessly circling in his pen at the Metro Toronto Zoo, what can he teach us about the wilderness? Not much. He is little more than a display object, and we become little more that his jaded spectators, our senses held at bay the chain-link fence.

In an ecological sense, you haven't "seen" a moose until you have watched the cascade of water and lily pads off the massive antlers as a feeding bull comes up for air, until you have smelt the earthy fragrance of peat churned by his massive hooves, until you have listened to the snapping and crashing of the alders as he slips into the shrubbery.

Parks provide the settings for such experiences, the opportunities to see wildlife that isn't forced to be wary of humans carrying guns. Perhaps more important for the urbanite who has grown accustomed to recreation that is constantly structured, parks act as gateways to provide an introduction to the wilds. At least in the more heavily used parks, a neophyte can venture into the wilds knowing that the portages will be marked, the campsites clearly designated, the dangers minimized. He or she is surrounded by a comforting structure of human regulations, safeguarded from the perceived anarchy of the wilds.

Once hooked, people come back again and again, becoming progressively more adventuresome. Experiencing wild nature firsthand usually comes in the guise of recreation, such activities as hiking, canoeing, or cross-country skiing. Tens of thousands of us every year make our pilgrimage to the wilderness; yet few of us could easily answer the simple question "Why?" When a cold icicle of rain trickles down your neck, or the blackflies carpet your mug of soup, the joys of experiencing the wilderness can seem downright irrational.

Without question, some of that motivation is competitive in origin — the urge to meet the physical challenges of wilderness travel, to prove yourself against all the adversity that nature can throw your way. It has been said that wilderness begins where you first feel fear, not only fear of the random hazards that might chance your way, but more so fear of your own inadequacy to deal with those hazards. The test is not to conquer the wilderness but to conquer yourself.

For some, wilderness offers the opportunity to throw off the shackles of domesticated routines. Wilderness travellers rejoice in the sense of freedom, the independence to make decisions unfettered by the institutions of polite society.

I recall one lunch on the Albany River, cold and wet and dreary, with some of our party soaked from a near-dumping just upstream. Hot soup was in order, we agreed, and a fire to dry out clothes. A small campfire would have done the trick, but we were on a bouldery shore lavishly littered with driftwood. Higher and higher we heaped the fire, with faggots thick as an arm, and soon the flames roared 6 m in the air. And with the flames soared our spirits, buoyed by the exuberance of uninhibited excess.

Wilderness recreation breaks down other human conventions as well. In Canada, we have more than our share of canoeing celebrities, including a couple of former prime ministers and even occasionally a prince. But in the wild, those titles don't mean much.

One night on the Chapleau River, for instance, we awoke to the unwelcome sound of rustling among our food packs. Not a bear, as we first feared, but a sleek and handsome skunk, gracefully arching his tail in the shaking beam of my flashlight. When he completely ignored my shouted warnings, I hastily decided we had enough food to share, and let him rustle to his heart's content.

Now, if I were a celebrity, do you suppose the skunk would have been impressed? Of course not. In the wilderness, all are equal.

That equality extends well beyond the synthetic sphere of human affairs. At home in the city, the imperatives of work and status and the six o'clock news may seem all-important. But to the loon on the lake, or the moose in the shallows, or the chickadee that comes to your camp, none of that matters. They, and all the other wild creatures, can live out their lives and carry on through countless generations without the slightest need for our six o'clock news. To a hawk, an unwary mouse is of far more consequence than the likes of you or me.

That indifference to human affairs somehow strengthens my feeling of kinship with wild places. Perhaps it is the realization that large parts of this planet are still beyond human control, that wild creatures go about their business independent of any consideration of human concerns. In the wild, other creatures are not our servants; they are beyond our judgment as beneficial or destructive. They are brethren, co-inhabitants of the thin skin of life that surrounds the globe, equal participants in the web of life.

When the wind cuts hard in our faces, or the crash of strong rapids means yet another portage, one of my canoeing friends is apt to remark: "I talks to the river, but the river don't care; he just keeps rollin' along." My friend, I suggest, has learned well the most valuable lesson that parks can teach us – that we are not all-powerful, that our technology is not the only force controlling the planet.

We humans have the power to destroy, but we cannot create a living river, a maple on a ridge, or even the lowly aphid that feeds on the maple's leaf. Experiencing the wilderness can bring us to understand our limits not just as individuals but as a species. We are part of a greater whole, albeit an important part, but still simply one part. In that knowledge, our approach to nature should be respectful, even humble.

Ontario's parks, then, must be measured in terms beyond the immediate, beyond the economic and recreational values that accrue to this generation. Parks stand as symbols of our common humility. Humility in our recognition that we need natural ecosystems as antidotes for our mismanagement, as reservoirs of genetic opportunities to meet the challenges of our common future, as refuges to allow other species to exist. But most of all, parks are symbols of our growing awareness that humankind cannot live independent of wild nature.

Ontario's Parks and the Health of Our Environment

Michael Keating

Throughout human existence we have lived on a green planet. Like every other species that dwells on Earth's surface, we have been tied to the plant life that converts sunlight into food. Now we have reached a turning point in human and natural history. For the first time in more than four billion years of life on Earth and three million years of human evolution, one species is physically reshaping conditions for life.

In two generations our physically dominant Western culture has gone from respecting, even fearing nature to changing our atmosphere and manipulating the vegetation and water supply of much of the world. We are rapidly peeling back the life-giving veil of greenery that covers the hard surface of Earth, reversing evolutionary history.

The original forests of Europe and of the settled parts of North America have been cut for timber, to clear land for farming and to build great cities. Now the vast forests of less accessible regions – the tropics, Siberia, and Canada's north – are being cut and burned as humans extend their farms, economies, and cities. When the land is denuded, soil blows away or is washed into the rivers and then the seas. Then the deserts advance, especially in Africa.

The clock is ticking on our wildlands. Every minute more

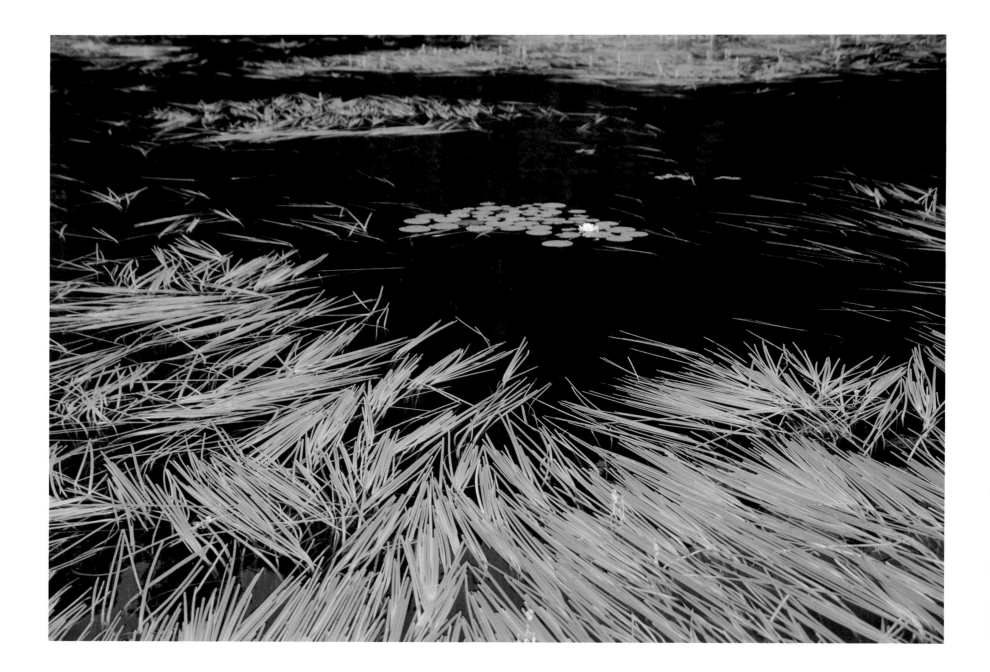

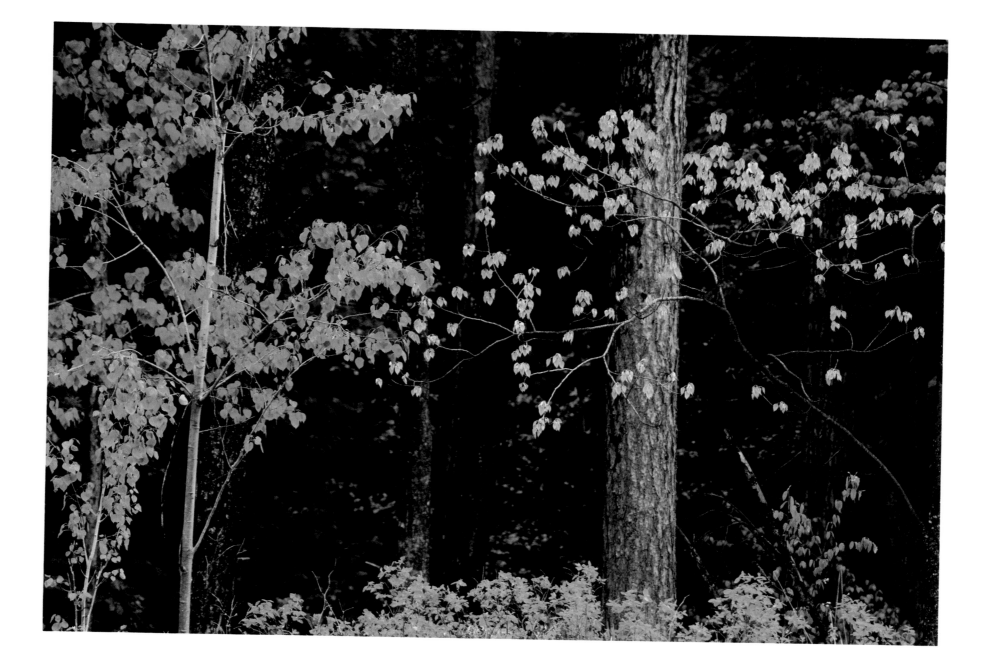

LEFT/BUR-REED, SAMUEL DE CHAMPLAIN PROV. PARK
BRUCE LITTELJOHN

ABOVE/ASPENS, PETROGLYPHS PROV. PARK
LORI LABATT

than one square kilometre of the world's forest is logged or burned. The planet probably loses a species of life every hour or so.

Two great forces of change are acting on our environment: a phenomenal population increase and a growing demand by everyone for more of everything. For most of history, the human population was small and we had little impact on the environment. By the dawn of agriculture, some 8,000 years ago, it was only about 8 million, and 2000 years ago it has been estimated to have been 200 million.

Three centuries ago the agricultural and technological revolutions began to change the role of humanity profoundly. We moved from the solar age, powered by horses, humans, falling water, wood fires, and wind, to the steam age, running more and more on fossilized non-renewable sunlight in the form of coal, then oil and natural gas. These revolutions meant that, for the first time, there were food surpluses and a large number of people could leave the land to work in factories.

The increase in food, followed by better medical care and mass migrations to less populated areas, triggered a population explosion. Human population has grown from 700 million in 1750 to more than 5.4 billion people by 1991. It is growing at the rate of three more people on the face of the planet every second. In one year that is 95 million people or nearly four Canadas. By the year 2000, there will be more than 6.3 billion of us and twenty years later there will be 8 billion and by the middle of the next century the population could reach 10 billion. The final figure is more a mathematical prediction than a likelihood. It is doubtful if the world can feed even 8 billion people on a long-term basis. Pressure on the environment is coming from more than sheer population. Everyone wants more of everything — more food, more cars, more energy, more big houses, and more private land.

As the world's population grows, wilderness shrinks. The next two decades will be our last chance to preserve large blocks of untouched wilderness as a legacy for future generations — an example of what the natural world used to be. Within thirty years the only wild areas left in the world, with the possible exception

of the polar, desert, and high mountain regions, will be in parks. It is urgent that we now decide how much of nature we want to preserve, not only for ourselves but for all generations to come. This will help to shape the kind of parks system that we leave for the future.

The face of the planet is changing so much that the effects can be seen from space. Rivers are dammed and diverted and lakes drained. Clearcuts of timber are so big they show up on satellite photos. The smoke from great fires sometimes obscures large parts of South America. Wind erosion carries soil from Africa as far as the Pacific Ocean. Light and heat from the great cities and gas flares from oil regions outline an expanding industrialized world to orbiting cameras.

Some forms of air pollution acidify vast areas of the earth, while others are warming the global climate and destroying the stratospheric ozone layer that shields life against high levels of solar radiation. Long-range air pollution means there are no more totally pristine areas left on the planet. Toxic chemical fallout has put PCBs in the livers of polar bears and penguins and radioactive fallout in reindeer. There is probably no human alive today without traces of toxic chemicals in his or her body fat. In humans and animals alike, chemicals are passed on from one generation to another through the placenta and mothers' milk.

What is the future of the natural world, of wilderness? And how will we preserve it? Wilderness is a place that has evolved naturally since time immemorial. It free of roads, buildings, machinery, and motors. A visitor should hear no sounds and see no sign of civilization except, possibly, aircraft flying high overhead, bound for somewhere else. There is no logging, mining, or damming of the rivers. There may be some subsistence hunting, fishing, or trapping but none at a commercial level. A truly wild region must be large enough so that wildlife species, especially the big animals such as bears, wolves, and cougars, can range freely and maintain healthy, diverse populations.

About one-third of the world is still wilderness with no obvious signs of human damage. Most of that is in the mountains or deserts: Antarctica; the high Arctic and Greenland; parts of

Tibet; the Sahara; the Rub al Khali in Saudi Arabia; and parts of the Amazon.

Virtually all remaining accessible and habitable areas are under assault from sprawling cities and spreading farms, ranches, mining, logging, and hydroelectric developments. Ever-longer road systems snake deep into wild areas, bridging rivers as they go. Along them come more and more people, ready to hunt the animals and clear the forests.

One way to measure the state of wilderness is to measure the forests. About 40 per cent of the land is still forest, but it is shrinking by about 200,000 km² a year—an area more than twice as big as Lake Superior. Because of habitat destruction, mainly the loss of forests, humans have begun the greatest extinction of plants and animals since the dinosaurs vanished 65 million years ago. There are scientific estimates that we could lose between 5 and 15 per cent of the life forms now on the planet over the next thirty years. Many wild species will survive only in parks, and some of the great beasts, such as the elephant, rhino and tiger, penned up in protective zoos.

In Canada, we still live with the image of a vast wilderness. It is part of our cultural heritage, our identity as Canadians. It is an inspiration for art and literature, part of the face that we show to the rest of the world. The great north country helps to make us different from most other nations. In our mind's eye, this wilderness is perpetual and immutable. It always has been and it always will be. The reality is that our wild country is being transformed into cities, farms, tree plantations, oil fields, mines, and holding ponds for hydroelectric dams.

The Atlantic hardwood forests and the wetlands of southwestern Ontario are almost gone. Grasslands once blanketed 1 million km² in the heartland of North America, but the largest remnant of tall-grass prairie in Canada is 10.5 ha within Winnipeg's city limits. Most of the Boreal forest that is accessible to loggers is slated for cutting. The same is true of the mountain forests and the temperate coastal rainforests of British Columbia.

On a transcontinental flight it is hard to look down and see pristine unbroken wilderness. Almost everywhere along the flight the eye will find buildings, roads, farms, clearcuts, hydro dams, or mine tailings. Growing circles of development spread out from our settlements. Today's farms and woodlots are tomorrow's subdivisions, office towers, warehouses, parking lots, and dumps.

A graphic illustration of how hard it is to see pure wilderness is revealed in a tourism poster for Canada's north. Probably by accident, the photographer included a strip of cut trees right across the image. It was a seismic line, cleared by oil and gas prospectors.

Even tourism is reaching out and changing the very wilderness that it needs for its own survival. Float planes and helicopters can now take hunters, anglers, canoeists, skiers, and hikers everywhere. When they get into the wilderness, the visitors find more and more power lines, logging roads, exploration stakes, and garbage left by other visitors. A growing number of the most attractive wild lakes have fly-in hunting or fishing camps.

The chemical footprint of our industrialized society also reaches far into our wilderness. Acid rain from power plants and smelters hundreds of kilometres away falls on remote northern landscapes. There it slowly dissolves natural mercury from the rocks and leaches this toxic metal into the food chain of northern lakes. Hundreds of other chemicals blow north from our settled regions. Lake Superior, the most "pristine" of the five Great Lakes, receives an estimated one tonne per year of toxic fallout from just four chemicals, including PCBs, DDT, lead, and benzo(a)pyrene, which causes cancer. Researchers believe that the DDT, which has been banned in Canada for years, is blowing in from at least as far away as Latin America, where it is still widely used.

Our environment faces far greater changes from air pollution. Each year, the world's industries, farms, and homes release billions of tonnes of greenhouse gases that are slowly warming our climate. As the atmosphere warms up, the planetary heat engine will shift into a higher gear, causing changes in the global circulation of wind and ocean currents. A hotter climate will send our environment into a mad scramble. Forest ecosystems and animal species will migrate north, lakes and rivers will warm up, and water flows will change in unpredictable ways. We know now that we will have a

different environment but we are not certain exactly what it will look like or if we will like it as much.

Ontario's wilderness encapsulates 8,000 years of history since the glacial lakes retreated, but that history book is fast being rewritten. Hydro developers are eyeing wild rivers for "clean" energy. Miners want the freedom to develop mineral resources wherever they are found. Much of the great northern forest is earmarked for cutting. If the forest companies follow modern practices, they will re-plant the cutover areas and the land will begin to turn green after a few years. Although this is good tree farming, these logged and managed woodlands should not be confused with the natural forest. Tree plantations can provide good habitat for some species, but they lack the evolutionary history and natural characteristics of true wilderness. In particular, they lack old-growth forest. Because they are almost always planted with a single species of tree for the convenience of harvesting, the managed forests lack the biological diversity and therefore stability of a natural forest.

South of the French and Mattawa rivers, we no longer have enough untouched country left to have a real wilderness park of at least 1,000 km^2. There are wild lands but only pockets of true wilderness. Almost every area of any size has been logged at least once, and the land is crisscrossed with roads, railways, and power lines. Only Algonquin Park provides a semblance of a large wilderness, though much of it is open for logging and, since 1991, for hunting by natives.

Farther south, where most of the province's nearly 10 million people dwell, there are only pockets and strips of wild country, mostly in parks or protected areas along narrow corridors such as the Niagara Escarpment. We have lost over 90 per cent of Canada's share of the Carolinian forest, and there is a struggle to preserve the remaining fragments. Three-quarters of the original wetlands of southern Ontario, including more than 90 per cent of the marshes in southwestern Ontario, have been drained or filled. Wetlands are the most productive of all ecosystems and are the nurseries for much of our wildlife.

If most of the world's remaining wilderness will be in parks,

how much can we count on? In 1987, the UN-sponsored World Commission on Environment and Development suggested that we should protect at least 12 per cent of the land to conserve species and ecosystems. Three years later, the head of the United Nations Environment Program said the world had about 4,500 parks and protected areas, covering some 3.2 per cent of the land. This figure must be highly qualified. Some of these "parks" exist only on paper and others, including some in Canada, are open to hunting, fishing, even logging, mining, and road-building.

How does Canada, with nearly 10 million km^2 and the second-largest surface of any country, stack up? According to official figures, 6.3 per cent of Canada has been set aside in parks, wildlife areas, and ecological reserves. That is an an area nearly the size of Manitoba. An analysis by World Wildlife Fund Canada in 1991 found that only about half of this area is actually free from resource extraction such as mining, logging, or hydroelectric development. Some of these parks and protected areas even allow sport hunting, motorboats, and fly-in camps, and therefore are far from pristine.

Ontario's land mass covers an important piece of the planet. It is as large as France and Germany combined. Its 261 parks cover 63,000 km2 or nearly 7 per cent of the province's land. About two-thirds of the park area is classified as wilderness, though most of that is in the far north, particularly in the remote Polar Bear Park in the Hudson Bay Lowlands.

Ontario's parks, especially those close to civilization, are not immune from conflict. Many people see parks as areas that should be protected in a natural state, but others want the same land for logging, mining, power developments, motorized recreation, cottage and lodge development, commercial trapping, and sport hunting. Our parks face growing threats from people who want to "use" this wilderness more intensively. Each would-be user has persuasive arguments, and most often the arguments involve jobs.

How do you put a value on wilderness compared to economic development? We know how many dollars we will pay for logs from a forest, metal from a mine, or a kilowatt hour of electricity from a hydro dam. But what is the value of the forest, the landscape, or the wild river left in a natural state? And how do you put a

price tag on the existence of another species? In Canada, the fate of over 200 species of mammals, birds, fish, and plants is at risk. One hundred of those rare, threatened, or endangered species are in Ontario. Life forms as diverse as the cucumber tree, the small white lady's slipper, the bald eagle, and the Lake Erie water snake find refuge in Ontario's parks and nature reserves. In the future, more and more species will depend on parks and protected areas for their habitat as more of the province is developed for industry, agriculture, and housing.

We know there are some tangible benefits to be gained from preserving wilderness. All our foods and many of our medicines and industrial products came from wild stock, and we need to save some wild gene pools in order to maintain a secure supply of those products. Time after time we have had to turn to wild plants for genes that resist diseases plaguing our crops. Scientists talk of wilderness as a natural laboratory. In recent years, a researcher found stunted 1,200-year-old cedar trees growing along the Niagara Escarpment. Their inner rings will tell us about a climate long past and may thereby help us understand climate in the future. The wilderness is also a classroom where people of all ages can go to learn how nature works and it is simply a place to be in contact with one's natural roots, one's evolutionary history.

It is a source of inspiration for the beauty expressed in such images as the paintings of the Group of Seven, the writings of Earle Birney and Margaret Atwood, and the films of Bill Mason. Wilderness has been part of our heritage, and preserving wilderness in Ontario's parks will be a gift to the rest of the world. The provincial parks are big enough and important enough to play a major role in maintaining part of the planet in a natural state.

The World Commission on Environment and Development (Brundtland Commission) gave us more than a target for parks preservation. It had a broader vision of the future. The twenty-two men and women, who came from around the planet, said that we will not be able to protect our environment if we do not change the way we live and do business.

Their 1987 report, Our Common Future, gave the world a complex challenge. It says that if we do not rapidly switch to lifestyles and forms of business development that are environmentally sustainable, we will face a growing cascade of environmental disasters. On a more optimistic note the commission also said, "Humanity has the ability to make development sustainable — to ensure that it meets needs of the present without compromising the ability of future generations to meet their own needs."

This is a gigantic task because it calls for fundamental changes in the way we live. Most energy generation creates pollution and uses up non-renewable resources. Most food production destroys and erodes the soil. Far more trees are cut than are planted. Weapons of mass destruction still threaten human survival. And at a planetary level, population growth is out of control.

If development and lifestyles are to be environmentally sustainable in the long term, they must be firmly rooted in a healthy, natural world — the wellspring of all economic activity. This requirement means that humans must draw a clear line between continued development of the land and preservation of some remaining wilderness. Both are valuable in their own right, but each is distinct and should not be confused with the other.

When the time comes to draw a line around a park, the question is always: How big? How much of the natural tapestry should be protected? One measure of a park's success is its ability to protect species of wildlife. A growing number of studies suggest that if parks are going to be effective in protecting a large number of species, the parks themselves must be large and they must have connections. Otherwise, they will only be islands of wilderness in a barren sea.

In much of the world and certainly in southern Ontario, individual parks cannot be big enough to allow large and diverse populations to flourish and maintain genetic diversity. The only practical way to maintain genetic diversity is to ensure that animals can move between parks and protected zones. And for such movement to be possible, we must provide routes of safe passage. If we close off the parks totally with no buffer zones and no corridors to other wilderness, it would be analogous to putting walls around our cities and trapping ourselves inside with no safe way of getting to the next town or city.

There is no magic formula for designing a park system to preserve species. We are doing it for the first time in evolutionary history. The best signals of how well we are protecting our environment will come from the top of the food chain. Only healthy populations of top predators such as the bear, wolf, cougar, and eagle will tell us that we are protecting enough wilderness and controlling chemical pollution.

Parks may not be part of development but they are very much part of sustainability. The challenge is to make it clear that using parks to preserve wilderness provides a valuable benefit for humanity. As wilderness continues to disappear, we must ask what kind of parks we need most. Ontario now has six classes of parks: Wilderness, Natural Environment, Waterway, Nature Reserve, Historical, and Recreation. Some of those parks are far from wild; they have groomed lawns and parking lots; they are tourist attractions and this brings money into the local economies.

Tourism will play a vital role in protecting our parks. People will pay more and more to protect our increasingly scarce wilderness and they will want to spend more time on those lands. With population growth, there will be tremendous pressure to turn natural parks into something more and more like playgrounds. One of our most difficult tasks will to be allow a level of recreation that does not bring destruction. Already, many parks suffer environmental damage because so many people want to be in the wild. In the future we will have to make more and more difficult choices about what level of recreation makes ecological sense.

Since wilderness parks do not produce revenue in ways that are easy to collect, it is unlikely there will be many private wilderness parks for the public in the near future. It seems reasonable that the province should put most of its effort into preserving as much land as possible in a natural state. The only "development" in provincial parks should be a minimal level of access by non-motorized means, backed up with interpretation, so that people can learn about and thus support the parks system. Private business can do a better job of building and operating entertainment and recreation parks.

Because ours is the last generation that can save large tracts of wildlands, it is important that we move quickly. In Ontario, the provincial government must preserve adequate amounts of parkland on the large tracts of Crown land that it now controls, mainly in the north. The rules for this task are spelled out clearly in the strategic plans and other guidelines developed over years by the Ministry of Natural Resources. It will take political will, driven by strong public support, to say that certain large areas must be preserved in a natural state for future generations. "Natural state" means they cannot be logged, mined, dammed, or used for sport hunting and motorized travel. Other areas may be partially exploited for commercial use but will have to be left in a semi-wild state so they can act as buffers for and wildlife corridors between wilderness zones.

Although large tracts of virgin wilderness no longer exist in southern Ontario, it is not too late to preserve some important pieces of land in a relatively wild state. It will take more than the stroke of a pen. Much of the wild land still left is in private hands. Since buying the land for the public would be very costly, conservation is more than a job just for government; the responsibility for protecting nature will fall more and more on private landowners who understand the value of wilderness. For centuries, enlightened business people have built cathedrals, temples, art galleries, libraries, and universities as legacies for their societies. One of the greatest gifts that could be left by people of this generation to the future is wilderness — something that can be preserved but, once lost, can never be re-created in its original form.

The lesson of history is that our parks are becoming ever more precious to us. As the world is carved up for more and more human uses, Ontario's parks will be seen as national and international treasures. No one will ever be blamed by future generations for having created too many parks.

RAINBOW FALLS PROV. PARK
LORI LABATT

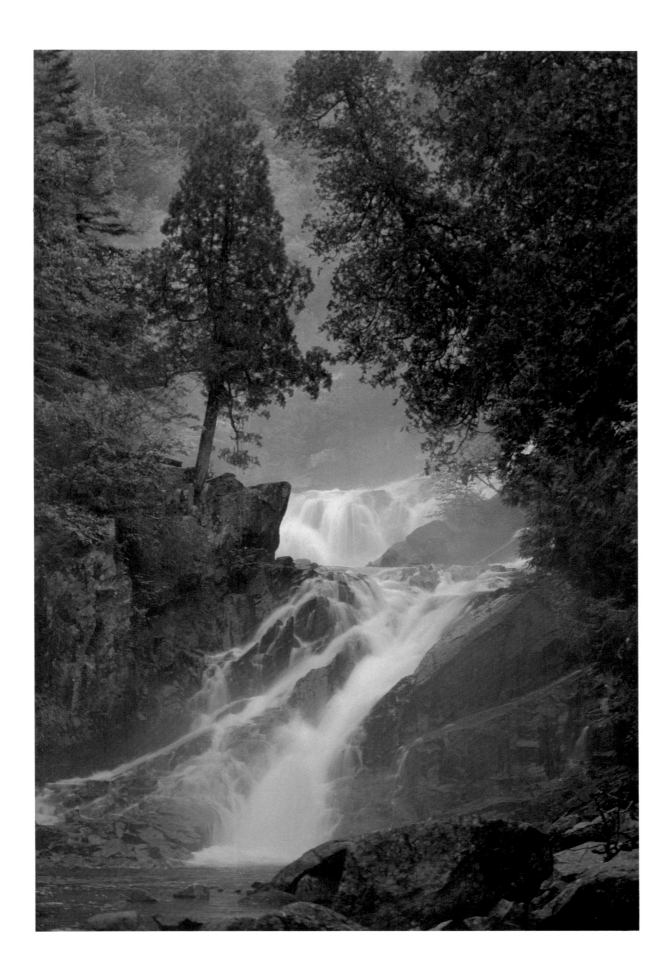

LEFT/SHORT HILLS PROV. PARK
LORI LABATT

ABOVE/KILLBEAR PROV. PARK
BRUCE LITTELJOHN

Laughter in the Labyrinth: Wilderness and Soul

Wayland Drew

Our psyche is part of nature and its enigma is limitless.
Thus we cannot define either the psyche or nature.

. . . C.G. Jung

The tale of Theseus and the Minotaur is among the most haunting of Greek myths, partly because of the labyrinth and its awesome inhabitant, and partly because of the hero's betrayal of Ariadne. After he kills the Minotaur and emerges from the labyrinth, Theseus rejects the very woman who saved his life. He severs the thread which bound him to her and to the green world of which she is a part. This cutting-off seems wilful and perverse, a kind of suicide, and as if to emphasize the sombre change in the hero, the myth recounts how he returns home under a black flag of death.

Later tales were told of Theseus—how he ruled Athens, waged war on the Amazons and married their queen, joined the Argonauts, befriended Oedipus, and failed in a journey to the underworld; but these events have not gripped our imagination like the story of the Minotaur. They lack the ambiguity. They lack the strangeness.

What happened there, deep in Earth? What happened in the heart of the hero? The tale provides few clues; only that baffling desertion, only that dark sail. Something besides the Minotaur seems to have died, but what exactly? The fact that Theseus voyages on in life is obviously ironic after the suicide of Aegeus; but there are more troubling ironies here.

For one thing, Theseus gains the throne because his father kills himself, and Aegeus leaps from the cliff because Theseus "forgets" to hoist the white sail. So from the beginning there is a hint of duplicity in Theseus' reign, a whiff of corruption.

Henceforth, he is propped up in power, propped up *by* power.

If the myth is suggesting that in rejecting Ariadne Theseus dies, or that part of him dies, then it must be that part which she represents, the vulnerable part sensitive to frailty and uncertainty, to mystery and natural change. The flexible. The feminine. Henceforth there will be no sinuous thread in Theseus' life, but only the rigidity of law.

Or perhaps—to grope farther still into this labyrinth of meaning—Theseus dies earlier. Perhaps the womb became the tomb. Perhaps his betraying of Ariadne and his neglecting to hoist the white sail are only confirmations of this death. Is the myth saying that in slaying the monster the hero becomes monstrous?

Is the confrontation with the Minotaur a test, a test which Theseus fails?

Such enigmatic tales link us still to the ancient world of gods and heroes, but the bond has worn perilously thin. We have kept little space on Earth for labyrinths, sacred groves, and mysteries. Any Greek god waking from long slumber and rising from Olympus would be shocked to see the devastation wrought by humankind. He would conclude that during his sleep we had gone mad beyond all hubris and waged ruthless war on the rest of nature. The great forests have been swept away, the wild creatures slaughtered, the air befouled, the streams, lakes, and oceans poisoned.

Dotted here and there he would see little pockets of greenery in the soiled landscape, little wildernesses, and in his omniscience he would know that without some extraordinary change, these islands of wild nature are doomed. They are doomed by population and pressure on the "commons". They are doomed by poaching, by the "harvesting" of some creatures and the

KAKABEKA FALLS PROV. PARK
PAUL von BAICH

ABOVE / OXTONGUE RIVER WATERWAY PARK
PETER van RHIJN

RIGHT / SILVER MAPLE, HILTON FALLS
CONSERVATION AREA
PETER GRIFFITH

sentimental protection of others; by timbering, mining, and other "resource extraction"; by corporate/political greed and expediency; by weirdly altered winds and climates; and by a devil's soup of contaminants. All these, the god would see, are ceaselessly eroding wilderness. The little zones of green will grow ever smaller and weaker, until at last they perish from what biologists call "the island syndrome" or "faunal collapse" — ecological cardiac arrest.

A sensible god would flee. Back to Olympus. Away to some other world. Anywhere apart from men and women.

Nothing we are doing at present will save the remaining wilderness. No political system we have devised (except those of "primitive" societies) is compatible with the wild or capable of defending it. All our notions of "conservation" or "preservation" are proving to be delusions and placebos. In spite of ourselves we have tried, and in spite of ourselves we have failed. Wilderness is being obliterated as surely by affluence and indifference in the West as it is by poverty and ignorance in nations coat-tailing the West.

We know this. We have known it for many years, and yet we pretend *not* to know it. In many debates conservationists have presented the stock arguments for the preservation of wilderness, always fervently and sometimes successfully. In many confrontations we have persuaded politicians and developers to delay or cancel "land-use" plans, all the while knowing in our hearts that we are fighting a rearguard action which our children and grandchildren will have to fight again, until finally there will be no point in fighting anymore. We know that we are failing. We know that what we are doing is little more than collusion in the liquidation of wilderness, yet we keep on. Why?

These are the conventional arguments for the preservation of wilderness:

1. Wilderness provides a "benchmark", a reminder of what was once normal and what might again be normal if humankind restrained itself.

2. Wilderness is aesthetically vital; it has inspired poets and artists.

3. Wilderness provides psychic support and spiritual consolation.

4. Wilderness is the source of ecological diversity, the lungs and heart of Earth.

5. Wilderness is given by God and we are charged with being good custodians.

All these reasons are superficially persuasive. The "benchmark" argument, for example, seems a sensible plea to maintain some natural standards in a welter of technological change and destruction. But let us look deeper. Surely, simply keeping standards is not enough; they must be applied to have validity, and precisely how do we expect to apply the conditions of wilderness? Do we expect to *create* wilderness? Obviously not, since we cannot create a single pond, a single earthworm. We may create a garden, but we will never re-invent the grizzly. We will never re-create the myriad and infinitely subtle relationships of the web of wilderness. So what use is this "benchmark"? None. In fact, the notion is worse than useless, since it tends to reassure us with its apparent reasonableness. It is a plea for museums or zoos.

As for the argument based on aesthetics, it's true that what is wild and free has always inspired great art — poetry, music, and painting — but to suggest that it should be kept *for that reason* is like saying we should cherish children to make an attractive family album. It is perverse and fundamentally anthropocentric. Nature is no model, no collaborator in humans' doodling, and there is something pathetic and embarrassing in art too reverential — as if the artist longed to reabsorb — or to be reabsorbed into — that natural Other. "Art is a lie that makes us realize the truth," Picasso said, and in this case the truth is that we are dangerously alienated from the conditions that engendered us. To the extent that it is a warning, "nature" art is useful, but no reason in itself for the preservation of wilderness.

The third argument, the spiritual or "psychological", is more subtle. It goes as follows: We must have wilderness because it makes us saner, makes us better able to deal with each other and therefore to create better societies. What are we really saying when

we make this argument? If we are saying that we atrophy spiritually when we do not participate in the mystery of wilderness, then there is validity here; but if we are saying that wilderness is important as vacation land, to provide therapy after the rigours of one working year and to prepare us for those of the next, then we are urging the consolidation of wilderness in the social system which is destroying both it and us. Unless wilderness remains incomprehensible and threatening, generatively *negative*, then it will be nothing more than a device of repressive tolerance, part of the insidious balm which soothes the split between ecology and economics.

The fourth argument, the biological argument for the preservation of wilderness, was put this way in *Our Common Future* (the Brundtland Report):

> "The loss of forests and other wild lands extinguishes species of plants and animals and drastically reduces the genetic diversity of the world's ecosystems. This process robs present and future generations of genetic material with which to improve crop varieties, to make them less vulnerable to weather stress, pest attacks, and disease. The loss of species and subspecies, many as yet unstudied by science, deprives us of important potential sources of medicines and industrial chemicals. It removes forever creatures of beauty and parts of our cultural heritage; it diminishes the biosphere."

Here the argument lapses comfortably into an anthropocentrism compatible with the notion of "sustainable development" urged by the Report. Essentially it becomes a plea to keep wilderness as a natural laboratory. Usually, however, the biological argument is stated more broadly as follows: We should preserve wilderness because it maintains genetic diversity, provides ecological stability, and meets such physical requirements of Earth as oxygen production, water recycling, and nutrient recombination.

One problem with this reasoning (besides the fact that scientists are busily splicing together more genetic diversity than we care to think about) is that species diversity cannot be maintained in islands; faunal collapse will occur at a certain stage of attrition, and attrition of areas politically vulnerable is inevitable without economic shifts so radical they must be perceived as disasters.

A second problem is that we believe we can keep the physical "plant" of Earth running without "pure" wilderness. The preservation of "green space" for this purpose has become part of land use planning, another expression of our technological cunning. We may be right. Perhaps we *can* coax the waning Earth to keep working for quite a long time while we control its deterioration to virtually undetectable stages; but however admirable the project of slowing entropy might be, it will sooner or later collapse under the weight of self-indulgence. After all, if we know we are dying, why squabble about how fast? Why not just live? Enjoy? Consume?

The fifth common argument for wilderness preservation is that God made us responsible for Earth, and not to maintain it well would be just plain bad stewardship. Although this is a Judeo-Christian argument, it is also compelling for non-believers. After all, we *are* responsible for Earth at least insofar as we hold the power of life and death over many of its creatures. Besides, it is humiliating to lose control and foul one's own nest. We like to think that humankind, inventor of reason, can do better. Therein lies a problem. The point of the idea of stewardship as it is presented in the parable of the talents in Matthew 25 is that the good steward augments and improves upon what is placed in his care; however, it is impossible by definition to improve upon wilderness. So either we are not stewards of wilderness (in which case we have some answering to do for our presumption), or the parable in Matthew 25 is more ironic than it appears.

A knottier problem with the stewardship notion is that it rests on the arrogance towards nature for which the Judeo-Christian tradition (Saint Francis excepted) has so often been taken to task. Put simply, Christians believe that humankind is made in the image of God and therefore superior to other creatures. We are God's surrogate. We are part of nature only to the extent that whatever we do under our God-given licence is "natural". So we come to the rationalization for the coercion and mutilation of nature which Christianity is powerless to stop. Christian

spokesmen will sometimes pay lip service to "protecting the environment", but even that word "environment" is revealing since it means only what surrounds *vir*, man. Forty years after Aldo Leopold's *A Sand County Almanac*, we still have no land-ethic, and no term to signify a vital, organic condition of which humankind is a relatively insignificant part. *Wilderness* is the best we can do.

Whatever truth may lie in these five arguments, they have become little more than platitudes and palliatives. We acknowledge them as ineffectual when we adopt the elegiac tone often used, for example, in the beautiful picture books North Americans love, all mountains and lakes, stately moose and misty mornings. Fundamentally, we know that these reasons are not enough. Perhaps we feel they are inadequate because they are merely *reasons*.

So, why *really* do we strive to preserve wilderness?

We must go deep to find truer answers. We must descend into the perilous country of the soul, that maze of monsters and contradictions . . .

First, let us acknowledge that setting aside wilderness panders to our ego and reinforces our sense of control. Only the powerful can grant reprieves. Besides, even if we do not understand the mystery in wilderness, we can at least contain it, cage it.

Secondly, we recognize wilderness as a symbol and microcosm of the complex life-web in which all living things participate, and we understand, or sense, that to destroy it utterly would mean to abandon hope. Wilderness thus becomes an index of our ecological enlightenment and a measure of the only situational ethic which counts.

Thirdly, we preserve wilderness to hedge our technological bet. Dazzled by its apparent success, we have cast our lot with a coercive and exploitative science; fortunately, there is still a wary animal in us that does not wholly trust the scientists. Deep down, we do not believe that the gene-manipulators and life-patenters know where their work is leading, or that chemists know poisons when they see them, or that physicists can ever make outer space humane. Therefore, we cling to the familiar, and what we know best even now, know in our genes, is wilderness.

So, fourthly and most important, we preserve wilderness simply because we need it. We cling to it unreasonably, viscerally. We remain creatures of the wild, no matter what compromises we have forced ourselves to make and what grotesque experiments we have attempted. Whenever possible we get as close to the wild as we can — a riverbank, a shore, an island — and when we cannot go to the wilderness we bring bits of it to ourselves — pools and pets, plants and gardens, recorded birdsong and whalesong, all wistful mementoes of the sublime mystery beyond our reach.

These are compelling reasons for keeping wilderness.

We must then ask why we are *not* keeping it. We must ask why we are violating these dictates of conscience and animal sanity, for surely we are. Every year we watch a piece of Earth as large as France become a desert. All of Australia, much of China, and over half of the United States is on the verge of becoming wasteland. Every year we destroy 110,000 km^2 of tropical forest to make lawn furniture, bird feeders, and disposable chopsticks. In three decades at the present rate, we shall have clearcut an area as large as India. Dioxins, PCBs, and DDT have all shown up in mother's milk, and they are just harbingers of future horrors. We are now routinely producing and loosing into the atmosphere 60,000 unnatural chemical substances, most introduced in the last forty years. By the year 2000, at the current rate, we shall have eradicated 60 per cent of all plant and animal species we know, as well as an incalculable number we do not know. Because we have overridden homeostatic controls other creatures respect, our population is growing at an alarming rate, and will likely double within forty years despite plagues, famines, and disasters. At this rate, with almost 6,000 people per square kilometre, Tokyo presents a hideous foreshadowing of the overcrowded future.

As Murray Bookchin observed twenty years ago, "Modern society is literally undoing the work of organic evolution . . . We are witnessing the end of a world."

Why?

For one thing, wilderness is simply incompatible with prevailing notions of technological and material "progress". We want the

"resources" wilderness contains and are therefore prepared to compromise it. Also, we are obviously trapped politically and economically in structures which cannot respond adequately to present needs, and we are too easily reassured by those we have placed in power.

Most important, however, is the fact that wilderness is terrifying. Wilderness is the opposite of history: a continuing state of timelessness and a living mockery of all that is fixed, static, secure, and civilized. It is unknown and unknowable, *mysterious*. Think of all the monsters our dread has projected there – centaurs, chimeras, dragons, manticores, gorgons, harpies, vampires, ghouls, werewolves, banshees, wildmen, sasquatches, cannibals, wendigos – and you have a hell worthy of Bosch. Surely the best defence against these freakish and half-human things is a pre-emptive strike on their habitat. So we wage war. We call this warfare "resource extraction", "harvesting", "recreation", and "research".

Of these, "research" may well be the most destructive. Research often is to ecological integrity what AIDS is to the immune system – the best disguised and most insidious assault. Research consists in reducing a subject to an object, then in breaking it further into definable components, then in measuring those components. "Without dissecting and anatomizing the world most diligently," Francis Bacon wrote in 1620, "we cannot found a real model of the world in the understanding."

Nomenclature and mathematics are the basic instruments of this scientific method. When we apply them in an orderly fashion we are by definition thinking logically, acting reasonably. Analysis makes good sense, we say. So, just as we can analyse anything else, we ought to be able to analyse wilderness. If we count lakes, trees, animals, and so on, measure them, describe them, and classify them, and if we do the same for each element of wilderness, then eventually we shall arrive at a full and complete understanding of what makes this natural "mechanism" work. In the meantime we surely cannot be doing any harm, can we? Are we not simply practising good science?

In making this assumption we overlook several things. First, alas, no research is "pure" research. For one thing, there are always troubling "externalities", signs of unquantifiable life beyond the microscope. For another, research is a political as well as a scientific process. Strings get attached to it, and obligations are imposed which require certain compromises. In a democratic and free-enterprise system a cycle of destruction thus begins: Quantification paves the way for exploitation, which leads to evasion, obfuscation, and rationalization, all of which necessitate more research, which results in further compromise of wilderness and therefore a new situation which must be freshly examined and quantified, and so on. As Lynn White, Jr., observed in "The Historical Roots of Our Ecological Crisis", "The issue is whether a democratized world can survive its own implications. Presumably we cannot unless we rethink our axioms."

Secondly, we overlook the fact that an organism can be thoroughly objectified and understood scientifically only when it is dead. As long as it lives it is unpredictable. Part of the scientific process, therefore, is to render inert what is inexplicable – soul or spirit or *numen* – or simply to position it safely outside the field of vision. This radical delimiting is what is often meant by "discipline" or "professionalism".

Most important, we overlook the paradox at the heart of physical research, for finally what is being examined with such scrupulous objectivity will dissolve into the laughter of sub-atomic particles, which become what perception makes them, either waves or matter. "What we observe is not nature itself," Heisenberg said, "but nature exposed to our method of questioning." Like quantum theory, wilderness reveals the inadequacies of the classical Newtonian physics on which Western "progress" has been based, for wilderness is more than the sum of its parts, and we cannot know how much more. No amount of "diligent anatomizing" will help us further. In fact, a blinkered faith in reductionism stands in the way of real progress. This is not to say that we should shutter up the house of intellect. On the contrary, we must enlarge it, build into it rooms for restraint, rooms for unrealizable possibilities, rooms for intuition, perhaps even rooms for forgetting. As William James said, "The art of becoming wise is the art of knowing what to overlook."

It hurts to admit that we have failed in a grand experiment. We have been so proud, so sure that we are superior to other animals. We have been so certain of those standards which convinced us that our law, culture, history, art, ethics, and civilization were superior to those of peoples who have lived in harmony with nature. "Primitive life," says Alan McGlashan in *The Savage and Beautiful Country*,

> "was in many ways harsh and meager, and primitive man was not, on the conscious level, a philosopher. The miracle and the mystery is precisely this: that he answered questions which he was not capable of even formulating — and his answers have never been bettered."

Of the many agonies indigenous peoples have endured, surely the one they are now undergoing at the hands of civilization is the most ironic and horrible. Like wilderness itself they are being murdered not because they failed but because they succeeded too well. Their two million years of success tower above our few centuries of failure. They stand with Banquo in the great hand of God, and we cannot endure them.

So here we are, doing so much worse with so much more, still full of pale faith in reason, quashing discomforting questions, pathetically hoping that the Hydra of problems we have created will yield to scientific analysis and relatively painless solutions. Here we are at the end of our tether, perhaps at the end of our tenure.

We are trapped in a Pyrrhic process, losing more with every victory. If we keep on as we are going now, we shall continue to placate the last of our conscience, our intuition, our instincts, our *soul* by setting aside little areas called "wilderness" or "parks", and for a time they will be more or less safe in the surrounding countryside, the humanized landscape. Then, as pressures mount, they too shall be eroded away as others have been. If we rely on the rational technology of mere survival, and if we postpone the inevitable ecological calamities long enough, then our descendants will inherit a few square metres of space, each living something she or he will still call life because, like the once-great flocks and herds,

whole species of definitions will have passed from Earth. At that point we shall have perpetrated the greatest disaster of all — the triumph of humanity over itself.

So long as we remain merely rational we shall be maddened by paradoxes. We will tighten our stranglehold on nature only to discover our hands on our own throats. We will control death only to find that we must control life, only to lose the spontaneity in which life lives. We will dismember wilderness only to feel its agony in our own bowels.

"How wonderful to have met with a paradox," Niels Bohr once said. "Now we have some hope of making progress."

Let us return to the myth of Theseus and write a different ending. Of course, this is a childish game because the myth exists, after all. But myths live in change and nuance, and more than all others the Theseus tale invites retelling. At each junction in the labyrinth alternatives present themselves and choices wait to be made . . .

So, let us suppose the young adventurer journeys to Crete with all the heroic intentions ascribed to him. He accepts Ariadne's clue and begins the journey into the bowels of Earth, into the convolutions of his soul. Gripping the thread of life he descends, searches, and at last finds the Minotaur.

Now, instead of some heroic reflex which would prod him to slay this terrifying creature, let us assume more compassion in Theseus, more restraint and curiosity, more faith, courage, and respect. He meets the monster's gaze and asks . . . a question. Or perhaps the Minotaur speaks first. They do not ask "Who are you?" because the answers, "I am the son of Pasiphae . . . I am the son of Aegeus . . .", have no meaning there. In the timelessness of that place lineage is a prison, history a trap. They must transcend identities. Both know that to succeed they both must win.

They negotiate.

In time, on the threshold of the maze, Ariadne hears laughter rising from the depths. She weeps with joy. When he emerges and embraces her, Theseus is still laughing. He sends seven youths and seven maids to Athens under a white sail, but he himself does not accompany them.

As for the Minotaur, it lives too.

O'DONNELL POINT NATURE RESERVE, GEORGIAN BAY
BRUCE LITTELJOHN

The People Behind the Parks: Ontario's Wilderness Conservationists

George Warecki

Despite a tradition in Canadian popular culture of celebrating wilderness, most Ontarians had little interest in wilderness protection until the early 1970s. Before the emergence of grassroots support for preservation, a handful of people led the way by drawing attention to the need for protecting Ontario's wilderness. They exerted an influence on provincial park policy far beyond their number by educating public opinion about the need for conserving natural environments. Conservationists—and a younger generation of environmentalists in the late 1960s—convinced politicians and civil servants to adopt more protectionist policies for publicly owned wildland. This successful record was the result of individual efforts, organization, and perseverance.

The following essay is a small sampling and celebration of Ontario's leading wilderness conservationists. Many others have continued their work with admirable zeal, but they cannot be mentioned here. Their efforts—whether acknowledged or not—have been that much more effective, thanks to the earlier feats of a few select crusaders.

Historians of the environmental movement have dwelt on the role of interest groups in the politics of preservation. But wilderness organizations are only as effective as their leadership. In Ontario, as elsewhere, individual experience was a crucial influence on the development of wilderness ideas which, in turn, shaped the course of political activity. The conservationists were a dynamic, diverse lot. Although many groups dealt with wilderness protection, they embraced people from different classes, educational traditions, and economic interests. This diversity of backgrounds helped to offset the lack of mass popular support for wilderness protection until the early 1970s.

Wilderness is, in large part, a state of mind, a perception coloured by human biases and cultural values. A plethora of individual tastes and traditions, then, altered the course of Ontario's wilderness conservationists. They were imbued with a civic-minded ethos that crossed the boundaries of modern states. Books, lecturers, students, and ideas moved freely between the United States and Canada, for instance, prodding a rather stodgy Ontario out of its localized values and inertia on wilderness protection. Indeed, American and British cultural influences deeply affected Ontario wilderness advocates. From the British they took traditions of natural history, voluntary conservation efforts, ecological concepts, and the idea of local nature reserves. They adopted a host of American ideas, including management concepts, organizational structures, and, during the late 1960s, lobbying tactics and mass-media techniques. By examining some of the influences which affected those who fought for wilderness, we may better understand the rich historical legacy of their pioneering conservation efforts and their impact on publicly owned wildland.

I

During the 1960s, several key people began to champion wilderness conservation in Ontario. Their efforts led to an explosion of public interest over the management and protection of the large provincial parks like Algonquin and Quetico. This awakening in Ontario was part of a wider environmental movement which profoundly touched the hearts of conservationists and fuelled preservationist sentiment across the province.

A broadening out occurred for several reasons. Popular notions of ecology, spread by the mass media, made wilderness

GREAT BLUE HERON
MICHAEL RUNTZ

issues more intelligible. There was also a new sense of urgency in preserving wildland. Widespread pollution and environmental deterioration led many to conclude that human survival might depend on the preservation of natural areas, as pools of genetic diversity and ecologically healthy "islands". Moreover, wilderness became a symbol of nature; what society did to wilderness was symbolic of an attitude toward the environment.

Increased leisure time and interest in the quality of life contributed to the preservation movement by creating an unprecedented demand for outdoor recreation in wild country. This development also forced some conservationists to contemplate the inherent conflicts between preservation and recreation in the wilder parks.

The wilderness movement gained cohesiveness as well as a degree of popular support. Previously, a few recreationist-based wilderness parks proponents and some naturalists and scientists who were nature reserve advocates had worked along parallel but separate lines. The two constituencies now joined forces to create a stronger preservationist voice. This new force shared ideas and publications, sponsored debates, and spread a public consciousness about the need for wildland preservation.

Augmenting traditional sources of preservationist strength was a growing contingent of people committed to the idea of wilderness — wilderness for its own sake, quite apart from direct physical experience with the wilderness as recreationists, field naturalists, or ecologists. The potent combination of aesthetic arguments, increasing recreational demand for wildland, growing recognition of ecological principles, and a surge in the ranks of citizens committed to the idea of wilderness together produced the modern preservationist movement. But leadership was very important. A select group of dedicated conservationists pushed and prodded the sleeping giant of public opinion toward the preservationist viewpoint.

II
An important architect of Canadian preservationist thought and activity in the early 1960s was R. Yorke Edwards. He was born in

Toronto in 1924, and his childhood, like that of so many wilderness advocates, included time for the study of birds and mammals. Through an Audubon Junior Club in a Toronto public school, he had become an amateur naturalist by 1937. In 1948 he graduated in forestry from the University of Toronto, and two years later completed his master's degree in wildlife biology at the University of British Columbia. Edwards then spent ten years as a research biologist for the B.C. Forest Service.

When the annual number of park visitors began to soar in the early 1960s, Edwards recognized a great opportunity for changing public attitudes about the natural world. Accordingly, he helped to lay the foundations, in terms of rationale, methodology, and philosophy, for the profession of nature interpretation. He used that expertise, after 1967, to produce highly successful interpretive programs for the Canadian Wildlife Service.

During the early 1960s, Edwards also fashioned critical thought on the need for protected wildland. In "Canada's Neglected Parks" (*Canadian Audubon*, May 1963), he warned that national and provincial parks were "being trampled to death". Rather than surrendering to caterers, prospectors, loggers, highway engineers, foresters, hunters, luxury hotel builders, and tourist trap operators, Edwards implored the public to support parks with landscapes unspoiled by humankind. Strongly influenced by the work of American preservationist Aldo Leopold, Edwards traced the misuse of parks to the "lack of a good guiding philosophy" imbued with ecological values. He encouraged the growth of citizens' preservation groups to lobby for more protective policies, following the American example.

The Canadian Audubon Society (established 1961) had already embraced the role of advocate in early 1962, when it proposed an expansion of the national parks system to mark Canada's centennial. Unfortunately, this proposal was doomed by lack of cooperation from the provinces, which owned most of the suitable public land. More timely was the society's symposium on "Park Management Policy" held in Toronto during March 1964. Highlighted by the work of university-based zoologists Drs. Douglas Pimlott, William Fuller, and Ian McTaggart-Cowan, the

symposium made a significant contribution to the drafting of a new national parks policy announced in September 1964 by Lester Pearson's Liberal government. The policy affirmed the national parks as "natural areas . . . in which are preserved for all time the most outstanding and unique natural features of Canada". These sanctuaries would be free of any new natural resource extraction including "mining, lumbering, prospecting, commercial fishing, oil exploration and production, even hunting". Only low-intensity and non-mechanized recreational pursuits would be allowed in the parks, although previous developmental footholds like hotels and townsites would remain.

Flushed with pride over this milestone, activists associated with the CAS maintained their vigilance over national parks. Within a few years, however, the society had been overshadowed by other conservation groups.

III

One of Ontario's most influential wilderness crusaders was Gavin Henderson. Like many conservationists of his era, Henderson was born and raised in the English countryside where he acquired an interest in natural history. In his early twenties, during the Depression, he travelled across Canada on the Canadian Pacific Railway and spent several weeks enjoying the spectacular scenery of Banff — Canada's first national park. This initial contact with what he perceived as wilderness predisposed Henderson to support wilderness protection.

Two years later, in 1934, Henderson settled in Toronto, where he met Frank Kortright, a diminutive but domineering member of the Toronto Anglers and Hunters club. Kortright eventually raised the idea of a provincial umbrella organization that would bring together all the groups concerned with conservation — naturalists, farmers, soil and water authorities, hunters and anglers, park advocates, business, labour, and a diversity of research and teaching disciplines. In 1952, Kortright offered Henderson the position of secretary of the newly formed Conservation Council of Ontario (CCO). This was the chance of a lifetime.

Working for the CCO "was a fabulous education", recalled Henderson. He drafted reports and briefs, organized conferences and seminars, and was responsible for disseminating public information. The group's experts included biologists J.R. Dymond, A.F. Coventry, and A.W. Baker, naturalist and ornithologist Clive Goodwin, Conservation Authorities director Arthur H. Richardson, geographer Edward G. Pleva, and many others.

During this time, Henderson read voraciously, especially works on wilderness preservation. Not surprisingly, most of this literature was written by Americans such as Henry David Thoreau, Ralph Waldo Emerson, George Perkins Marsh, Joseph Wood Krutch, John Muir, Aldo Leopold, Sigurd Olson, Olaus J. Murie, and many others. These writers shared a wilderness ethic grounded in respect for the natural world. The ethic was emotionally charged and strengthened by some understanding of ecology. Henderson enthusiastically embraced these values and incorporated them into his own wilderness philosophy.

Philosophical works were not the only American influence affecting the new secretary. During the 1950s, the wilderness movement in the United States matured as preservationists struggled to have Congress pass a national wilderness act. The politics of preservation south of the border was fascinating news for Canadian conservationists and provided them with inspiration for future political action. Observations and values expressed by American writers resurfaced in the CCO's *Bulletin*, which Henderson edited from 1954 to 1965. By 1964 the journal had 7,000 subscribers. This excellent circulation enabled Henderson to stimulate thought on conservation among a select audience, many of whom took part in later initiatives to protect wilderness in Ontario. The idea of wilderness which Henderson espoused, therefore, was very important to the future direction of the preservation movement.

Henderson monitored American developments in outdoor recreational planning, as did others associated with the Federation of Ontario Naturalists (FON) parks committee. In the late 1950s, preservationists in the United States attacked the concept of multiple use for its alleged destruction of wilderness values. Henderson used the same rationale to criticize the management of Ontario's

provincial parks. He objected vehemently to the shoreline reserve mechanism used by the Department of Lands and Forests (DLF) to strike a balance between logging and recreational aesthetics. From his ecological perspective, shoreline reserves created a mere facade, or "cosmetic wilderness". The proper approach to managing the wilderness parks, he argued, was to maintain ecological integrity. If "one part of the system is disrupted all parts are affected". Natural resource extraction – logging, mining, and trapping – had no place in a wilderness.

From the late 1950s until he left his position with the CCO in 1965, Gavin Henderson strove to educate public opinion in Ontario about the need for natural areas, including nature reserves and wilderness parks. By mid-decade, he was reaching a wider audience. A new and long-awaited national parks advocacy group had been organized in November 1963, largely because of the persistence of Henderson and other concerned individuals. But the National and Provincial Parks Association of Canada (NPPAC) did not become an effective lobbying force until 1965, after Henderson had taken over as executive director.

The NPPAC perceived national parks as "sanctuaries of nature" – a view that precluded commercial exploitation of their natural resources. The organization also rejected the assumption that parks should "provide for every kind of use requested by the public". Henderson stated bluntly that the NPPAC "wants the people of Canada to know about their parks, to take pride in them, to understand their purposes – and to get angry and militant whenever they are threatened".

Henderson brought to the association years of conservation experience with the CCO and the FON, as well as his aesthetic and ecologically inspired concept of wilderness. He and his followers promoted this ideal in speeches, public forums, news releases, and briefs to government agencies and especially in *Park News*. Indeed, the NPPAC's most significant contribution in Ontario was to educate a new generation of wilderness advocates, providing a conceptual touchstone and a practical political example for future preservation efforts. Joining Henderson in this educational process was a small core of dedicated conservationists who preferred to work through other channels.

IV

One key development in the preservation movement was a strengthening of the alliance between nature reserve advocates, motivated by scientific and educational aims, and recreationist-based wilderness parks proponents, supported by a growing public constituency committed to the idea of wilderness. Forged in the late 1950s and early 1960s, this force was galvanized into action by Douglas H. Pimlott (1920–78), a professor of zoology at the University of Toronto. In the 1960s Pimlott gave the movement scientific expertise and legitimacy, a clear conceptual framework, strong leadership, an agenda for action, and a political direction that was hitherto lacking.

Douglas Pimlott was born in 1920 in Quyon, Quebec, near Hull. During the Second World War he served in the Royal Canadian Navy on the North Atlantic and was demobilized at war's end with the rank of lieutenant. He took a bachelor's degree in forestry from the University of New Brunswick in 1949 and, after conducting moose studies for the Newfoundland government, enrolled at the University of Wisconsin, where he took his Ph.D. in wildlife zoology in 1959. At Wisconsin, Pimlott combined his faith in Christian Science – an intensely private religion which encouraged the rigorous pursuit of self-improvement, guided by daily reading and meditation – with new influences that shaped his subsequent career. Two American books had a powerful impact on his thought: William Vogt's *The Road To Survival* (1948) and Fairfield Osborn's *Our Plundered Planet* (1948). Vogt deplored the effects of competition and profit on the landscape. Osborn warned that humans must recognize "the necessity of co-operating with nature".

Pimlott heard these dissenting cries in the wilderness of postwar prosperity. He was also deeply impressed by Vogt's strategy for conservation campaigns, which emphasized research, public education, and action. As Pimlott's friend and fellow environmentalist Monte Hummel wrote, "[t]hese were really the three key components of his life."

Pimlott was also "profoundly impressed by the writings of Aldo Leopold", who had left his mark indelibly at Wisconsin. Leopold's plea for an "ecological conscience" in *A Sand County*

Almanac (1949) and the thorny issues raised in *Game Management* (1931) influenced Pimlott's thinking. Moreover, he saw practical applications of Leopold's gospel. Wisconsin boasted the most advanced nature reserves program in North America. It featured a system of ecologically based and scientifically representative sanctuaries, selected and managed with the aid of advisory committees staffed by government officials, scientists, and lay citizens. Pimlott mulled over this efficient and radical example of natural areas preservation and eventually applied these lessons to Ontario.

From 1958 to 1962, Pimlott conducted research in Algonquin Park which won him an international reputation as an expert on the ecology of the timber wolf. Like American ecologist Sigurd Olson thirty years earlier, Pimlott perceived the wolf as a symbol of wilderness. The Algonquin research demonstrated that the wolf population was essentially self-regulating in numbers, despite government attempts to control the species through periodic hunts and a wolf bounty. Pimlott's studies paved the way for a successful, publicly backed campaign against the wolf bounty in Ontario (1967–72).

In 1962 the zoologist quit the DLF in favour of a teaching position at the University of Toronto's zoology department, where he remained until his untimely death in 1978. During those sixteen years, he helped to establish a graduate program in resource management and an undergraduate environmental studies curriculum. Through his teaching positions in zoology and a cross-appointment at the faculty of forestry and landscape architecture, Pimlott influenced a crucial generation of Ontario students. By 1970 Pimlott was Canada's most effective and influential environmentalist. Perhaps his most enduring legacy, however, was his contribution to the Ontario wilderness movement.

In the early 1960s Pimlott had become involved with the Canadian Audubon Society's park policy committee. From this position, he focused his attention on wildland issues in Ontario. Pimlott knew from firsthand experience in Algonquin that "preservation . . . took second place to timber extraction in the large, northern parks". He realized that professional foresters, who staffed senior positions in the DLF, were taught a utilitarian management philosophy which left little room for aesthetics. These foresters seemed intent on maximizing an annual harvest of timber; such an approach downplayed "basic ecological relationships" and jeopardized natural values in provincial parks. Pimlott's training enabled him to criticize the profession from within. He resolved to educate public opinion about natural areas, in ecological terms, and to attack the DLF's management of wildland.

Pimlott launched his crusade with an article entitled "The Preservation of Natural Areas in Ontario" (*Ontario Naturalist,* 1965). It was a brilliant critique and a blueprint for preservation politics for the next decade.

Pimlott charged that the DLF had little regard for preserving natural ecosystems — either as wilderness parks or nature reserves. He explained the notorious loophole in the Ontario Wilderness Areas Act (1959) which permitted resource extraction on designated lands larger than 260 ha (640 acres). Pimlott cited the lack of nature reserves in either Algonquin or Quetico Park. He also revealed that the Algonquin Wildlife Research Area, originally suggested by the FON and established by order-in-council (1944), was no longer protected; the order had expired through neglect. Worse yet, part of that area, containing a rare stand of red spruce, had been placed under timber licence for cutting.

Pimlott challenged the DLF to strike a better balance between recreation, preservation, and resource extraction within the provincial park system. He called for a new park classification scheme (recently extolled in *Outdoor Recreation for America,* 1962) which entailed designation, zoning, and management of different classes of parks for different types of users. He explained the urgent need for additional wilderness parks and a system of nature reserves. Moreover, Pimlott demanded that the department issue both a detailed statement of provincial park policy and public plans for each park, outlining ecological resources, management goals, and procedures. He also called for a new Natural Environment section within the parks bureaucracy, staffed by ecologists and geographers.

Without strong public support, preservationists would never defeat development-minded interests, Pimlott warned. He urged the dormant FON to resume its decades-long educational mission by employing the news media, circulating public statements, and

challenging provincial park policy. Pimlott himself adopted these tactics in the 1960s.

The initial trumpet blast in Pimlott's crusade sparked a resurgence of FON activity. It included renewed effort by local naturalist clubs to establish small sanctuaries. Pimlott's colleague at the University of Toronto zoology department, Dr. J. Bruce Falls, initiated a new round of meetings with the DLF to design a system of nature reserves. By the late 1960s, the department had responded by appointing ecologists to the Parks Branch to deal with reserves, and an advisory board like the Wisconsin precedent. A third impact of Pimlott's opening salvo was an explosion of interest in wildland, revealed in the pages of *Ontario Naturalist*. In all of this literature — exemplified by Fred Bodsworth's "Wilderness Crisis" (1967) — the focus was on an ecologically oriented concept of wilderness.

From 1965 to 1967, Douglas Pimlott intensified his crusade. In the fall of 1965 he began three years of discussions with contacts on the need for a provincial citizens' organization in Ontario to cooperate with the NPPAC. Pimlott's strategy was to cement an alliance between hunters and anglers, wilderness trippers, naturalists, scientists, conservationists, and planners. Together, they would focus their attack on a common enemy — the forest industry and professional foresters — touching off one of Ontario's greatest wilderness battles.

V

The Algonquin Wildlands League (AWL) was the province's most outspoken and politically effective association of wilderness protection. It was established in 1968 by a handful of well-educated middle-class males. Each had canoed in Algonquin Park and objected to intrusions which were combining to erode its natural character, including modern mechanized logging, the expanding road network, powerboats on interior lakes, and crowding by campers. The founding members included business executive C. Abbott Conway (president), Douglas Pimlott (first vice-president), naturalist and film producer Dan Gibson (second vice-president), Canadian Audubon Society director Patrick Hardy

(secretary), Federation of Ontario Naturalists president and author Fred Bodsworth, Ontario Federation of Anglers and Hunters president and Sudbury physician Dr. Robert Longmore, Kingston metallurgical engineer Joseph O'Dette, and Huntsville tourist outfitter David Wainman. New officers in September 1968 included publicist Walter Gray, J. David O'Brien (treasurer), and gas distribution executive Jeff Miller.

Pimlott, the AWL's founder and moving force, played a key role in directing its early activities. He brought to the AWL his scientific training in forestry and wildlife management, a firsthand knowledge of Algonquin Park, experience with the DLF's bureaucracy, and an emotional commitment. He participated in public meetings, analysed government documents, and wrote several articles on behalf of the AWL.

Other AWL directors had talents specifically tailored for pressure-group activity. Walter Gray, for example, was a Toronto-based public relations executive with impressive credentials. He had been Ottawa Bureau Chief for the *Globe and Mail* from 1960 to 1963 and had held a similar post with the *Toronto Star* from 1967 to 1968. Gray's experience and business connections contributed strongly to the group's success. One example of his organizational expertise was to stage the "Quetico Summit Meeting" (3 October 1970) to publicize opposition to commercial logging in that park. This meeting was a pivotal event in the Quetico campaign.

In several wilderness battles, the AWL effectively employed newspapers, television, radio, letters to the editor, and citizens' letter-writing campaigns designed to bombard politicians and civil servants with paper. All were designed to shape or express popular opinion. The AWL staged one open meeting and panel discussion in Toronto in 1968 and three similar gatherings during the summer of 1973 in Huntsville, Ottawa, and Toronto. These meetings provided good copy for the media, increased public awareness about Algonquin Park, and raised the AWL's public profile. When the campaign bogged down during the early 1970s, the AWL successfully recruited the provincial New Democratic and Liberal parties. The conservationists fed information to both Opposition parties, who gladly attempted to embarrass the Progressive

Conservative government inside and outside the legislature. This remarkable success in securing the attention of influential news media during the "Algonquin Alert" was chiefly the work of Walter Gray.

Like a good pressure group, the AWL claimed to speak for "the public". Critics of the sensationalism and public relations techniques must not forget that, in 1968, preservation-minded planners within the DLF's Parks Branch needed strong public support. The AWL generated and articulated that support.

The AWL was not a one-man show but a dynamic group. Fred Bodsworth was a journalist and a dedicated naturalist. A gifted writer, he also wrote novels which frequently carried a powerful ecological message. Patrick Hardy, managing director of the CAS and editor of *Canadian Audubon* since 1962, had first encountered Algonquin in 1929 as a youth at Camp Ahmek. His passionate, forceful defence of wilderness values was an essential ingredient of the AWL. Other important stalwarts included Dave Wainman, a tourist outfitter in the Huntsville area, who had ten years' experience as a timber scaler for the DLF. Wainman brought to the group firsthand knowledge of conditions in Algonquin Park, communication skills, and a hilarious sense of humour. Finally, Dan Gibson, an award-winning producer of nature programs for radio, television, and motion pictures, added both a naturalist's expertise and a knowledge of wildland resources beyond Algonquin.

One of the AWL's most colourful characters was Abbott Conway. For many years he ran a Huntsville logging company, fed by timber harvested in the Algonquin region. During the late 1950s, his pastime of listening to wolves howl in the park brought him into contact with Douglas Pimlott, who was then conducting wolf research. In 1968, Pimlott shrewdly recruited Conway—then a successful Guelph tannery executive—to be the "front man" for the AWL. Like many others, Conway was concerned about the destructive impact of modern mechanized logging on Algonquin's wilderness values. The AWL gained a person of strong convictions, with colourful language and the stomach for battle.

On 13 March 1968, Conway presented a statement on behalf of the AWL to the provincial legislative committee on natural resources and tourism. He argued that the park's yellow birch and few remaining stands of white pine were almost exhausted. Conversely, the demand for recreation in natural surroundings was increasing dramatically. Conway asserted that "[l]umbering, as it is practised in Algonquin Park today, is not compatible with its future". In the absence of an approved departmental master plan for the park Conway recommended: (1) that 50 per cent of Algonquin (the western half of the park) be set aside as a primitive zone, free of logging and mechanized recreation; and (2) that the eastern one-third of the park be designated a multiple-use zone, with continued logging, in accordance with the DLF's new 1967 classification system. This proposal soon received widespread support, as the AWL became the first wilderness organization in Ontario to successfully employ mass media techniques.

VI

The AWL's accomplishments can be traced to the efforts of talented and committed individuals. In June 1970, for example, Douglas Pimlott led a four-man AWL task force into Lake Superior Park to investigate logging operations. Its other members were Bruce Litteljohn, a Toronto schoolteacher and historian, who was a former Quetico Park ranger and historian for the Parks Branch; C. Brian (Charlie) Cragg, a professor of Chemistry and Natural Sciences at York University; and Dennis Voigt, a graduate forester. The result was the first book-length critique of Ontario provincial park policy, entitled *Why Wilderness? A Report on Mismanagement in Lake Superior Provincial Park* (1971). The book embarrassed some in the DLF, heartened others, and helped to tilt the balance of park policy toward more protective considerations.

In the fall of 1971, Litteljohn and Cragg led the directorate in an agonizing critical examination of the AWL's long-range strategy and philosophy. This internal debate produced the first edition of *Wilderness Now* (May 1972), published in booklet form. Although it was not a grand intellectual achievement, making an unassailable case, it did set forth the AWL's philosophy, which now rejected mechanized recreation and resource extraction as violations of ecological integrity in wild parks. Moreover, the booklet

was the first attempt by anyone to outline a system of wilderness parks for Ontario. *Wilderness Now* had an important impact on both conservationists and provincial park planners, continuing the complex dialectical process by which the AWL and the civil service influenced one another. By the late 1970s, prompted by the AWL, government planners had synthesized a new, comprehensive provincial wilderness protection policy.

Not until 1973, when political developments demanded a response, did the AWL apply its new ecologically inspired philosophy to Algonquin Park. That year, faced with ever-worsening prospects for significant primitive zones in the park, and encouraged by both the New Democratic and Liberal parties, the AWL withdrew its 1968 zoning proposal. Henceforth, it demanded the gradual phase-out of all logging operations in Algonquin Park.

The outcome of this battle — a government decision to allow restricted logging, and to maintain Algonquin as "the average man's wilderness" — was a reasonable compromise. Despite the AWL's bitter rhetoric, it had enjoyed remarkable success. It had generated crucial public support for wilderness values, and had secured a greater role in the decision-making process. By 1974, the AWL had also forced the government to establish a more protectionist policy for Algonquin Park, firmly rooted in an official master plan. If other battles had produced mixed results — logging was limited to 50 per cent of Lake Superior Park and completely eliminated from Killarney in 1971 — it was not for lack of effort.

The AWL's most successful battle was the Quetico campaign (1969–73) to eliminate commercial logging in Quetico Provincial Park and to reclassify it as Primitive. Bruce Litteljohn led the struggle, which quickly evolved into a symbolic environmental issue. AWL strategists tapped into the surging ranks of environmentally conscious Ontarians in 1970 by circulating 1,000 copies of a leader's information package, which fostered the development of many local "save Quetico" groups. They were encouraged by the passionate advocacy of Gavin Henderson, American preservationists Sigurd Olson and Charlie Ericksen, biologist Dave Bates and schoolteacher Bill Addison of Thunder Bay, homemaker

Ethel Teitelbaum of Toronto, and dozens of other activists. As Litteljohn explained, the Quetico battle became "the crucible for the conservation movement".

The AWL built Ontario's first broadly based wilderness preservation movement through efficient organization, well-timed publicity, and dramatic public meetings. To resolve the crisis, the provincial government established a citizens' advisory committee, which held public hearings across the province in the spring of 1971. The public response was staggering: the committee received some 263 written briefs, 4,500 letters, and 144 oral presentations. Published transcripts of the hearings reveal that support for wilderness preservation had expanded dramatically. It now came from men and women in various regions, rural and urban, from a variety of age and social classes and a wide spectrum of occupational backgrounds, from politicians in all three parties, and from some native Indians. This overwhelming response convinced William Davis's Progressive Conservative government to ban logging in Quetico Park in 1971, and to designate it a Primitive-class (now Wilderness) park in 1973.

In the mid-1970s, broad support for wilderness preservation began to wane in Ontario as the popular wave of environmentalism temporarily receded. Five years of fiscal restraint in the provincial parks bureaucracy slowed the master planning process to a snail's pace. In this uncertain climate, both civil servants and conservationists abandoned their piecemeal approach and turned to design a system of provincial wilderness parks. Since then, much progress has been achieved in protecting Ontario's wilderness. And yet, few observers would claim today that the wilderness is safe from destruction. Serious threats such as acid rain, recreational overuse, and resource extraction continue to plague provincially owned wildland. A parks system, no matter how well supported by protective government policies, does not guarantee the survival of wilderness. But thanks in large part to the efforts of some dedicated conservationists, Ontario's wilderness heritage stands a fighting chance of survival.

LADY EVELYN SMOOTHWATER PROV. PARK
LORI LABATT

Ontario's Natural Diversity

T.J. Beechey & R.J. Davidson

Portraits of Earth from distant space depict the Great Lakes as a stunning chain of sapphires marking the North American heartland. To the lee of the Great Lakes, Ontario's vast expanse of land and countless lesser lakes and islands stretch northward to the prominent Hudson and James Bay coasts. Between these two outstanding marine environments, the province's land- and waterscapes span 22° of longitude and 15° of latitude, or roughly a twenty-fifth of the earth's circumference — north to south, east to west. This vast area incorporates a significant portion of the continent's natural heritage. Through the eyes of an astronaut, Ontario is truly an impressive image, clearly discernible from an earthly orbit.

The elements of Ontario's natural heritage are highly diverse. They trace the creation of an expansive landscape and the evolution of intricate terrestrial and aquatic ecosystems. The province's geological history spans a period of more than 3 billion years. Its physical features represent the Precambrian, Paleozoic, Mesozoic, and Cenozoic eras, each a significant chapter in the creation of the planet. The rocks and fossils of the Canadian Shield and adjacent lowlands of Hudson and James Bay and of the Great Lakes–St. Lawrence record the construction of the continent and the evolution of life on Earth. Ontario's landforms illustrate the ancient work of continental glaciers and the recent actions of gravity, wind, and water.

During the course of this development, Ontario has experienced a wide range of climatic conditions ranging from tropical to arctic regimes. Today's climate, combined with Ontario's diverse physiography, continues to govern the character and extent of the province's ecosystems, biotic communities, and species. The ameliorating influence of the lower Great Lakes in the south, juxtaposed with the attenuating effect of Hudson Bay in the north, produces a combination of climatic regions that defies typical continental patterns. When latitudinal and longitudinal climatic belts are superimposed on Ontario's physiographic base, plants and animals (and sometimes ecologists) are sensitive to

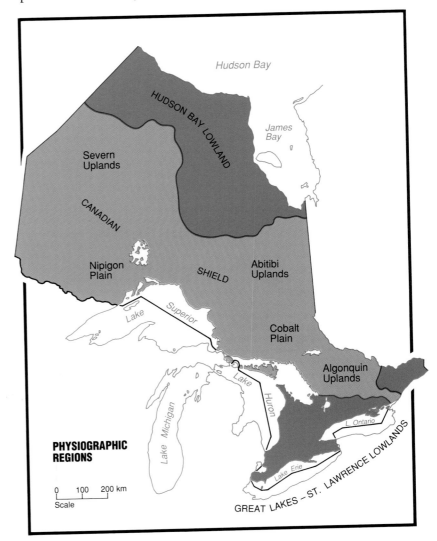

PHYSIOGRAPHIC REGIONS

0 100 200 km
Scale

84

many distinctive ecological divisions, ranging from extensive natural regions to discrete local communities.

Ontario's climate and physiography continue to shape the nature and distribution of contemporary ecosystems, flora, and fauna. Polar conditions penetrating Hudson Bay support the southernmost intrusion of tundra into North America. South of this region, extensive peatlands of global significance merge with the vast Boreal forest of the northern Canadian Shield. Farther south, transitional forests under more temperate influence dominate southern portions of the Shield surrounding the upper Great Lakes. South of the Shield, the Great Lakes–St. Lawrence Lowlands support remnant mixed forests, which eventually merge with precious fragments of rich deciduous forest in the narrow Carolinian zone north of Lake Erie.

The province's wide-ranging ecological conditions are reflected in its diverse and cosmopolitan biota. The provincial flora includes some 2,000 species of native vascular plants; about 450 species of mosses and liverworts; and approximately 1,000 fungi, lichens, and algae. Ontario's natural habitats are home to thousands of yet-uncounted invertebrates and close to 600 vertebrates comprising 302 birds, 84 mammals, 24 reptiles, 42 amphibians, and 150 fishes. With a mix of species representing distant corners of the continent—Arctic, Boreal, Great Lakes, Carolinian, prairie, coastal plain, and other affinities—pedigrees are enormously varied and make Ontario a truly important ecological crossroads in North America.

As wondrous as this natural legacy may appear, it remains far from secure. Millennia of species immigration has been drastically altered in the brief time since European habitation. Outright extinctions of some species, coupled with local extirpations of others, have left the provincial biota impoverished. The extinction of species such as the passenger pigeon and the eastern cougar symbolizes the cost of complacency and neglect. More than one-quarter of Ontario's native flowering plants are recognized as rare by botanical authorities, at the same time that as many alien species have been introduced. The near elimination of prairies, severe loss of wetlands, and drastic conversion of southern forests have placed many species of plants and animals in peril.

In response to our strained relationship with nature, protected natural areas, including provincial parks, are one important mechanism to help curb further losses to Ontario's natural heritage and provide refugia for future restoration efforts. In all regions of the province, Ontario's provincial parks are symbols of hope, providing a vital role as benchmarks of pre-settlement conditions, essential sanctuary for deprived species and diminishing spaces, and cathedrals for spiritual and environmental revival. As such, provincial parks are essential to the well-being of all Ontarians, including, first and foremost, native species and the critical spaces essential to sustain them.

ORGANIZING NATURAL DIVERSITY

If we are to protect this diverse natural heritage, we must secure adequate samples of each typical element and sufficient lands and waters to maintain their scientific, physical, and ecological integrity. To this end, the elements of Ontario's natural heritage have been defined by the Provincial Parks and Natural Heritage Policy Branch in separate planning frameworks that describe Ontario's geological and ecological diversity and set targets for protecting this heritage. These frameworks take their direction from the cabinet-approved Ontario Provincial Park Policy and the Ontario Provincial Parks Planning and Management Policies. Both frameworks are used to guide the selection of Ontario's provincial parks and areas of natural and scientific interest.

Ontario's geological diversity has been summarized in a framework for the conservation of Ontario's earth science features. The policy direction provided for this framework is: "to protect a system of earth science features representative of Ontario's earth science history and diversity". To satisfy this policy, earth science features have been defined as the physical elements of the natural landscape, created by geologic processes and distinguished by their age, stratigraphy, and topography. Typical or representative features are then organized into forty-four themes based on their age, composition, shape, and environmental relationships. Within this

context, more than 1,200 typical rock types, fossil assemblages, landforms, and related geologic processes are identified as protection targets.

The province's ecological diversity has been summarized in a framework for the conservation of Ontario's biological features. The policy direction set for this framework is: "to protect a system of life science features representative of Ontario's life science history and diversity". In response, the framework establishes the procedure for selecting natural areas to represent the range of ecosystems found in Ontario. It divides the province into thirteen site regions and a subset of sixty-five site districts based upon climate, physiography, and biological productivity. (See map, page 94.) Within each site district, finer "landscape units" are defined on the basis of their recurring landform and vegetative patterns. These patterns, and the communities and species that they support, constitute the ecological systems and elements to be protected.

SELECTING NATURAL HERITAGE AREAS

The frameworks rely on the concept of *representation*, or the selection of areas with typical, or characteristic, natural features and systems. An individual area's biophysical diversity, natural and scientific integrity, and special features also influence its selection. Similar areas are then analysed and compared, and those containing the best examples of natural features are rated as *provincially significant*. Areas of lesser value are graded *regionally* (or *locally*) *significant*. The concepts of geology, ecology, representation, and significance have been employed in the last fifteen years to assess the natural values of existing provincial parks, to select new provincial parks, and to initiate a new program for areas of natural and scientific interest.

Today, the provincial park system includes 261 provincial parks comprising about 630,000 km² of lands and waters. More than 700 areas of natural and scientific interest also have been identified. It must be stressed that most of these natural and scientific areas have only been identified, *not protected!* On public lands, protection and compatible use will be pursued through a variety of designations. On private lands, property tax rebates, agreements with private landowners, conservation easements, and the municipal planning process are among the basic tools being used for protection. When complete, the network of provincial parks and areas of natural and scientific interest hopefully will provide for a system that adequately represents and truly protects the elements of our natural heritage.

OLD WOMAN BAY, LAKE SUPERIOR PROV. PARK
LORI LABATT

LEFT / WILLOW CATKINS, MOUNTSBERG
CONSERVATION AREA
ROBERT McCAW

ABOVE / WATERFALL, NIAGARA ESCARPMENT
LORI LABATT

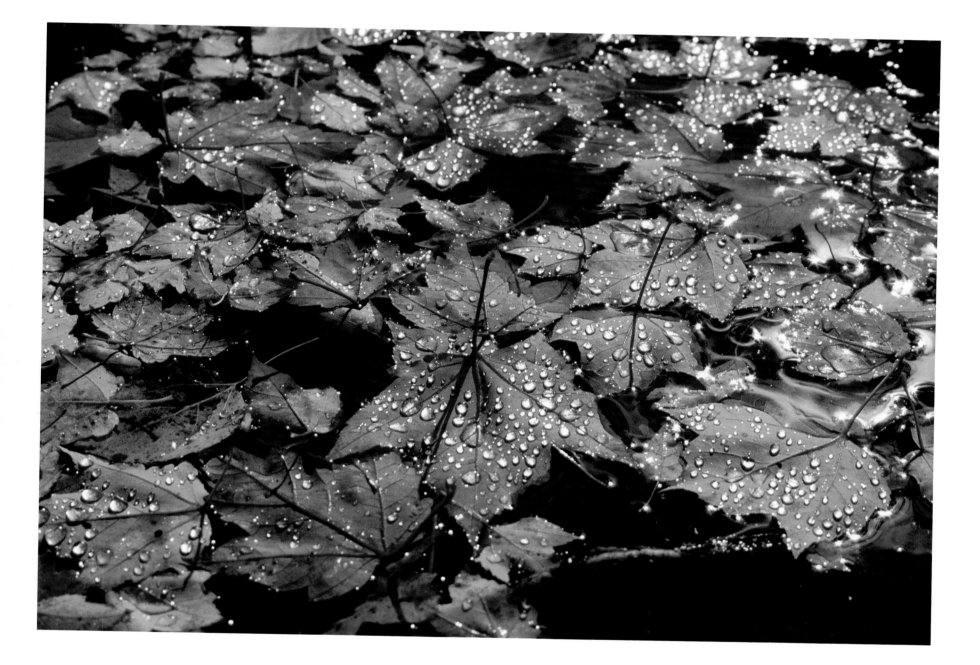

LEFT/EDGE OF THE MARSH, POINT PELEE NAT. PARK
LORI LABATT

ABOVE/KAWARTHA HIGHLANDS PROV. PARK
PAUL CLIFFORD

LEFT / AUTUMN REFLECTIONS, BALSAM LAKE PROV. PARK
SAM KOLBER

ABOVE / STAGHORN SUMAC, BOYNE VALLEY PROV. PARK
BRUCE LITTELJOHN

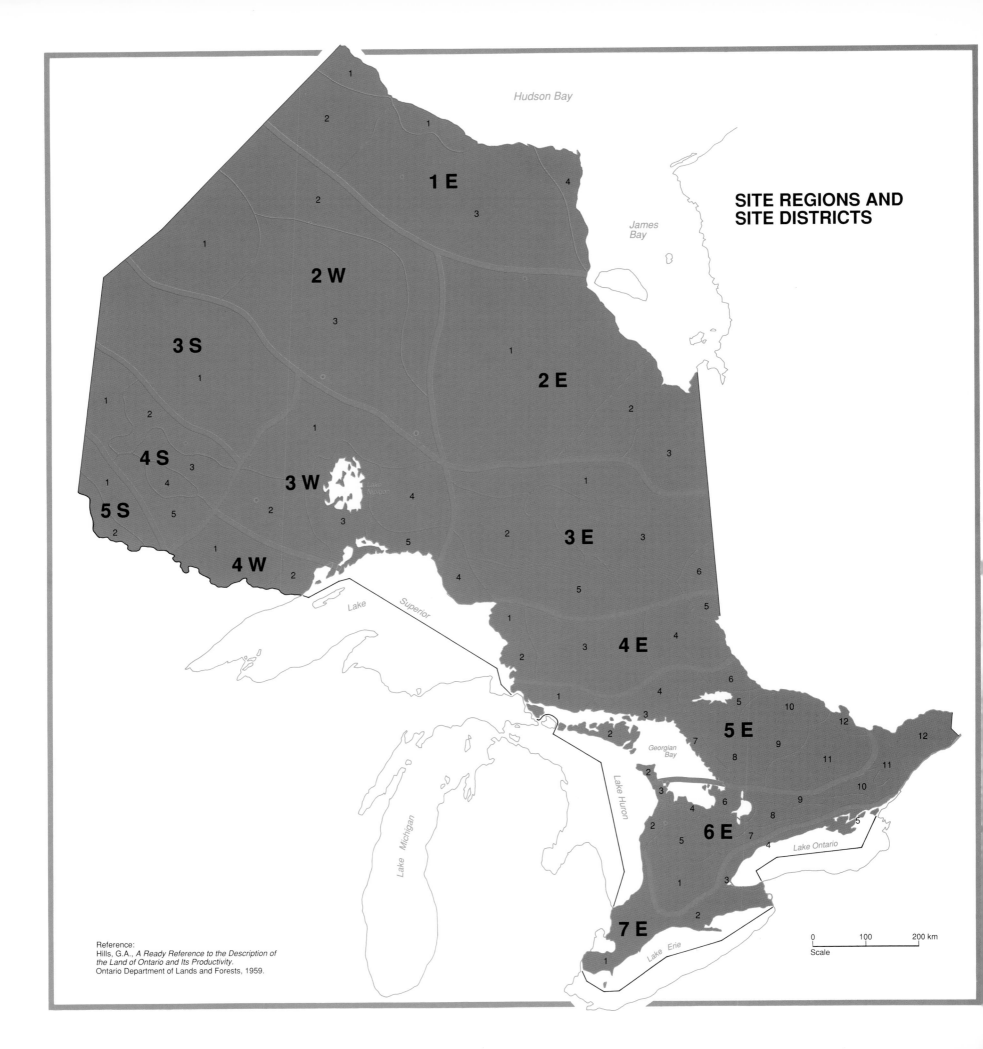

SITE REGIONS AND SITE DISTRICTS

Reference:
Hills, G.A., *A Ready Reference to the Description of the Land of Ontario and Its Productivity*.
Ontario Department of Lands and Forests, 1959.

Scale
0 100 200 km

The Great Lakes–St. Lawrence Lowlands

T.J. Beechey & R.J. Davidson

CREATION OF THE LAND

Ontario's cottage country—its lakes, streams, wetlands, and rocky cliffs—invoke memories of lazing by the dock, paddling in the calm of first morning's light, or an exhilarating workout on the ski trail. To a geologist, the rugged landscapes of Muskoka, Haliburton, Hastings, Lennox–Addington, and Frontenac counties conjure up different images—of an ancient, lifeless continent ravaged by wind, water, gravity, and the waves and currents of a primal sea. The southern margin of this continent, called Laurentia, is now marked by a narrow ribbon of sand, cobbles, and boulders that separate the Canadian Shield from the adjacent Great Lakes–St. Lawrence Lowlands. These sediments also mark the end of the Precambrian era, but more about that later.

The new Paleozoic era witnessed the submergence of Laurentia and the emergence of shallow, clear carbonate seas teeming with new life. A profusion of snails, shellfish, corals, and trilobites flourished. This great evolutionary experiment was altered about 400 million years ago as land began to rise in the area now occupied by the Appalachian Mountains. Carbonate seas were soon buried by mud, sand, lime, and salt as the land rose, sank, and rose once again. Again, carbonate seas rich in marine life invaded the land. Then followed new mountain building and the final emergence of land some 350 million years ago. Over millennia erosion has since removed much of these marine sediments to expose Laurentia's ancient highlands.

In the past million years, the elements have continued to shape Earth. River valleys were cut into soft shales formed from Paleozoic muds; gorges and escarpments were carved into hard limestone deposited by carbonate seas. A succession of continental glaciers accentuated this landscape by gouging out river valleys and streamlining bedrock highlands. The last great glacier, the Wisconsinan, then buried the entire province beneath thousands of metres of ice. As this ice melted, it broke up into smaller independent glaciers, one in each of the Great Lakes basins. These smaller glaciers advanced and retreated from the basins: carving the modern Great Lakes; sculpturing exposed bedrock; depositing thick sequences of till, sand, and gravel; and creating a rich assortment of glacial landforms.

Today, the south displays a complex array of features and landscapes. The erosive effects of ice and water are seen in the irregular hills and lakes of cottage country; in the limestone plains of the Manitoulin, Bruce, Prince Edward, and Ottawa–Carleton areas; and in the cliffs, gorges, and waterfalls of the Niagara Escarpment. Caves, sinkholes, and talus slopes also are associated with these landscapes. Glacial sediments can be seen in the Oak Ridges, Palgrave, and Orangeville moraines. Eskers, kames, kettles, and drumlins dominate the Peterborough, Dundalk, and Waterloo areas. Post-glacial shorelines, lake beds, and inland dunes are found adjacent to the Great Lakes and in the Ottawa–St. Lawrence valley. Our contemporary Great Lake shorelines boast impressive shore cliffs, beaches, spits, forelands, and coastal dunes.

GREENING OF THE LAND

With the ebb and flow of geological time, Ontario has hosted a succession of life forms and ecosystems, of which today's complement is a small fraction of the total. Recession of the Wisconsinan glacier provided the most recent setting for occupation by today's biota. Retreating to the north, it first unveiled southern Ontario, opening up a freshly glaciated landscape with an impressive array of site conditions to support the colonization of species quick to immigrate from the west, the south, and the east.

As varied as the biota of southern Ontario is today, it represents a youthful movement in geological time. Seemingly aggressive and resilient, its rapid development over some 15,000 years has proven to be delicate and vulnerable to European settlement and use. To such early naturalists as Father Hennepin, John Goldie, David Douglas, and John Macoun, southern Ontario today would be a foreign land, for their accounts of the province's rich and diverse ecosystems, landscapes, and biota are images of the past. The tapestry of natural scenes that they portrayed, only a few generations ago, has been supplanted by a settlement grid of lots and concessions, land clearance and development—human design in conflict with nature. Natural areas once draping southern Ontario have now been reduced to isolated patches and ribbons.

Fortunately, today's remnants retain vignettes that substantiate the earlier exploratory accounts and suggest few absolute losses. Among them, those of Ontario's deep south, or Carolinian Region 7E, are among the most splendid in Canada. Basking in long hot summers and short mild winters, at the same latitude as northern California, these precious remnants are a cornucopia of biological treasures and oddities fascinating resident naturalists and visitors. Boasting more than seventy different kinds of trees including tulip, cucumber magnolia, black gum, sassafras, Kentucky coffee-tree, and red mulberry, this tiny region houses more species than any other in Ontario. Organized around subtle environmental gradients, the arboreal component, with an impressive supporting cast, produces an array of communities unique in Canada—cactus barrens, red cedar savannahs, oak parklands, sycamore bottoms, mesic prairies, freshwater marshes. Special spaces are home to special species—prothonotary warbler, yellow-breasted chat, Blanchard's cricket frog, blue racer, Fowler's toad, Karner blue butterfly . . . the list goes on. Regrettably, their current status is so depleted that every fragment is critical, justifying the special conservation attention being assigned to this region.

Flanked by the Carolinian forest and the Canadian Shield is a more temperate transitional region (Site Region 6E) extending from Lake Huron to the Ottawa River. More varied in physiography, a harsher climate works to constrain the diversity found to the south. Originally a region of temperate forests and numerous wetlands, it too has succumbed to conversion and fragmentation. Today, mesic forests of sugar maple and beech prevail among arboreal communities, with formerly widespread communities of hemlocks, oaks, and pines restricted to enclaves. Stressed environments associated with Great Lakes shores, interior bedrock plains, escarpments, and wetland pockets delight naturalists with botanical and zoological oddities that cannot compete with the vigorous growth on more productive sites. Boreal inclusions capture species that first colonized along the retreating ice front, making accessible communities and species now more at home on the Canadian Shield.

In southern Ontario as viewed from a distance, the historical domination of temperate and mixed forests is a theme struggling to persist today. The magic and the mystery of forests capture the imagination of young and old alike: trees that make sugar, woodlands that sleep in the winter, explosions of spring flora, choruses of songbirds and amphibians, riots of autumn colour. Though seriously depleted in the landscape, upland remnants still retain these functions, accessible to all who cherish them. Across the south, provincial parks house these ecosystems, along with many of the more unique environments, communities, and biota, to provide perpetual opportunities for study and appreciation and a nucleus to build upon.

PROVINCIAL PARKS IN THE SOUTHERN LOWLANDS

Settlement patterns have greatly restricted the numbers and distribution of provincial parks in the southern lowlands. The conversion of the forest to an agricultural landscape has eliminated opportunities to establish large wilderness and natural environment parks. Land tenure and transportation patterns have made it impossible to create continuous waterway parks. Those parks that have been created are restricted to the shores of the Great Lakes, the Niagara Escarpment, or Shield country, where traditional recreation values are high. These parks also were created when both lands and dollars were more readily available.

RED-WINGED BLACKBIRD, LONG POINT PROV. PARK
BRUCE LITTELJOHN

Many of our existing provincial parks in the southern lowlands incorporate outstanding natural features and systems. Pinery, Rondeau, Long Point, Presqu'ile, and Sandbanks include superlative examples of spits, bars, beaches, and dunes supporting communities and species confined to the Great Lakes. Short Hills, Credit Forks, Mono Cliffs, and the many nature reserves along the Escarpment illustrate the geological and ecological conditions of the Bruce and Niagara peninsulas and Dufferin County. Charleston Lake, Frontenac, and Bon Echo all provide exceptional representation of natural features and conditions on the Canadian Shield.

While the values of these landscapes are well represented in our parks, other values of the southern landscape are not. The province's spectacular glaciated landscapes, upland forests, river valleys, wetlands, prairies, limestone plains, and alvars are inadequately represented in the existing park system. The securement of these values and the sound ecological management of our protected areas are the two most important challenges that we will face in the 1990s. In securing areas, private stewardship and municipal planning must increase in importance, to protect both specific sites and the integrity of landscapes to sustain them. Further, more emphasis will have to be placed on cooperative initiatives for areas of natural and scientific interest, wetlands, and environmentally sensitive areas. The management of these areas must balance increasing demand for recreation, resource utilization, and the primary need to maintain natural diversity.

LEFT / FORKS OF THE CREDIT PROV. PARK
LORI LABATT

ABOVE / DEVIL'S PUNCHBOWL, NIAGARA ESCARPMENT
LORI LABATT

Carolinian Canada: Significant Bits and Pieces

Kevin Kavanagh

Mid-afternoon, and the air had become unseasonably hot and humid. Stretched out on a sandy beach, propped against one of the many massive logs lying in the sand, I was intrigued by the head that kept popping up out of the water before me. Down suddenly here, up again over there. For a few minutes the hot sun overpowered me and I dozed off. Awakening, a minute passed before I could once again locate the whereabouts of the hunter. Leaving the water, it tested the air and slowly began to slither up the sandy beach towards the dense tangle of shoreline forest. On that early May afternoon, the humid, warm air contrasted sharply with the still frigid water from which the Lake Erie water snake had emerged. As its body warmed on the sand, its speed picked up and it soon disappeared safely into the deep shadows of eastern cottonwoods lining the shores of Pelee Island's Lighthouse Point.

Closing my eyes again, I revelled in the tranquillity and wildness of this stretch of beach. But it is a fragile tranquillity. In Ontario's deep south, no true wilderness remains, only bits and pieces of a former biologically rich and varied landscape. Yet if it were not for the protection of some significant bits, the Lake Erie water snake that had captured my attention would not have had access to a quiet beach or been able to find a safe haven in which to retreat. In all likelihood, it would be extinct. In large part because of the presence of several small protected areas on Pelee Island, it has hung on and instead only bears the dubious distinction of being "endangered".

Tragically, little is left of such southern oases. Estimates vary, but it is probably safe to say that nearly 90 per cent of the natural habitats in this region have already been destroyed. In regions around Windsor and Toronto, the loss is even more catastrophic: only about 2 per cent of the landscape can be described as natural, the rest having been consumed, altered, or degraded by human interests. Although the factors vary, many declines in population levels of plants and animals in southern Ontario can be linked to widespread habitat loss. Protected areas, represented by a scattering of small provincial and national parks, conservation areas, and private nature reserves, are all that provide any future for these Carolinian species in Canada. Yet they continue to be islands of green, in the truest sense of the term, harbouring Canada's greatest concentration of rare, threatened, and endangered species, some 40 per cent of the national listing of species in jeopardy. Although relatively small in extent, this southern region known as Carolinian Canada remains one of the unique areas of the nation—tobacco and peach country to some, a biological paradise to others.

On that early, hot spring day, it was easy to see how Carolinian Canada received its popular name. Stretching south of a line from Toronto to Sarnia, the region's summers come early and often explode across the landscape. They follow winter temperatures that are moderated by the neighbouring waters of the southern Great Lakes. In this relatively mild climate are found species normally associated with the southern United States, particularly in the neighbourhood of North and South Carolina. Leafy forests with trees like sassafras, black gum, tulip tree, cucumber magnolia, Kentucky coffee-tree, eastern flowering dogwood, and sycamore mix with the more common American beech and sugar maple of adjacent areas to the north.

In addition to varied forests, this region is bordered with extensive shoreline dunes and wetlands and some of the continent's easternmost patches of tall-grass prairie. Altogether, these habitats provide the backdrop for rare species of mammals, birds, fish, reptiles, amphibians, plants, insects, and even clams that often exist nowhere else in Canada. In a spring cloak of vibrant green, "deep south" is both illusion and reality. Exclaimed a friend of

TUNDRA SWANS, RONDEAU PROV. PARK
BRUCE LITTELJOHN

mine as we walked alongside a forest swamp earlier that morning: "This looks so much like the bayous of Louisiana, I expect at any moment to see an alligator crawl up onto a log." Such is the magic that these areas can create for "northerners" all too tired of a long, cold winter.

The rich biological diversity of this region is perhaps why those sites receiving protection are so cherished — and why major conflicts arise when unprotected areas are threatened with destruction. Place names like the Rouge River Valley, Backus Woods, Springwater Forest, Skunk's Misery, and Warbler Woods conjure up memories of long and sometimes heated campaigns for their protection.

Fortunately, some outstanding protected areas are well known too — perhaps none more than Point Pelee National Park. Representing the most southerly spit of Canadian mainland, the park has become best known as one of the hottest places in North America to see birds during the spring migration. Promises of trees "dripping with warblers, scarlet tanagers, and indigo buntings" lure upwards of 5,000 people a day to this small park at the peak of the birding festival in mid-May. Row upon row of binoculars pointed skyward line the network of boardwalks and trails near the "tip", as it has become known by the birding crowd. Away from the tip, the crowds gradually thin out, and one can wander among forests of large hackberry with its peculiarly ridged bark often draped in vines. Along the western and eastern shorelines, where Lake Erie gales keep the forest canopy more open, dense thickets of hop-tree are mixed with a scattering of southern trees such as blue ash, red mulberry, and honey locust bearing its formidable armour of thorns. Where dry sands have failed to support trees, patches of prickly pear cactus clump like giant pincushions — a discovery that surprises many people on their first visit to the park. Hardly scenes that are conjured up when one thinks of Ontario!

As with many other natural areas in southern Ontario, the importance of this park far outweighs its small size. Each spring, millions of dollars from park visitors find their way into the local economy. No wonder the nearby town of Leamington hoists a huge "Welcome Birders" banner over its main street. More important, Point Pelee is a natural outdoor laboratory and education centre all wrapped together. Here many urban-based visitors likely experience their first taste of the great outdoors. For them, Point Pelee becomes one of those special places where deep-rooted feelings first stir, and are aroused again with each annual pilgrimage.

But being small and situated in close proximity to major urban centres can put a strain on the natural features that the park was meant to protect. To maintain the park in its natural state, innovative management strategies are required. A case in point stems from the thousands of birders who visit the park each spring. A lot of vegetation can be trampled through the excitement of multitudes seeking out a skulking rare bird such as a Kentucky or worm-eating warbler. When studies confirmed that the crowds were having a less than desirable impact on the high-use area near the tip, staff responded by creating "seasonal birding trails". Polite signs were strategically posted urging visitors to stay on the main trails, while other trails were closed outright to encourage plant regeneration. The signs helped create public awareness of the need to protect the park's plant life. With this gentle prodding, birders were left essentially to police themselves, a job that many now take on with friendly enthusiasm.

But the plant life of Point Pelee continues to be threatened by a less cooperative alien that innovative management has yet to confine. The culprit: garlic mustard. Widely planted in local gardens, this tasty herb has escaped into Point Pelee and taken over large areas of the forest floor. It grows so thickly that the native flora is squeezed out. Unchecked, it will have serious long-term impacts on the natural vegetation of the park. Imaginative control methods will need to be developed that effectively eliminate the garlic mustard without jeopardizing the remaining natural vegetation. Unfortunately, Point Pelee is not the only Carolinian site to suffer invasions of alien plant species. For example, black swallow-wort, or dog-strangling vine as it is sometimes known, is aggressively invading disturbed sites in the Rouge River Valley in Toronto. In each situation, action is required if the native species are to thrive.

As an additional means of easing people pressure at Point Pelee National Park, staff have recently begun to encourage visitors to take in nearby Rondeau Provincial Park. Although small by provincial standards, Rondeau contains one of the largest remnants of

old-growth Carolinian forest in Canada adjacent to extensive wetlands and shoreline habitat. Massive black walnuts, tulip trees, and sycamores attest to its southern character. Mixed in are American beech, sugar maple, red oak, and white pine that are equally impressive in their dimensions. Here one can get a semblance of what southern Ontario looked like to the early pioneers. I recall taking a friend from Manitoba on a walk through Rondeau late in the afternoon one early November day. With his prairie upbringing, he had not spent a great deal of time in forested areas and upon entering the park remarked at how strange it felt to be surrounded by such large canopied trees. I promised to show him a tulip tree I had earlier found in the park that was over a metre in diameter. As we approached this tree, towering nearly 40 m overhead, a mature bald eagle alighted in its upper branches. While we admired this majestic bird, the distant hooting of a great horned owl began echoing through the forest. Another plaintive call caused us to glance up, in time to see a flock of tundra swans slip through the fading light on their way south to the saltwater marshes along the mid-Atlantic coast. Needless to say, my prairie friend was impressed. So was I. We have lost so many places where such scenes could unfold that it was immensely reassuring to know that at least one small pocket of old-growth forest remained in Ontario's deep south where one could absorb the spiritual offerings of nature.

Despite these pleasant Rondeau experiences, there is something less than natural that strikes most visitors upon entering the park's forest: evidence of deer-browse so intense and complete that much of the forest understorey resembles open parkland. Rondeau's small size and its isolation among corn and soybean fields render it incapable of supporting large carnivores such as the timber wolves and cougars that once roamed here. As a result, over the past several decades the white-tailed deer population has exploded in the park to levels incompatible with the forest vegetation. Tree seedlings can rarely survive more than a couple of years of heavy browsing, and the beautiful carpet of spring flowers has seriously declined.

To look through the wire fencing of two exclosures that were set up more than a decade ago to keep the deer out is to gaze into a garden of lush green growth. The experience with these exclosures and an assortment of ecological assessments have indicated that Rondeau's forest is endangered by excessive browsing. Local roadways have become like petting zoos, with deer (and raccoons) commonly wandering up to slow-moving cars for handouts. Such abnormal behaviour, by wildlife *and* people, reflects conditions that a natural environment park should strive to curtail.

As in other small protected areas throughout the eastern United States and southern Canada, deer in Rondeau have recently faced a cull to reduce the impact of their browsing. Additional methods aimed at limiting population growth, such as birth control, are being considered to keep the herd in check. Yet proposals to significantly reduce deer have caused a furious backlash among those who advocate the humane treatment of wildlife. Animal rights groups have challenged both the methods and the ecological arguments for deer management in these parks. When culls are proposed, park staff are confronted by demonstrations at park entrances. These events underscore the difficulties in managing a small area where nature no longer maintains its own balance, and where practical solutions to difficult ecological problems can become a public relations nightmare.

In other Carolinian habitats, pressing management issues take many forms. Among the few remaining tall-grass prairie, oak barren, and alvar plant communities, invasion by shrubs and exotic or alien plants (species that are normally controlled by natural periodic fires) is threatening the natural balance. With natural wildfire no longer a part of the disturbances experienced by these plant communities, conservationists must strive to duplicate what nature has had suppressed. Thankfully, controlled burn programs are being considered, researched, and developed in time to halt further shrub invasion in places like Pinery and Turkey Point provincial parks, St. Williams Forestry Station, and the Ojibway prairie near Windsor. Among wet shoreline habitats, the situation is equally urgent and in some ways more complex. Polluted waters, altered shoreline sedimentation patterns, development, and recreation have interplayed to destroy many of these fragile habitats. Protection of shoreline habitats and shallow bays in this region will require more sensitive planning regulations for marinas, condominiums, and other recreational developments if what is left of these habitats is to remain. In the vicinity of Long Point, a

biologically rich sand spit stretching 23 km into Lake Erie midway along its north shore, such issues are already being hotly contested as cottages, proposed condominium developments, and recreational uses compete for space adjacent to sensitive wetland and dune habitats.

The opposite end of Lake Erie from Point Pelee lies on one of the most beautiful natural features in the Carolinian zone. The portion of the Niagara Escarpment squeezed between Lake Erie and Lake Ontario, best known for its orchards and vineyards, supports a thin ribbon of lush forest clinging to the escarpment face. It has been saved more by accident than design, since the rocky topography has made for poor farmland. A short hike on a quiet autumn day in the vicinity of Niagara Glen can lead one through magnificent forests of impressive specimens of tulip tree and black walnut. Scattered throughout are massive boulders, draped in ferns and other undergrowth, that have tumbled down from the cliffs above. Hidden among the boulders may lie animals and plants that still wait to be discovered or re-discovered after not being seen here for decades.

Unfortunately, only scattered bits and pieces of this ribbon have secure protection: protection for the remaining areas depends on the fate of the federal Niagara Parks belt and Ontario's Niagara Escarpment Plan. Intended to conserve the natural escarpment features, protection measures in this plan are regularly challenged by developers and local governments who claim the plan is too restrictive. Hope for the escarpment lies in maintaining a strong plan to control development incursions. Any weakening of this document will undoubtedly mean the loss of more Carolinian habitat.

In 1984, agencies worried about the continued loss of significant Carolinian habitat launched a cooperative program called Carolinian Canada. Their mandate was to shortlist unprotected sites in greatest need of attention. Funding for the project came from the Ontario government, Wildlife Habitat Canada, World Wildlife Fund Canada, and the Nature Conservancy of Canada. From a list of more than 2,000 small sites, thirty-eight were ultimately selected. Attention was then focused on these sites through a five-year program of land acquisition and private stewardship

which drew numerous landowners into a region-wide Carolinian network. Once protection for these thirty-eight sites, shoreline parks, and escarpment areas has been achieved, a network representing a wide range of biological diversity characteristic of southwestern Ontario will begin to take shape.

Surprisingly, one of the sites is within Metropolitan Toronto, Canada's largest urban area. The Rouge River Valley, nestled on the eastern boundary of the city, became a symbol around which thousands of urbanites would rally. When this wild Carolinian habitat was threatened by potential development, numerous organizations and private citizens flooded Scarborough City Hall on several occasions to deliver strong and often emotional pleas for its protection. Ultimately, a potential residential and commercial development site became a provincial park reserve, an extraordinary designation for a major metropolitan area. The determined action and leadership provided by a citizens' group called Save the Rouge Valley System is testimony to what can be accomplished when those concerned about protecting natural areas are well organized, determined, and visionary.

Initiatives developed to protect other sites under the Carolinian Canada program included the introduction of tax benefits for private landowners with significant hectarage and in a few instances outright acquisition. Today, protection for some of these sites is more secure, but the job is yet to be completed. Only through the continuation of the Carolinian Canada initiatives will there be long-term hope for the protection of these thirty-eight sites.

But these sites, although a significant start, won't be enough to protect the full range of natural diversity of this region. I think back to my afternoon on Pelee Island when I strolled along the beach. The water snake had not reappeared. For now, it was hopefully safe beneath some fallen cottonwood log. As I began to explore a new section of beach I wondered if these protected bits of land would hold their own. I found myself wading at times through drifts of zebra mussel shells, an introduced scourge that was destroying life in the calm waters offshore. Behind the next log were the corpses of four cormorants and a white-winged scoter. I wondered if they had died of natural causes or as the result of a

FISH POINT NATURE RESERVE, PELEE ISLAND
ALLEN WOODLIFFE

poisoned food source. Closer inspection had shown that one, at least, had died of another cause—it had strangled itself on abandoned fishing line. Despite the designation Nature Reserve, there was evidence of human intrusion all about.

Such discoveries provoke and sharpen my sense of loss for other species no longer found in this area—eastern cougars, timber wolves, black bear, and wapiti. I catch myself wondering which species now endangered will next become extirpated or extinct. Yet my optimistic side strives to find ways to curb further loss and is buoyed by those creatures that have hung on. Such feelings were reinforced when I came upon a tangle of vines and fallen tree limbs filled with a frenzy of avian activity. Magnolia, black-throated blue, and hooded warblers were all snapping up insects hatching in the late afternoon sun. After a long northward trip, they had found a strip of quiet beach on which to feed and rest before continuing their migration. For these species, this Nature Reserve was providing the niche for which it was intended.

It is natural to mourn the loss of our Carolinian wilderness, but it is imperative that the loss not obscure our search for improved protection of this region. I still find frequent opportunity to celebrate the bits and pieces saved. And although a pristine Carolinian wilderness may be gone forever, I believe that it is still within our grasp to establish large protected wild areas in southern Ontario. It may be too late for the eastern cougar or black bear to once again roam Carolinian Canada, but I hold out hope for the bobcat and the fisher. To realize such a dream will take some ingenuity, far-sighted planning, and extensive regeneration and reforestation. Most important, it will need the support of people who believe that it is not just desirable but possible.

Already we find community organizations becoming involved in replanting small areas with Carolinian trees and shrubs, and allowing natural processes to return these sites to a semblance of their former richness. Careful planning, on a larger and longer-term scale, could undoubtedly identify areas where there are enough pieces left that, if reconnected, would produce a major Carolinian wild space. Technically, we have the science of restoration ecology on our side. Private stewardship and land trust programs can be further developed to help secure such a vision. Political will can be nurtured and cultivated.

The urgency to protect Carolinian Canada dictates that we can't afford to lose any more bits and pieces. Yes, the challenge may be great—but do the numerous species that have stubbornly hung on deserve anything less?

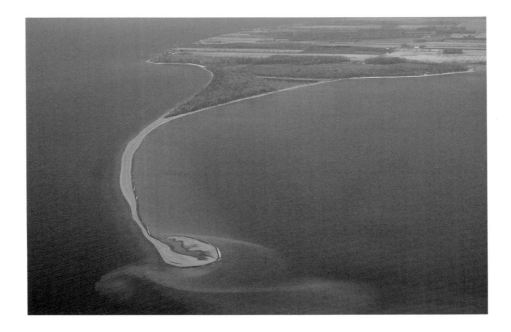

Presqu'ile Reflective

Gregor Gilpin Beck

On an exposed shoreline, I sit in quiet anticipation of spring. The frozen ground and subtle colours of early March are, for many, too reminiscent of November's moods and hues. But for me, a new phase in that gentle continuum which is the shifting seasons draws me closely to our parks and wilder places.

At dawn today, I have heard a signal from the marsh that the new season is just beginning. Male red-winged blackbirds have begun to lay claim to cattails, with increasing numbers clinging to the brown and brittle stalks. Scarlet epaulets, in brilliant contrast to the land, along with the distinctive cries of "oh-ka-reee", triumph the opening movement of the symphony that is spring. At off-shore islands, hundreds of gulls join in the chorus as they, too, return to breeding grounds. That the human audience in the symphony hall of Presqu'ile is small suggests that we all do not share a common idea about when the first lyrical movement of spring really begins.

In truth, the morning is cold, and the strong northeast wind has dictated winter clothes. Hundreds of ducks—redhead, canvas-back, goldeneye, and scaup—are concentrated in two small pools of open water on what is usually the leeward side of the point. This recent cold snap keeps the bay frozen, the waterfowl far offshore, and encourages me to explore more sheltered parts of the park.

By late morning, the strengthening sun softens northern chills and I relax on a piece of driftwood at Owen Point, gazing across the open waters of Lake Ontario. There is something about the moment that calls for reflection . . . perhaps some subtle blend of the dimensions of space and time.

I contemplate why this temperamental time of year puts me in a reflective mood. Perhaps it is the wait for the increasingly per-ceptible signs of spring which forces me to consider the previous cycle of the seasons, and why I am drawn here so frequently.

For naturalists, the lure of Presqu'ile is strong. The park itself is composed of a spit of land jutting out from the north shore of Lake Ontario, with dunes and wooded areas in various stages of succession. This process has allowed for the establishment of a rich mosaic of habitats, ranging from the cattail marshes to moist hard-wood forests. During migration, Presqu'ile is a major stopping point for a wide variety of bird species as well as monarch butter-flies, and is, in this regard, similar to Point Pelee National Park on Lake Erie. For many of us, though, Presqu'ile is much closer to home and does not have the competitive crowd of binoculars and telescopes to be found at Pelee on a weekend in May or September. This combination of wildlife, place, and tone reflects the spirit of the park.

At Owen Point, the wide sand beach gives way to a narrower, steeper beach made of stones which angles east, protecting estab-lished dunes and marshes to the lee. In recent weeks, ice formations have begun to disappear, but large, rafted sheets and remnants of ice volcanoes persist. Winter's snows have largely melted, and the wind begins its non-discriminating sorting of what both human-kind and nature have left behind; images of the previous cycle of the seasons are being resurrected.

The beach is surprisingly clean—testimony perhaps to a conscientious staff, but no doubt to winter storms as well. There is, of course, the occasional soft drink can and lost toy, but it is spent shotgun shells which appear with greatest frequency. At Owen Point they can be found by the dozen and accompany the remnants of a duck blind which the ice ignored.

The discarded shells themselves reflect only the surface of an issue. The fundamental question is whether or not it is possible for a park to be all things to all people, without betraying the special characteristics which make it worthy of protection in the first place. Here at Presqu'ile on this clear, cold morning, I am struck by the irony of a park that erects blinds for a few hunters in autumn

and another for a throng of bird-watchers in spring. Both groups, I suppose, celebrate the large concentrations of migrant waterfowl to be found in the waters of Presqu'ile. But hunting itself is not at issue here. It is a question of the compromise of values which make this place unique.

One's perspective of parks and wilder places is by nature personal. My images and perceptions of Presqu'ile are almost certainly different from those of others, although we may all share a need for places to exercise our enjoyment of the outdoors. For me, the experiencing of atmosphere in this park is strongest from late autumn to early spring when there are few people with whom to share the land. This perspective, I suppose, may seem selfish. But the feeling is honest, and it is personal. The emotions one feels towards natural places reflect the land, its wildlife, its wildness, and its spirit. They cannot be explained. But when I walk the length of the beaches of Presqu'ile during an October gale or explore the secrets of a frozen marsh in winter, I sense the essence of place, and I gain a better understanding of what I am. Seeing a peregrine

falcon streak by me in the eye of a grey and black autumn storm is not my primary goal in visiting Presqu'ile, but the *chance* of such an encounter adds to the mystery and lure of the park. Crowded beaches and campgrounds of summer indicate that many others enjoy Presqu'ile for reasons different from my own. I believe, though, that we all share a sense of the importance of having parks, not just large and distant but near to home as well.

By noon the wind has shifted to the west and Owen Point no longer offers shelter. The drifting pans of ice slow, stop, and reverse direction in response. A lone man walks along the narrow beach, binoculars and telescope in hand. We share our observations, then slowly wander off, each in our own direction. Today Presqu'ile remains quiet, but the gentle shift in the continuum of changing seasons has begun. The pace of the park will quicken now, the number of visitors increase, and the hush of winter will be lost for the year. But on another day, I know that I will sit again on this exposed shoreline, in quiet anticipation of spring.

The *Other* Wasaga Beach Provincial Park

Daniel F. Brunton

"I wouldn't be caught dead there!" you say. It's nothing but a strip of sand littered with muscle cars, macho young bucks, and largely naked beach bunnies. The air is filled with the sound of hard-pounding ghetto blasters and the smell of suntan oil.

Well, even the worst of "the strip" isn't quite that bad, but it can be unattractive. Fortunately, there is a whole other, far more edifying Wasaga Beach we can experience. This is the *original* Wasaga Beach, a rich and beautiful relict from a time when bunnies were rabbits and bucks had antlers.

Wasaga Beach Provincial Park consists of 14 km of broad, gentle sand beach and a large inland block of huge sand dunes. The beach has been largely annihilated as natural landscape by years of intensive recreational use, but the dunes are another matter. This landscape was created thousands of years ago on the shore of a huge post-glacial lake and even maintains some of the plants and animals of that era.

The dunes began to form about 4,500 years ago as the waters of post-glacial Lake Algonquin slowly receded in what is

now the Wasaga Beach–Collingwood area. Extensive low dunes appeared on the sand and gravel bar deposited across the shallow lagoon which extended inland into central Simcoe County. The climate was hotter and drier then, and strong onshore winds pushed sand from the low, hummocky ridges which made up the transverse dunes into huge crescent-shaped (parabolic) dunes. These dunes were well developed by about 3,000 years ago. Even after the climate cooled to near modern conditions, the lake levels continued to drop, exposing additional beach sand which was also blown onto the growing parabolic dunes. Water levels stabilized about 2,500 years ago, stopping the supply of new blow sand, but not before one of the largest, highest dune complexes in the Great Lakes region of North America had been created. A variety of wetland habitats, varying from spring-fed fens to peaty meadows, were left along the Nottawasaga River valley in the former lagoon area.

The dunes provided dry, hot, sandy habitat ideal for some of the southern and western plants and animals migrating into Ontario about 4,000 years ago. Expanses of calcareous, fen-like meadows and treed fens formed along the shores of Lake Huron's Nottawasaga Bay and extended into the old lagoon area on the Nottawasaga River side of the dune field. At the same time, a small number of organisms evolved to fill the highly specialized requirements of life on Great Lakes dune fields and beaches. Many of these found their way to Wasaga.

The dunes today are largely forested with red oak, white pine, and red maple on lower slopes and white and red pine towards the heights. For thousands of years, windstorms and forest fires were the only major disturbance. Sandy barrens and herb- and shrub-dominated clearings (sand prairies) were probably extensive in the higher dunes and are still scattered here and there.

The scrubby common junipers, once abundant in these clearings, constituted the preferred nesting sites of the prairie warbler (designated *nationally rare* by the authorities). Recreational pressure and, ironically, successful fire "protection" have prevented regeneration of the habitat, and the birds are no longer found here. But the remarkable Hill's thistle still occupies the edge of such clearings in lightly disturbed ground in the adjacent pine forest. It is designated *globally rare and nationally imperilled*, its entire world population being restricted to such sites along the Great Lakes shores. Only half a dozen Canadian populations are known, all on Lake Huron. Most consist of a few, usually sterile plants. The plant appears to require the moderate impact of light, relatively cool spring forest fires, which remove the duff and expose the mineral soil without significantly affecting the protection offered by the forest canopy.

Frequently occurring with Hill's thistle at Wasaga, though slightly less ecologically demanding, is Houghton's cyperus (*provincially imperilled, nationally rare*). This southern sedge also occurs in the high dunes where the ground has been physically disturbed. Along with both these nationally significant plants are found other unusual southern and/or western species of dry, hot, seemingly inhospitable sand prairies: rockrose, pink polygala, Gronovius' hawkweed, both species of New Jersey tea, and Oakes evening primrose.

One wonders what advantage there could be for these plants to develop such highly specialized habitat requirements — requirements which seem to threaten their very existence. But for thousands of years these species did not have human technology to deal with, and their beach and dune habitat was secure. In our ecological ignorance we have interfered with the ecology of these dunes in subtle and direct ways, changing their natural rhythms.

Wasaga's rarest species is also a plant of the dunes. The spotted wintergreen is designated *nationally endangered* (though it is common in parts of the eastern United States). A small, attractive heath, it was found in the 1970s in the lower transverse dunes but was not seen in recent inventory studies; it may no longer occur here. Its loss would leave the other Ontario stand (near Lake Erie) as the only known Canadian population.

The relict wetlands have their own surprises, such as the fen-like meadow along the shore of Marl Lake. It is much like the spectacular Nottawasaga Bay shore meadows, which are disappearing under condominiums and estate developments at a staggering pace. Marl Lake too has its exceptional species, including the

(*nationally imperiled*) beaked spikerush, a southern sedge of rich, flooded fen meadows. The most bizarre rarity of them all may be a tiger moth discovered in a small forested fen in the former lagoon area. The insect is considered by the authorities to probably represent an undescribed species. More remarkable, however, is that the appearance of this harmless caterpillar closely mimics that of an extremely rare, poisonous species which also is undescribed for science and which is not found within several hundred kilometres of this fen. A complex ecological mystery remains to be solved here.

Part of the high dune area is now contained within a nature reserve zone in the park, and large additions to that zone have recently been recommended. In order to preserve these remarkable habitats and their creatures we will have to find ways to replicate the natural processes which our technologies and recreational demands have excluded or altered.

Wasaga Beach Provincial Park is obviously more than bathing beauties and beach towels. It is also a complex, ecologically intricate, and very special natural landscape of great antiquity and natural significance.

The Bruce Peninsula

Anne Champagne

Water so clear it seems like sunlight incarnate. So it appears on gazing into the cold, lighted harbours on the east side of the Bruce Peninsula. Of all the natural marvels of the Bruce, perhaps none is so striking as these sheer ivory cliffs washed in brilliant sunlight, their roots immersed in lucid turquoise water that turns yellow-gold near shore. As one travels westward, wild orchids and ferns of every description abound. Brilliantly coloured warblers fill the trees. Fens created by the warm lakewater of the west coast are alive with rare species.

The Bruce Peninsula, encompassing the northern spine of the Niagara Escarpment, is truly one of the province's remarkable natural enclaves. Despite its many cottages and hamlets and its relative proximity to larger towns, one can lose oneself in deep forests and discover gentians on isolated beaches. In more than twenty years of roaming the Bruce, it has never failed to fascinate this naturalist.

It begins and ends with the ancient rock backbone of the peninsula. Already old when dinosaurs were just beginning their tenure on the planet, the escarpment tilts west from the 60-m cliffs and rock beaches on the Georgian Bay coast to bury itself in sand and fens along the western shore.

The eastern coastline is pocked with caves, cut by water eroding soft limestone and shales beneath the peninsula's hard dolomite cap. North of Cypress Lake, fantastic shards of limestone erupt onto beaches and fall into Georgian Bay, layer on layer of glistening, aged ivory fanning out into multilevelled terraces.

Together with the maritime climate and scant soil, limestone bedrock is a cause of the exceptional diversity of wildflowers on the Bruce. Rare plants have evolved in such unusual habitats as expanses of pitted exposed limestone (alvars), crevices in rock and cliffs, and sand dunes. Cabot Head in Bruce Peninsula National Park is the only large area of protected alvars in the province.

ROSE POGONIA ORCHIDS, BRUCE PENINSULA
PETER van RHIJN

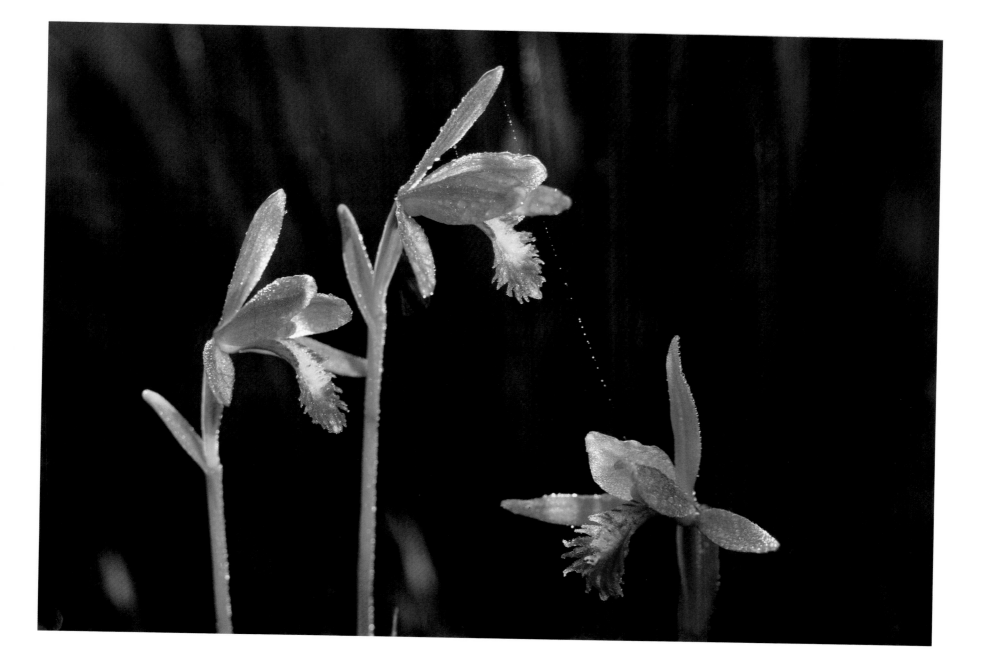

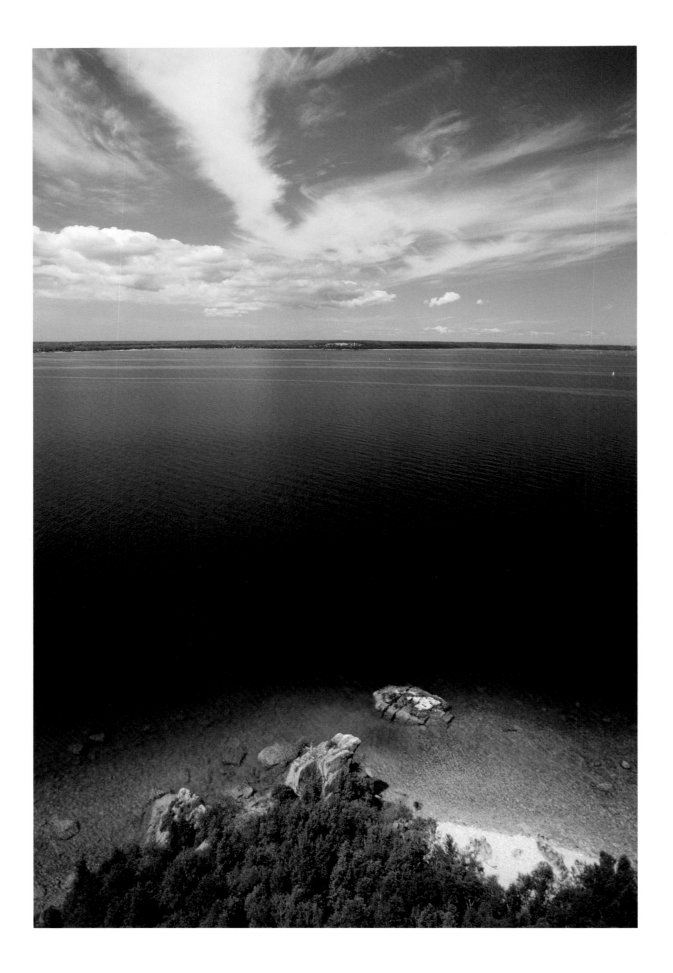

Limestone is the cause even of such biological oddities as the fish in Gillies Lake at the north end of the Bruce, turned a ghostly white from calcium dissolved in the water.

Water drains reluctantly on the Bruce, is trapped in rock ledges and becomes marshlands, swamp forests, and fen/bog complexes. Blue-eyed grasses, tiny shocks of deep blue at the tip of thin stems, appear unexpectedly, as do rare fringed gentians. There are prairie species such as white camass, arctic flowers such as bird's-eye primrose, and plants found only on the Bruce such as dwarf lake iris. This botanical cornucopia, orchids and ferns in particular, draws visitors from across the continent.

Among the ferns that excite visiting botanists are the rare walking fern, slender cliff brake, and hart's tongue fern, all of which emerge somewhat magically from rock. Protected limestone faces along the escarpment are ideal nurseries for the likes of walking fern, the elongated tips of its triangular leaves forever seeking out a rooting medium in the wisps of soil gathered in the pitted rock.

There are more orchids here than anywhere else in the province—forty-four species. Coming upon one can be something of a revelation. Fantastic shapes are ordinary for them. Sepals cascade around ornately structured petals with swollen or fringed lips. On the Bruce, they range from the beautiful purple-red of moccasin-flowers to the ripple of tiny white flowers whirling around the stems of slender ladies' tresses like spiral staircases.

Most of these orchids live in wet soil. The ram's heads bloom deep red in bogs and moist woods, rose pogonias in wet meadows, small purple fringed orchis in swamps. Rare and beautiful, they are often casualties of the continual destruction of wetlands, which are, biologically, the most productive habitats.

The large expanses of exposed rock which characterize the peninsula are bound to yield interesting reptiles, and the Bruce's herpetofaunal population is among the most diverse in the province, including rare massasauga rattlesnakes, Fowler's toads, and spotted turtles.

The Bruce is also a funnel for migrating birds. Raptor watchers are lured to the Bruce's east coast in particular to watch the migrations. Broad-winged hawks, for example, converge on Tobermory in spring, waiting for good weather to cross north.

This is one of the province's meccas for birds, with more than 300 species known. Coastal islands are alive with colonies of gulls, terns, and herons. Thick conifer woods ring through with the calls of hundreds of black-throated green warblers. Even small patches of mixed woods draw a remarkable profusion of vibrantly coloured warblers, among them parula, Cape May, Blackburnian, pine, magnolia, bay-breasted, and rare prairie warblers. The clear musical sound of the western meadowlark is also a highlight.

Mammals and birds on the Bruce are a mix of southern and Boreal species. The usual wildlife survives here, with a few twists. Opossums have crept up from the south. Marten somehow persist, and fisher are being reintroduced. River otters and mink slip through rivers and streams.

All this biological and geological wealth has been recognized over the years with the establishment of protected areas on the peninsula.

One of the most unusual of these is Fathom Five National Marine Park, off the mainland north of Tobermory. As nineteenth-century European settlers tested where the Great Lakes might go, fragile wooden ships splintered against the peninsula's shoals and foundered, often in waves over 3 m high. Accumulated since the mid-1800s, more than twenty-one ships now lie deep in the translucent waters of what has become the first of twenty-nine planned (and yet to be established) national marine parks in Canada. Not surprisingly, Fathom Five is a magnet for divers.

If plans come to fruition, five Great Lakes aquatic regions will eventually be protected in the national park system. But such protection cannot be taken for granted. In the case of Fathom Five it is significant to recall that it began life as a provincial park and only became part of the national park system in 1987, following thirty years of pressure for protection on the part of environmentalists.

Marine parks take in land as well as water. Fathom Five includes distinctive flowerpot islands—columns of layered limestone fluting up from Georgian Bay, capped with trees like a vase of flowers. There are orchids here and rare plants, isolate and

evolving apart from neighbouring wildflowers on the mainland. The islands are worlds unto themselves, and those free of human intrusion are changing in the same mysterious ways all life has done for millennia before our presence. For them there is hope.

Bruce Peninsula National Park is the terrestrial companion to the marine park. It covers most of the northern peninsula. Once again, the road to national park status has been long and sometimes tortuous. The most recent proposal on which public consultation took place dates back to 1981, but public prompting for a park long predates this. In 1985 a socio-economic study concluded that the upper Bruce Peninsula would benefit financially from a park. St. Edmunds Township, in which the park lies, eventually supported the park under certain conditions. Lindsay Township to the south decided not to participate, and the proposed boundaries accordingly shrank north. Conditions duly met, an agreement was signed to establish both the terrestrial and marine parks in 1987. Provincial park lands at Cypress Lake were transferred to federal jurisdiction, county lands were sold to the federal government, and private lands were bought when willing sellers appeared. Lands contested by First Nations in land claims were excluded from the park.

In terms of human use, as well as environmental protection, the effort seems to have been justified. Some 300,000 people are expected to visit the park each year, and indeed recreation and tourism are now the mainstay of the peninsula. In the park people are free to hike, ski, canoe, photograph, and do any other activity that does not harm the natural environment. They are not permitted to hunt, trap, or use all-terrain vehicles. Snow machines are limited to one trail. The Canadian Parks Service will attempt to control species that are not native to the peninsula, in the hope of restoring something of its original matrix of living things. Parks Service philosophy, happily, is to interfere with natural processes as little as possible—an almost unheard-of attitude of humility in park managers.

Hunting continues on private lands but not on national park lands. Parks are, after all, a microscopically small portion of the land and water area of the province (about 6 per cent), whereas hunting can occur on virtually all other Crown land—over 80 per cent of Ontario.

The establishment of this major park highlights the land use conflicts that are epidemic in this province, especially in southern Ontario. Some major chunks of land were lost from the park. The entire northwest corner of the peninsula at Driftwood Cove was sold to development interests. A stretch of the east coast was lost when the county sold out to private interests before the Canadian Parks Service had sorted through conflicts over appraisals to buy the land. In the process, over 1,200 ha of cliffs and forests near Emmett Lake between Cave Point and Cypress Lake campground were opened to any kind of development private interests might want. Some feel that the park cannot survive the loss, so important is this section of land.

Large parts of the Bruce have been logged. Second-growth forests of white birch, aspen, white spruce, balsam fir, and cedar followed logging and fires when settlement occurred in the 1870s. Parks are, after all, not necessarily set up where there are the most significant plants and wildlife, but where and when those who would take as much as can be taken have spent themselves. In the case of the Bruce, pockets of natural land are left, and other areas have healed as best they can, although second-growth forest can never compare to original wilderness.

While there have been losses, there have also been breakthroughs, many outside the national parks. On the Bruce Peninsula patches of land are now Federation of Ontario Naturalists (FON) nature reserves, or Conservation Areas, or Niagara Escarpment parks, or cared for as part of the Bruce Trail, or too rife with poison ivy to be much bothered with. The Bruce is fortunate to have attracted protectionist aid from many camps.

The number of areas protected by or with the help of the FON, a non-profit environmental organization, attests to the peninsula's value for natural history. The FON funds made three nature reserves a reality on the Bruce—Dorcas Bay, Petrel Point, and Long Swamp—and helped purchase three other properties which are run by the Grey—Sauble Conservation Authority: Red Bay, Bruce's Caves, and Walker Woods Conservation Areas. The intent was to protect

unique and significant natural areas over the long term. The FON nature reserves are usually products of desperation, last attempts to protect exceptional and threatened natural areas.

Dorcas Bay and Petrel Point protect some of the peninsula's scarce and extraordinary fens. The least known and rarest of wetland types in Ontario, fens are vast flat meadows of grasslike sedge and rushes which are frequently awash with orchids and insect-eating vegetation such as butterwort and pitcher plants. There is no place in this province with fens as rich as those on the west side of the Bruce Peninsula. Dorcas Bay is perhaps the most exceptional shoreline habitat on the Bruce, and Petrel Point protects 21 ha of the least disturbed fen in the lower peninsula.

Long Swamp nature reserve, a cedar swamp and quaking fen near Owen Sound, protects the only known round-leaved orchis and ragged fringed orchis communities on the Bruce and one of two bogs on the peninsula. Red Bay, just south of Petrel Point, protects a sphagnum bog, sand dunes, hardwood forests, and 200 m of shoreline.

The formation of caves by dissolving and weathering action is shown more clearly at Bruce's Caves than just about anywhere else on the peninsula. Skinner's Bluff Conservation Area is a Natural Environment Niagara Escarpment Park, meant to preserve natural and cultural features and outstanding landscapes. It is a nodal park, one of which is assigned to each segment of the 725-km escarpment.

In Walker Woods a pocket of wilderness survives: old-growth forest of cedar, hemlock, and white pine, parts of which are thought never to have been logged. One has to wonder at a culture that can only bring itself to protect wilderness forests in a fraction of a 14-ha Conservation Area, even in an area as extraordinary as the Bruce. However, in Walker Woods one can find 350-year-old cedars. The huge hummocks topped with ancient trees and corresponding hollows filled with wildflowers are not often seen, and will soon not even be a memory but for the few fragments such as this salvaged forest.

The Ministry of Natural Resources has designated Areas of Natural and Scientific Interest (ANSIs) on the Bruce, such as Lion's Head promontory, Hope Bay forest, Little Cove–Cave Point, Cabot Head–inland lakes, Bear's Rump Island, and the undoubted site of deep spiritual traumas–the Slough of Despond.

There is ample reason to remain concerned about the health of the Bruce, despite all these parks and protected areas. Nature Reserves and Conservation Areas are small biological oases; as with all parks, there is the risk they will become islands in an ocean of development. More cottages are being built in large subdivisions, and at the time of writing both Red Bay and Petrel Point are seriously threatened by such plans. Drainage patterns are inevitably affected by roads and large buildings forced onto a landscape which did not evolve to cope with them. Anything as delicate as a fen can suffer badly from altered water flow, and even die out completely.

Other development happens here, and there are other threats. Trail bikes and walking people erode sand dunes around Sauble Beach and elsewhere. Gauley Bay (Greenough or Bradley Harbour), the only large unoccupied shoreline remaining on the Canadian lower Great Lakes, could be sold and developed tomorrow and there would be no recourse. Human population pressure on scarce beach habitat likely led to the departure of nationally endangered piping plovers, last seen at Oliphant in the 1960s. Overfishing rapidly caused the collapse of even the incredibly bountiful fisheries at the Fishing Islands. Overuse appears to be the inevitable end of human interaction with nature, at least in most of the cultures remaining after the careful eradication of the gentler ones by consumer societies.

Some of the protective categories for the Bruce's natural areas don't carry much weight. The ANSIs have very little protective status; they can be snuffed out without thought, and are. The Bruce Trail, which stretches virtually the entire length of the Escarpment — 720 km from Queenston to Tobermory — has been rerouted so often that the Bruce Trail Association is now trying to buy up the trail route and is about halfway to completing the purchase. There is very little money for acquisition of the remaining lands needed for the national park; witness the loss of two key segments.

Wetlands have no protection — no policy, no legislation —

and can only be protected by tangential references in unlikely legislation like the Fisheries Act, Public Lands Act, and Conservation Authorities Act. The most significant wetlands in the province are routinely annihilated while concerned neighbours watch helplessly.

While the Bruce is far from safe, the more southerly Niagara Escarpment parks may be in better shape, given the presence of protective legislation and dedicated Escarpment Commission staff. More than 100 parks now protect natural environments on the escarpment, linked by the Bruce Trail. But protection is not always guaranteed. For instance, some of the largest and most ancient beech, ash, and maple trees in one escarpment park — trees in some cases over 200 years old and over 2.4 m in circumference — were logged for a research project on private woodlot management. This depredation occurred despite the fact the park is one of the few remnant old-growth forests in southern Ontario.

But as far as anyone knows, the national parks are here to stay, as are the FON nature reserves. And there is now international interest in the Niagara Escarpment that should lend weight to attempts to keep it intact. The escarpment is significant enough to have attracted international recognition as a UNESCO Biosphere

Reserve. Botanists from across the world come to examine the escarpment's ferns, and geologists to see some of the best exposures of Paleozoic rock and fossils anywhere.

There are cedar trees so old on the escarpment that some were here at the end of the Middle Ages, before we realized our planet wasn't at the centre of the galaxy. Some are an astonishing 500 or 700 years old. Perhaps by the time we recognize that human beings are not at the centre of the universe, with all things created for our use, we will understand what hallowed ground this is, together with other such vestiges of the province's original wilderness.

Like so many parts of the province, the Bruce Peninsula and the Niagara Escarpment of which it is a part need continued care. The threats to both are legion. That areas so remarkable are yet so vulnerable indicates how far we are, culturally and psychologically, from understanding the value of wild nature. How easy it would be for the forces of industrialization to obliterate these natural treasures! Too many still see nature as a meaningless collection of commodities to trade, rather than the physical and spiritual wellspring of our lives.

LEFT / *WASAGA BEACH PROV. PARK*
LORI LABATT

ABOVE / FLOATING HEART BAY, LAKE SUPERIOR
LORI LABATT

The Canadian Shield

T.J. Beechey & R.J. Davidson

CREATION OF THE LAND

The rocks of the Precambrian era record the history of Earth's primitive crust. They tell of a thin, discontinuous skin forming at the surface of the cooling planet. They show how this crust was uplifted and penetrated by violent volcanic eruptions, and how molten lava and eroded crustal rocks spread out into a primitive, lifeless sea. By 2.5 billion years ago, the area now occupied by northern Ontario had consolidated into a small continent. As this land mass rose, streams, currents, waves, and glaciers eroded its surface and dropped its sediments into marginal seas. These seas produced blue-green algae which helped add oxygen to the atmosphere. These marine deposits fused with existing lands about 1 billion years ago to form the ancient continent of Laurentia.

The ensuing deposition of Paleozoic seas, uplift of the Appalachian Mountains, and emergence of North America first buried and then exhumed Laurentia, exposing what we now call the Canadian Shield. More recently, glaciers have advanced and retreated across the Shield, sculpturing its hardened surface, stripping its highlands of soils, and filling its lowlands with sand, gravel, and water. The glacier's final retreat was followed by desolate, wind-swept tundra and the gradual invasion of cold-to-temperate Boreal forests. Today, the Shield can be broken down into several distinct physiographic regions known as the Severn, Abitibi, and Algonquin uplands; the Sutton Lake, Port Arthur, and LaCloche hills; and the Nipigon and Cobalt plains. (See map, page 84.)

The Severn Uplands in the northwest and the Abitibi Uplands in the northeast are dominated by barren bedrock highlands dotted with small, isolated lakes, ponds, and swamps. They contain many large, irregular-shaped lakes and countless smaller lakes, linked by fast-flowing streams. These lakes are noted for their rocky cliffs, pocket beaches, and deep waters. Parts of these uplands have been mantled by crescent-shaped moraines; by ribbons of eskers, kames, and kettles; and by the sediments of ancient post-glacial lakes. These traits are well displayed in Opasquia, Woodland Caribou, Quetico, Wabakimi, and other provincial parks. South of the French River, the Algonquin Uplands display similar traits. Here, numerous interconnected irregular-shaped lakes, eskers, kames, kame terraces, inland dunes, and spillways dominate the landscape. These features abound in Algonquin and neighbouring parks.

North of Lake Superior, the Severn Uplands give way to the Port Arthur Hills and the Nipigon Plain. These hills are composed of flat, interbedded sedimentary and igneous rocks that have been eroded for a billion years by running water, waves, and glaciers. The plain consists of thick, flat volcanic flood basalts that have poured out across the land from weaknesses in the Earth's crust. These features are illustrated by the "Nor' Westers" near Thunder Bay and by features in Kakabeka Falls, Sleeping Giant, Ouimet Canyon, and Lake Nipigon provincial parks. North of Lake Huron, the LaCloche Hills and the Cobalt Plain dominate the landscape. Here the hills are the roots of ancient mountains and the plain is an area of flat sedimentary rocks resting atop the Abitibi Uplands. These hills and plain are graphically illustrated in Killarney and Lady Evelyn–Smoothwater provincial parks.

GREENING OF THE LAND

Comprising close to two-thirds of the province, the Canadian Shield is a dominant segment of Canada's ecological identity. Immortalized by writers, poets, and painters, the spirit of this vast rugged land retains a wild character long lost in the south. Its terrestrial systems and food chains continue to function, with black bear, timber wolf, lynx, wolverine, fisher, and pine marten still playing senior predatory roles. Housing a substantial portion

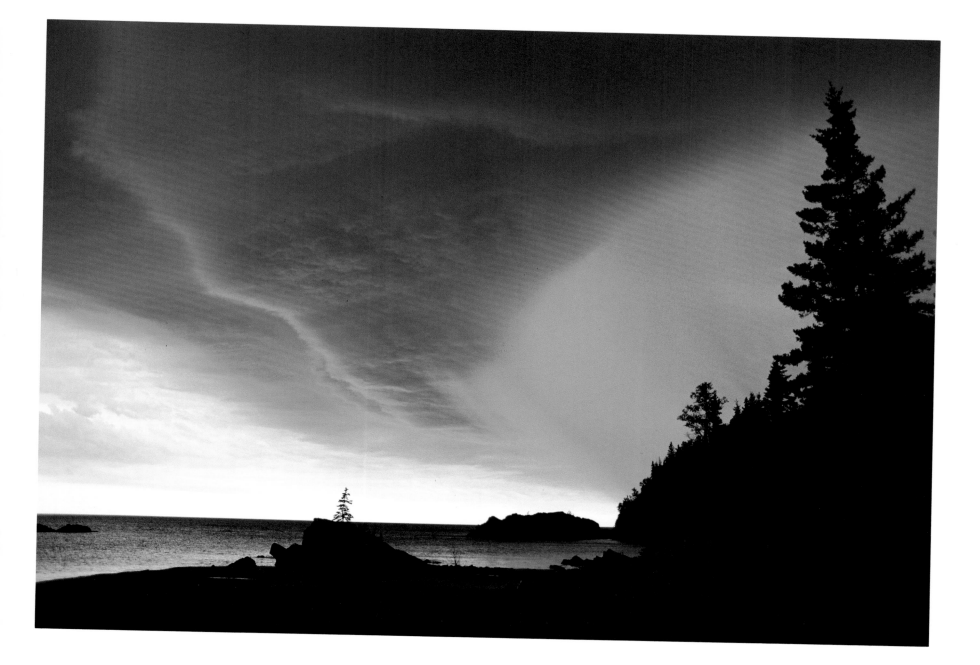

LEFT/WINTER, BON ECHO PROV. PARK
BRUCE LITTELJOHN

ABOVE/STORM OVER LAKE SUPERIOR
JOHN FOSTER, MASTERFILE

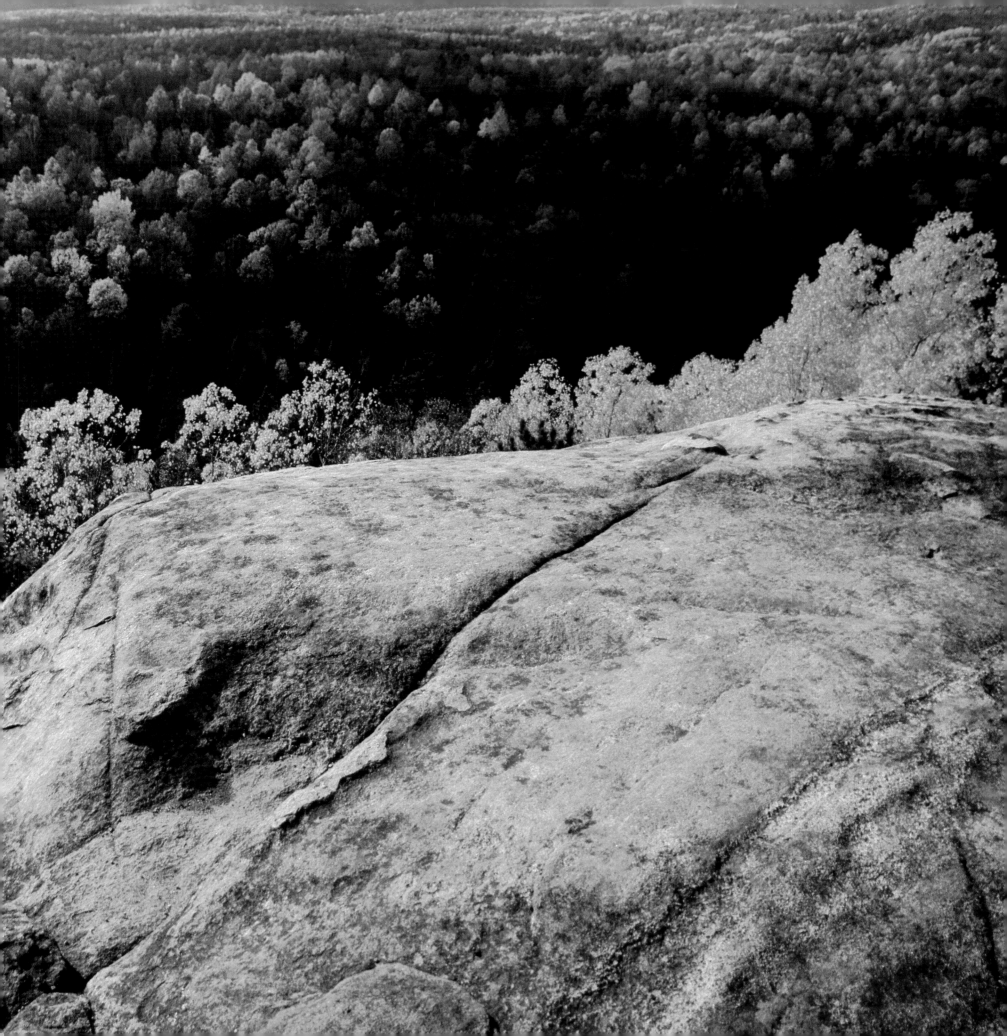

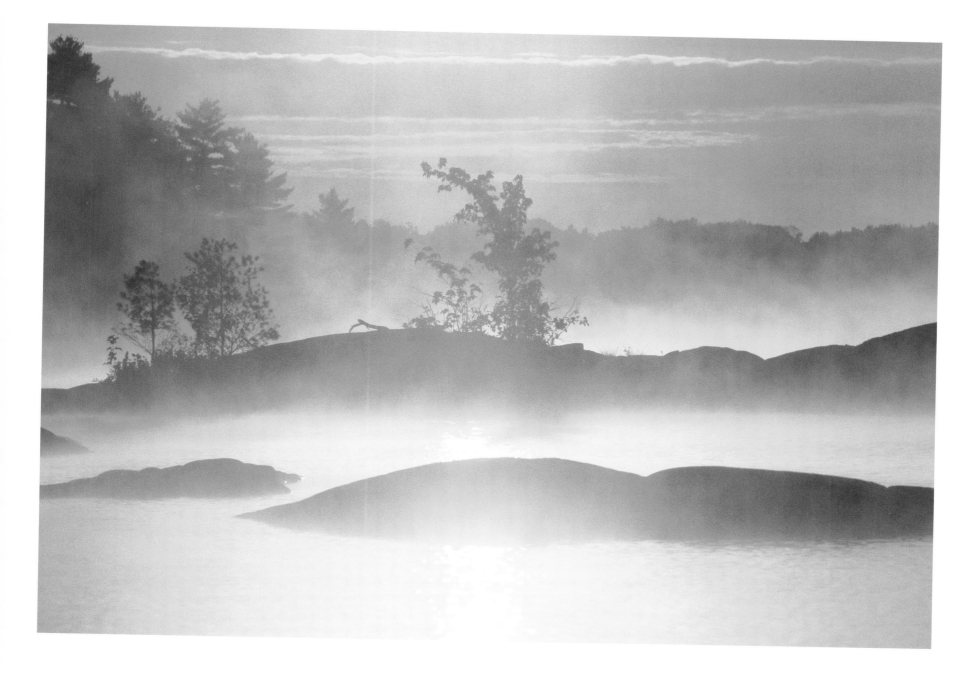

LEFT/VIEW FROM THE LOOKOUT,
ALGONQUIN PARK
LORI LABATT

ABOVE/STONEY LAKE, KAWARTHAS
BRUCE LITTELJOHN

of the upper Great Lakes, fed by interior lakes and mighty rivers reaching to the height of land, this region adds substantially to Ontario's representation of marine and aquatic ecosystems.

More recent emergence from glacial ice, combined with harsher conditions, serves to increasingly restrict the diversity of species and communities along a northern gradient. Obeying universal laws of latitudinal zonation, Shield country is innovative in its casting of characters to convey an illusion of species diversity that does not exist. Although hardwood species are greatly reduced, tolerant hardwood communities persist, principally east of Lake Superior and south to include the Algoma, Temagami, and Algonquin regions. More varied topography provides for more dramatic microclimatic, soil, and moisture gradients yielding seemingly infinite combinations of surprisingly few species. Where tolerant forests do occur, they perform like their deciduous counterparts to the south—summer green, spring flora, and autumn splendour. Typically, stag pine protrude like flags from forest canopies, reminiscent of their once widespread occurrence in the square-timber days, and symbols of debates surrounding old-growth conservation.

Boreal inclusions, confined to colder-than-normal situations in the south, displace the tolerant hardwoods at latitudes above the Lakehead. Sweeping to cover the Severn and Abitibi uplands, this broad band of mainly coniferous forest is part of a circumboreal belt extending across North America, Europe, and Asia. Home for the grey owl, sandhill crane, and woodland caribou, and the spritely wood warblers annually exported to Caribbean climes, it is hard to comprehend how such an elegant ecosystem could develop within the last 10,000 years.

Minor communities are important elements of Shield country, adding to the habitat variation and breaking the monotony of seemingly endless forest cover. "Moose pasture", a common euphemism for wetlands in the north, does not do justice to the variety of wet meadows, swamps, marshes, bogs, and fens, which often exceed the biotic diversity of the surrounding forests. In the west, prairie species intrude into moisture-stressed environments, with bur oak bottoms of prairie affinity occurring in the Lake of

the Woods area. In colder-than-normal situations, around Lake Superior, botanical treasures of arctic-alpine affinity cling to footholds likely established during the retreat of the glaciers.

Owing to the poorly developed arboreal mix of short-lived species, renewal is an important process for regeneration and nutrient recycling. Historically, fire has been the natural agent for renewal, recently supplanted by suppression and timber harvesting. Debate over the suitability of timber management as a substitute for fire continues to polarize viewpoints on the subject. In the meantime, substantial provincial parks, where fire management may be compatible, retain options for side-by-side comparisons of natural and silvicultural management regimes.

PROVINCIAL PARKS ON THE CANADIAN SHIELD

The very nature and character of Ontario's provincial parks is embodied in the Canadian Shield. Its majestic lakes and streams, rugged forested landscape, and profuse wildlife attract both the casual and the dedicated naturalist. Where better to camp, canoe, fish, ski, or just appreciate nature than in Algonquin, Lake Superior, Neys, or Sleeping Giant parks? These and other Shield parks provide excellent representation of Ontario's geological and ecological diversity. Opasquia, Woodland Caribou, Quetico, Wabakimi, Lady Evelyn–Smoothwater, and Killarney provincial parks and Pukaskwa National Park provide wilderness in seven of nine site regions. These Wilderness Parks, supplemented by Nature Reserves and other park classes, provide the nucleus of an impressive system of protected areas.

Although Ontario has made major progress in completing its provincial park system on the Canadian Shield, much more work remains to be done. Geological features and ecological patterns that are within this system must be supplemented by those that are not. The Lake of the Woods and Lake St. Joseph areas have no Wilderness Parks. Other parts of the northwestern uplands require additional Natural Environment and Waterway parks. In the northeastern uplands, several new Waterway parks will be needed to complete that portion of the system. A number of spectacular Nature Reserves, north of Lake Superior, help to

PETROGLYPHS PROV. PARK
COURTNEY MILNE

round out the representation of some features of the upland and of the Port Arthur Hills and Nipigon Plain. Elsewhere on the Shield, however, only a handful of Nature Reserves have been established.

In addition to its wildlands, the Shield is the source of much of our province's wealth and prosperity. Its forest products, minerals, hydro power, and tourism industry depend upon continuing access to resources. The need to both *protect and develop* our natural resources in a sustainable manner poses an interesting challenge for the 1990s. To start, new Wilderness, Natural Environment, and Waterway parks will be needed to complete representation of Ontario's site regions. Inventories also will be needed to identify new Nature Reserves and areas of natural and scientific interest. Collecting this information will require a long-term commitment, in view of the enormous size, relative inaccessibility, and incomplete knowledge of Shield country. A commitment also must be given to mitigating the inherent conflicts between provincial parks and other resource uses through open public consultation involving all interested parties.

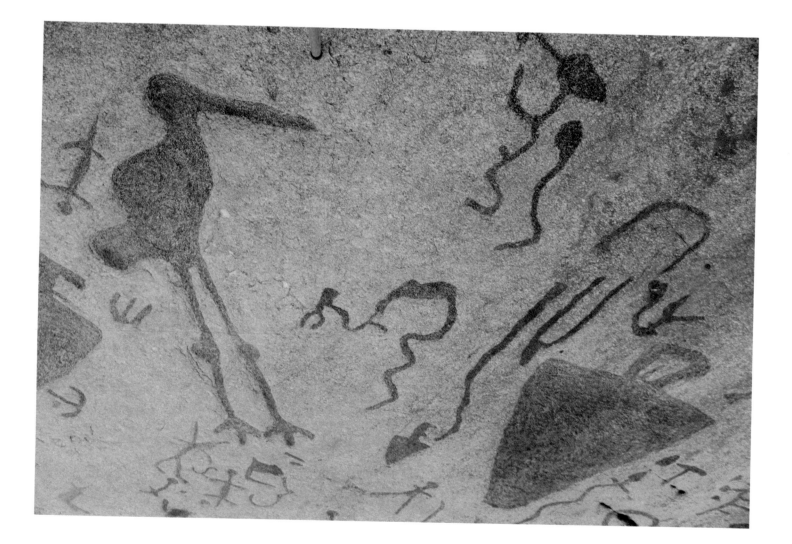

Algonquin Park at One Hundred Years: Some Thoughts from a Privileged Observer

Dan Strickland

Dan Strickland calls himself a "privileged observer" of Algonquin Park because, unlike the rest of us who merely get to visit, he has now lived and worked there year-round for over a quarter of a century. As park naturalist he has introduced hundreds of thousands of people to the beauty and secrets of Algonquin, both in person and through his extensive writings on park subjects. Here he looks back at some of his marvellous Algonquin experiences while at the same time offering us some gentle challenges on the way we think about the natural world around us.

My first visit to Algonquin Park was on the Thanksgiving weekend of 1960. I had borrowed my father's car and, together with two companions from one of my first-year classes at the University of Toronto, had set out to finally see for myself what that big green blob on the map called Algonquin was really like.

Just as so many visitors do today, we entered the park at the West Gate and then drove to Canoe Lake. There at the Portage Store we rented a canoe and for a few sunny hours explored the famous lake where Tom Thomson had painted and died forty-three years earlier. Later we continued on to the old Park Museum at Mile 13 (Km 20 today!) where I was lucky enough to meet and briefly chat with the legendary Algonquin Park naturalist Russ Rutter. Afterwards we walked the Hemlock Bluff Trail and watched totally fascinated as a beaver cut down a small poplar near the Opeongo Road. Most of all I remember the extraordinary numbers of tame deer in the Cache Lake area. Algonquin was world renowned for its deer back then, and we counted forty-two of them ourselves as we hiked along, with twenty-six being in view at one place all at the same time.

Our visit to the park was certainly memorable but it was also very short, and at the time I hadn't the slightest idea that it would be so personally significant to me — and in more ways than one.

To begin with, it turned out that Algonquin was where I would spend the greater part of my life. My next trip to the park was in 1965, not as a visitor this time but to begin work as one of the summer naturalists. I spent much of those early years, as I do now, learning more and more about the park. I used to spend hours poring over the map wondering what it would be like to visit Koko Creek, for example, or Mangotasi Lake, or Lost Dog Lake, or Loonskin Lake, or "Old Baldy" up north of the Wildlife Research Station.

I eventually visited all of those places and many more besides, but even today there are lots of nooks and crannies in Algonquin that I have never set foot in. A park like Algonquin has more than a lifetime's worth of lakes, rivers, bogs, and clifftops to explore. It also is an inexhaustible treasure trove of experiences to savour and intriguing relationships to discover.

In this regard I have been especially fortunate in being able to benefit from knowing, and learning from, a long list of Ministry of Natural Resources and university scientists who have worked over the years on dozens of research projects. I think of Dr. Tony Bubenik, who introduced me to the fine points of moose calling and opened up a whole new world of spectacular early-morning watching, and learning about, wildlife behaviour. Or I think of the time that George Kolenosky, one of the original Algonquin wolf researchers, came up to the park in January 1970 to teach me how to conduct an aerial wolf census. He certainly was a good teacher! The first day out we actually saw seventeen wolves and the second day another eleven. The highlight occurred at Lake LaMuir, near the very centre of the park. For a few minutes we circled above that wild, horizon-to-horizon landscape and looked down at two bald eagles slowly circling in turn above two wolves

that were standing on the ice beside the last scraps from an old deer kill. Even today, that breathtaking scene is frozen into my consciousness as one of indescribable power and magnificence.

But Algonquin provides so much more than isolated snapshots of the natural world. It also gives us a chance to see how extraordinarily complex and dynamic that world is. Here I must confess that I have an unfair advantage over most people — one given to me by spending so much time here and therefore being able to see changes over the years that would not be apparent to occasional visitors.

When I made my first visit to Algonquin, for example, I just assumed — as I am sure most people do today — that a great park like this one was somehow frozen in time and immune to what was going on in the rest of the world. Little did I know that my first visit was going to be the only time that I saw the "old Algonquin" — the one that generations of Ontarians had come to think of as *the* place to see deer. When I returned to the park in 1965, the deer had largely disappeared. And yet, in the 1990s, a whole new generation could grow up thinking of Algonquin as *the* place in Ontario to see moose. Quite obviously, a dramatic change in Algonquin wildlife had occurred, and I count myself lucky to have witnessed both the present chapter in the story and also the tail end of the previous one.

We are very lucky in another way too because we think we actually know why the spectacular deer/moose switch happened. It was no secret that deer were originally rare or absent in our part of Ontario, but reached unprecedented numbers in the late 1800s and the early part of this century. Logging and uncontrolled fires destroyed many old forests, which were succeeded by lots of brushy young growth — ideal feeding grounds for deer. It was also well known that the introduction of aircraft into the fight against forest fires in the 1930s, and generally better forest management later, caused a great reduction in the production of new deer habitat. These trends could obviously account for the abundance of deer in the park's early days and then their more recent decline, but how could one explain the reverse fortunes of moose?

Why would moose be so rare when deer were common, and only reach high numbers when the deer population dwindled? Thanks to research carried out by Dr. Roy Anderson, now of the University of Guelph, we know today that deer carry a parasitic brainworm which is normally transmitted harmlessly enough from deer to deer through snails or slugs accidentally eaten when deer are browsing on vegetation. There is nothing to stop a moose from eating one of these infected snails or slugs, however; and unfortunately for the moose, the parasite can be deadly for the larger animal. When deer are abundant, so are infected snails and slugs, and it is almost certain that any moose in the area will also be infected and die as a result. This pattern neatly explains why, when deer were common in Algonquin, moose were rare, and then when deer became rare (meaning few or no infected snails or slugs), moose were able to survive, reproduce, and multiply to the numbers we know today.

I think this story is fascinating in itself, but it also makes the larger point that natural ecosystems are not "carved in stone". On the contrary, they can be remarkably fluid and changeable even if the changes are slow and often even undetectable to the casual observer.

The deer/moose story also makes the point that there is far more beneath the surface of natural scenes than meets the human eye. This is a theme that I believe can't be emphasized too much. To give you a good example, who among Algonquin campers has not fallen asleep on a moonlit night in July listening to the laughter of loons ringing across the water and thinking that this incomparable music is the very essence of our northern wilderness?

But wait a minute. Is it realistic to think that loons call for us, just because we like the sounds they make, or that other loons (the intended audience, after all) share the same enthusiasm? Loons may be warm-blooded, air-breathing fellow vertebrates, but they still are so different from us that we will never truly succeed in knowing what it would be like to be one of them. To the extent that we can try, however, the truth about those fantastic summer night concerts would be something like the following. The ringing yodels that we find so beautiful are terrifying threats given by the male loon towards neighbouring pairs or wandering single birds

who have entered his territory. The yodels signal a deadly serious readiness to attack, to stab, to bludgeon and to kill. And don't imagine for a minute that he won't make good on his threats. Fights to the death among adult loons may be rare — the invader usually beats a quick retreat — but loons have been observed to kill neighbouring loon chicks or mergansers who got caught in the wrong place at the wrong time.

I hasten to add that there is nothing "cruel" about this — that is a distinctly human concept that doesn't apply at all here. It's just that resources are limited for loons (not enough lakes and fish to go around), and over millions of years the loons that have been successful in raising young and leaving descendants have been the ones that were ready to defend a territory and ruthlessly eliminate any competition. I don't mean to depress anyone with this news or to suggest that we should stop enjoying summer-night loon choruses — far from it. But if we are truly serious about respecting the natural world, we have to understand and accept it the way it really is. We cannot decide which animals are "good" (loons for instance) and which are "bad" (perhaps bats or snakes) just because the "good" ones happen to look or sound beautiful to us human beings. After all, what have our emotions got to do with the reality of a natural ecosystem?

An even better example of what I mean is provided by the way we react to the size of animals. We all say "Wow!" when we see a big bull moose, but nobody gets enthused by the sight of a male mouse. I am sure most park visitors find the very notion of taking mice seriously to be ludicrous. And yet, the fact is that mice are much more important than moose. Even in Algonquin where they are now common, moose are in most years outweighed by mice on a per-area basis — and obviously vastly outnumbered as well. Because the Algonquin mouse herd comes in millions of tiny packages (rather that just a few thousand big ones), and because the metabolic rate of each individual mouse is much higher than that of an individual moose, the mice of Algonquin eat and process far more shoots, seeds, and other vegetable matter than do the moose. Not only that, but mice form the food base of a whole host of bigger animals — foxes, weasels, owls, and hawks — whereas moose

are at best only occasionally taken by one predator, the wolf. Putting it another way, the Algonquin ecosystem would suffer a serious collapse if mice could somehow be eliminated, but it would hardly miss a beat if there were no moose. Think about this the next time you see a lordly bull moose standing on an Algonquin lakeshore.

There is something else I believe people should think about whenever they contemplate a living plant or animal. It is a lesson that we often find hard to accept, but it is one that cannot be dispensed with in reaching a realistic understanding of the natural world. The lesson is this: *Most living things do die, must die, and should die at a very early age.* Now, we may not like the fact that most Bambis are ripped apart by bears or wolves before they are a few months old, and we may even get upset when we learn that 99.9 per cent of all sugar maple seedlings are killed by the shade of their own parents, but we cannot escape the fact that these things must happen. The simple truth is that every organism which reaches reproductive age produces as many offspring as it possibly can, and there just isn't enough room or resources for all the offspring to survive.

Take Algonquin's moose, for example. We believe that they are now holding steady at somewhere between 3,000 and 4,000 animals at the end of each winter. Every spring, however, almost every adult female will produce at least one calf. Let's say, just to be on the conservative side (allowing for yearling cows not yet of breeding age), that one each means the addition of "only" 1,000 calves to the Algonquin moose population. It sounds wonderful, and it certainly is prolific, but a moment's reflection will show that such an increase on an annual basis is totally unsustainable. As a matter of fact, if the moose herd is truly holding steady from one year to the next, the birth of 1,000 moose also necessarily implies the death of 1,000 moose over the following year. Think of it! A thousand moose must die every single year in Algonquin Park if the population is merely to remain level.

We may fret about which animals will die (usually the youngest, as they are the weakest), and we may not like how they die (being devoured alive, falling through thin ice, or being debilitated from heavy tick infestations are a few of the usual causes), but we

ALGONQUIN PROV. PARK
WILLIAM REYNOLDS

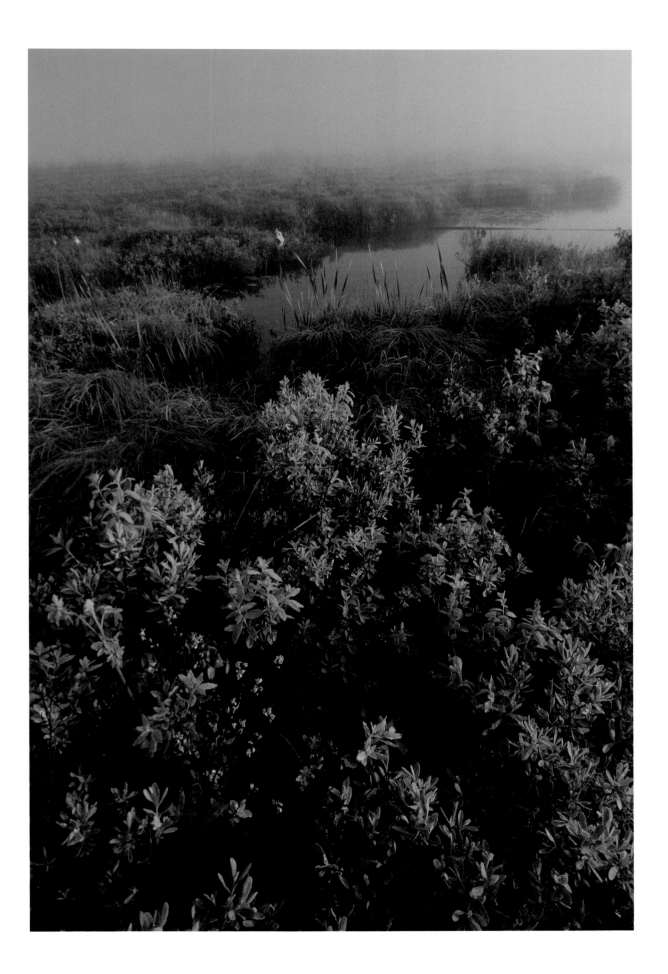

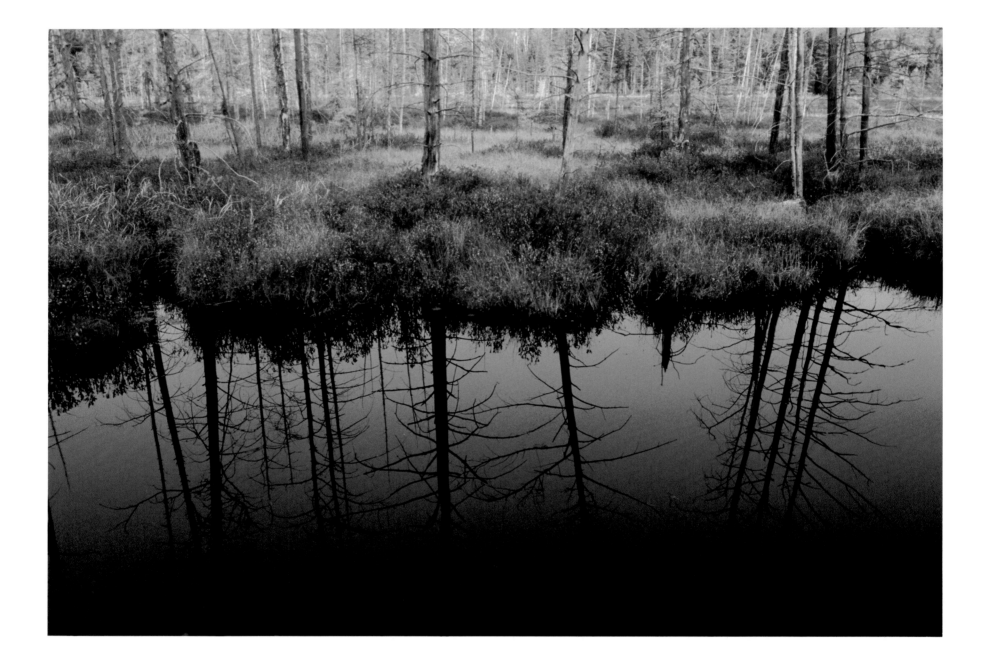

can't change the fact that 20 to 25 per cent of all the moose in Algonquin have to die, every year. Nor should we *want* to change that fact—unless we are somehow prepared to see the moose population increase by 20 to 25 per cent every year . . . forever? No, once again we have to accept the natural world as it is, and not try to shoehorn it into some romantic human notion of the way things should be.

The lesson to be learned from a harmonious, wild ecosystem is that individuals count for nothing. Only the system itself is important. Only the system can be preserved in all its intricate and pitiless beauty.

If some of the lessons we can learn from Algonquin Park take a bit of getting used to, others, happily, are more reassuring. For example, in the last decade or two there has been much concern about the threat of acid rain, especially in an ostensibly vulnerable area like the park with its high altitude and poor, thin soil. At times I have shared the general despondency and I wouldn't want to minimize the potential risk. And yet the fact is that in Algonquin Park we have detected no sign of the maple forest decline seen in other areas, often attributed to acid rain, and we have seen no losses of fish. It is true that we have fifteen acidic lakes, but the evidence seems to suggest that most were acidic to begin with, and besides, contrary to the usual public impression, such lakes are far from "dead".

Bat Lake, near Highway 10, now visited by one of the park's interpretive trails, is a good example. Its water is very acidic (pH 4.75) and it certainly is fishless, but it is full of life nevertheless. Probably because there are no fish, the lake is a veritable "soup" of predatory midge larvae, and they in turn attract migratory bufflehead ducks (otherwise very scarce in Algonquin), as well as supporting a major nursery of yellow-spotted salamanders. Perhaps 2,000 adult salamanders return to Bat Lake in the spring a couple of weeks after the ice is gone, to mate and lay their eggs in big, fist-sized milky white masses. Some of my best Algonquin Park wildlife viewing has occurred on cold May nights drifting along the shore of Bat Lake in a canoe, watching the great salamander spectacle with a flashlight. Not bad, and

certainly not the usual picture of a supposedly "acid-dead" lake.

I could go on with dozens of other examples of the marvellous experiences to be had and discoveries to be made in Algonquin, but I sense that space and the editors won't let me. I hope by now, in any case, that the true value of the park has become apparent, at least as perceived by this very privileged observer. Algonquin is first a place for the exploration and enjoyment of an endlessly beautiful and complex natural world, and second a bridge to a deeper understanding of that world.

For me, it was all summed up by a person who came on one of our Public Wolf Howls over twenty years ago. It was quite late in the year, just before Labour Day, and there were very few people left in the park. Only a few hundred showed up at our Outdoor Theatre bundled up against the cold to hear the introductory talk, but they listened spellbound as Russ Rutter, the old naturalist I had met on my first visit to the park, related what we knew of the wolves of Algonquin. He told how the late Doug Pimlott, one of Canada's greatest voices for wilderness preservation, had headed up a wolf research program in the park in the early 1960s. He explained how the wolf's true role in the Algonquin ecosystem was slowly clarified after years of hard work tracking and counting the wolves, analysing their scats, and examining the remains of their prey. He told how, thanks to this research, old attitudes of ignorance and hatred were slowly giving way to a more sane and realistic understanding. And, of course, he told the audience how we had learned ten years earlier that wolves will actually answer human imitations of their howls. At the time, the discovery was a major breakthrough permitting the researchers to find otherwise undetectable wolves, but recently it has also become a dramatic way of introducing park visitors to this most mysterious and elusive of wilderness animals.

We then set out in a long procession of cars, first down the highway and then several kilometres up a bush road to where we had heard wolves the night before. Cars arrived and stopped, engines were turned off, and people quietly got out and waited patiently. Soon the last car pulled up at the end of the line, its lights were turned off, and the entire procession melted into the darkness, utterly silent beneath a million unblinking stars.

WOLF HOWL POND, ALGONQUIN PROV. PARK
DONALD STANDFIELD

One of the staff sent a long low howl rippling out into the night. The lonely sound echoed coldly back from hills across a nearby lake and bog and then subsided into nothingness. Half a minute later we tried a second time and once again there was no reply. But wait! Yes! A wolf howl drifted in from far off to the north and then, from no more than a hundred yards away, a whole pack burst forth in an almost deafening clamour of howls from the adults and yips and yelps from the pups.

It went on and on, seemingly forever, in an unforgettable wilderness symphony. When the last mournful howl from one of the adults finally faded away, I am sure many of our first-time wolf howlers could scarcely believe that they had actually been there and not dreamed the whole thing. We waited there in the darkness, novice and veteran alike, gazing up into the heavens and thinking of our incredible good fortune in being there that night. Where else in Canada or indeed the world could we and so many companions first learn about wolves and their world and then go out and experience both so profoundly and dramatically?

After a ten-minute wait, we tried again — with a similarly amazing response — and then we started for home. I was soon back at the end of the road with other staff helping to direct cars out onto the highway. It was then that a car slowed up, a woman rolled down her window and said just one word that perfectly captured that particular Algonquin experience and a thousand others as well.

"Fantastic," she said.

Algonquin Park – Some "Freeze Frames"

Warner Troyer

During the three years we lived in South Asia, on an "island paradise" 650 km from the equator, we often bemused friends with photos from Algonquin Park. Their favourites showed us wearing snowshoes atop house-high snowdrifts by a frozen lake, or feeding chickadees in the snow. "What is it like?" they asked.

Well. It is 7,653 km² of parkland in central Ontario created by an act of the Ontario Legislature in 1893. By then massive logging had negated any suggestion of an "unspoiled wilderness". But if never a true wilderness park, Algonquin became a wildlife sanctuary and something much more — a nature sanctuary for people. Here a workaday urban teacher, artisan, or plumber could split wood, raise honest blisters, dream by an open fire. Here five generations of ardent conservationists have built their nature skills and their commitment to our common environment. Paddling, swimming, and sailing are the envied skills. Canoe trip routes let most anyone in reasonable health experience a genuine sense of self-reliance and kinship with what feels, to most, enough like wilderness — not least on the night a bear comes through the side of the tent for the remaining peanut butter sandwich! No, we told our tropical island friends, we didn't have any wild elephant or leopard, no crocodiles, not even a pet mongoose to discourage the local cobras. No glistening, infinitely long beaches on the Indian Ocean either, nor schools of tropical fish to swim with. Yet, for three years, our happiest fantasies revolved around Algonquin Park. We only knew we were truly "home" when we took our first cup of coffee to the shore of Smoke Lake to watch sunrise over the

PIPEWORT NEAR BIGWIND LAKE PROV. PARK
JAMES L. HODGINS

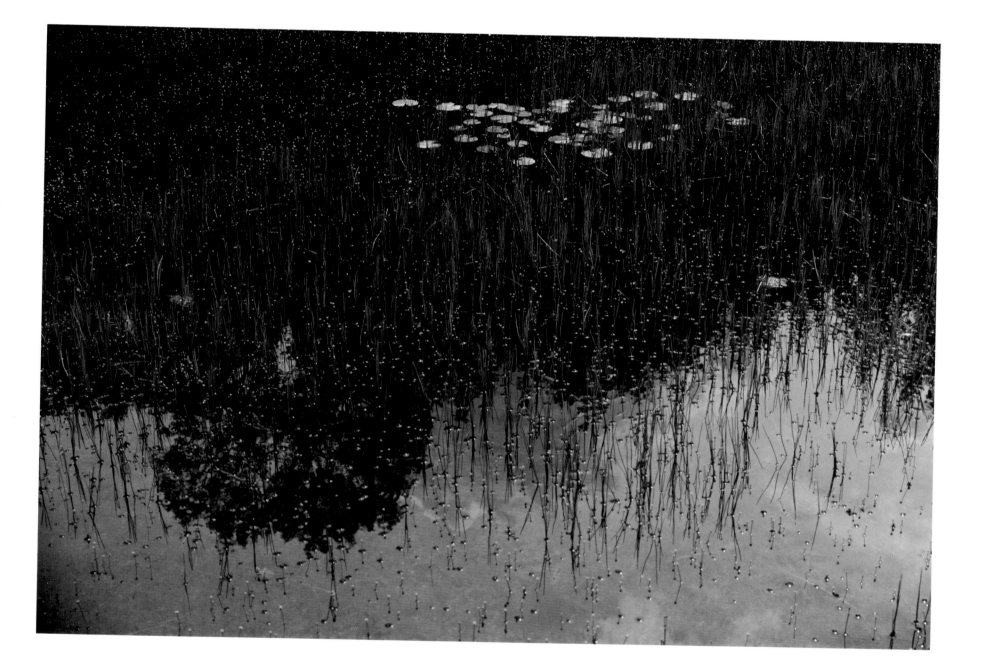

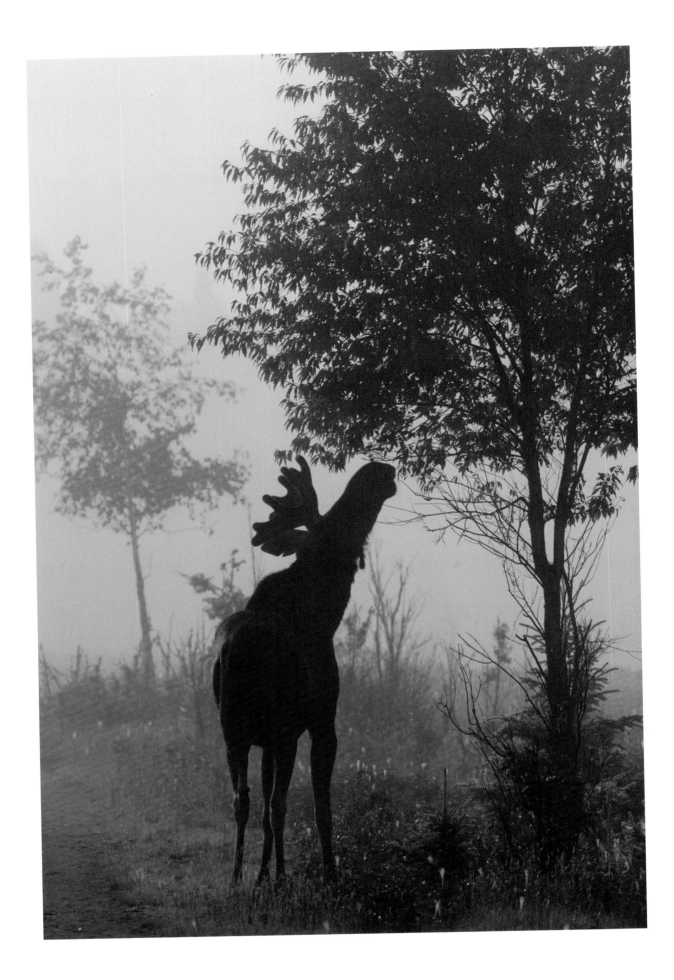

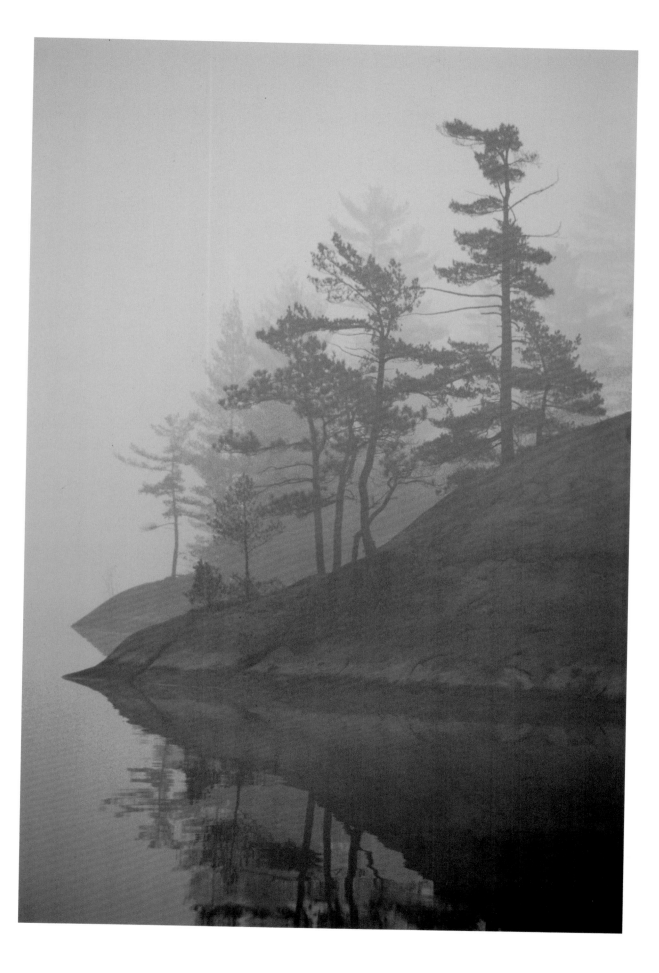

MOOSE, ALGONQUIN
PROV. PARK
MICHAEL RUNTZ

RIGHT / WOLF ISLAND
PROV. PARK
BRUCE LITTELJOHN

gold and scarlet autumn-painted hillside across the bay. But why, from all Canada's treasure house of nature and beauty, this particular chunk of geography landscaped and sculpted, 11,000 years ago, in the retreat of the last ice age? Why, for me, only and always, Algonquin Park? My love for the park has been somewhat less than 11,000 years abuilding.

This brief essay, along with the manuscripts of four books and of countless magazines and newspaper articles, film scripts and outlines, was written at my Algonquin Park cottage on Smoke Lake. It is, I suppose, the serenity and the indelible forces of nature which make that work so integral to our lives; we are specially blessed because our work has extended Algonquin's magic — in literal, sensory terms — far beyond the park and into the greater fraction of our lives spent, necessarily, outside the park — whether in Toronto, Manhattan, or Beijing.

So, even with a background of city sirens and traffic, let me see a snapshot of a grandchild hand-feeding a chipmunk; or hand me any of those books or articles agonized-over at the cottage, and immediately I smell the cedar and pine, sense hummingbird wings thrumming just offstage, hear midnight wavelets lapping the quartz outcropping by the birch tree below our den.

Sure, we write and work in the city, and in other odd places as the occasion — and the deadlines — demand. I've hammered at my portable typewriter on the tailgate of a jeep in northern China and in the highlands of Ethiopia, in a felucca on the Nile above Luxor, and on up-ended suitcases in airports from Lagos to Moscow. But "it ain't the same". Once spoiled, the commonplace, journalistic muse covets the companionship of redpolls, nuthatches, and sun-dappled water interrupted by the occasional solemn, steady, and immensely satisfying pull of water against paddle with its accompanying riffle of passage under the stem of the canoe.

Over more than twenty years we've played host to (or been tolerated by) black bear, beaver, mink, otter, lynx, deer, moose, flying squirrels, owls, and myriad birds. The loons — and sometimes the wolves and owls — call "taps" for us at night, and the woodpeckers, squirrels, ravens, and blue jays summon us to breakfast — theirs and ours. We've come to think of all these wild but

trusting creatures almost as family; many return year after year and seem almost to recognize the pet names given them by now two generations of children. Among them, they have brought joy and promise to us and our children, as they do, now, to our grandchildren. Bless them all.

So for me, Algonquin Park is more narrowly finite than the sprawling geography of the highway maps or even the canoe route guides. It is a chunk of shoreline on Smoke Lake, just off Highway 60, and a series of freeze-frame memories as vivid as Disneyland holograms. Those fragments cover twenty-three years now, and myriad bays, trails, skyscapes, and feelings. Their common denominators are their occurrence within Algonquin, their direct and vivid reality in the labyrinth synapses of memory, and the constant sense of joy and privilege I've found in a lifetime's pleasuring at the hands of Mother Nature.

So I've no overview of Algonquin Park for you, or even a narrative structure. Those I'll leave to the scientists and the novelists. Instead, here's a fragment of a minstrel's anecdotage — a dipperful of Algonquin memories which may begin to say why it seems to be the centre of my life and the paradigm for life's richest realities:

All Algonquinistes understand we have only two sorts of day in the park: gold and silver. Some of those "silver" days, though!

My first canoe trip with a gaggle of kids: 4:00 a.m. and the skies opened over Burnt Island Lake. In minutes our (untrenched) tents were flooded, the sleeping bags sodden, the youngsters as cold, miserable, alarmed as I. Only one flashlight would work; one son, asthmatic, was finally bundled into a sleeping-bag-transformed-to-wetsuit between my wife and me, until dawn. At first light a fitful, smoky fire failed to dry socks, sweaters, shirts, or spirits. We portaged back into Joe Creek, made and ate Spam and peanut butter and jam sandwiches sitting in the canoes under a calm, silver sky and, magic and wonder restored, watched for two hours as a young beaver cut and swam off with tender saplings from the mossy shore just yards from our floating brunch.

There've been many more canoe trips since that embarrassingly truncated thirty-hour odyssey. The sunrises and sunsets have

always seemed the best bits, when nature wraps the soul in velvet colours and proves Einstein right, ten times out of ten: Time, space, and energy are all one, their sum greater than their parts, their theology the infinite beauty of sky-painted colour, pattern, and variety on the park's lakes.

The days can be wonderful: Typing on the porch at a first sturdy "desk" built of scrap two-by-fours as chipmunks paw-print my manuscript en route to the peanut tin; a feisty sunfish charging tirelessly and nibbling at my intruding toes as he guards the nest cupping his mate's new eggs; the construction of our first "butter-fly feeder" — a plump raisin sliced in half on the porch railing for the "house" monarch, an indolent creature who takes frequent rest breaks on our hats, our shoulders and hands, and sucks the raisins dry for over a week before moving on; a mid-lake, magic, silent circle of more than a dozen loons imitating a square dance, rising up on beating wings, advancing in pairs to the centre of the circle in a wash of water and retreating to the perimeter only to be copied by their companions; the silent, luminous eyes of a child watching, from the canoe, a mother loon, her chick as securely balanced on her back as an elephant-borne rajah tiger-hunting from his capari-soned howdah; a stately-Victorian merganser nanny herding a fluffy, gabbling, undisciplined nursery raft of twenty-three (we counted and photographed them!) ducklings along the shoreline on a navigation and foraging training expedition; a sudden beaver, diving under the prow of the canoe, then surfacing and pistol-cracking his tail on the lake a paddle's-length away to emphasize his territorial precedence; the wondrous rhythm of twin paddles thrusting a canoe through still water with nary a thump of shaft on gunwale or a splash between strokes; a heron erupting in flashing blue, white, and grey from a monochromatic tangle of roots and rocks a fly-cast from the canoe; a grouse, drumming her way into a brushscape near her nest, her mime of broken wing a marvel of courage and artistry alike; on a crisp October day, flickering light from the Franklin stove reflected on the warm balsam logs of the den as we write; sunlit hours floating in the lake, alternately explor-ing twin universes — down, through mask or goggles to the darting minnows, lazy crayfish, cruising bass or perch — up, past birch,

hemlock, cedar, spruce, and pine to cloud-built cities linked some-times by migrating geese or the silent, 10-km-high vapour trails left behind by folk imprisoned in airborne aluminum canisters; even terror in the sunlight, once — an October boat overturned into gale-driven, 10°C water with no other craft on the lake — a three-hour ordeal, kicking, and stroking the wave-tossed, upturned hull and motor to shore — a reminder of mortality, and a salutory dose of hypothermia, and humility. The days alone need their own book — no, their own lifetime's experience.

But it is the dawns and darks that haunt and mark and mys-tify. In the false dawn and just after, Smoke Lake justifies its name as the day's first tentative warmth condenses vapour off the water's surface in a 2-m-deep, lake-hugging, horizontal blanket; now paddle softly, silently past the edges of reality — that moving bulk of waterline mist must certainly be the gliding presence of Tom Thomson's green canoe. Soon the sun will beam the mist away; the lake, and the park, will stretch and yawn and chirp, chuckle, riffle, and zephyr itself awake. But just now, for an eternity of precious moments, the electric charges of life are confined to you and your paddle, your tiny sanctuary patch of lake and slowly swirling cotton air.

And the nights! Some random recollections, with no special chronology or logic:

A pair of flying squirrels — our "regulars" — running, leaping, pivoting like clockwork mice as they squabble over sunflower seeds at their feeding stations on the porch; then, legs outstretched, soaring 15 m and more from high in the white pine to the shad-owed base of a cedar.

Out on the lake on a hot August night. Love-making is possible in a canoe, we learn, but (ever prudent) we leave a pulsing red flashlight on the thwart lest some traveller come thundering by in a powerboat. At the least appropriate moment, one does, beam-ing the brightest, whitest spotlight in Algonquin and shouting, "I saw the red light! Are you in distress?" "Not", we replied, "until you came along!"

The dinghy is just 3.4 m long, with a 1.2-m beam, but my

son and I built it, and a deep breath will move it on still water. The gaff-rigged sail, orange, is black against a milky way I think I can touch — but I don't want to wave it away; there's a drop of brandy in my coffee and the water is chuckling complacently under the squared stem of the light hull; the mast-tip moves gently from the centre of the dipper to the North Star; a loon grieves, a hill and a lake away, and is answered by one more near. I am moving maybe 100 years (and a half-dozen light years) every five minutes or so; it seems about fast enough.

Last night, for wonder-filled hours, I watched while God amused herself by dropping a fluorescent canopy of greens, purples, and reds over this small circus we operate down here. The northern lights were awesome.

There was an owl calling from across the lake — a three-quarter moon competing without success with the much more splendid light show covering the northern quadrant of the sky — and a loon chuckling her kids to sleep down the shore a bit. A few restless perch popped out of the glassy, black water by the dock to see who was shining these brilliant green spotlights in their eyes.

I felt very insignificant, and very privileged. It's a privilege no one should ever be denied, one we must keep for our children and their children — the opportunity to swim and paddle through clean water, to taste the sweetness of clean air, to hear the owls and the loon — to see the perch or the otter playing in the moonlight. If we *all* can keep "our" lake, "our" park, "our" planet well and whole.

As I write this, two of my grandsons are swimming and hoping to see the eight ducks which paused for a feather-fluffed, hour-long evening snooze on our dock last night; a pair of nuthatches are amiably sharing some seed 2 m from my computer and a ruby-throated hummingbird on a tiny cedar twig is standing agitated sentinel duty over *his* nectar-filled feeder; across the den, the sun is dropping across the window high in the wall I face while I type, and the late afternoon breeze, stirring a huge old hemlock, is scattering a lacy kaleidoscope of sun motes over the log walls and pine floor. I'm surrounded by the best arguments the gods can provide for the preservation of our environment. A best beginning *must* be to share and encourage such experience, such sense of "family" with nature, such joy in preserving and nurturing what's simplest, cleanest, best in our lives.

I'm reminded, this night, that the word "ecology" springs from the same Greek root, *eco*, which means stewardship or management of a household; that's only possible if we share the responsibilities as well as the rewards. Once more, "the Greeks have a word for it". It seems apt — and urgent.

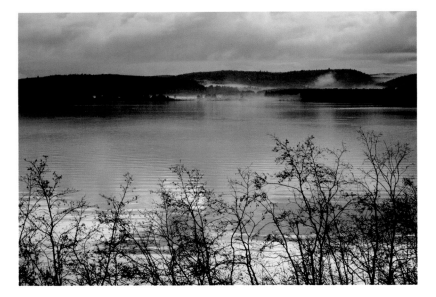

Learning about Learning: The Park-as-Teacher

James Raffan

"I think children know that nearly anyone can learn the names of things; the impression made at this level is fleeting. What takes a lifetime to learn, they comprehend, is the existence and substance of myriad relationships: it is these relationships, not the things themselves, that ultimately hold the human imagination."

. . . Barry Lopez, *Crossing Open Ground*

Early each May I go with students into the back country of Frontenac Park for an overnight. The two-day hike is their first outing in a twelve-month teacher education program. I set them loose in groups of four or five, not only to smell the awakening forest floor, or to count birds, but also to explore each other's company, to find their way, and to learn their first lessons of teaching—without chalk, without books, without walls. I take them to Frontenac to experience the park-as-teacher.

A school bus pulls off the Perth Road north of Kingston. Twenty-four fresh student teachers spill out onto the shoulder filling the crisp morning air with laughter, clanking buckles, zipping zippers, and the rip of new velcro. Sun-washed yellow jackets, blue tuques, red pants, green packs, and pink bandannas mingle and sort into clusters around maps and compasses. One by one, four groups show me the route they have chosen to the campsites we've booked; they explain their systems for log-keeping, navigation, safety, and first aid; then each breaks off down a 4-km laneway to the park's east gate.

After the last bubble of voices drifts down the road and out of earshot, I follow, adding my boot prints to the snaking patterns of tracks leading to the interior. It's not long before I catch up to a group crouched around a patch of delicate yellow flowers. They're struggling to find the plant's name. One woman pulls a wildflower field guide out of her pack and asks how many stamens the flower has. Someone else asks, "What's a stamen?"

Joining the group, I inquire why it is that these flowers grow on this side of the road and not on the other, and why it is that they all seem to grow together in a clump and not as individuals evenly spaced over the ground. Someone suggests that there's more water on this side of the road and that this plant likes water. Another suggests that that's just the way things are. Another suggests that maybe this side of the road gets more sun and that this little plant likes the sun. I push further and ask why it is that this plant is blooming at this time of year. If the main mission of the plant is to make sure its genetic material gets to the next generation, why is it that it has decided that the second of May is a good time to flower, especially when the risk of frost is so high? Then someone else picks up the idea and wonders how it could be that these delicate little creamy yellow-tinged flowers could have survived last night's frost. "Look at that puddle, there's still ice around the edges." Speculation continues.

I say goodbye and make my way back onto the road. A voice follows me: "Do you know the name of these flowers?" "Yes," I reply, and carry on down the road.

A pileated woodpecker flits and dips its way through the trees and across the road. The flight pattern is distinctive, like waves in cross-section. It sweeps up to a tree well back in the woods and disappears. Seconds later a staccato scolding resonates through the trees. Far down the road, I see another group chattering along. It looks like they're telling jokes. Do they know a bird is warning the world of their passing? Probably not. By the looks of things they have missed the flowers too. Perhaps something else will catch their fancy.

We're walking along what I imagine to be one of the earliest settlers' roads into this region. The rocks here are old, some as old as a billion years, and all are part of a giant finger of the Canadian

Shield that stretches through southeastern Ontario into Appalachia. I can't help wondering what it must have been like for families with names like Page, Amey, Leeman, Kemp, and Babcock, nineteenth-century pioneers who brought horse and plough down this road and farmed this thin-soiled land. How would they feel about their hard-won thoroughfare turning into a footpath? I wonder too if the groups ahead recognized the patches of sumac that nearly cover the remains of two wheels and an old seed drill to the left of the road.

Up ahead, groups wait at the park gate for a last orientation check before each goes its separate way. People seem more relaxed already, less self-conscious about how they look or what they say. Two keen botanists are comparing lists of wildflowers sighted along the way. But the guarded quizzical look of a woman whose eye I catch tells me that the Latin and high-speed patter of common names are not for everyone. She's holding a feather.

"Hey, look at that!" A woman sitting on the opposite side of the gate is pointing to sparkles of light emanating from the middle of the track. She shows us tiny filaments of ice emerging from black mud through the delicate green mosses. More people crowd in and have a peek. Like pipes from a miniature pipe organ the fragments of ice stand in clumps, perhaps 2 cm high, and reflect the colours of moss and the curious onlookers that surround them.

There is much talk as people spread out along the raised mossy ridge in the middle of the cart track. It's apparent to at least one person that if there ever were pieces of this ice on the road we've walked so far, they are not there now, having been obliterated by the impressions of knobby Vibram soles. Or maybe we were simply not ready to look this carefully until now.

The interesting aspect of this encounter is that the object of curiosity is not a plant, yet it is every bit as delicate and colourful; it is not an animal, yet it has aroused our fascination; and most important at this point in the hike, it has not a name, nor is a name important. It is just something that nature has created at this place on this day in Frontenac Park. Touch it and it melts. Just look at it and it captures the imagination. By now even the botanizers are prone, examining the crystals with a hand lens.

With much of the hike still to do, I remind the groups that there is also a job to be done. Their goal is to reconnoitre their respective routes, taking notes that will later allow us to assemble a composite picture of the educational potential of this part of the park. What is there to be wondered about that could serve a teacher bringing a group of students into this area? Meanwhile, my students have to be at their designated campsites on Big Salmon Lake by evening, but their schedule of travel is up to them. Off they go, seemingly less boisterous than when we first left the bus, perhaps looking more and talking less.

The land in this northeastern corner of Frontenac Park is ice-scoured, rough-hewn, and beautiful in its own rugged way. Wise old faces of lichen-encrusted pink and grey Precambrian granite watch over stands of crowded young hardwoods and guard the margins of lakes with names like Bear, Black, Clear, Labelle, Buck, and Devil. In a few places, old fields and open grassland areas are home to solitary crabapple and hawthorn trees. Occasional log ruins mark places where nineteenth-century loggers, miners, and farmers let the land be. There is water too, for beavers have built many dams and created substantial sloughs, as if they instinctively knew Shield drainage is bad.

Developed only in the early 1980s, the trails in most places are not yet trampled into gutters. The absence of people and the rugged landscape give an attractive wild bearing to the place, but I fear that my students will think this is wilderness. It may have been once, but like most Ontario parks Frontenac's natural impression is illusory and very much a product of human enterprise.

For my purposes, however, Frontenac is a far cry from city parks and the remnants of open space closer to town. From the point of view of what the park has to teach about teaching, these protected 70 km^2 veritably pulse with life and possibilities for learning.

I catch up with one group who have been lost for an hour. "Are we glad to see you!" they say in unison. Apparently, they lost the main trail in an open stretch and somehow got turned around. At first they thought they'd magically reached Big Salmon Lake two hours ahead of schedule, but after doing some checking with

AMERICAN BEECH,
OXTONGUE RIVER WATERWAY PARK
PETER van RHIJN

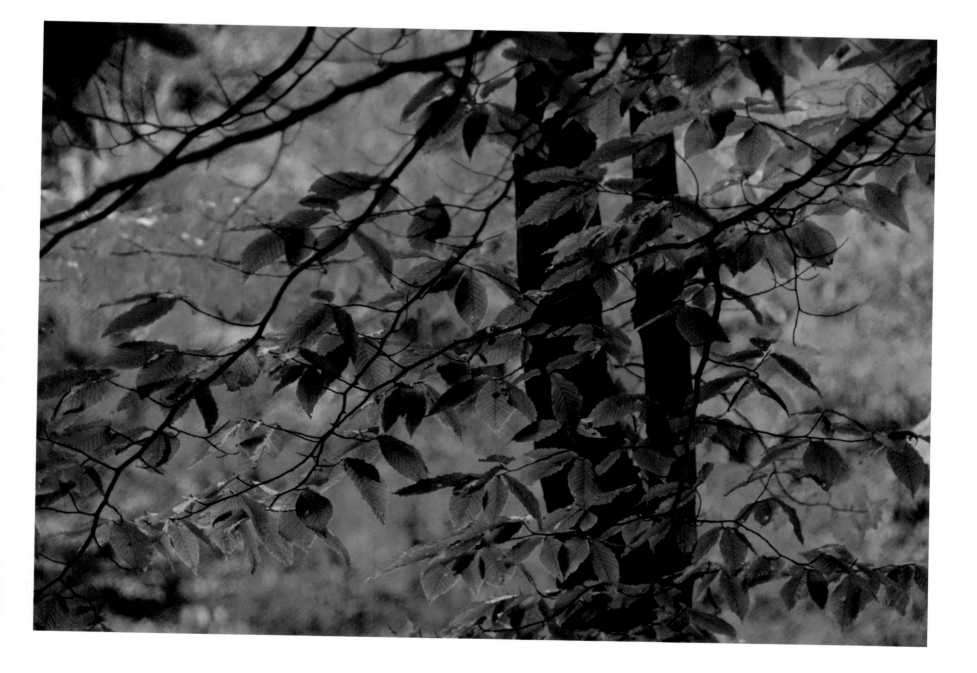

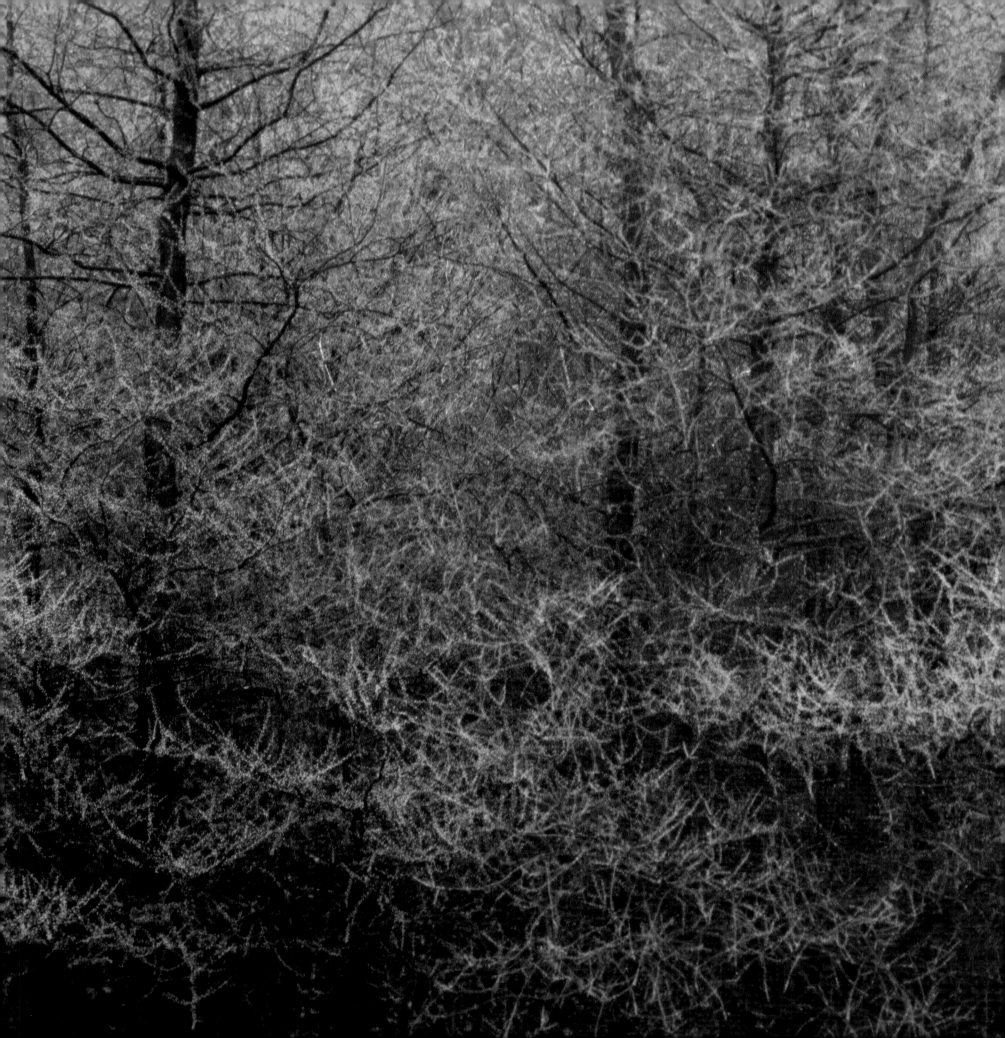

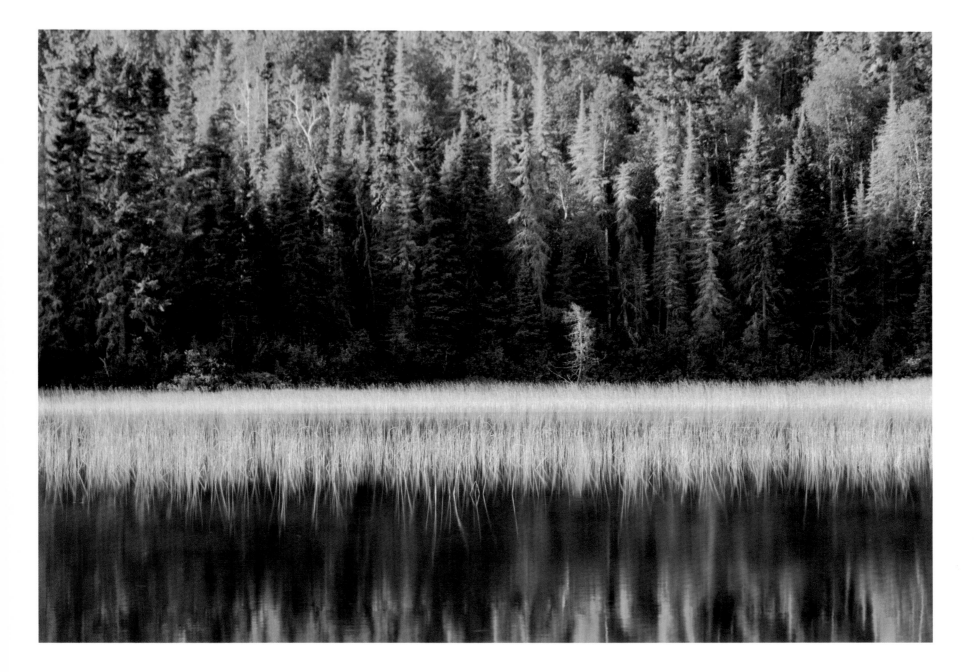

LEFT / TAMARACKS, KAWARTHA HIGHLANDS PROV. PARK
PAUL CLIFFORD

ABOVE / FERN LAKE, QUETICO PROV. PARK
BRUCE LITTELJOHN

the map and compass they realized the water they were on was too small and ran predominantly east/west instead of northeast/southwest, as does Big Salmon Lake. Damn the beavers! Eventually they recrossed the trail and recognized features they'd seen before. But, they were quick to add, they'd seen two other kinds of wildflowers, the remains of a mouse stuck onto the tine of a hawthorn tree, lots of differently shaped and coloured scats, and, best of all, a small porcupine at eye level in a white pine sapling! And, probably for the first time for them all, they were beginning to see that maps are of little use for navigation until the user has some sense of what the drawn features look like in reality. With this new awareness, they were planning to pay closer attention to the trail markers from here on in.

Along the south shore of Big Salmon Lake, I run into a group perched on rocks and grassy knolls beside the trail. In the middle of the circle is what looks like a dead or sleeping porcupine. A football-player type in the group takes a stick and gingerly rolls over the hide to show me what they have found. It is as smooth and pink as if it had been scraped with a knife. There are no bones, no guts, no muscles, no fetid smells; the pelt is fresh and supple.

The animal has been unzipped from the belly. The fur there is as soft as any I've felt, even sheared beaver or rabbit. The quills on the back lie smoothly on each other pointing toward the ground. There is an almost imperceptible clicking noise as I stroke with the grain of the quills.

For twenty minutes we talk, speculating about how this animal met its end. We decide that the remains look too new to be the result of an accidental death. The clean stripping of the carcass suggests a deliberate and expert dispatch. One person remembers an uncle saying that fishers can kill porcupines. He thinks the fisher runs up the tree and attacks the vulnerable belly. But, someone asks, what about that tail with all the quills? Maybe this porcupine was killed on the ground. The animal that killed it would either have had to flip it over and dive on its belly or attack its head. Hard to say.

We look around for other clues. A nearby oak tree has many chewed outer branches, a suggestion that the dead creature may have lived right around this spot for some time. By now we've

walked all around the carcass, so any tracks that might have been here have been ruined. Too bad. Nevertheless, we are impressed by our discovery that even the quilled porcupine has at least one natural enemy, and that it's probably a fisher.

Some time after this short trip, one of the students from that group wrote me a letter to explain that he'd been asking some questions of people and reading a bit to find out more about this curious park find. His findings confirmed that the animal was almost surely killed by a fisher. We were right. Apparently fishers are well known for their appetite for and ability to kill porcupines. They will circle the porcupine on the ground, biting it in the face until it is dead before rolling it over and opening its gut; or, if the porky climbs a tree, the fox-sized fisher is such an adept climber that it can circle around and attack the animal from above. For this student, the encounter in the park was of sufficient intensity to lead him to find time during a busy schedule to solve the mystery.

I camped that evening with the group that had found the porcupine pelt, plus a second crew — thirteen of us in all — at a campsite on Big Salmon Lake. We joked about the rocket-shaped fibreglass outhouse, set up tents on the prepared tent pads, and lit a small fire under the grill. We watched as a dozen turkey vultures soared on the updrafts along a nearby ridge and fussed themselves into a tree silhouetted against the setting sun. In ones and twos we talked over steaming bowls of lentil surprise, recapturing the high points of the day, making new connections between people and park finds. Long after the sun had gone down, the surface of the lake seemed to have collected every stray vestige of light from the sky and the western horizon — just enough to allow last stragglers to bed to see the outline of two loons calling into the night.

The next day, each group made its way along separate paths to the trail centre at Otter Lake. On my instructions, sometime during the day each person taught a trailside lesson on something — something he was good at, something she had seen along the way, a song or a story, something each thought might help others get more from their experience in the park. These lessons behind them, the groups approaching the trail centre were much different in tone and style than the ones that had left the bus the day before. More cohesive, less spread out. They seemed quieter — tired

perhaps — but also more alert and attuned to what was going on around them. Loads, I noticed, had been redistributed to lighten the burdens of people with sore feet or other problems.

Superintendent Lloyd Chapman welcomed us with a presentation about the park, its threshold-to-wilderness theme, and its challenging wilderness skills program. As Chapman explained the park's three zones at a magnificent wall-sized aerial photo of the whole area, there were intent nods and smiles, especially when he drew his finger along the trails we'd just walked or mentioned some of the things we'd seen.

Every year the hike is different. Sometimes the trees are in full leaf, sometimes there is just the purple haze of stands of maples laden with buds about to burst, sometimes the trees are quiet. Sometimes old ski tracks make the trails almost too obvious, and other times busy park beavers leave groups lost or thrashing around for hours in search of trail markers on unflooded land. But regardless of such differences, this Frontenac overnight is an important part of my students' teacher training. Over the days, weeks, and months that follow, we revisit the Frontenac outing, we have similar experiences in other contexts; and for most students, this process of reflection reveals a set of fundamental principles about teaching and learning.

They realize the centrality of context in effective education. They learn that there is no substitute for encountering a real porcupine, or the remains of one, when it comes to understanding what it might mean to live a porcupine's life. They come to appreciate that it is one thing to have twenty-four individuals and a teacher shut up in a room with a book of things to learn, and quite another to set out on an educational enterprise, unhampered by such constraints, whose very success is predicated on mutual understandings and trust. They learn the power of working with a common goal — a goal through which individual fears and abilities can be acknowledged, can be understood, and can contribute to the common quest. They realize that it often takes time and shared challenges to bring to life a sense of wonder. They learn that learning through experience leaves connections that last. They realize that the simple acts of preparing a meal or sharing a heavy load, despite the fact that they elude formal testing, are shared

experiences that form bonds of trust and friendship that allow other more purposefully educational efforts to sink in. They realize that the educational context set by being in the park — travelling together, camping together, exploring together, getting lost together — is one in which they can turn first to their own resources to solve problems, *real* problems, but never without help nearby.

But perhaps even more important than lessons about educational context, my students learn that Frontenac Park by its very nature presents and demands education as a process. In a park, learning is finding out, being able, slowing down, making sense, helping out, being there, making do, and going places.

Park learning — process learning — focuses not so much on individual facts and figures, as might be learned from a textbook in math, or science, or English; rather, it highlights relationships between and amongst the myriad parts of the natural and human environment. An overnight hike can teach that everything is interconnected with everything else — the wildflower with the conditions on the forest floor, the water with the soil, the ice columns with the molecular structure of water, the fisher with the porcupine, the turkey vulture with the wind, the beaver with the park trail planner, the camper with the loon.

Such matters could be the subject of a lecture or two to beginning teachers, but they'd very likely never get the point. I am sure that time in Frontenac Park and places like it can teach my students about relationships and about learning as a process in ways and to depths of understanding that I simply could never match. As a teacher of teachers I can focus their attention on the kinds of things they should look for while they're in the park, and I can help them reflect on what happened while they were there, but there can be no substitute for the park experience itself — a fundamental encounter with a natural landscape with minimal distractions from commerce or industry. It is here, regardless of the number of visits, where I too can always be a learner along with my students.

Learning about relationships in the natural world and learning about learning as a process is important because it can release us momentarily from an ingrained tendency to objectify the world around us. We have maps and landscapes, subjects and objects,

minds and bodies, and we study all of these in school. The connections, the relationships between phenomena, are much more elusive. They are more difficult to teach people about, more difficult to measure. In school students learn about trees, porcupines, and fishers, and maybe that they form a classical producer/herbivore/carnivore food chain; but those students have no reason to remember any of this. Students who encounter a fresh, glistening pelt, by contrast, have sights and smells and common experience mixed with natural curiosity and wonder; they have a reason to want to learn, a reason provided by a place in which such things are allowed to live or die and yet be accessible enough for students to find them.

Frontenac Park is such a place.

Valley of the Sorcerer

David Harding

"We came again to the high land . . . serving as the boundary and wall of the river. It was here that my people, because they could not persuade me that this mountain had a mortal soul . . . manifested a . . . displeasure towards me, contrary to their usual behaviour." So wrote the French missionary Gabriel Sagard, describing an incident on the Mattawa River in 1623. The first people of the river are gone now. Broken by wars, epidemics, and forced dispersal, the Nipissing Tribe no longer exists as such. Their blood flows on, in dark-haired lads and Métis beauties, in towns as close as Mattawa perhaps. The river too flows on, for the spirits they honoured still free its current, still speak in its rapids and even rumble in the mountain walls. Geologists would say that obstructions in the form of moraine deposits left by the last glacier cause the rapids and their sounds. Geologists would state that since the ancient valley is an active earthquake zone, minor tremors can cause the occasional rumbling detectable by human senses. Logical explanations, but the river knows better; from its warm surface the spirits' breath weaves countless auroras in the cool morning air. The river remembers its Mataoui people, for the brittle shells of their birchbark craft danced across its waters and dotted its campsite beaches for millennia.

The Mattawa River follows a 600-million-year-old faultline eastward from North Bay to Mattawa town. This faultline marks the northern edge of a graben that sank between the hills of the northwest Laurentians and the Algonquin highlands to the south. The western three-quarters of the channel and a pristine segment of the lower valley are protected in two provincial parks, Mattawa River and Samuel de Champlain (Sam). Part of the traditional boundary between northern and southern Ontario, the Mattawa is not wilderness. There are cottages and motorboats. Yet the little river whose walls echo its current, as the Ojibwe say, proffers some 60 km of history and sweet canoeing.

From the deep, blueberry-hue basin of Trout Lake, its source, the Mattawa snails eastward through a section of channel containing the Stepping Stones. Large rounded boulders frequently protrude above the water level, serving as a perch for gulls and, in

BASE OF TALON DAM,
MATTAWA RIVER WATERWAY PARK
LORI LABATT

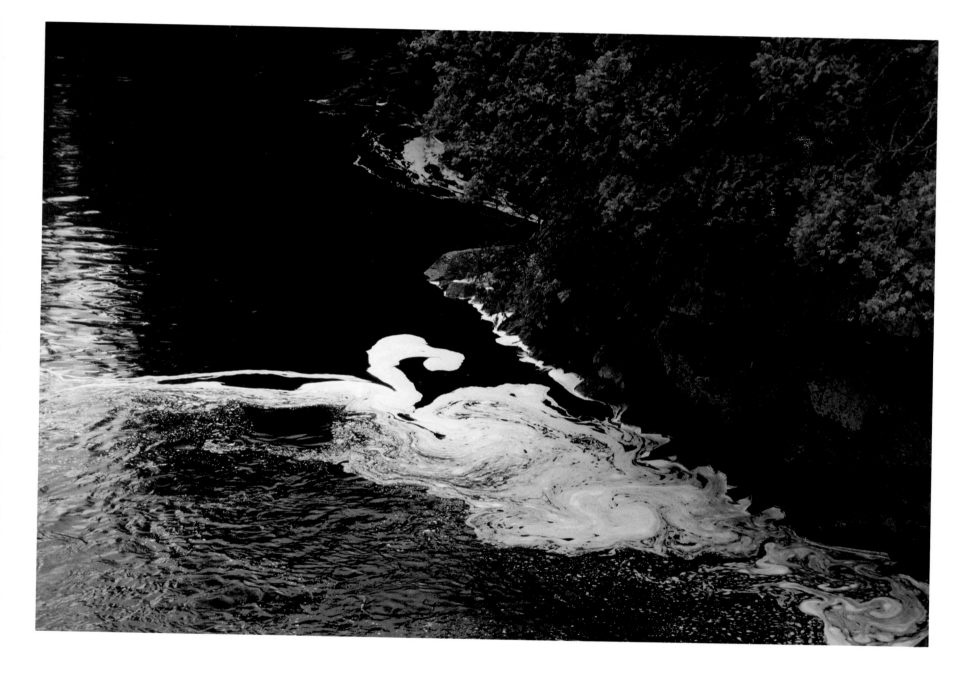

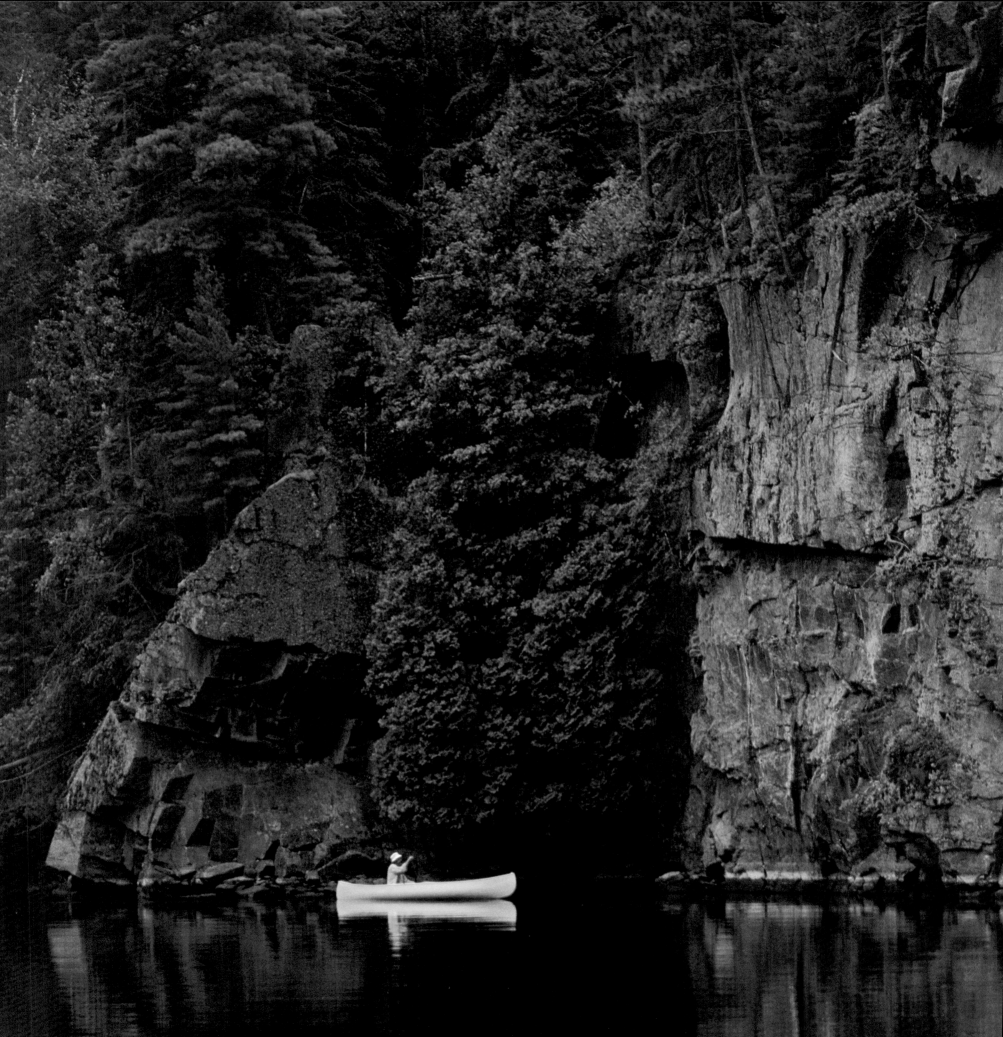

the time when there were giants, a crossing point for an oversized warrior or a "demon" manitou perhaps. "Apart from their communications with demons I found them very kindly and polite" and "an excellent people": that was how Sagard described the Nipissing. Their propensity for shamanism and reputed ability to cast magic spells on their enemies earned them another name, Sorcerer. Unfortunately their shamans or medicine people could not protect them from alien pestilence or musket-toting Iroquois who invaded via the Ottawa and Mattawa rivers in 1648. The resulting losses and dispersal marked the beginning of the end of Nipissing tribal identity.

The Mattawa alternates fat and thin: placid lake and river portions interspersed with steep, narrow descents. Below the Stepping Stones the river eventually widens to form Turtle Lake. Such expansions harbour scattered dagger-toothed leviathans that the Nipissing called "maskinonge". Warm afternoons and weedy shallows can stimulate a feeding frenzy amongst these Mattawa muskies, which show a fondness for black lures, toy poodles, and unsuspecting people's toes. (In 1990 a boy was attacked on Trout Lake, also the site of the poodle's demise.)

For a few thousand years in early post-glacial times the Mattawa River was the main outlet of the Great Lakes. As the Mattawa Valley became free of melting glacial ice, the basins of lakes Huron and Michigan would drop vertically by over 120 m. The huge ancestral Mattawa River simultaneously barrelled out of Turtle Lake through three different channels. Fur brigades of professional traders such as the Nipissing, the Ottawa, and the *coureurs de bois* likely followed the "abandoned" middle channel through Pine Lake, which the French called Robichaud. According to Indian legend Pine Lake was formed by the thrashing tail of a child-napping monster beaver. The present river takes the north channel, whose lake names, including Werewolf, Moosegrass, Whitethroat, and Bigfish, suggest colourful stories of their own. From here on down, the river retains its French place-names more or less intact, though *le lac du Champs plains* (flat fields) is now called Champlain Lake.

Sharp-eyed trekkers on the portage from Pine Lake to Talon Lake will spot large rounded holes near the trail. These are not hairy mammoth pit traps but excavations dug in 1904 during the last of three government surveys to assess a possible ship canal from Montreal to Georgian Bay. (From an engineering standpoint the feasibility was high.)

Talon Lake is named for the most famous Intendant of New France, and the first Frenchman to actually set foot there, Jean Talon. The first and easily the most infamous white person to ascend the Mattawa was another Frenchman, Étienne Brûlé. Despised by the missionaries for his womanizing ways, Brûlé was the first white to see the Great Lakes and the first in the New World to be eaten in a cannibal feast, "a first I could have done without", as his ghost would say on a guided "Spirits Hike" at Sam.

Like two gorgeous sisters, Trout Lake and Talon Lake favour one another in beauty, size, and background. Almost every sand beach on both served as a summer campground for Indian peoples, some from about 5,500 years ago to the near present.

A wave of white adventurers followed Brûlé up the Mattawa: black-robed missionaries, buckskinned *coureurs de bois*, swarthy voyageurs and shanty boys, determined women such as gifted artist Frances Hopkins, and some of the biggest names in the exploration of Canada. None except Champlain perhaps is more famous than bold, blond-haired Alexander Mackenzie, who in 1793 followed the Indian trail to the Pacific, eleven years before the Americans Lewis and Clark. Mackenzie's portage "where many men have been crushed to death by their canoes and others have received irrecoverable injuries" may have been the still-dreaded Portage de Talon. In Mackenzie's time 80 per cent of all the fur trade in North America was controlled by the North West Company, whose main trade route lay along the Mattawa, part of the great canoe highway between Montreal and the West. Half a century before, when *la petite rivière* was still part of New France, a lucrative slave trade also funnelled down the Mattawa, mainly Sioux Indians captured by Cree, Assiniboine, and Ojibwe.

After the merger of the North West and Hudson's Bay companies in 1821 the Mattawa–Montreal trade route was abandoned for the shorter Hudson's Bay route. At least one large canoe continued to ply the Mattawa. George Simpson, the head honcho of the expanded company, loved to travel by express canoe. These

sleek craft, with their burly crews of parti-coloured voyageurs and their high white prows decorated with mystic symbols for speed and good luck, represent for some the consummate form of the canoe. Ascending the Mattawa in 1830, Simpson's delicate young wife, Frances, called Talon Falls the most wild and romantic place she had ever seen.

Part way down the splendid channel between Talon Falls and Pimisi Bay you'll see a curious humpbacked island known as the Watchdog. Here the Indians and voyageurs left tobacco sacrifices to ensure safe passage on the river. You can almost feel the Watchdog frowning at the polychrome canoes that now pass by without offering the traditional gift. Ever vigilant, the Watchdog would seem to have a pact with a big rock of mean disposition that hunkers in a downstream rapids called the Little Paresseux. Not a few unwary travellers, too reckless to make Portage de la Prairie, have had their canoes swamped or capsized by the beast in the Little Paresseux.

Generally the valley's spirits are friendly, though they would hide away some of its most intriguing aspects: rock structures of unknown origin that include a serpent effigy, for example; pucka-skwa pits and natural ochre-coloured cliff markings that look like pictographs. The location of one hidden treasure is here revealed: about 70 m downstream from the Watchdog, about 20 m in from the north shore, is an impressive channel pothole about 2 m wide and 3 or 4 m deep. Local legend has it that Indians and voyageurs cached provisions here.

A remarkable observer and writer of nature, Louise de Kiriline Lawrence, lived on Pimisi Bay for almost fifty years. The Indian word *pimisi* is believed to mean "here I rest", the name and state perhaps inspired by the portages upstream and down. Pimisi centres an area containing large bodies of pure-white marble; a small outcrop is visible at the highway rock cut nearby.

Below Pimisi the river hurtles northward in a sparkling sally of rapids and riffles. At the under edge of the deep fast flow, small-mouth bass loom like fat olive teardrops, the little ones sporting a characteristic splash of white, black, and orange on their "tell-tails". The highlight of this downstream run is the 8-m Paresseux Falls, where even the voyageurs had to portage. In 1920,

chutes of timber magnate J.R. Booth stood on both sides of the falls. Apparently floods accompanying Hurricane Hazel in 1954 washed away most traces of old logging dams and chutes on the Mattawa system.

Just around the bend below Paresseux Falls, chiselled in the south-facing cliff, is Porte de l'Enfer, "gate of hell", traditional lair of a people-eating demon and source of marvellous tales concocted by the voyageurs. Geologist Sidney Lumbers suggested that the cave may be an Indian mine, source of the red ochre pigment for sacred rituals and pictographs. Its proximity to a loud powerful waterfall spirit may have given this ochre special import. The steep unfriendly approach, the poison ivy, and the deadly loose rocks in the ceiling might lead the sensitive to wonder if the spirit of the people-eater still lurks inside.

East from the cave a stark, wild, deceptively peaceful mood seems to pervade the river. Fractured bedrock cliffs shear up from the sleepy water's edge and the northern hinterland rises far beyond. A few people, including nature writer R.D. Lawrence, have seen cougars in the valley. Moose, deer, and black bear are common. Timber wolves are not uncommon. One cliff reveals a large natural face resembling that of a tobacco store Indian. This stone-faced Kaw-liga stares out at the treacherous bluffs on the north side. Deceptively gentle on top, some are coated with a loose mantle of fine unstable talus. The author once skidded upright out of control down one of these bluffs and was only saved by a cedar tree in his path. We found the remains of a deer and a wolf that had likely perished in such a fall. Another unfortunate incident involved a member of a deer survey crew who accidentally dislodged a boulder that roared down the precipice and through the side of his canoe.

The somewhat sombre spell is broke by a flirtatious wink of a rapid called Les Épingles or the Needles at the entrance to Bouillon Lake. The picturesque Des Roches Rapids at the outlet of the lake marks the boundary of the two provincial parks, Matt on the west and Sam on the east.

The next named set of rapids on the downstream junket is the Campion, set at the mouth of the Amable du Fond River, which tumbles north from Algonquin Provincial Park. The

Campion represents the geographic centre, the historic core, and the very essence of Sam. Charlie Laberge knew this when he placed the first of his large bark trade canoe replicas in a modest display building nearby. Nowadays you can see, touch, and even smell this wonderful tribute to the voyageurs in a hands-on museum conveniently located near the park entrance.

Étienne Campion was a Canadian who traded in the Upper Country before and after the French and Indian War. As the guide for Alexander Henry, the first English-speaking person to see the Mattawa, Campion advised his charge to wear French clothes and keep his mouth shut so that he would not be harmed by the Nipissing or other tribes. Like most northern Indians the Nipissing were anti-British and steadfastly loyal to the French. Nipissings had died fighting for Montcalm on the Plains of Abraham just two years before (1759). In his later years Campion is noteworthy as one of the few 'French' partners in the North West Company. Henry was renowned for the parties he threw at his home in Montreal.

One way to enjoy the Campion Rapids is to run them and the nearby Horserace Rapids in a canoe or large tire tube. (Have an eye for the ghosts of drowned log drivers and their horses that old-timers say they've encountered here.) Another way is to don swimsuit, life jacket, and old sneakers and angle for bass and ciscos among the boulders. There are other compelling attractions at Sam—the canoe-friendly lakes, for example, the pretty gorges of Cold Stream and Purdy Creek, the pine-spiced vistas on the Étienne and Kag Trails, the mysterious groves of giant hemlock, the high lonesome lookouts in the remote northeast, and the bikini'd sands of Moore Lake on a hot Sunday afternoon. But if Sam has a spirit or a soul it's the one that sings to the cardinal flowers and purple fringed orchis along the rapids of Monsieur Campion.

Sam's interpretive staff used to conduct "moonlight canoe hikes" downstream from the Campion. One quiet night three huge boulders suddenly rumbled down a nearby slope, ploughing the water with a triple "skerblooch" and rocking the canoes with mini tidal waves. Was the uncanny timing of this incident simply coincidence or was it the work of a river spirit playing a little joke on some very startled paddlers?

Near the eastern boundary of Sam the depth of the Mattawa exceeds 105 m, remarkable for a small river. This is the haunt of 2-m sturgeon and the lodge of the fire dragons of Indian mythology, meteorites compelled to remain in deep water by day lest they set the world on fire.

Ten pleasant kilometres past Sam's eastern boundary the downstream traveller reaches the actual "Mattawa" or "meeting of the waters". Here, where the little river melds with the mighty Ottawa, the town has created Explorers' Point Park, with a striking log museum building standing on the site of a former Hudson's Bay Company post. Here, with the massive promontory of the Ottawa's north shore as a backdrop, you could have watched the canoe brigades heading north for Temiskaming, Abitibi, and even the vast salt bays of the Cree and Inuit. More likely the singing, sweating crews would turn their vessels southwest up the Mattawa, with goods bound for Huronia, Superior, Athabaska, and beyond. To the east, on the somewhat easier downstream run, lay Hochelaga (Montreal), Trois-Rivières, and old Quebec. The canoe route across North America laid such a solid east/west foundation that a great country was built on it, despite the designs of the ambitious new republic to the south. Lines from Stan Rogers' wonderful song "Northwest Passage" come to mind where he sings of the heroes who passed this way:

"And through the night, behind the wheel, the mileage clicking West
I think upon Mackenzie, David Thompson and the rest
Who cracked the mountain ramparts, and did show a path for me
To race the roaring Fraser to the sea."

For the canoeists who would follow in their portage steps, the rugged landscapes of the Mattawa Valley are little changed from those that greeted Sagard 370 years ago. As a friend from Kent said, "It's beautiful! This is what I hoped Canada would be like." Surely the primal spirits that guarded those unspoiled places must remain as well. They are part of a deep legacy all but lost.

Rhythm in Rock: Georgian Bay

Philip S.G. Kor

One day while walking in downtown Toronto, I passed an art gallery featuring huge canvases depicting Georgian Bay; they were round and full, pink, organic, redolent of mother earth. Georgian Bay. A little surprise on Yonge Street; a gentle break from the hustle and the heat of the city, and I'm back drifting silently between the rock walls of the French River.

The paddle slips into the water, left, right, left, right, quietly, wet. Tiny droplets of Georgian Bay drip from the paddle's blade, making little plopping sounds on the water surface. The baby blue hull of my kayak glides over the inky blackness of the French River, highway of the voyageurs. The rock surfaces around me are rounded, pink, soft. And yet the French River is an impossibly straight gash through this living, organic landscape.

It was not always that way, of course. Ontario is a veritable museum of geology and landscape process. This is nowhere so true as in the Boreal fringe on Georgian Bay, where the geology lies naked, unhidden by soil or forest cover. The story it tells, one of upheaval and erosion, screams from the tortured banding of the minerals and the convoluted surfaces on the landscape. The rocks tell tales of continents colliding, mountains rising and falling, the influx of warm tropical seas, and of passing glaciers grinding, and water, lots of water, carving granite into shapes Michelangelo might envy.

The museum which houses this rich geological heritage is the provincial parks system. The shelves in the museum are the individual parks, each housing pieces of the puzzle which fit together to explain the complex story of the shaping of Ontario. On Georgian Bay, they include French River Provincial Park, designated primarily to protect the integrity of the cultural elements of the fur trade route, but also highlighting a vast and complex, and very enigmatic, geological history. Killbear Provincial Park is situated in an area where glacial lake sediments have been reworked by Lake Huron to form a chain of crescent beach slivers and low, rolling sand dunes in the backshore. Limestone Islands Nature Reserve protects an unusual flora on small platforms of limestone well out in the open water of the bay.

We pitched our tents on the crest of a rounded little knoll of rock under a gnarled Tom Thomson pine near the mouth of the French River. One can throw a baseball across the island. It is one of thousands in this archipelago of white-fringed, almost Aegean islets protecting the northeast shore of Georgian Bay from the full fetch of approaching storms. Geologists call them whalebacks: they lie like a giant pod of motionless creatures in a moving inland sea of wind-tossed waters. We had come to spend a few days exploring these islands after an idyllic paddle down the French River. As a geologist, I am fascinated by this landscape in which there is no soil, where large boulders sit in solitary silence, almost lonely, like great southern *inukshuks*, sentinals pointing the way or simply marking the spot. The roar of the millennia, a geological roar of ages, fills me with awe as I contemplate the spectacle about me.

About a billion years ago, two continents collided to produce a mountain range rivalling the Rockies in height and grandeur. Sediments and granites, volcanic flows and much older metamorphic rocks were melted together and twisted like pretzels into fantastic shapes before they cooled and hardened. The unrelenting forces of erosion, by wind, water, and ice, completely levelled these mountains into the flat rock plain, called a peneplane, that we know today as the Canadian Shield. Only the core of these mountains is recognized today, in a broad band of rock at the southern edge of the Shield called the Grenville Province. The contact zone between the colliding continents, at the edge of this "new" supercontinent of North America, is called the Grenville Front and is

THIRTY THOUSAND ISLANDS, GEORGIAN BAY
J.A. KRAULIS, MASTERFILE

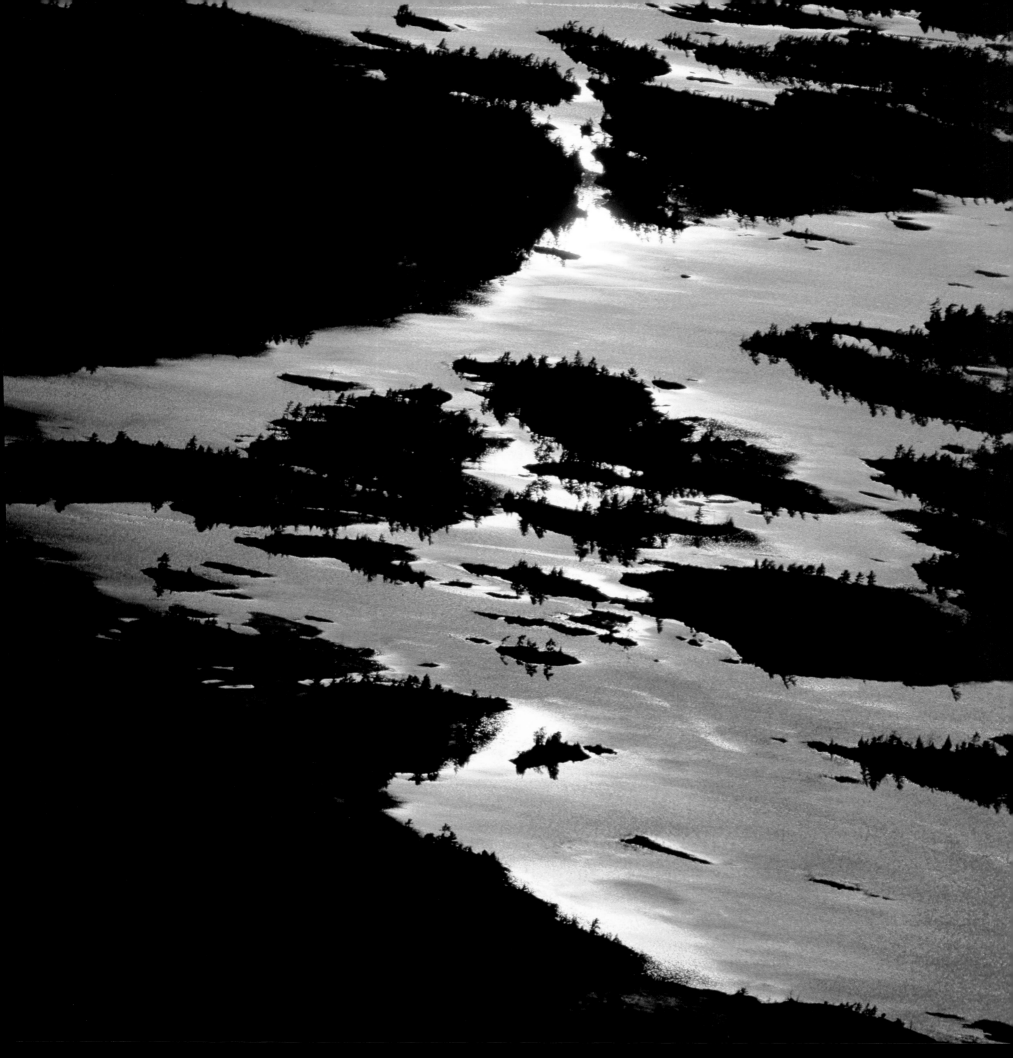

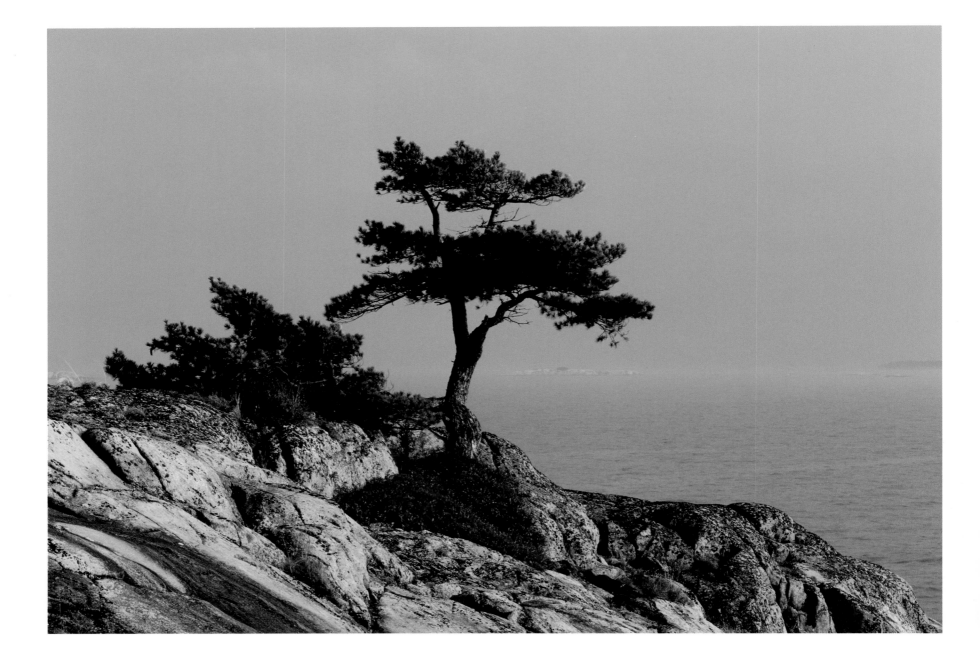

recognized by long narrow structures in the rock. These structures were cut deeply by erosion of large rivers in the millennia since the peneplane was formed. The most spectacular of these is the French River, a route so navigable it would briefly carry the commerce of a continent between its banks.

The landscape was already flat when the glaciers of the Ice Age first crept through the great lake basin over two million years ago. Since then they have come and gone many times, each new advance removing the evidence of the last. In the Georgian Bay area, their passing is particularly enigmatic because, at first glance, so little remains. What could the low rounded hills of rock and tiny patches of sand and soil say about these grand events? What clues are there for us to see? A journey through the provincial parks on the bay is a spectacular way to begin to understand this story.

Only the very last glacial events are recorded in the Georgian Bay area. These occurred about 11,000 years ago. The largest ice cap the world has ever seen, a creeping blanket which covered almost all of Canada and the northern United States, was in full retreat. Melting exceeded advance, and in fact helped to rot the glaciers from within. As the climate warmed, huge lakes accumulated at the front of the ice, on top of the ice, and, perhaps most significantly, under the ice. As the ice became thinner, the pressure from the waters under the ice increased such that huge floods were released across the breadth of Ontario. Single events probably lasted only a few hours or days, but their effects were catastrophic and devastating. The floods scoured the ground beneath the ice, removing some—or in places all—of the sediment laid down previously by the ice. Where bedrock was exposed, its surface was sculpted into artforms designed by a combination of nature and mathematics, artforms known to geologists as s-forms (sculpted forms). On top of the flood, huge tongues of ice were carried southward, giant blue-white fingers reaching out one last time. Geologists make jokes about Noah's Ark when discussing this concept. The timing is about 10,000 years off, but the concept of the great flood is the same. When I camp at the mouth of the French River, where these features are best seen and described, and where they are protected in nature reserve zones in

the park, I can't help but hear the deafening roar of a wall of water 30 m high and 100 km wide, thundering southward beneath a blanket of ice.

In Iceland I have camped on a sand plain at the foot of Bradurmerkajokull, an ice cap which drapes a highly active volcanic zone and which regularly produces such floods, or "jokullaups". At night in the tent I would strain to listen past the groaning icebergs in the nearby lake for the thunder that might signal the release of another jokullaup! Standing 3,000 km and 10,000 years away on the shore of Georgian Bay, I also strain to sense the roar that must have accompanied the release of water that created the barren sculpture I'm standing on.

After the glaciers had finally retreated past the continental divide, their legacy was huge volumes of meltwater which collected in the basins of the Great Lakes. These giant bodies of water, higher than present levels, are known by names such as Algonquin, Minong, Nipissing, and Algoma, names conjuring up images of the native cultures which lived and thrived on their shores. In the Georgian Bay area, glacial Lake Algonquin covered all the low ground below the Algonquin Highlands, flooding Parry Sound, Manitoulin Island, and the Bruce Peninsula under many metres of water. The Georgian Bay basin was tipped to the northeast by the weight of the ice, and like a giant saucer spilled the accumulated meltwaters through the French River and Lake Nipissing area to an ocean invading the St. Lawrence valley. The mighty French River, which countless fur traders and farmers, scientists and adventurers, artists and entrepreneurs followed to open up the continent for European commerce, is today a mere trickle in comparison. Once it carried the overflow from an entire continent in the opposite direction!

Exposed rock characterizes Georgian Bay, but if all this rock begins to be monotonous, visit the sandy beaches of Killbear Provincial Park. This Natural Environment park is readily accessible to a wide variety of visitors to discover the geological past of the area. Here a big dollop of sand and glacial till was spared by the forces of the great subglacial floods. During times when lake levels in the Georgian Bay basin dropped below the present shoreline,

winds whipped the freshly exposed sands into dunes. These are preserved today under a thin forest cover. The modern lake has washed the edge of this deposit to produce the stars of the park, shimmering ribbons of white sand between the low, now-ubiquitous mounds of sculpted bedrock. The shoreline outcroppings of rock are here, as elsewhere, round, organic, pink. With the sand and dunes covering them, the effect is not unlike an earth woman asleep under a blanket. In summer, when the beaches are covered with the tanning bodies of sun worshippers, the subliminal effect can be quite erotic.

Of course, the landscape is also interesting in a more mundane way. Low bluffs that cut into the sand behind the beaches were formed when the lake level in Georgian Bay was higher than it is today. Where the sand has been removed to expose a shallow platform of boulders, we see the shore of a long-lasting lake called Nipissing that once washed the area. Native peoples probably camped here 5,000 years ago, for all the conditions that make the Killbear area so beautiful today existed then. The four-hour traffic jams to get home hadn't yet been invented, and a visit to the Nipissing beach was probably a bit more pleasant.

The rocks here also display some textbook features of glacial erosion. These include the aptly named "chattermarks", thin curving forms created when boulders frozen to the bottom of the moving ice were bounced along the rock surface. Long lines of these features resemble an odd ladder with curved rungs and no supporting framework, lines of crescent moons in a pink sky. The "horns" of the chattermarks generally point in the direction that the ice was flowing.

Out in the open water of the bay opposite Parry Sound are the Limestone Islands, flat little platforms barely above the level of the lake, composed, oddly, of sun-bleached limestones. If you first see the islands from the air, as I did, they shine like pebbles in an azure sea and look very Caribbean. Intense green shoals rim these shining jewels. Once you are on the ground, the pale limestone

reflects heat and light in abundance; on a summer's day, it's like stepping into the centre of a frying pan. These little rock deserts are isolated by an ocean of blue. There is nowhere to hide amid the short stubble and low wind-blasted trees. These islands are only about 10 km from shore, but it seems like thousands — you might be somewhere off the coast of Africa. Geologically these islands are also far away in time from the rest of Georgian Bay. They are composed of the tiny hard remains of untold billions of sea creatures which dwelled in a vast tropical sea that covered the interior portions of the North American continent more than 400 million years ago. The islands are designated a provincial Nature Reserve, mostly to protect unique flora but also to represent these interesting rock structures within the parks system.

On our last day at the mouth of the French River, my friend and I were hiking and exploring the shoreline of yet another granite gem. We were being deliberately scientific, cataloguing in our notebooks and cameras the wondrous diversity of forms sculpted into the pink hardness of the rock. Heads bent to our task, we came upon a hollow in the sparse shrubbery where the smooth surface shone with the brilliance of thousands of stars, tiny mica crystals in the granite. Through the centre of the outcrop ran a narrow sinuous curved channel, splitting the site in two. The effect was strongly spiritual. Early natives would surely have revered this site as magical.

Freshness and silence. Untrodden solitude. Unique panoramas of an offshore island belt. Edmund Andrews, an American physician and scientist from Chicago, used these words to describe the area west of the French River in 1883. Now, camped at the brow of a small whaleback island in the moonlit shadow of a cluster of Tom Thomson pines, listening to the soft snapping of the dying fire and the gentle lapping of waves on the shore, we rejoice that after more than a hundred years the original freshness and silence of this great inland sea still remain.

VIEW FROM GRANITE RIDGE, KILLARNEY PROV. PARK
PETER GRIFFITH

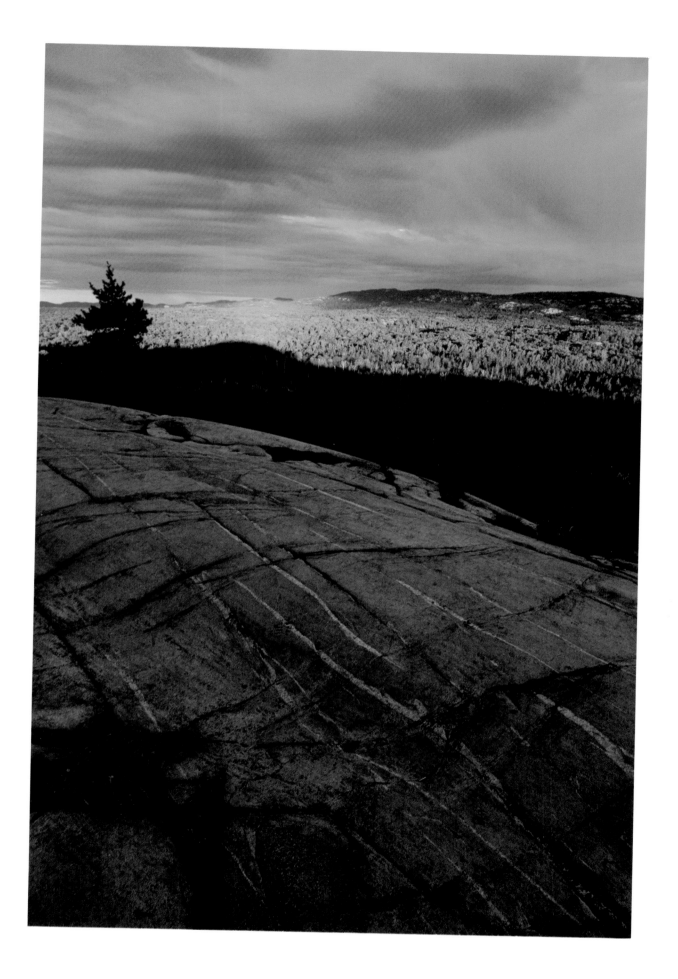

Killarney – The Wilderness Edge

Kevin McNamee

Albert Schweitzer once said: "Man can hardly even recognize the devils of his own creation." Crossing Nellie Lake in Killarney Provincial Park, one could not be faulted for failing to recognize the "devil" at work here. The lake is clear, so clear, you can see almost 30 m down and observe your canoe's shadow on the bottom. It is so peaceful; perhaps too peaceful. It is then that you realize this lake is dead.

In the world of environmental crimes, Nellie Lake is a smoking gun; the drawing room is Killarney, Ontario's smallest Wilderness Park; and we are the butler that stands accused of murder. Society generated the acid rain that silenced most of the lake's wild creatures. In just over thirty years, industrial pollutants have reduced Nellie Lake to but a mockery of an aquatic ecosystem that took eons for nature to create.

Killarney Provincial Park sits on the edge of the Canadian Shield, snuggled up against Georgian Bay just southwest of Sudbury. Its myriad lakes and hills offer tremendous opportunities to experience the raw power of nature. The white quartzite and pink granite of the La Cloche Mountains have attracted wilderness enthusiasts for decades.

Killarney also represents the southern extremity of Ontario's vast wilderness landscapes. Farther south, the opportunity to preserve a wilderness area of similar size, free of industrial resource extraction, no longer exists. The threat of encroaching development on northern Ontario's wilderness is as clear as the acid-dead waters of the Killarney region. Thus, Killarney must inspire people to protect the environment, just as it inspired scientists, conservationists, and politicians to battle acid rain.

In 1966 Harold Harvey introduced 4,000 pink salmon into Lumsden Lake, a remote lake in Killarney. A screen across the lake's outlet kept them captive. Next year, the University of Toronto zoologist failed to find any sign of the fish. However, he did find some dwarf suckers that were abnormally small, with no young among them. Even worse, there was no sign of fish species recorded there five years earlier, including lake trout, perch, and lake herring.

Harvey also found that the acidity levels of lakes in the area had risen a hundredfold over a ten-year period. By 1972, Harvey's research concluded that the 1.6 million tonnes of sulphur dioxide emitted each year from the Sudbury smelter was producing sulphuric acid water. It fell as rain and, in the winter, as snow. In the spring, the highly acidic snow would melt and rush into the lakes and streams of Killarney, producing acid shock loading, which in turn was killing the fish and other life.

This discovery led to a continental fight to get the governments of Canada and the United States to cap emissions of sulphur dioxide and to stop acid rain. It culminated in November 1990 when President George Bush signed the Clean Air Act, which, coupled with action in Canada, will produce a 50 per cent reduction in sulphur dioxide emissions across the continent by the year 2000. It was Harvey's commitment to research in the Killarney wilderness that triggered the long fight to stop this "devil" of our own creation.

Harvey's research underscores one of the values of parks and protected areas. They are benchmarks against which we can measure the impacts of human activities on the natural world. Lumsden Lake is remote, with no nearby road or human development. Its "pristine" nature provided an outdoor laboratory; thus, any abnormal changes to the area could not be blamed on local developments. Rather, what was killing thousands of lakes like Lumsden had to be coming from civilization.

One body of water, just north of Lumsden, the government named Acid Lake as a testimony to the devastation wrought by society on the Killarney wilderness. But other lakes in Killarney are a testimony to how its landscape can inspire acts of beauty and foresight. Two lakes, Carmichael and Jackson, are named after

KILLARNEY PROV. PARK
DAN GIBSON

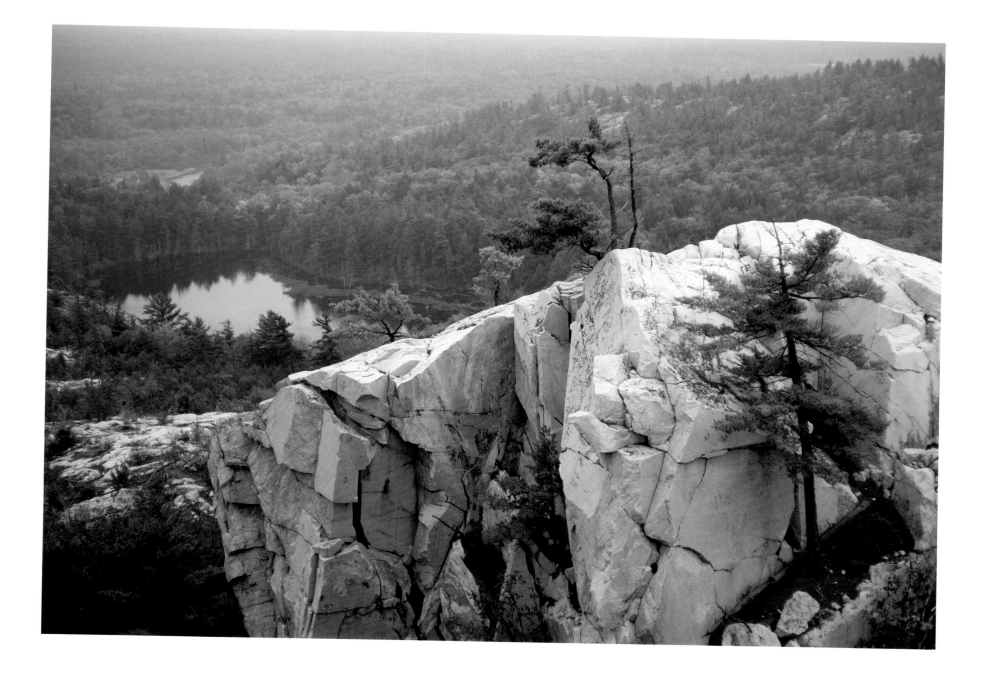

Franklin Carmichael and A.Y. Jackson, members of the Group of Seven, who captured Canada's wilderness lands on canvas to international acclaim.

In his 1982 essay on the Group of Seven, David Wistow of the Art Gallery of Ontario writes that their "paintings are synonymous with [Ontario's] vast hinterland" for it is here "the essential character of their work . . . was established." Franklin Carmichael's daughter recalls: "As an artist, my father felt the La Cloche, especially the eastern section, was the most challenging and gratifying landscape in the province."

Carmichael introduced A.Y. Jackson to the La Cloche area, and it was from this introduction that the first actions to preserve the Killarney wilderness emanated. En route to Trout Lake from Baie Fine in September 1931, Jackson learned from the superintendent of the Spanish River Lumber Company that the big pine trees on Trout Lake were going to be cut the following winter. After sketching the beauty of the lake's islands and quartzite hills, Jackson contacted Fred Bridgen of the Ontario Society of Artists (OSA). Jackson tells the rest of the story:

> "[Fred] said there was going to be a big convention in a few days of all the natural history and similar societies from all over Ontario, and it would be a fine chance to bring the matter before these people. At that time I was rather shy and too scared to address a big meeting. So Fred suggested I should write a letter telling him about it. He would have it read to the convention. That was done and by good luck Mr. Finlayson, the then Minister of Lands and Forests, was at that meeting. He went to see Fred and told him he could arrange with the Spanish River people to have an exchange of limits into another area and this was done."

In 1933 a park was established around Trout Lake, which was renamed O.S.A. Lake. Although O.S.A. Lake is now acid dead, it remains symbolic of the contribution the society made to Canada's natural heritage. In 1964, the O.S.A. reserve was expanded to 344 km² with the creation of Killarney Provincial Park. Its later classification as a Primitive Park within the Ontario park classification system prohibited resource exploitation. In 1972, on Jackson's ninetieth birthday, the government honoured his role in the creation of the park by naming Jackson Lake.

Sixty years to the month that A.Y. Jackson first visited O.S.A. Lake, I spent several fall days on an island in the middle of the lake. Canoeing the trail of this landscape painter was inspiring. I revisited Wistow's essay and the following words rang so true: "[their paintings] capture that rare but unforgettable moment when the mind can free itself from all associations of past and present, and sense only the overwhelming reality of nature itself."

A night on Grace Lake several years earlier reminded me of how people are losing touch with that "reality of nature". Hard-driving rock music blasted away from a distant camp. It was a sad commentary on society's relationship with nature — campers' needing some connection to their urban lifestyle in order to enjoy a weekend in the wilderness. A real beer commercial in stereo.

But in another sense, is this not a natural outflow of our continual promotion of the recreational value of wilderness? Many of Canada's earlier parks were created to protect great scenic wonders, such as the Rocky Mountains of Alberta and the interior lakelands of Ontario. We built resorts in Banff and Algonquin to accommodate the rich so that they could enjoy the wilderness while resting comfortably at night. As technology improves, we can now bring more of our creature comforts with us. But surely this is not what wilderness was meant to be like?

The Ontario government established a clear wilderness parks policy in 1978 and changed Killarney's classification from Primitive to Wilderness. The Wilderness category acknowledged both the biological value of undeveloped lands and the need for a contemplative type of recreation within wilderness areas. Wilderness parks were defined as "substantial areas where the forces of nature are permitted to function freely and where visitors travel by non-mechanized means and experience expansive solitude, challenge and personal integration with nature".

Visitors to Killarney can experience solitude (radios at Grace Lake notwithstanding) despite the fact it is Ontario's smallest

Wilderness Park. The government uses a permit system to limit the number of campers on each of the lakes to protect the environment from overuse and to ensure that visitors are dispersed. Of course, the growing number of weekend canoeists seeking to escape Toronto ensures that even in October most of the camping permits are gone by Saturday. Ah wilderness!

On the other hand, Killarney fails to meet the government's own minimum biological criteria for Wilderness parks. The 1978 policy suggests that Wilderness parks should average about 100,000 ha in size; at the absolute minimum, they should not be less than 50,000 ha. When the policy was approved, Killarney was just over 34,000 ha. To the Ontario government's credit, it enlarged the park in 1983 to just under 48,000 ha. (This move finally gave wilderness protection to Grace Lake, which has been painted by both A.Y. Jackson and Robert Bateman.) But even at that, Killarney barely meets the criteria for a Wilderness park.

In expanding the park, the government did use ecological criteria for the first time in setting Killarney's boundary. The earlier boundary was a straight line that carved lakes in half; now the northern boundary is the height of land north of the La Cloche mountains. Such a boundary provides a better natural buffer against any industrial or commercial developments outside the park. This principle must be more rigorously applied in the setting of boundaries for other parks across Canada.

However, the impact of acid rain on Killarney exposes the ecological failings of park boundaries. National and provincial parks are not fortresses with solid walls that protect wilderness areas from air and water pollution and other trans-boundary impacts. The acid-dead lakes of Killarney demonstrate that we cannot draw a line around a wilderness area and preserve it while continuing to exploit the rest of the landscape with little or no attention to the need for conservation.

Acid rain will not allow the forces of nature to "function freely" in Killarney unless society ensures that no more acid rain falls on the park. A parks policy can have the best of intentions, but unless adjacent landowners and neighbours respect park values in their daily operations, parks will always be under siege.

The acid-dead lakes tell us, amongst other things, that if we wish to maintain large tracts of unaltered wilderness, then we had better clean up our act outside them. Action is needed to ensure that human activities outside protected areas take into account their ecological and intrinsic value to society and the planet, and are coordinated to ensure that park values are perpetuated.

Killarney Provincial Park was part of the North Georgian Bay Recreational Reserve, established by legislation in 1963 to "protect the environment of the reserve and also to achieve optimum recreation use". Here were the underpinnings of an ecosystem approach to managing the landscape as an integrated whole, rather than on a piecemeal basis. Perhaps the reserve was ahead of its time; but there is still a need to coordinate land use amongst the various political jurisdictions in Killarney so that the natural and cultural values of this landscape endure.

Over the years, the Killarney landscape has inspired actions that question society's emphasis on extracting economic value from natural resources with scant attention to ecological consequences. A.Y. Jackson questioned the need to log this area; his legacy is Killarney Provincial Park, one of the "crown jewels" of Ontario's parks system. Canadians refused to accept acid-dead lakes as an inevitable product of industrial development and pressured government and industry to stop the acid rain.

In its 1991 report on protected areas, the Canadian Environmental Advisory Council concluded that "if protected areas do not inform and inspire society to apply a land ethic in all human activities, they fail in their essential mission". The Group of Seven had a similar vision; Wistow writes that they were motivated "to reveal to a southern audience the spell-binding glories of this vast landscape". Killarney and other parks must build on this mission and inspire visitors to apply a conservation ethic in their daily actions.

We desperately need that inspiration as development reduces Canada's opportunity to dedicate more wilderness lands to protection. To date, only 3.4 per cent of Canada is preserved in a wilderness state, free of logging, mining, and hydroelectric development. In ninety-one of Canada's approximately 350 natural regions, we have lost the chance to preserve an area the size of Killarney. We can't afford to lose more.

The next time you see a painting by the Group of Seven, ask yourself, "Does that landscape still exist?" "What wilderness areas are being lost to the technological "devil" that society has unleashed across the landscape? Careful monitoring of the natural forces of life in wilderness parks such as Killarney will help us discover, and inspire us to act against, other ecosystem-destroying "devils" of our own creation. If we fail to do so, we stand to forfeit the planet's ecological future.

Two Wilderness Poems

Margaret Atwood

One of my first conscious memories is sitting in the bottom of a canoe. I spent the early part of my life mostly in the bush north of North Bay and then north of Lake Superior, and my parents were strong conservationists; so it's not at all strange that images from this sort of environment should have appeared a great deal in my work. I've felt for a long time, and still feel, that if you destroy wilderness you are destroying a part of yourself.

These two poems are fairly simple. The first one is about the disappearance of leopard frogs in the north, due to the effect acid-rain runoff has on their eggs. The second is about the common lichens and reindeer mosses you step on any time you walk across rock in the north.

Frogless

The sore trees cast their leaves
too early. Each twig pinching
shut like a jabbed clam.
Soon there will be a hot gauze of snow
searing the roots.

Booze in the spring runoff,
pure antifreeze;
the stream worms drunk and burning.
Tadpoles wrecked in the puddles.

Here comes an eel with a dead eye
grown from its cheek.
Would you cook it?
You would if.

The people eat sick fish
because there are no others.
Then they get born wrong.

This is not sport, sir.
This is not good weather.
This is not blue and green.

This is home.
Travel anywhere in a year, five years,
and you'll end up here.

Lichen & Reindeer Moss on Granite

This is a tiny language,
smaller than Gallic;
when you have your boots on
you scarcely see it.

A scorched brown dialect
with many words for holding on;
a grey one, with branches
like an old tree, brittle and leafless.

In the rain they go leathery,
then soft, like skin.
They send up their little mouths
on stems, red-lipped and round,

each one pronouncing the same syllable,
o,o,o, like the dumbfounded
eyes of minnows.
Thousands of spores, of rumours

infiltrating the boulders,
moving unnoticed over
the ponderous noun of the landscape,
breaking down rock.

NORTH OF LAKE WANAPITEI
KARL SOMMERER

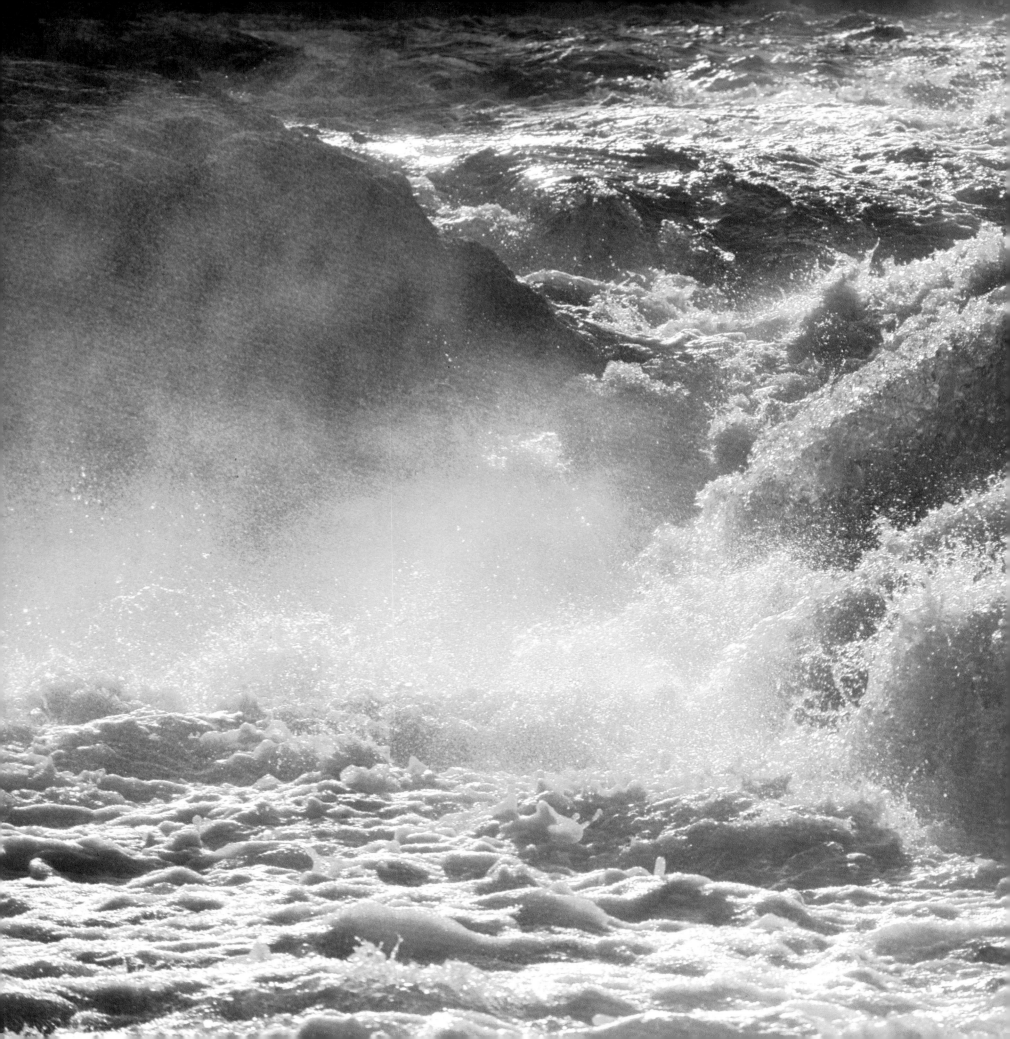

Temagami

Hugh Stewart

From the perspective of mid-life, I realize that much of my view of the world, my sense of what constitutes a worthwhile life, and many of my most important friendships all emanate from my time spent in the bush in Temagami. So, when given the opportunity to explain why the area is an important part of Ontario's natural legacy, I will be inevitably and consciously presenting a subjective explanation. But perhaps my perspectives will strike chords in others. After all, social values are nothing more than values shared by individuals. Before our wilderness legacy is safely preserved, belief in its social and ecological values must be more widely held and firmly acted upon.

When I was thirteen I came to Temagami to a canoe trip camp. I had been to camp already, in Algonquin Park, and I remember the trip leaders there always talking about Temagami: the size of the lake, the coldness of the water, and the seemingly endless number of canoe routes. The place was indeed wonderful. Who needed to read adventure stories when you could go to Temagami in the summer?

Within a few seasons I began to become familiar with some of the routes and landmarks. Almost everyone got to "the trout streams" at least once a summer, but your age determined the route taken. You could not go to places like Florence Lake or Sunnywater Lake or Matachewan via the Montreal River until you were fourteen or fifteen. By the time I was in my mid-teens I was firmly convinced that what was truly exciting and important happened on the trail in Temagami in July and August, and what went on from September to June was merely what had to be endured between seasons.

When I was old enough to plan and lead my own canoe trips, the route possibilities seemed endless. Many nights we would talk in the staff cabins of routes here, routes there, and figure out devious ways around the camp schedule so that we could be "out" for the extra day or two which would enable us to get to some particular place. For me it was Solace Lake, inaccessible and mysteriously tucked away between Florence Lake and Sturgeon River. It must have been on my fourth or fifth try that weather, time, and personnel all harmonized and I made it. We could describe whole routes from memory, including campsites, lengths of portages, obstacles on portages, paddling times from one place to another. On many a winter walk to school in the city I would run through the routes I wanted to do the next summer: How many days' travel would be required to get from Frank's Falls to Sunnywater? How much extra time should be allowed for headwinds on the long paddle back from Elk Lake after going down the Makobe?

At first I did not fully understand why spending time in Temagami was important. It felt right, and a group of contemporaries loved the country and the life of the trail as much as I did.

Nowadays I have no idea of what has become of 99 per cent of my school and college friends, but I know what my canoeing friends from the summers of my youth are doing. During my university years I began to understand why my canoe tripping times were so important to me. It was a combination of feeling physically strong and seeing myself and the younger boys with whom I travelled stripped of pretence and cover that I valued. Not all personal relationships were harmonious, but the real character of people seemed to become quickly obvious. Each fall I felt psychologically strong and mentally energetic. The summer would carry me a long way.

These years also enabled me to come up to Temagami in mid-May, which was usually just before the leaves, and work on opening up the camp, fixing buildings and docks, and repairing canoes. During this time I also came in touch with the wealth of literary and historical material written on the North in general

and the Canadian Shield in particular. I discovered poets, novelists, and artists who felt as I did about the bush; some of them, such as Lampman and Scott, even came to Temagami.

One incident in the evolution of my values stands out from those camp years. I was somewhere around twenty, and, as with many camps, it was the tradition to have a religious service of some sort on Sundays. The camp director asked me if I would give the "sermon". I panicked a bit, for I was not a practitioner of any organized religion and was extremely skeptical of religious teaching. How (I asked myself) can I make this "sermon" relevant to what is going on here at camp? I ended up giving a little talk which I felt summarized the lessons of the trail. There are forces much bigger than us out there that we must respect and to which we must accommodate ourselves. My examples from canoe trips were ones which many of us in the hall had shared. It was a primitive, unsophisticated explanation of values I have since refined and tried to put into practice, but nevertheless crucial.

For a decade my wife and I ran our own wilderness travel business in Temagami called Headwaters. It was a marvellous opportunity to put into practice many of the ideas I had absorbed and enable others to enjoy the physical and spiritual benefits of wilderness travel. I suppose we were involved in education in a private, quiet, unbureaucratic way. When you travel the landscape under your own power, the strength of the natural forces is poignantly felt. We wanted people to be aware of how strongly the enduring natural features of the Canadian Shield have affected social and political development. We also hoped to show how the best travel methods — canoe and snowshoe — are those inherited from the native peoples. We saw the wilderness experience not simply as a physical challenge and a chance to learn travel skills, but as an intellectually and spiritually stimulating experience as well.

There is one occasion from the Headwaters years which recurs in my memory from time to time. It was a February day in 1979 or 1980, and I was with a group of six or seven on a ski outing east of Anamanispissing Lake where our lodge was. It was fairly cold and there was intermittent snow, but with a big fire and logs to sit on, we were having a comfortable lunch. Conversation flowed easily; soon, however, I realized that one conversation was taking priority. Sandy, a pipefitter from Sarnia, and Wilhelm, a professor of mathematics from Heidelberg, were discussing nuclear bombs and the fate of humankind. Both brought relevant knowledge to the exchange. Sandy had worked on the construction of a nuclear power station in New Brunswick, and Wilhelm studied probability theory. The differences in nationality, age, education, and social and cultural backgrounds were immense but irrelevant. These two people, unknown to each other four days before, were sitting around a fire in the northern Ontario bush immensely enjoying comparing ideas and delighting in each other's company.

The occasion was satisfying to me because people were doing what I hoped they would on our wilderness trips: learning about themselves, learning from each other, and thinking about the relation between humans and their environment. I have wondered many times since if we would so carelessly despoil the world's land, air, and water and be so much at war with one another if more of us could sit together on logs in the bush, feeling nature's power instead of our own power, and trying to sort things out.

One April day in the early 1970s I was working with Frank Wood, fixing some canoes in his shop. I asked him how he got to Temagami. He responded that he had come in the 1940s, just to stay for a season, but was still there. His explanation was that "the place kind of gets in your blood". This is a common expression often used by people to explain their presence in a remote or rural area over a long period of time. I have frequently thought about that conversation and Frank's answer. After spending many years living with my family on an island in the middle of Lake Temagami, I think what Frank meant is that your psyche and spirit blend with the rhythms of the landscape. To belong to a way of life whose patterns are dictated by the natural environment is psychologically and spiritually comforting. How you travel at different times of the year and what you do in the different seasons to carry out your trade, or to keep the mechanics of home life working smoothly, is determined almost entirely by weather.

LAKE SUPERIOR
JANET FOSTER, MASTERFILE

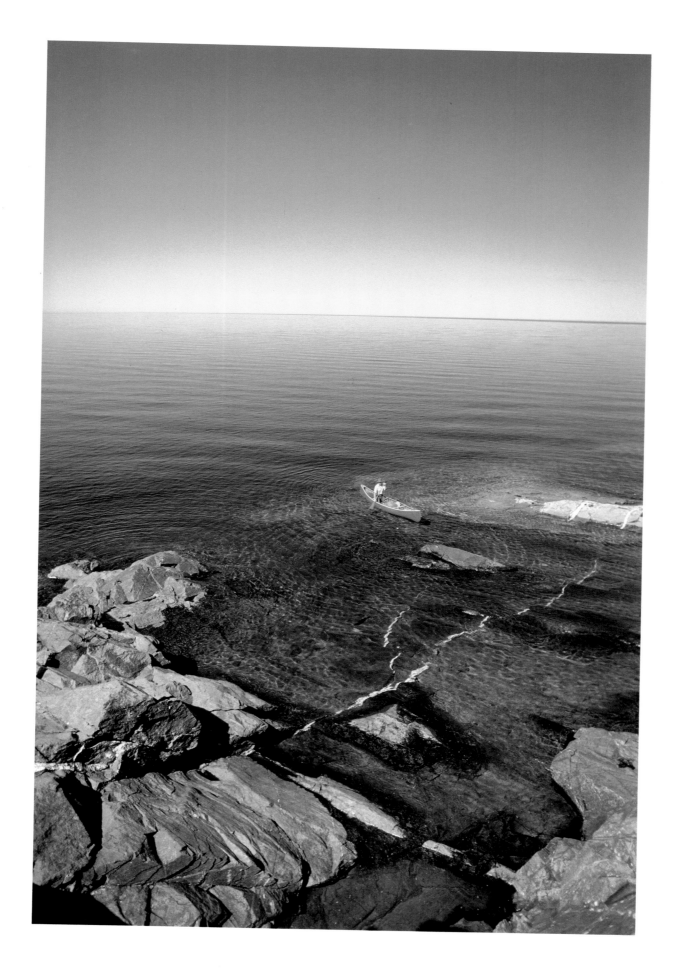

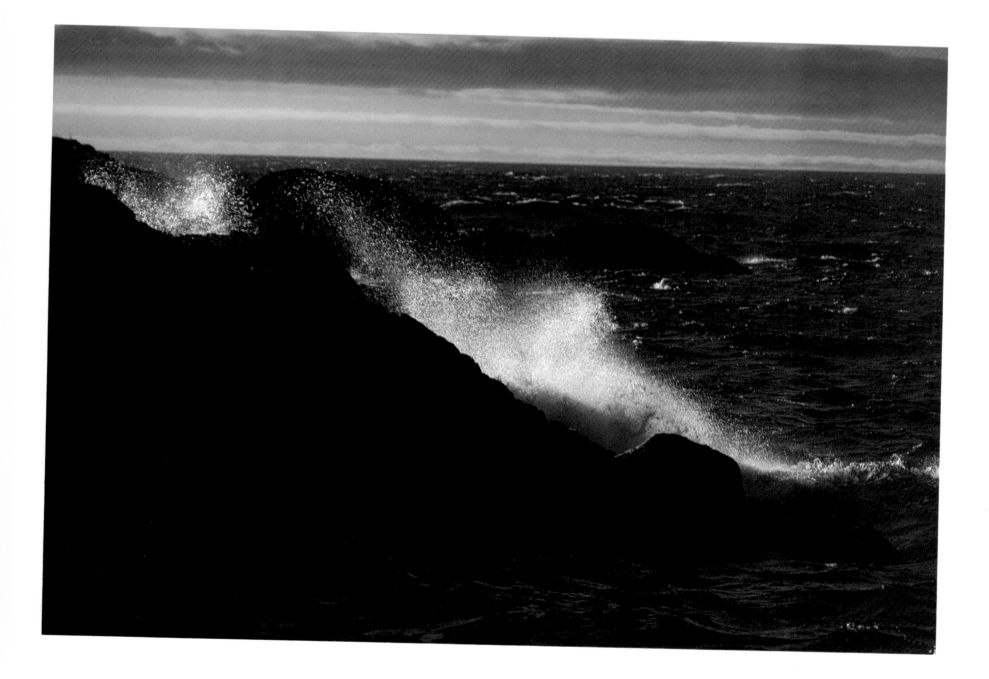

LEFT / SUNSET AT NEYS PROV. PARK
LORI LABATT

ABOVE / MICHIPICOTEN ISLAND PROV. PARK
BRUCE LITTELJOHN

Some things, like cutting and hauling dock logs and firewood, are much more easily done in winter, whereas others, like scouting out new trails, are best done in the fall after the leaves are down. I once made extensive notes on such things and determined that in a year on the lake, there were not four but fourteen different seasons, each with its own distinct character and in each of which your travel pattern or conditions were different. Similarly, whereas in English there is but one word for snow, Indians and Inuit have many different words for it. This fact does not tell us as much about philology as about the indigenous cultures of the north. For those living intimately with the natural environment, the subtle differences in snow from one day, week, or month to another are crucial.

Feeling the rhythms of the landscape is not "unrealistic" romanticism. Many times I recall being cold, wet, and exhausted and wishing I were anywhere but where I was. At times I was frightened and unsure of the outcome of a particular journey by boat, snowmobile, canoe, or snowshoe. Some days we did not take our children to school at Bear Island because it was too windy or too slushy to make the 6-km crossing. At first this seemed a frustration for children and parents, but on reflection the lesson learned was much greater than any that would be taught in school. In the immediate, practical sense there were lessons in judgment about travelling in open water or over the ice which my children saw being made; but more important, we were all learning that we cannot prevail over nature and that to try to do so is a perilous exercise. I cannot help but extrapolate that lesson to the larger scale. Many of the environmental "problems" and imminent catastrophes that we face seem to me to have evolved because we have inflicted our economically and politically determined schedules and needs upon the natural timetable: not enough of us have been prevented from going to school when it was too windy.

At no time were the rhythms and the need to adapt to them more strongly felt than at break-up and freeze-up. I kept meticulous notes at these times of the year about how the ice came and went, when and where we travelled. Not only were the forces of nature vividly awesome during these weeks, but they seemed to regulate themselves. Some years break-up would be triggered by a heat wave, other years by wind and rain. Yet within about a two-week period you could count on the ice going out. Coincident with the ice leaving was the reappearance of loons and ducks, peepers and frogs, and a whole host of other species, sounds, and smells. The interrelatedness of it all was wonderful to behold, and doubtless it was our enforced stay on the island that made it all so vivid. These things are easy to miss when one is travelling to a job forty-eight weeks a year by car, bus, or train, impervious to the weather, and racing to the lake on summer weekends or the ski trail on winter weekends.

I have searched for a rational explanation of why the experience of those years on the lake was so invigorating. It has to do with the realization that we are an inextricable part of those same elemental forces that are causing the winds to blow and the ice to come and go. Surely ways of life which bring us to this awareness are the appropriate and right ones for us humans.

People's relationships and intimacies with Temagami differ. I have lived some of these and have had insights into others. My earliest intimacies were those of a summer wilderness canoeist. Later I developed affinity with place from living in one corner of a lake season after season, year after year. I got to know each dead tree and big rock on the shoreline, when to expect particular rocks to show above water, which places to expect slush in the winter. By looking at the wind in front of our dock, I could tell exactly what the wind and waves would be like in a particular spot 5 or 6 km from home. I could tell by a sense I really did not understand when the wind was liable to change in the middle of the night and when I should therefore check boat moorings.

And yet my intimacies with the landscape are dwarfed by the far more detailed understanding and sensitivities the Indians have. When you spend time, a lot of time, in a place like Temagami, you can grasp how comprehensive has been their understanding of the physical world about them. The original Indian place names are often so much more fitting than ours. We refer to the stream draining Florence Lake as the South Branch of the Lady Evelyn River, but they call it Washkidjewan, which literally means "curving river

which almost turns back on itself". The lower part of the same river they called Mangnahmaygoszeebi, or "trout streams". What we call the S narrows between Lake Temagami and Cross Lake was originally known as Mucwanakganakshing, "the place of the bear snares". We call the most commanding hill in the area Maple Mountain; to the Indians it was Sheebayjing, "place of the spirits". Which names reveal a closer affinity with the landscape?

The more I travelled in the area, the more I could feel the presence of countless generations of Indians. The logic of many portages made sense when I realized that they were used in the late fall or winter. Long before I knew there was archeological verification of a small village on a favourite campsite on Smoothwater or Songewagamingue Lake, I sensed something special and secure when I arrived there on a canoe trip. Always something seemed to say, "Rest here a while, this is a good and comfortable place." When I learned there had been a native community there periodically for the last 1,500 years, my reaction was not one of surprise but rather, yes, of course, it fits, that makes sense, that is the most appropriate and strategic location for a settlement for some distance around.

Many of my friends in Temagami have their own special connections with the landscape. My friend who runs a trapline knows every pond, every creek, every interconnecting trail, every beaver house in a 240-km² area. He derives intense satisfaction from that detailed knowledge of his corner of the world. In contrast to the canoeist's summer intimacy, he starts on the trail in late fall, works through freeze-up, and continues on into midwinter. I have always found it interesting to sit down and talk with others whose bond is different from mine. I know foresters who have been developing their appreciation of tree stands as long as I have been memorizing canoe routes. To me a certain lake will mean a particular campsite or vista or portage; to them it may mean a stand of birch, pine, or poplar or a place where they have a jack pine plantation under way. Whereas my associations are waterways with the forests as the backdrop, my forester friends' link is to the forest and for them the waterways are the backdrop.

In the early years of my familiarity with the landscape I was largely unaware of the other correlations I was later to understand. It is revealing to look back on my own time and see how my relationship with the landscape changed. Once I began to live in Temagami year round I used resources: firewood; lumber, logs, and poles for buildings, sheds, and docks; and cedar for building canoes. Much of the satisfaction of living as I did was in knowing where there were accessible trees suitable for these purposes. Part of my annual ritual was cutting firewood in the fall and hauling it in winter. I looked forward to firewood time as much as to canoe trip time or winter camping time. Similarly, it was the ritual of friends from Bear Island to set their nets in the fall in specific locations to catch lake trout and in other locations in the spring to catch pickerel. Using the resources, be they wood or mineral, fish or fur, is necessary to all those, native or white, who live close to the land. Traditionally the native peoples always thanked the Great Spirit for giving them the animals on which they depended. Our society does not thank; instead it takes, more and more avariciously.

When it became obvious that the government's plans for land use in the Temagami area were for resort-style recreation on one hand and for increased industrial activity on the other, I became, for a time, an "activist". It seemed to me that the needs of the large, long-standing community of non-mechanized wilderness travellers were being ignored and that their case had to be put. We organized, prepared the requisite briefs, appeared before the inevitable committees, attended countless meetings with municipal representatives, Ministry of Natural Resources personnel, provincial politicians, and the rest. Eventually the Lady Evelyn–Smoothwater Park was created and I, like others, spoke favourably of it. But something left me uneasy. The arguments all seemed to become polarized around extremes: either the forest is a place to harvest trees for industry, or it is a place where we recreate and rejuvenate ourselves. The frequent contention of the forest industry and its regulator, the Ministry of Natural Resources, is that canoeists and anglers do not go inland from the shorelines. Hence the solution to the problem is to preserve canoe routes through tree plantations. What you see when paddling the Lady Evelyn River is a classic example of this lazy, simplistic land use

policy. Although they were not at first clear to me, I felt there were more sides to the issue than were being addressed.

What I was not fully cognizant of during my time as wilderness lobbyist was how living close to the natural environment over an extended period of time had changed and enriched my perspective. Sensible and sustainable land and resource use is not just deciding which areas will be parks and which will be given to industry as a source of raw materials. During the raging debates of the late 1980s and early 1990s I find myself and people I know in sharp conflict. Long-lasting solutions are hard to come by because all concerned feel threatened. My sense is that we have let the scale of industrial activities accelerate too quickly with the result that their impact has increased proportionally. Decisions as to what forest resources are to be harvested are made according to what the mills need to keep going and keep profits growing.

The natives have something to teach us. In getting along in the natural environment of northern Ontario for hundreds of years, the Indians have learned a lesson we have not yet been able to grasp: the resources can be used at a moderate rate and still sustain life. They also know instinctively what we are only slowly coming to realize: that everything in the bush is interconnected. A single act of ours — clearcutting a large area, for example — may change a whole range of things, including water levels and water temperatures, fish behaviour, animal habitat and behaviour, and, of course, forest cover.

There is a major paradox we must now face squarely and can no longer evade. As more and more people choose the concrete and plastic world of urban life and become further alienated from the natural world, the more intense become their demands for wilderness areas. Obviously this is a collision course and a threatening one. The impulses to consume and to preserve come from the same source: us. As long as we continue to want increasingly affluent and comfortable lives, we are in trouble. Our intellects can deduce that immutable phenomena such as carrying capacities, species diversity, and natural population control so clearly illustrated in plant and animal communities also apply to the human community. The media can convince us of the need to recycle and of the coming catastrophe of the greenhouse effect. But ultimately it is necessary to *feel* the natural forces to truly understand them. Temagami is a place where you can do this. If we continue to lose such places and their opportunities, we put ourselves at peril.

I have been stimulated for much of my life by the chance to define myself in relation to the outdoors and its elemental forces. Having had to live with water, wind, snow, ice, slush, swamp, and rock for extended periods of time, I have acquired some idea of how I, as a human, fit into the world around me. That is why the Temagamis of this world are such important places. It is imperative that I continue to feel these forces from time to time. I suppose that is why I shall always return to Temagami, a place where I can feel part of the natural system, a place where I, as a human, feel at home.

QUETICO PROV. PARK
BRUCE LITTELJOHN

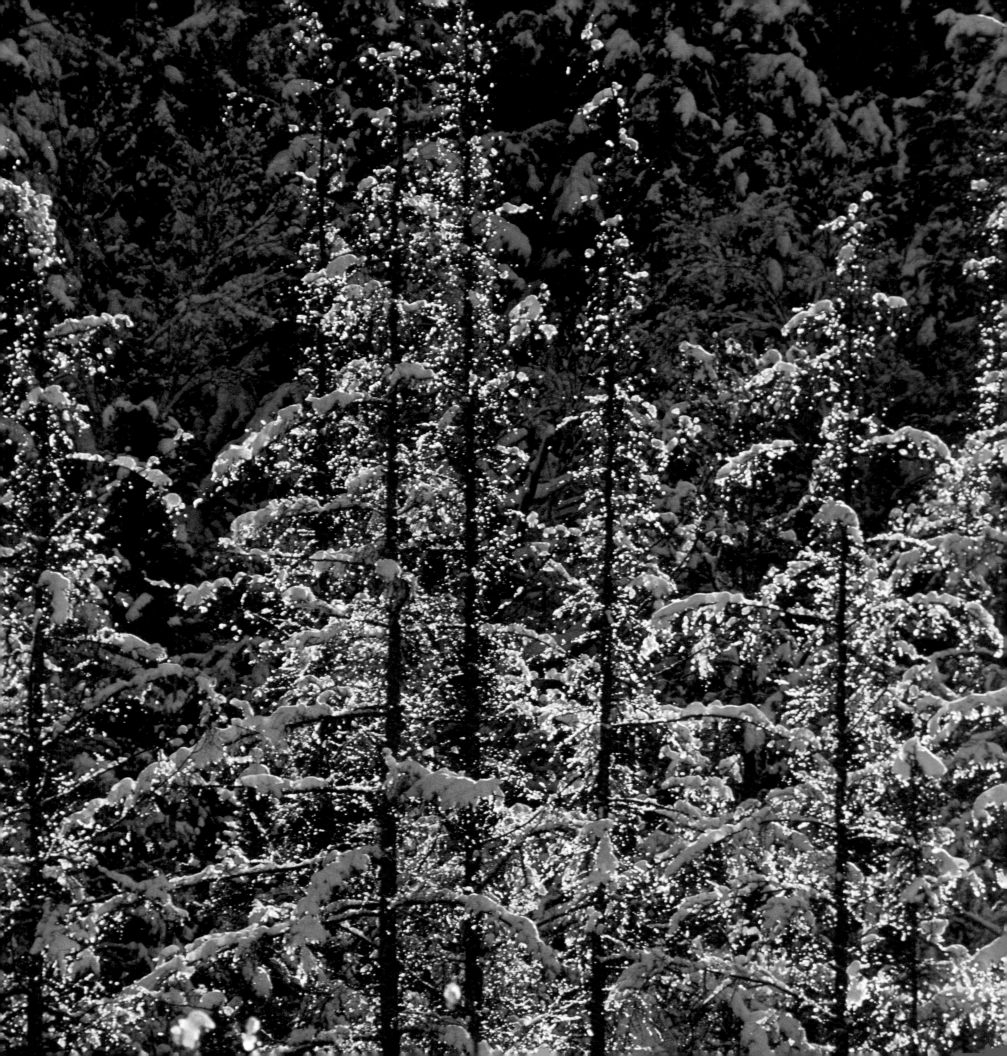

Missinaibi River Wilderness Park: Requiem or Hope?

George J. Luste

Does the Missinaibi River in northern Ontario have a future as a heritage wilderness park?

The question begs to be considered. A despairing optimist might still cling to a hopeful "maybe" — but the facts suggest that a truthful realist should reply with a clear "no".

It is vividly clear to this observer that the *wildness* in this unique wilderness waterway park is dying a slow death. Multiple abuses and political compromise have infected it with an HIV-like virus which will inexorably doom this extraordinary heritage. Like the oil-polluted beaches of Kuwait and Alaska with their stark images of struggling, oil-blackened waterbirds, the fate of the Missinaibi wilderness may already be sealed. And if it is, we will be the poorer for its passing.

Free-flowing rivers are remarkable creations. They pulse and throb in a dynamical interplay of gravity, water, and landscape. All three embrace each other in a myriad of combinations and variations as the forces interact, resisting here, yielding there, slowly sculpting the landscape, in an endless dance to the sea. And then back again — as the molecules of water evaporate and return to the landscape — to repeat a cycle older than life itself.

To the receptive canoeist the wilderness river is a symphony of motion and emotion reflecting the seasons of one's own being. Its current provides the measured, purposeful flow of variation, enveloping the visitor in the soothing relief of limpid, serpentine pools, in the exciting cacophony of wild and chaotic cataracts, and in the brooding baritones of its deep canyons. There is a resonance between emotion and landscape as the flow of the wilderness river overwhelms the visitor with a sense of place and a joy for life itself.

From the more utilitarian perspective, we have always used these moving pathways to our material advantage. Ancient portage trails attest to their convenience for early nomadic travel and foraging along their shores. European settlers later constructed mills with waterwheels to grind grain, and later still used the larger waterways for industrial transport and commerce. More recently we have caged and harnessed the energy of their primordial force for our urban comforts, which we enjoy far from the generative source and the eerie mournful whine of the imprisoning turbines.

There seem to be no limits to our powers — or our lack of restraint in their use. The possibilities are alarming. Given our ever-increasing capacity to alter nature, perhaps the single most critical question we as a species confront is: *Will we subjugate and despoil every last vestige of freedom and wildness in nature before we realize our symbiotic interdependence with it; before we perceive that it is an extension of our own existence, that its wildness is essential for our very survival, and that we must preserve it if we are to survive?*

Now we ourselves have become the one endangering force that threatens the whole planet. Our assault on nature can be likened to an endless holocaust in which the temporary survivors, be they rivers or habitats, have no possibility for regenerative procreation. One by one the wilderness rivers and habitats on this planet die at our hands. As they disappear, they are not replaced. There are no new progeny.

The Missinaibi River has a special, personal significance. I first canoed its full 500-km length in 1973. It was a wonderful, inspiring experience. Since that encounter I have sought to further the well-being and conservation of this magnificent natural resource, so that future generations might also be the beneficiaries of similar spiritual comfort and physical joy. But the intervening two decades since 1973 have not been kind to this dream. My most recent return visits to the Missinaibi have been melancholy, bittersweet experiences. Yet there once was so much promise and possibility.

As a waterway and as a river the Missinaibi has exceptional

geographical, historical, and wilderness attributes. Because of these unique attributes it has been nominated to the Canadian Heritage River System. It is not only unique. It is also extraordinary.

If Canada's land mass is likened to an hourglass, the Missinaibi is its narrows. It cuts across the thin geographical land-neck of Canada, joining the salt water of the Arctic Ocean in James Bay to the height of land just a few kilometres from Lake Superior. In the north, near James Bay, it joins with the Mattagami, the Abitibi, and other waterways to form the Moose River.

The Missinaibi is the shortest waterway, from north to south, across the Precambrian Shield and the Hudson Bay Lowland; and prior to the completion of the east/west railroads, the Michipicoten–Missinaibi–Moose River corridor was the most important transportation route in northwestern Ontario.

The history and economy of early Canada were dominated by the fur trade. Just three years after the granting of its charter in 1670, the Hudson's Bay Company established Moose Fort in the Moose River delta on James Bay. It and later posts at Wapiscogamy, Missinaibi Lake, and Brunswick Lake along the Missinaibi played a central role for some two hundred years until 1863; as historian Doug Baldwin puts it, "The Missinaibi River was the life-blood of the Hudson's Bay Company in Northwestern Ontario."

Its topography is breathtaking, and its many rapids and falls read like a wilderness Arabian Nights to the adventurous canoeist, with names such as Thunder House Falls, Conjuring House, and Hell's Gate Gorge.

At its headwaters in the south, the Missinaibi River is accessible at Missinaibi Lake by road or nearby train and at Peterbell by train. Halfway to James Bay, at Mattice and Hearst it can be reached by road and train again. The northern terminus of the Polar Bear Express train from Cochrane is Moosonee in the Moose River delta. Easy accessibility is, of course, ideal, but it is also a double-edged blade. On the one hand such accessibility is vital for the wilderness recreation seekers who do not have the experience, the financial resources, or the time to explore the remote, faraway rivers of the Canadian Arctic. On the other

hand the accessibility invites intrusions and abuses from the nearby lumbering interests and the all-terrain vehicle users from local communities.

Because of its topography, its history, and its past reputation, the Missinaibi is recognized as a world-class wilderness river, sought after by canoeists from the U.S.A., Europe, and Asia. As a renewable resource it can provide recreation and tourism benefits in perpetuity — provided it is not permanently stripped of its wilderness attributes. Today the Missinaibi is the last significant free-flowing river we have left in Ontario that is also readily accessible to most of the province's population by road or train.

A wilderness river, like a thin silk thread across the landscape, is fragile. Its narrow corridor has no land mass to buffer and protect it from mechanical intrusion. It is not safeguarded by many hundreds of kilometres of totally uninhabited wilderness. It is perhaps the most tenuous and vulnerable park concept there is.

A linear wilderness-river park, such as Missinaibi, is a recent creation in Ontario. There are no precedents, no successes or failures to guide the planners. It is therefore a daunting challenge for the parks planners, who are in uncharted waters and must be guided by a thoughtful, clear, and determined vision of what it is they must conserve. It is of some concern that the Ontario parks system has only six classes of parks and that officially the Missinaibi is classified as a Waterway Park, not as a Wilderness or a Wilderness Waterway Park. There is no "Wilderness Waterway Park" class as such, and this shortcoming reflects part of the real problem: as a waterway, the Missinaibi River has little in common with the Trent Canal or the Thousand Islands stretch of the St. Lawrence.

In 1973 one could paddle the full length of the Missinaibi and only encounter the jarring presence of civilization in the vicinity of Mattice. Since 1973 the wilderness degradation of the waterway has been profound. Today sections of the upper river are a mess, and there seems to be little or no willingness on the part of government to admit to or correct this degradation.

What has gone wrong? What has happened since 1973?

Kimberly-Clark's Spruce Falls Power and Paper Company out of Kapuskasing has clearcut extensively on both sides of the Missinaibi since 1973. Their operations have left a wake of destruction which has reduced the Missinaibi wilderness to a hollow ghost of its former self. Like the deadly HIV, not all of the damage is immediately or visually obvious. Similarly, while some aspects of the Missinaibi wilderness may be still functioning, its eventual death as a wilderness is certain unless an immediate intensive-care rescue is launched.

In places only a transparent curtain of a few isolated trees is left between the river and the clearcut desert behind. Why? Spruce Falls was not short of trees — they cut less than their allocation quota from the province entitled them to. Why wasn't the river given a decent buffer of uncut trees? New clearings exist along the riverbank, and old access roads once used by the pulpwood cutters are still bare, increasingly eroded, and prone to erosion. Why haven't they been permanently closed, restored, and replanted? At a number of locations determined anglers and joy-riders with all-terrain vehicles now use them to access the river. A large fibreglass powerboat is left on the river bank within the "park" as mute testimony of their presence. There is a new, unauthorized and presumably illegal, "private fishing road" on Crown land with a parking lot on the Brunswick River for all-terrain vehicles and four-wheel drives. Why was this allowed?

But the most fatal wounds of all are the two camp-95 bridges across the Missinaibi and Brunswick rivers. They did not exist in 1973. These major bridge crossings are located at the most isolated and scenic section of the upper Missinaibi. Such access routes become irreversible and permanent. This is the real HIV that will destroy the wilderness integrity of the Missinaibi. When they were first built, to access tree cutting on the west side of the Missinaibi for the Kapuskasing pulp mill, it was promised that they were temporary and would be dismantled once their use by Spruce Falls was complete. To date this promise has not been kept, and there are now interests who argue that they must be retained indefinitely.

The Wilderness Canoe Association of Ontario has recommended that if these two bridges are left in place, the notion of a Missinaibi Wilderness Park be abandoned and the charade be terminated.

This specific concern raises two further issues that go beyond the tragic fate of the Missinaibi itself. First, is there any real evidence that lumbering interests can co-exist with wilderness values in the proximity of a park? Second is the question of commitment by the politicians and public servants to conservation and wilderness preservation. Does anybody with public responsibility care that the Missinaibi, a unique and historic waterway, provides one of the last chances to save a significant free-flowing wilderness river in Ontario?

PICKEREL LAKE, QUETICO PROV. PARK
BRUCE LITTELJOHN

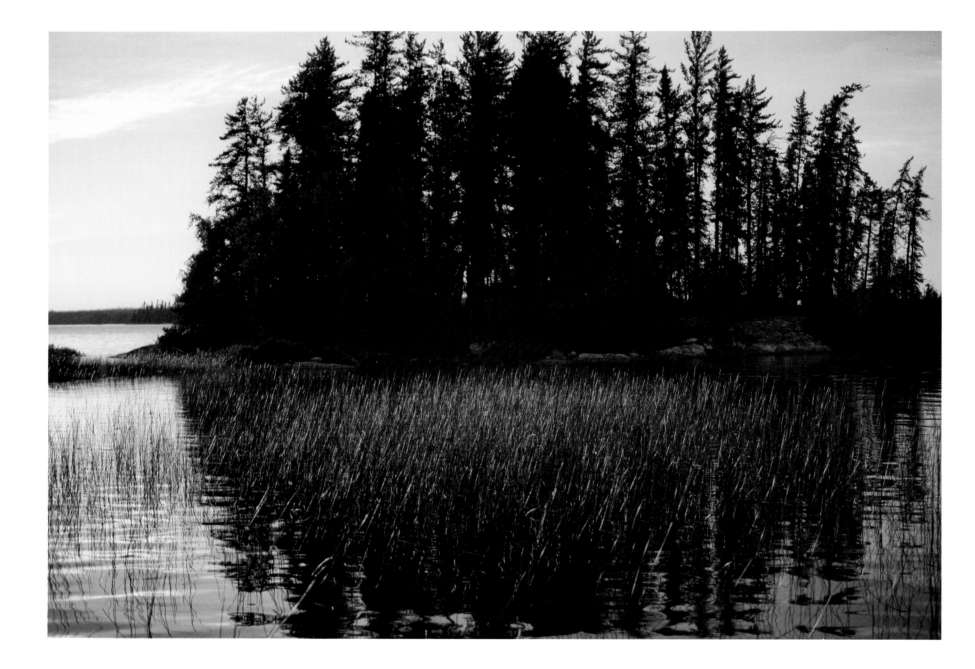

Lake Superior Provincial Park

Alec Ross

It's a safe bet that the majority of people who pass through Lake Superior Provincial Park never give it much thought. As they roll north on Highway 17 from Sault Ste. Marie towards Wawa and the fabled Big Goose, they probably notice the sign welcoming visitors to the park and other signs that mark the campsites and picnic grounds at Crescent Lake, Agawa Bay, Katherine Cove, Rabbit Blanket Lake, and Old Woman Bay. The park lies in the transition zone between the Great Lakes–St. Lawrence and Boreal forest regions, and shrewd observers might notice how the predominant forest cover in the park changes from hardwoods like maple and yellow birch in the south, to white birch, white spruce, poplar, and balsam fir in the north. But most drivers just cruise along to wherever they're going, oblivious or unconcerned about the details of their surroundings. The rounded Precambrian hills, the trees, the cliffs, the waterfalls at Sand River, and dramatic Lake Superior vistas flash by and remain in memory as vague images which, if the drivers are later prompted to remember them, will be described generically as Great Scenery.

The above assumes that drivers travel in perfect conditions, when Algoma's glorious scenery is visible. Their memories of the park will be quite different if they encounter a Lake Superior summer fog that envelops Highway 17 in an impenetrable veil and they're forced to pull over to wait for it to clear. If the drivers are caught in a winter blizzard, they'll have stories about blinding whiteouts that slowed their pace to a timid crawl, or of black-ice pavement, tractionless as a skating rink, that facilitated the Ford's inexorable slide from a curve into a snowy ditch.

However vivid or fuzzy their recollections of Lake Superior Provincial Park may be, people today can at least experience its hiking and cross-country ski trails, canoe routes, and campgrounds with relative ease. It wasn't always so simple. After its creation by a provincial government order-in-council in 1944, comparatively few souls in Ontario knew the park existed. Fewer

still made plans to actually go there. The reason, of course, was that the bulk of it was inaccessible by road. When the park was born, Highway 17 stretched only as far as Montreal River Harbour, near the park's southern boundary. Eight years later it had crept ahead 16 km north to Speckled Trout Creek. But it wasn't until 1960 that construction crews pushed the highway through to Wawa and opened the entire length of the park to anybody with a car.

Despite the lack of a road, visitors had been coming to the area for over a century. The early travellers used canoes, steamboats, and native guides to get around, and some recorded their experiences of the remote locales in words and pictures. They included the physician John J. Bigsby, who wrote *Shoe and Canoe*, a classic travel account and natural history of the Superior region. Another was the Irish-born painter/writer Paul Kane, who painted a portrait of the Ojibwe chief Maydoc-Game-Kinungee (translation: "I hear the noise of the deer") during a stopover at Michipicoten in 1848. Frances Anne Hopkins, the wife of a Hudson's Bay Company official stationed at Sault Ste. Marie, painted many of her famous documentary canvases of the fur trade era along the shores of Lake Superior. One of the most familiar, *Voyageurs at Dawn*, shows a band of grizzled voyageurs camped on a cobble beach; one man stands on a rock and squints out into the mist of the lake, while companions variously slumber under an overturned canoe, huddle around a cooking fire, or collect wood. Mrs. Hopkins may have done the painting at Michipicoten or Agawa during one of her husband's inspection tours of the trading posts there.

Before long the artists, naturalists, and scientists venturing to Superior were joined by affluent anglers, many of them Americans from Chicago or Detroit, who raved about the region's fabulous fishing opportunities and extolled the virtues of an Indian guide named Towabanasay, who more than once demonstrated his uncanny ability to locate elusive deer by smell alone. Today, a lake and a hiking trail in the park bear Towabanasay's name.

SMOOTHROCK LAKE, WABAKIMI PROV. PARK
BRUCE PETERSEN

By the 1930s a few remote lodges could be reached by boat from the Soo or Montreal River Harbour. After 1912, the Algoma Central Railway (ACR) provided access to the lakes, rivers, and resorts of the interior. Today the ACR defines about 29 km of the park's eastern boundary, and in summer and fall the Algoma Tour Train rolls out of Sault Ste. Marie and affords its passengers spectacular views of the Agawa Canyon.

It was the ACR which carried the individuals who helped make the "wild, rugged, tumultuous" Algoma landscape forever a part of the Canadian artistic imagination. In the autumn of 1918, a handful of Toronto artists named Lawren Harris, J.E.H. MacDonald, and Frank Johnston took the first of several excursions they would take on the railroad in the next few years with their friends A.Y Jackson and Arthur Lismer. The men who, with Frederick Varley and Frank Carmichael, comprised the original Group of Seven resided in boxcar number 10557—which the obliging ACR had converted into living quarters—and hiked, paddled, or used a handcar to get to their chosen painting locations.

There was much in Algoma to attract an artistic sensibility. "We found that at times, there were skies over the great Lake Superior which in their singing expansiveness and sublimity, existed nowhere else in Canada," reminisced Harris in a personal account of the ACR boxcar trips. "We found that one lake would be friendly, and another charming and fairy-like, the next one remote in spirit beyond anything we had known, and again the next one harsh and inimical."

My most vivid memory of Lake Superior Provincial Park stems from a solo canoe trip along Superior's north shore in September 1987. I paddled through the cliff-sided, cave-riddled islands near Cape Gargantua, then lingered for a while at the Devil's Chair—a distinctive pyramidal rock formation upon which Nanabozho, the fabled giant of Ojibwe legend, is reputed to have rested after leaping across Lake Superior. But the afternoon wind came up, and about 5 km later I was forced to land on a crescent-shaped pebble beach below Cape Chaillon.

To my relief I found a protected campsite which some wag had dubbed the Red Rock Hilton; the name was painted on a scrap of plywood propped up on a driftwood log. Halfway up the beach was the Red Rock River, so called because of the unmistakable three-storey-high cliff that guards the place where the river spills into Lake Superior. I learned later that A.Y. Jackson had once been here to sketch the massive rock.

Since I was stormbound, I decided to explore upriver. It was narrow and boisterous, but the farther I ranged from the lake, the more profound the silence around me grew — except for the chattering sound of the river. Its greenish-brown water cascaded down in steps of short, busy rapids, splashing its way over and between moss-covered boulders. At intervals were deep pools teeming with skittish schools of pink salmon. I ducked under the windfalls that lay in a jumble across the river's narrow gorge; overhead, the pines and cedars formed an arching canopy that filtered out most of the daylight. The treetops swayed gently, tickled by the gusty wind from Superior, but down here, 25 m below, I felt only a slight breeze.

The quiet, the gloom from the overhanging tree roof, and the earthy smell of the mosses gave me a feeling of privilege—that I was somewhere no one had ever been or ever would be. I squatted on a rock and stared into a pool, hypnotized by the swirling bubbles trapped in the eddies and the multicoloured pebbles on the bottom that shimmered under the water's surface. I savoured my aloneness in this idyllic, secluded place.

Then I noticed a small gold rectangle affixed to the rock on the other side of the pool I was contemplating. The rectangle shone with a dull gleam: it was a plaque. It informed me I was sitting, not at an undiscovered hideaway, but at Fred's Hole. The marker had evidently been placed there by five of the late Fred's erstwhile fishing buddies, whose initials were inscribed under the words "Memory replaces presence."

The tarnished plaque reminded me that Fred and I were only two in a long line of visitors who had probably experienced subjective yet comparable emotions in this spot and at other spiritually rejuvenating locales on Superior's coast. I'd read that Indian braves on vision quests used to sit and fast for days in the curious cobble-beach depressions we know as Pukaskwa Pits; perhaps the seekers also frequented places such as this one on the Red

Rock River. I felt uniquely privileged at the time, sitting alone beside Fred's Hole, but my reason told me that others had visited the beautiful territory around me for generations.

Indeed, the region has a long history of human presence. Archeologists such as Thor Conway have unearthed artifacts at the Pic River and at Sinclair Cove which suggest that nomadic native groups from the Shield cultures hunted and fished in Lake Superior Provincial Park as long as 2,500 years ago. Some twenty-seven other ancient campsites have been discovered elsewhere within the park boundaries. Evidence indicates that small Algonkian tribes, who in time became known collectively as the Ojibwe, lived in summer camps at the mouths of rivers like the Agawa and the Sand, where trout were plentiful, and in winter travelled inland to hunt moose and woodland caribou and to trap muskrat, beaver, and other creatures.

The aboriginal families didn't always remain in the hinterland. For maple sugaring in spring and the annual whitefish run, many gathered at Sault Ste. Marie to trade with neighbouring tribes from Michigan, Manitoba, and southern and northwestern Ontario. Historians estimate that around 1622 the natives made their first contact with a white man, Étienne Brûlé, at the Soo. Eighteen years later, in 1640, the *Jesuit Relations*, the voluminous official records of the early Catholic missionaries, first mentioned the "Saulteurs", or "people of the rapids". Later writers noted how remarkably adept the Saulteurs were at spearing and netting fish in the turbulent St. Mary's Rapids.

The Jesuits who came to bring the Christian God to the native flocks were also the first to map Superior's coastline, and by 1700 the basic shape of the lake was known. These pioneering cartographic forays opened the door for further exploration, mainly for mercantile purposes, and for the next half-century independent French fur traders and their European goods arrived in ever-growing numbers.

In 1725, a French trading post was established at an Indian village at the confluence of the Magpie and Michipicoten rivers, and smaller adjunct posts were subsequently built at Agawa Bay and Batchawana Bay. The regional headquarters at Michipicoten was strategically located at the geographical crossroads of fur trade canoe routes to the far northwest, northeast to Hudson's Bay, and southeast to Montreal. Successive posts at the site would be home to Hudson's Bay Company and North West Company traders, independent traders, voyageurs, and Indian families.

The last permanent trading concern, operated by the Hudson's Bay Company, closed for good in 1904. Its remains now lie buried under hummocks of grass in a clearing across from Brad Buck's thriving marina on the Michipicoten River.

For the traders who occupied the lonely posts, daily existence was not easy, but the natives who supplied them with pelts had an even tougher job of survival. Alexander Henry, who wintered at Michipicoten in 1768, noted how the rugged upland terrain and adverse climatic conditions made life gruelling for the nomads. "Such is the inhospitality of the country over which they wander, that only a single family can live together in a winter season; and this sometimes seeks subsistence in vain, on an area of five hundred square miles," wrote Henry.

Henry's journals also made mention of Shingwauk, an Ojibwe chief and medicine man who sided with the British general Sir Isaac Brock in his fight against the Americans in the War of 1812. The native leader may also be the same person described by Henry Rowe Schoolcraft, an Indian Agent and assiduous ethnographer who was stationed at the American Sault during the first third of the nineteenth century. In his masterwork, *Intellectual Capacity and Character of the Indian Race*, published in Philadelphia in 1851, Schoolcraft penned a description of some drawings done on a birchbark scroll by a chief/shaman named (and spelled) Chingwauk. The chief's handiwork depicted two sets of rock paintings, one on the south shore of Lake Superior, and another on the north shore at a place Chingwauk called Mazhenaubikiniguning Augawong, or Agawa.

Schoolcraft never saw the rock art his informant had described so accurately. The site was known to local anglers but remained hidden to the outside world until 1958, when a pioneering expert on Canadian Shield Indian rock art, the late Selwyn Dewdney, used Schoolcraft's reference to rediscover the

most enduring relic of native history in the Superior region, the Agawa Rock pictographs.

The main figures are painted in red ochre at the bottom of a slightly overhanging granite cliff sheltered by some islands just north of Agawa Bay. Among other things, observers find canoes, caribou, a man on a horse, serpent-like creatures, birds, fish, and a rendition of Misshepezhieu, the Great Lynx of Ojibwe legend. According to Schoolcraft, the drawing of five canoes and the figures surrounding them commemorates a daring three-day crossing of Lake Superior by the chief and shaman Myeengun ("wolf of the mermaid") and a group of Indian warriors. Some figures are tiny and indistinct and blend in with the white and pink colouring of the granite. Others, like the horned Misshepezhieu, still stand out boldly despite decades of wear from ultraviolet light, water runoff, and, more recently, the fingers of careless tourists.

The remarkably durable pictographs have been interpreted as historical records depicting great deeds, clan totems, and symbols of sacred worship. No one, probably, will ever know their exact meaning. It may be beyond a modern person's ability to comprehend what prayers or whims motivated the artists who created them, though Ojibwe elders such as Dan Pine at Garden River have contributed valuable insights to increase our understanding. But whatever the status of your Indian knowledge, on a quiet morning you can squat on the sloping platform with your face towards the lake, feel the stillness and the power of the rock and the water, and get a sense, however remote, of what Agawa really is—a place of the spirit.

The first Europeans in Algoma took little stock of the animistic brand of spirituality symbolized at Agawa. After all, the desire to replace the natives' Great Spirit with Jesus Christ had brought the original trickle of non-natives to the area. But, as was the case whenever the Old World culture encountered an indigenous one, spirituality ultimately took second place to more secular matters. In Algoma this meant chopping down the trees that grew on the landscape and extracting the minerals that lay beneath it.

The first stabs at European-style mining came from prospectors like Denis de la Ronde in the 1730s, who hoped the copper deposits of Indian legend at Michipicoten Island and Mamainse

Point might contain silver or lead ore. But seekers of Algoma's motherlode of copper would have to wait until 1845 before they made a significant find at Bruce Mines on Lake Huron's North Channel.

Indians had mined the earth for thousands of years for metal to make fishhooks, points for arrows and spears, and decorative objects. But with their ages-old reverence for the land, the natives couldn't fathom the destructive, shaft-sinking mentality of the newcomers. In *Superior: The Haunted Shore*, Wayland Drew wrote that the native and white approaches to mining were "as different as a skin wound from a body thrust . . . [To] pierce the earth itself, and then to enter that wound and burrow there like a maggot—how could that be an honourable endeavour for a man? Clearly, those who did such things were diseased, without respect for themselves and for the land they walked upon, and the powers that so degraded free men could be nothing but evil." What was worse, the Indians were rarely consulted by the white men who took up pickaxes, drills, and dynamite to exploit Indian land. In the 1840s and 1850s, such cavalier attitudes with regard to native homelands resulted in a series of occasionally violent skirmishes between Indians and miners known as the Michipicoten Wars.

The conflicts were a major impetus behind the two Robinson Treaties of 1850, which extinguished aboriginal title to the land in present-day Lake Superior Provincial Park, established about a dozen small Indian reserves, and set the stage for the numbered treaties signed later on the western Prairies. In Algoma, the pacts opened the door for further mineral exploration by the Montreal Mining Company and other enterprises, mainly for copper, but also for gold and iron. Most exploration took place over the next fifty years, with varying degrees of success, in the Wawa area.

The most momentous find occurred in 1896: a body of high-grade hematite ore, found north of Wawa Lake. The promising claim was purchased for $500 by Francis Hector Clergue, an ambitious lawyer-cum-promoter from Maine whose name would become synonymous with Algoma's dawning age of industrialism. Within a decade of his arrival in Sault Ste. Marie in 1894, his syndicate laid the groundwork for the industrial base of the

entire region. Algoma Steel survived on iron from the Helen, Josephine, Lucy, and Ruth mines near Wawa, and in 1900 rolled the first steel produced in Canada. Clergue, who was a bit of an eccentric—he kept a pet moose—named the Wawa mines after his sisters. He also played a big role in ushering in Algoma's era of large-scale logging.

Through the 1960s most of Lake Superior Provincial Park's 1,350 km² was leased to three logging companies: Abitibi-Price Inc., Weldwood of Canada Limited, and Weyerhauser Canada Ltd. Though it was restricted to certain zones, the logging took its toll. In June 1970 an "investigation team" from the Algonquin Wildlands League found evidence of careless logging practices—eroded roadways and blocked culverts, dilapidated shacks, shoddily constructed bridges over streams, and stands of ratty second growth. Two members of the investigation team, Bruce Litteljohn and Douglas Pimlott, published their findings in a slim volume called *Why Wilderness?*, and included several recommendations on how to protect the park's natural heritage from such depredations in the future.

But *Why Wilderness?* didn't exactly bring the logging industry in Lake Superior Provincial Park to its knees. When the Ministry of Natural Resources adopted its 1979 Master Plan for the park, logging was still prominent among the stated park uses. Now, in January 1991, two companies—St. Mary's Paper and Lajambe Lumber, both of Sault Ste. Marie—hold leases that allow cutting in the Recreational Utilization (RU) Zones that cover roughly half the park area. All logging activities have been suspended pending the completion of an updated Master Plan, which is unlikely to appear for some time. The options for logging in the park reviewed so far include maintaining the status quo, ceasing logging altogether, and conducting operations "at the level to which good practice is possible".

Each option has its proponents; I prefer the one that prohibits logging. I'm aware of the arguments of foresters who say that the best way to ensure the survival of a forest is to "manage" it carefully with selective cutting and conscientious reseeding, and that responsible logging practices pose no real long-term threat to animal habitats. I've spoken with foresters who were so certain of these

methods that, hearing them presented so earnestly and persuasively, I was almost convinced they were right.

Almost convinced, but not quite. In the real world, few logging companies cut selectively and ensure that meaningful reseeding occurs later. Moreover, the companies conveniently ignore the fact that the forests—which some foresters say require human "assistance" in order to survive—prospered well enough, by themselves, long before humans ever dreamed of intervening. And I just don't buy the idea that logging doesn't threaten forest ecosystems in the long term.

One root of the logging/conservation conflict is that the opposing sides judge the value of forests in different ways. One side sees an economic resource only measurable in terms of millions of board feet and dollars, whereas so-called "tree huggers" see places whose main worth is spiritual and unquantifiable, contributing to humanity's spiritual well-being merely by existing. To the former group the terms "forest" and "tree farm" are synonymous; to the latter they represent polar opposites.

But to debate these philosophical stances is to skirt the central question as it relates to Lake Superior Provincial Park and every other park in Canada: Is it appropriate that there should be logging in a public park? I always thought provincial parks were meant to preserve and protect the natural environment, to provide spaces for people to stroll among the pines, shoot rapids in a canoe, or watch birds. That they should be places where D-9 Caterpillars can bulldoze virgin wilderness, and loggers buzz away with their chain saws, somehow does not jibe with my mental picture of a park. When I drive through the park on Highway 17 or paddle on Lake Superior, I'd prefer to know that when I look into the receding hills, the trees I see are not cosmetic false fronts, buffer zones of prettiness left by logging companies.

If there must be further development of the park, let it revolve around projects that are faithful to the idea of respect for the earth that native people knew so well. Above all, conduct it so that the land and water are preserved, not only for the enjoyment of future generations but, as Bill Mason was fond of saying, for their own sake.

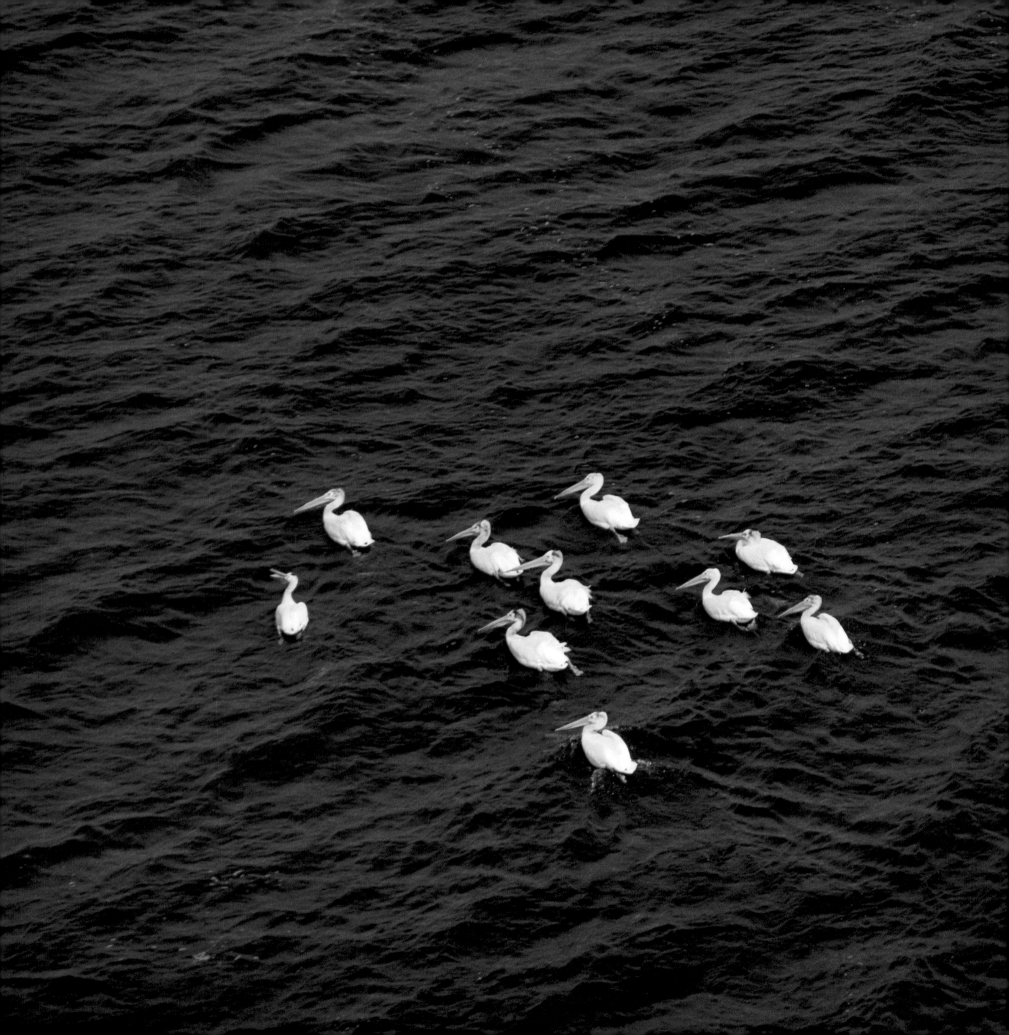

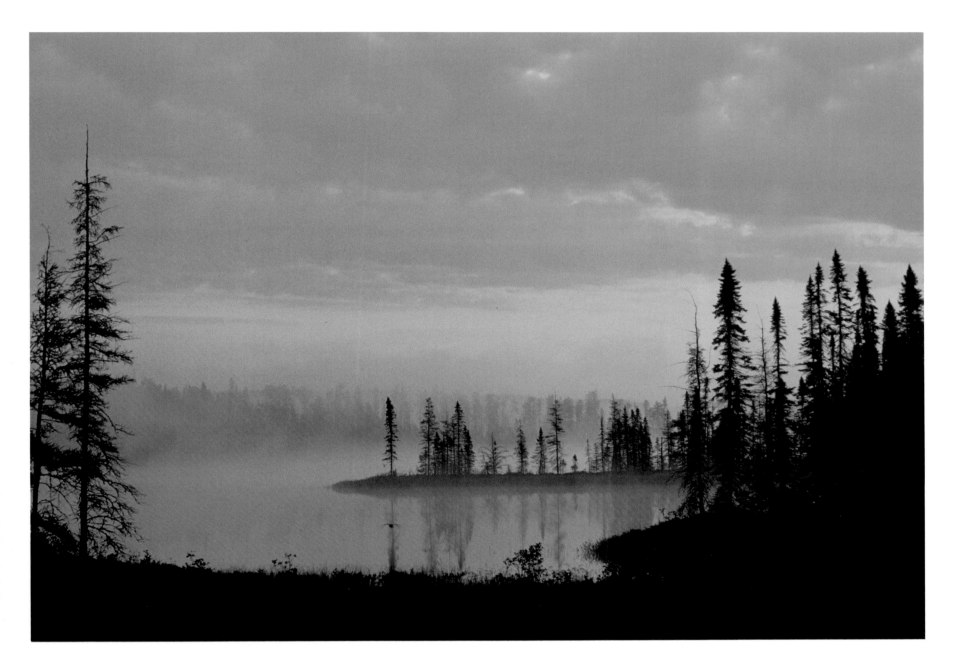

LEFT/WHITE PELICANS, LAKE OF THE WOODS PROV. PARK
BRUCE LITTELJOHN

ABOVE/NORTHERN DAWN
JOHN DE VISSER, MASTERFILE

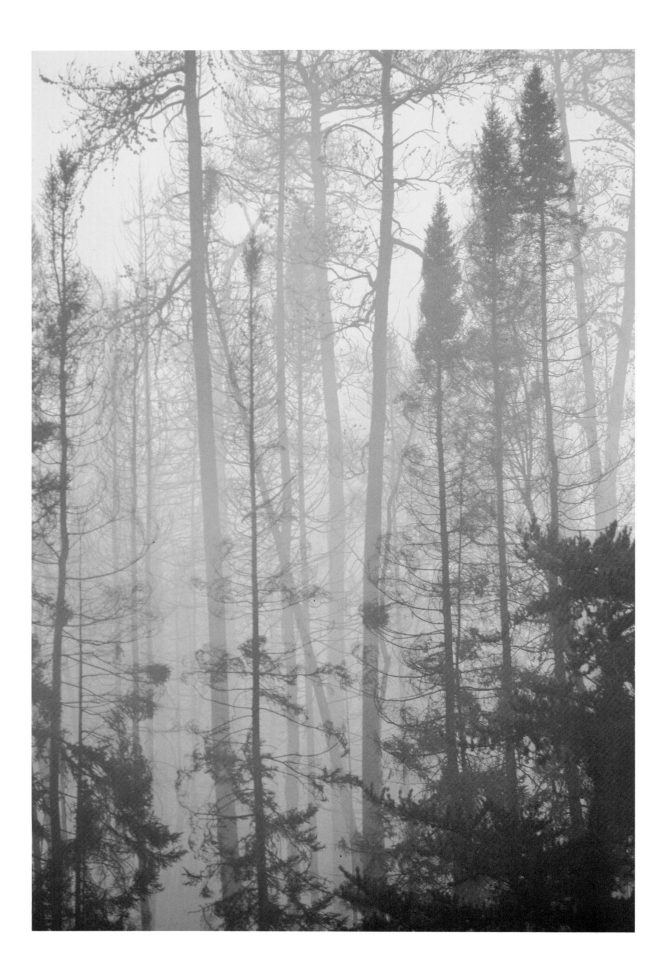

Ontario's Prairie Boreal Wilderness: Woodland Caribou Provincial Park

Daniel F. Brunton

After a long hard day of bushwacking, we were tired out and content just to drift along the spruce-lined shores of Kilburn Lake. Our canoe hugged the shore as we squinted into the lowering sun in hope of adding one more sighting to an interesting day of plant and animal observations. For whatever reason, we didn't see it until we were right alongside . . . a shadow moving at the water's edge.

Only 25 m away, on the shoreline, a woodland caribou watched our approach. Here in full view was one of Ontario's most magnificent and elusive large mammals. She moved slowly along the shore, looking about, browsing occasionally on aquatic grasses and ignoring the two excited human beings now bobbing offshore only 10 m away.

For almost twenty minutes we revelled in it all, silently following the doe as she went about her business until, quite suddenly, she slipped back through the spruce, up the sloping shore, and was gone. Our fatigue now completely forgotten, a jumble of reactions and observations filled the remainder of our travel back to the campsite.

That, in a nutshell, is much of what makes Woodland Caribou Provincial Park wonderful. The setting for our wilderness encounter was literally as it had been for thousands of years. She was doing what she and her kin had done for many centuries in this place. We were treated with an indifference that was both complimentary and lovely to behold. Now how many truly wild and natural places are there like *that* in Ontario?

Woodland Caribou is an ancient landscape but it is new as a park. It is one of a handful of large Wilderness Parks created in northern Ontario in 1983. And it is large: at over 4,500 km² it is more than half the size of Algonquin Provincial Park. Moreover, unlike Algonquin, 'Caribou is *ecological* wilderness. Its forests have

never been cut. No roads infiltrate its heartlands. No railways or powerlines cross any portion of it. The rivers are undammed. The impact of humankind is, however, felt at fly-in fishing and hunting camps, particularly in the central portion along the Bloodvein River.

The essentially pristine condition of 'Caribou results from isolation rather than good planning. Situated some 200 km north of Kenora on the Manitoba border east of Red Lake, the park area was north of economic logging limits (until recently) and out of the way for most travellers. But human beings have visited the park in the past. Although the park's scoured Canadian Shield landscape only emerged from the icy waters of post-glacial Lake Agassiz 11,000 years ago, people were here by at least 6,000 years ago. Aboriginal hunters searching for wapiti (elk), woodland caribou, and bison left archeological evidence 3,000 to 5,000 years ago throughout the park. Indeed, while Romans were conquering much of western Europe, the Laurel people were living in small villages here. Their settlements were occupied until the beginning of this century, with various groups of natives living semi-nomadic lives while exploiting the rich fish and game resources of the area. Beautiful pictographs from the prehistoric era are found along the Bloodvein, Gammon, and Oiseau rivers. A particularly magnificent set of pictographs near Artery Lake includes a large and dramatic image of a bison.

As with most of the Canadian Shield, 'Caribou was first visited by fur traders travelling inland from Hudson's Bay, and native fur trapping in this area was established by the 1600s. An intense period of rivalry between the Hudson's Bay Company and its Canadian competitors led to the establishment of a fur trading post along the Bloodvein River in the park area and the

decimation of fur-bearing animal populations. Trapping continues today, but at a much reduced level. It is still dominated by native people; over half of the park's forty-eight traplines are run by natives.

The Bloodvein River served the Hudson's Bay fur traders as an important secondary access route to the Manitoba plains. For this reason, and because of its outstanding natural condition, the river (including that portion in the park) has been designated a National Heritage Waterway.

Recreational use of the park's waterways was developed earlier in this century by local anglers from the gold mining community of Red Lake to the east. They continue to come today, but fly-in fishing now provides the largest number of visitors.

Good fishing is certainly a major reason for coming to 'Caribou, but it is by no means the only one. The magnificent wilderness character of the area is a significant attraction, particularly for the small but growing number of recreational canoeists. With an abundance of long, relatively protected lakes and infrequent, short portages traversing a pristine landscape, it is a canoe tripper's dream.

'Caribou is not like other Ontario wilderness areas. It has a special and unique "feel" to it that captures a visitor's imagination very quickly. From the air, this is hard to imagine, for the terrain looks flat and monotonous. It appears to be an endless carpet of conifer forest interspersed with scattered hardwood stands, bogs, lakes, and narrow, winding rivers. Occasionally, however, large bands of exposed bedrock are displayed. It is these which make 'Caribou different.

These areas are the burns. Here, terrifyingly powerful forest fires raced across the landscape consuming tens of thousands of hectares of jack pine forest. Such gigantic fires spare only wetland sites and occasional, randomly fortunate patches of hardwoods. So great and so regular are such fires that over one-third of 'Caribou has been burned over in the last thirty years. Indeed, it appears that the entire park is burned over, on average, every ninety or a hundred years.

Fire, almost always caused by lightning, is the single most important factor influencing the ecology of 'Caribou. In fact, it is such a normal and indeed vital part of this landscape that the Boreal forest as we know it — that northern transcontinental band of conifer-dominated forest between subarctic and temperate regions of the continent — would disappear if fire were completely suppressed. Not only are the forests themselves dependent on a natural regime of fire, but so also are many plants and animals of both upland and wetland systems.

Natural forest fires rarely burn effectively in young forests that lack a dense undergrowth: there simply isn't enough fuel to keep them going. However, old forests past their prime growth period, which contain an abundance of forest floor litter and old branches, are ripe targets for fire. They are also particularly prone to insect infestations, disease, or windstorm damage — all important agents of forest renewal.

When a fire burns through a jack pine forest, the highly combustible old trees are destroyed; the forest floor is then flooded with light and is also cleared of the almost impenetrable "duff" layer of roots, partially decayed leaves, and other organic material. The mineral-rich ashes fertilize the soil. Fire is also critical to regeneration in that the jack pine cones will open to release their seed only after exposure to intense heat. The rain of seeds resulting from fire-opened cones creates a sea of seedlings on a freshly cleared, weed-free, fertilized bed.

The patchwork pattern of variously aged, fire-born pine stands reflects differing degrees of susceptibility to disease, physical damage, and fire. These differences encourage biodiversity and give the natural environment greater "bench strength". When the mineral-rich wood ash is washed into lakes and streams in runoff, it also enhances aquatic biological productivity by reducing water acidity and increasing nutrient content. Large, intricate aquatic plant and animal complexes, involving everything from invertebrates to eagles, are dependent on these nutrients.

'Caribou burns readily because of its thin-soiled, conifer-dominated landscape and, most important, because summers are hotter and drier here than anywhere else in Ontario. The park is ecologically more similar to the dry Boreal forests of central Manitoba and Saskatchewan than to Boreal forest north of

Lake Superior — hence the term "Prairie Boreal" to describe it.

The diversity of life and colour found in burns in 'Caribou contribute a great deal to the special "feel" of the place. Imagine the life of this burn at Irregular Lake in the south of the park: a lush carpet of soft green jack pine seedlings covers the ground, contrasting boldly with the fire-blackened remains of stumps and logs and the grey-brown trunks of weathered snags. An amazing profusion of flowering plants mix with this incipient pine forest. Velvet-leaved blueberry, pinweed, Bicknell's geranium, pale corydalis, hooked violet, fireweed, and many others offer a dazzling display of form and colour to the scene. The late-summer blanket of reddening stems and leaves of fringed bindweed paints hillsides scarlet. And the sounds! Overhead, American kestrels patrol amongst the snags, searching out voles and large insects and chattering noisily at any-one who dares to disturb *their* burn. Three-toed and black-backed woodpeckers chip flakes off scorched bark in search of boring-beetle larvae, themselves participating in the great task of reducing the burned forest to nutrients for the new forest. The remarkably loud crunching of those feeding larvae which do escape the wood-peckers and other predators is another common sound of the burn. The renewal and growth is vigorous throughout.

Despite the intense heat of such fires, areas of sodden black spruce bog are spared by the advancing inferno. These form islands of mature green trees in an expanse of charred snags. How curious it is to stand in the midst of a huge, dry burn and hear the ringing sound of a Connecticut warbler or the nasal buzzing of a boreal chickadee wafting up from some distant and often hidden bog!

'Caribou is in one of the biologically least known areas of Ontario. A recent natural environment inventory determined that many of the vascular plants here represent new range records. A full dozen species are rare in Ontario and five are known from more sites here than all other provincial recorded sites put together. Most visually spectacular is the beautiful prairie crocus. Another westerner, the intricate parsley fern, is almost common in a number of reindeer lichen mats on arid, blistering-hot granite outcrops in burned jack pine forest. Both are otherwise known in Ontario

from only one location. Similarly, the western subarctic floating marsh marigold is found along boggy creeks in at least five loca-tions in the park — more than double the remaining number of Ontario recorded sites. Two western plants found on hot, rocky slopes in 'Caribou are known from nowhere else in Ontario. These include an obscure fern, prairie spikemoss, and the prairie grey-stemmed goldenrod.

Western affinity is evident in animal life too, as indicated by the abundance of the western red-sided garter snake and the appar-ent presence of a colony of Franklin's ground squirrels.

Then, of course, there is the woodland caribou that gives the park its name. Its numbers have declined alarmingly throughout much of its North American range in recent times. Studies have put its park population at about 120 animals, or one for every 3,750 ha. That density is typical for woodland caribou popula-tions and indicates that even seemingly large wilderness areas such as 'Caribou may not be all that extensive for some species.

The critical factor for caribou survival is, once again, natural fire. The caribou require vast quantities of reindeer lichen in their winter diet. The lichen forms dense growths, like grey coral, cover-ing bedrock outcrops and the ground under older, sand-based jack pine forests. It is present in sufficient amounts to support winter-ing caribou in jack pine stands between sixty and a hundred years old. And so caribou concentrate in three large areas in the park where jack pine forests are generally of that age: between Linge and Bigwood lakes in the northeast, around Gammon and Royd lakes in the central portion, and between Haggart and Aegean lakes in the southwest.

It is crucial for maintaining these caribou populations that the park always have large areas of jack pine forest of suitable age. To preserve such, it is necessary to ensure that natural forest fires continue to burn at the frequency and to the extent which they have for thousands of years. Stop the fire, cut the trees, or otherwise disturb the connection between elemental nature and those remarkable creatures, and the park's caribou will disappear just as surely as they have throughout their former range across south-central and central Ontario.

There is so much more to describe. We could consider the common and spectacular bald eagles, which nest throughout the park and are encountered daily, or the curious and rare heather vole found in mature jack pine forests at Haggart Lake, the white pelicans that visit from the west in late summer, the palm warblers that sing lustily from spruce bogs, or the rare narrow-leaved sundew which catches blackflies in patterned fens. There are, after all, more than 150 breeding birds, mammals, amphibians, and reptiles and over 420 vascular plants recorded from the park. This brief account is enough, though, to demonstrate what a natural treasure and a wilderness jewel Woodland Caribou Provincial Park represents. But with increasing recreation and resource extraction pressure, it won't stay that way without our help.

The Ontario Ministry of Natural Resources completed a management plan in the late 1980s which has made progress in advancing wilderness protection in the park. Although some of the outpost camps remain (one is so large that its summertime population exceeds that of many far northern settlements), significant improvements have been identified. Fly-in fishing, for example, is prohibited from 85 per cent of the park.

Most important, the Ministry plan recognizes several critical principles:

- Natural fire is an important and necessary ecological agent in the park.
- Large-mammal populations can only be managed by considering them as part of the entire park ecosystem and not a feature to be contained by zoning.
- Park uses which jeopardize wilderness objectives cannot be permitted.
- Resource protection, wilderness recreation, and heritage appreciation are the foremost priorities of park managers.

To this end, over 85 per cent of the park is now in protection zoning (Wilderness and Natural Zones). The Bloodvein River National Heritage Waterway occupies a further 7 per cent. Four Access Zones (in which physical developments are permissible) occupy 9 per cent of the park at its periphery.

Is this a perfect solution? No; it is, however, a major step in the right direction and should ensure that the essential wilderness character of the park remains intact until a broader public commitment to the ecological integrity of our rare, truly wild places results in complete protection for it all.

Woodland Caribou Provincial Park is an exotic and captivating wilderness of great ecological and cultural importance to Ontario. In conjunction with Manitoba's magnificent 4,000 km^2 Atikaki Wilderness Park, which abuts it to the west, 'Caribou forms the heart of a wild area of international importance. Our challenge and responsibility is to keep it that way.

WOODLAND CARIBOU PROV. PARK
BRUCE LITTELJOHN

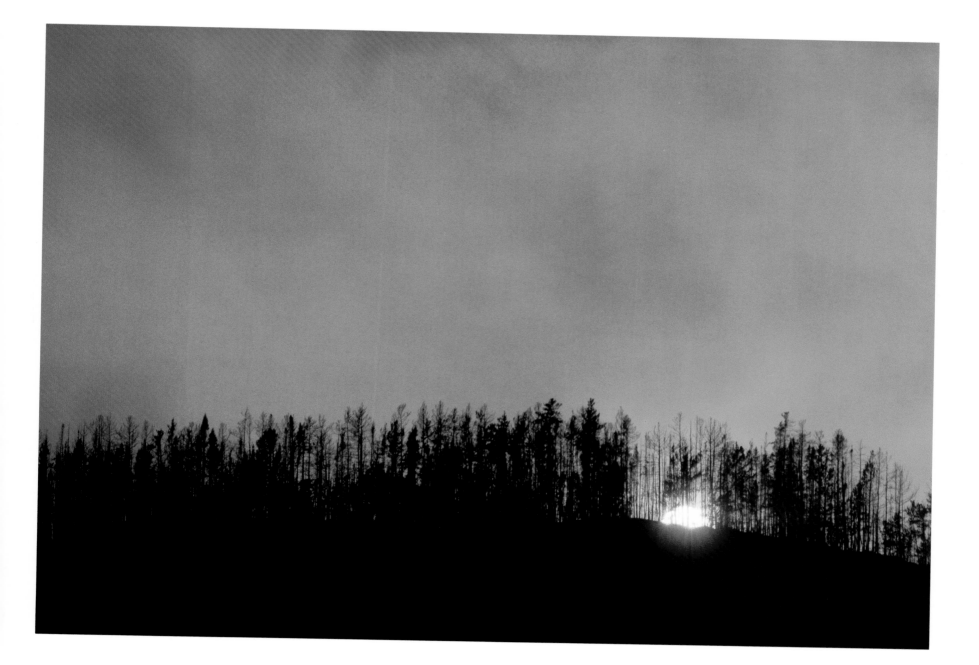

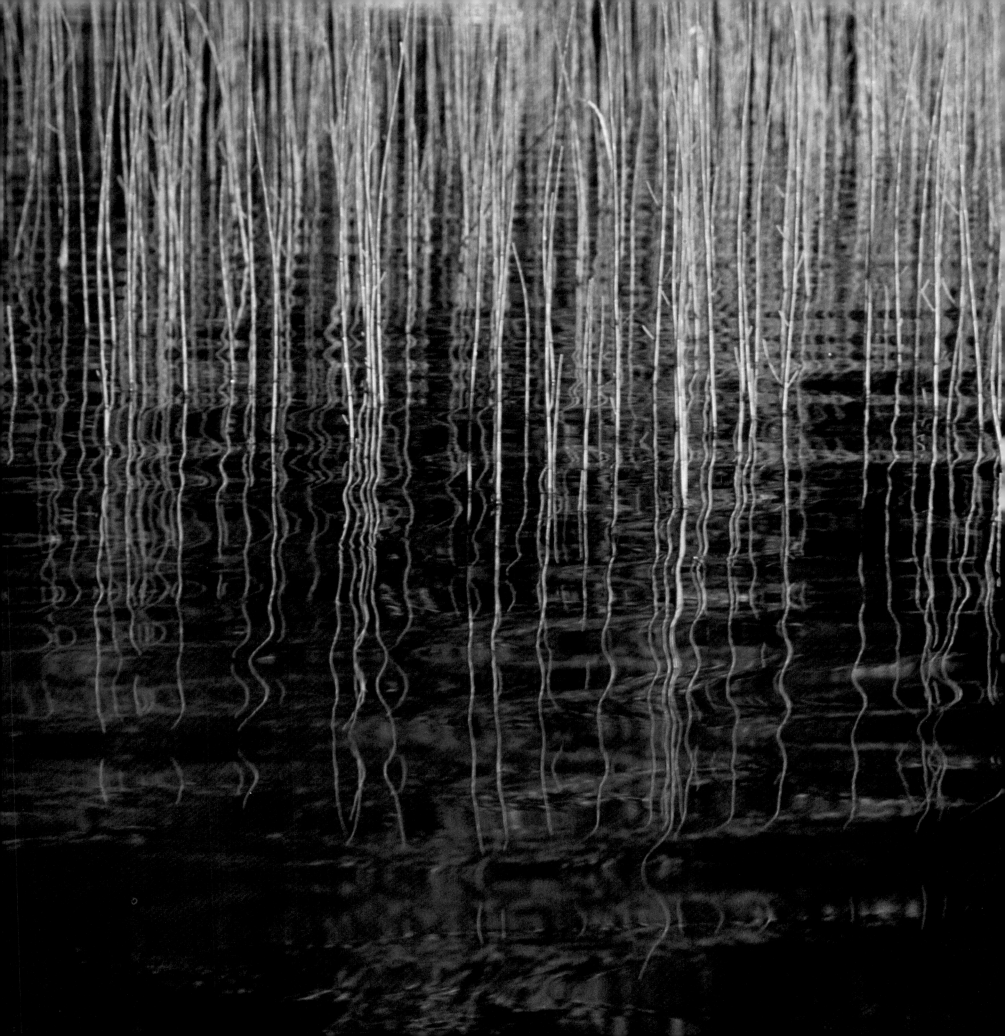

Photographic Impressions of Opasquia

Lori Labatt

The Beaver banked sharply, described a long arc over a glittering race of rapids marking the southwest arm of East Lake, then smoothed out on final approach. A gentle touch, then the roar of the engine was muffled by the whoosh of spray as we skimmed across the ribbon of water leading to new photographic adventures. We taxied into a sheltered bay to unload canoe and gear; then our pilot took off quickly to avoid a gathering storm and we were alone in the wilderness.

Bruce Litteljohn, co-editor of this Wildlands League book, looked at me and grinned: "Do you think there might be a cover shot out there?" He teased me because at the time he had the most suitable contender and knew it. I refused to rise to the bait. "Let's go and make some photographs, and we'll see!"

We didn't have to go far. Ahead, the storm clouds gathered, reflecting darkly into waters that lay like quicksilver, heavy and inert. In the calm before the storm, we recorded our first impressions of Opasquia. Low hills covered with black spruce flanked the waterway, relieved by an occasional poplar or birch. The transparent green shadows of the forest floor lay hushed and mysterious. A bald eagle rose in slow majesty and soared away at our approach.

This idyllic interlude ended abruptly when sheets of rain cascaded down, obliterating the view and complicating our search for a campsite. When it cleared, we made camp in instalments, stopping frequently to record images created by the dramatic combination of sunset and stormy skies.

Opasquia, one of Ontario's newest provincial parks, covers 4,730 km² of wilderness abutting the Manitoba border about 245 km north of Red Lake. The Opasquia Moraine is the first visible indicator of the park. A 2-km-wide ridge rising 100 m above the surrounding landscape, it is dotted with round kettle lakes formed by buried ice blocks of the Late Wisconsinan glaciation which melted to leave these distinctive depressions.

Opasquia is kind to canoeists, for many of its lakes are riverlike in form, with narrow arms reaching in diverse directions. Such topography offers endless kilometres of shoreline to explore, all of them fairly sheltered from strong winds and waves. Careful study of our maps allowed us to plan an extensive trip with only a handful of short portages — a boon to heavily laden trippers.

An unnamed river beckoned. We paddled a few kilometres against the current, anticipating the satisfaction of floating back down. Miniature marshes of horsetail jutted out from the banks, the slender green wands casting wobbly reflections on the moving water. A split waterfall stopped us, and we climbed to the top to photograph abstract water patterns and cool off in its shady pools. Ghosting downriver, we marvelled at the poplars that soared like columns toward a lucent green canopy that shimmered with the slightest breeze, and were moved to name the river in their honour.

Identifying places made our map a little more user-friendly, for we were travelling in a nameless void between East and Cocos lakes, two of but a half-dozen places names in this huge park.

A mink, delicately munching a crayfish lunch, was spotted near a chute of fast water funnelling between polished rock walls. We duly entered "Mink Chute" on the map and ran it in unorthodox fashion with me and my wide-angle lens draped over the bow.

A leisurely morning coffee was interrupted by the appearance of two yearling moose swimming across the lake. We grabbed cameras and ran for the canoe. A hard paddle brought us close enough for a couple of photographs before they scrambled out of "Twin Moose Lake" and disappeared into the forest.

My favourite place name involved a rapid encountered on day four. It was only a 2-m drop, but a large rock at the tongue channelled the water hard alongside a curving wall of rock, and the wisdom of experience suggested that we portage the gear and run the rapid with an empty canoe. Laden with packs and tripods, I

SPLIT FALLS RIVER, OPASQUIA PROV. PARK
LORI LABATT

started across an ancient trail and, rounding a curve, bumped smack into a large black bear. We both stopped in surprise, then the bear graciously turned and ran before I did, thus saving me the ignominy of having "Lori Run Rapid" inscribed on our map. Would anyone really believe that I was just running back for my camera? Bruce canoed through "Bear Run Rapid" with great finesse as I photographed with one eye on the trail in case my furry friend returned to watch the show at "his" rapid.

We'd come to this remote new park to record its natural qualities and be refreshed by its wildness, but the experience was degraded frequently and surprisingly by objectionable evidences of human occupation. Fly-in hunting and fishing camps, with their attendant garbage and noisy motors, are simply not in accord with Ontario's Wilderness Park designation.

Our travels in Opasquia coincided with a hot spell of ferocious intensity; so after days of meandering through narrow waterways in the relentless heat, it was a treat to enter the wide expanse of Cocos Lake and find a strong wind blowing in our direction of travel. We hoisted sail (a large plastic garbage bag slipped over two paddles and held aloft — not pretty, but effective) and scooted effortlessly down the lake to make camp by a tumbling waterfall. The hot winds persisted, and although thunder rumbled distantly, the rain so desperately needed did not come. The forest was now so dry we dared not light an evening fire, to the great joy of an organized and predatory band of mosquitoes that immediately recognized our vulnerability.

At 3 a.m., an eerie green glow, strong enough to rouse us, illuminated the tent. We dashed outside, oblivious to the happy hordes of mosquitoes, to photograph and revel in a magical display of northern lights. Ethereal shapes of green, pink, and white moved sinuously across the sky in dream patterns. Photography finished, we lingered to savour the rhythm and flow of nature's remarkable celestial choreography.

The enervating heat found us seeking shade most of the next day. Returning to camp late in the afternoon, we remarked on the faint smell of smoke in the air as we beached the canoe. Glancing upwind, it was disconcerting to see a huge wall of smoke advancing toward us. Within seconds, we were enshrouded in billowing, dense clouds so acrid our eyes stung and breathing was difficult. A perfect time, I thought, to grab my tripod and say to Bruce, "There's a great cover shot here!" But common sense prevailed and we dashed for the tent instead. We must have looked like characters from an old silent movie in speeded-up motion as we unpitched the tent, loaded the canoe, and made a hasty and probably undignified retreat from the ravenous fire that seemed ready to engulf us. On the water, our canoe surged forward as though the Old Man of the Lake himself were pushing it, and we slowed only after we'd put a good distance behind us.

At sunset, smoke sat layered on the horizon in an unusual palette of colour, and the extraordinary images recorded more than made up for the fire's earlier intimidation.

During the restless night, we often woke to find our campsite cloaked in a conspiracy of smoke. Hazy shadow-pictures formed and re-formed in the grey gloom. We felt great relief when dawn brought clearer air and a sense of relative security. Columns of smoke still soared upward in the north and southwest, but the fires did not appear to be moving in our direction.

I had cherished the mild conceit that if our plane failed to rendezvous on the appointed day it really wouldn't matter, but with fires and dwindling supplies a reality, I confess to unabashed delight when the drone of an aircraft proved to be the trusty Beaver.

As we winged south and the northern reaches of the Boreal forest receded, we reflected on the images we'd made for this book that celebrates our province's magnificent and diverse natural heritage. Opasquia had indeed provided photographs for celebration. It had also reminded us that even the splendid isolation of this newest park gives no guarantee that wild nature will be respected.

All of us must recognize our own responsibility if we hope to enjoy, in the years to come, a place of solitude and wonder, a place of mystery and delight, a place called wilderness.

COCOS LAKE, OPASQUIA PROV. PARK
LORI LABATT

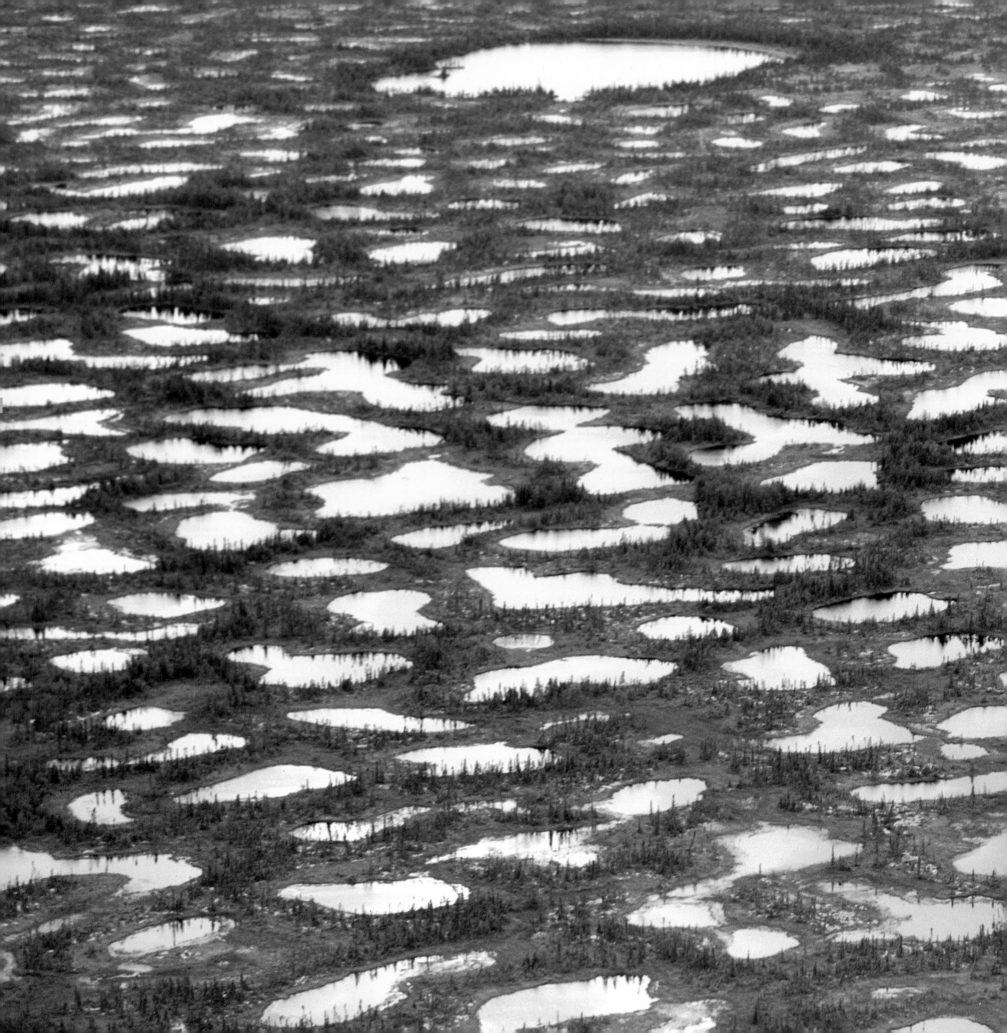

The Hudson Bay Lowland

T.J. Beechey & R.J. Davidson

CREATION OF THE LAND

Travelling northward through the myriad lakes and streams of Shield country to the majestic rivers of the Hudson and James Bay lowlands, one cannot help but notice the immensity and solitude of Ontario's wilderness. The contrasting landscape patterns of the Shield and lowlands are unmistakable – especially in the Sutton Hills, where ancient Precambrian rocks break through a thin veneer of younger Paleozoic rocks. These contrasting landscapes also are abundantly evident when one descends the Kesagami, Missinaibi, and Winisk waterways by canoe: from the irregular Shield, through patterned lowlands, to the bay.

The vast northern lowlands consist of an expansive sequence of flat-lying sedimentary rocks of the Paleozoic and Mesozoic ages. These sediments record the advance and retreat of ancient seas, the building and tearing down of great mountain ranges, and the ultimate erosion and exposure of the Shield. The James Bay Lowland also records evidence of evolving terrestrial plants and animals and the emergence of the North American continent. The stories written in these rocks are well displayed in many of our provincial parks, including the Missinaibi River and Severn River Waterway Parks and the Sextant Rapids, Coral Rapids, and Williams Islands provincial Nature Reserves.

In the last million years, the northern lowlands have experienced multiple advances and retreats by continental glaciers. These events are recorded by a unique sequence of glacial and interglacial sediments in Missinaibi Provincial Park. It was the final retreat of the glacier, however, that shaped the character of the lowlands. About 8,000 years ago, the ice mass retreated into the bay, depositing clay till, proglacial lake sediments, and vast amounts of organic peat in its wake. With the final melting of the glacier, and the removal of its enormous weight from the land, the lowlands slowly began to rise, forcing water out of the bay toward the ocean.

This phenomenon, known as *isostatic rebound*, is responsible for the creation of a multitude of parallel raised beach ridges in Polar Bear Provincial Park. The rising of the land and the beach construction continue to this day, adding new area to the park every year. Isostatic rebound also has had a profound influence on the evolution of the lowland river systems. As the flat lowlands began to rise, major drainage systems, with long primary streams, developed at regular intervals along the coast. The Severn, Winisk, Attawapiskat, Albany, and Missinaibi/Moose rivers flowed northward to empty into estuaries and marshes on James and Hudson bays. Running water created large drainage basins, incising the banks of their streams and entrenching their beds into underlying glacial and bedrock sediments.

GREENING OF THE LAND

Muskeg and permafrost country – another world – tamarack, snow geese, willow ptarmigan, arctic flora, mosquitoes and midges. Anyone familiar only with wetlands south of the lowland cannot comprehend the expansive, elegant systems flanking Hudson and James bays. All scale is warped and the senses numbed when this spectacular landscape is viewed from low-flying aircraft. Altogether, these lowlands comprise one-third of the province, an area comparable in size to the British Isles.

The ecosystems of the Hudson and James Bay lowlands represent nature's latest attempts to green Ontario's most remote landscapes following the retreat of the Wisconsinan ice front. With fewer species than neighbouring southern regions and more limiting physiographic conditions, she has done so with creativity and imagination, weaving an ecological kaleidoscope of colour and form onto the flat, newly emergent landscape. No shade of green or earth tone has been spared in her canvas picturing gallery forests on meandering rivers, isolated oxbows, endless string fens,

countless pools, tamarack thickets, coalescing bogs, productive sedge meadows, untreed tundra, saline marshes, and tidal flats.

Scientists studying these lowlands are coming to understand the genesis and organization of their bewildering patterns of communities and their biotic composition. Like the Southern Lowland and the Canadian Shield, the northern lowlands comprise a series of regions and systems determined by climatic and physiographic conditions, past and present. At the coarsest level, three principal regions can be discriminated: high Boreal forest, subarctic forest, and tundra.

Technically, Boreal forests (represented by Site Region 2E) extend into the lowland roughly to the latitude of Akimiski Island, penetrating beyond as gallery forests on the levees of some river courses and as isolated outliers. On well-drained conducive sites, the productivity of these forests is comparable to those of the Severn Uplands at similar latitudes. North of this zone (in Site Region 1E), a broad band of subarctic forest, characterized by a mosaic of spruce/lichen parklands, bogs, and fens extending between Manitoba and James Bay, eventually merges with true untreed tundra flanking Hudson Bay.

The tundra belt marks a fitting contrast to the Carolinian region some 1,000 km to the south. With as few as seventy-five frost-free days a year, it seems to defy laws of diversity and productivity in its variety of teeming wildlife. Among the world's largest terrestrial carnivores, the polar bear tops a food chain of arctic species eventually dependent on a permafrost-based herbivory. The coastal area provides internationally important staging areas for snow geese and many other species of waterfowl reliant on foraging productive goose-grass meadows and estuarine marshes. Housing Cape Henrietta Maria, and with a large core of permafrost terrain, Polar Bear Provincial Park is truly world class. If we consider it together with Lighthouse Point and East Sister Island Nature Reserves in Lake Erie, we realize that Ontarians can experience environments and wildlife typical of southern temperate ecosystems and the high arctic right at home.

PROVINCIAL PARKS IN THE NORTHERN LOWLANDS

In striking contrast to the south, the northern lowlands have not been significantly altered by human intervention. Their inaccessibility, harsh climate, relative lack of timber and mineral resources, and low population densities have helped maintain a vast wilderness. Large representative samples of this wilderness are protected in Polar Bear and Kesagami Lake Wilderness Parks. Other elements of the lowlands are found within the Winisk River and Missinaibi River Waterway Parks. Polar Bear provides excellent representation of raised beaches cross-cut by rivers emptying into coastal tidal marshes in an arctic setting; Kesagami, Missinaibi, and Winisk illustrate the transition from Shield to lowland.

Still, vast portions of the northern lowlands remain both untouched and unprotected by park status: the coast and tidal marshes west of Polar Bear; the elongated arms and estuaries of the Severn, Albany, and Attawapiskat rivers; the Attawapiskat and Gypsum Mountain karst regions; and the great inland wetlands and peatlands. The Ministry of Natural Resources has identified a number of candidate provincial parks to round out the representation of these features. These include proposals to extend the Severn and Attawapiskat Waterway Parks to the river mouths and to add several new Nature Reserves to protect lowland values.

The final regulation of these or any other park candidates will not be easy. First, existing and newly collected information about candidate areas must be analysed and presented in background information documents. Second, an open process of public consultation will be needed. This consultation must address the needs and aspirations of the people of the First Nations. Partnerships with native Canadians will be essential to the identification, protection, and management of parklands in the northern lowlands. At the same time, the needs of other resource users must be recognized. The potential impact of new parks on mining, hydro, tourism, and other activities must be assessed.

BEACH RIDGES, POLAR BEAR PROV. PARK
ALLEN WOODLIFFE

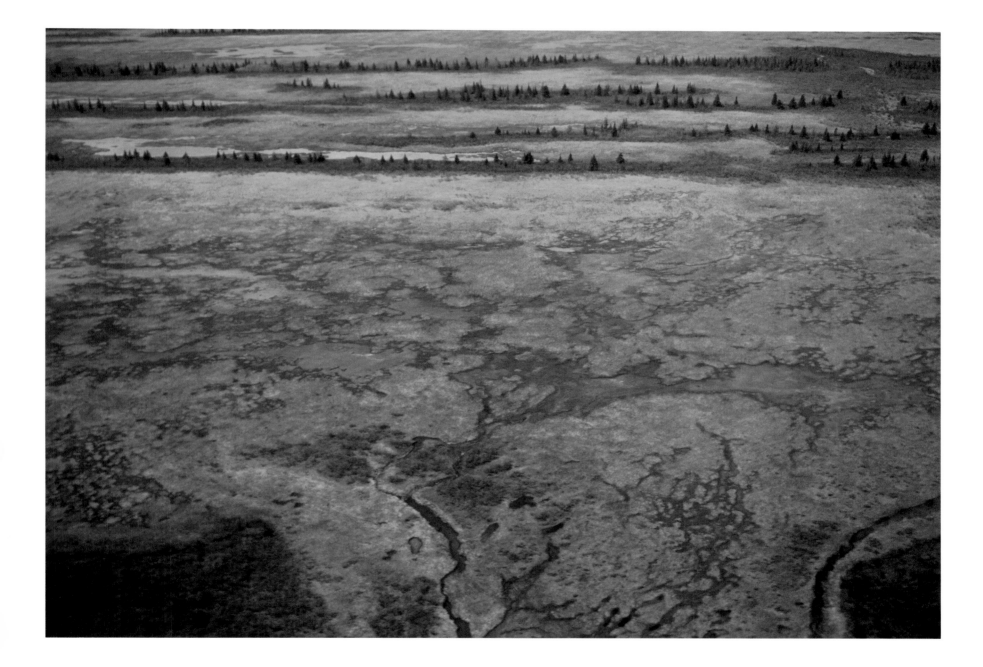

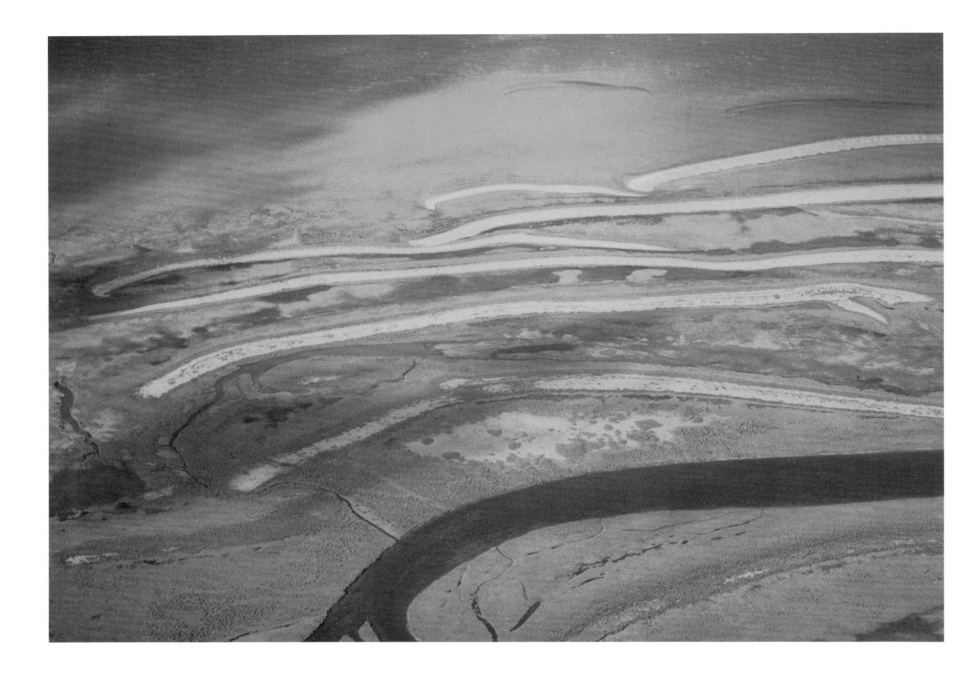

LEFT/CAPE HENRIETTA MARIA, POLAR BEAR PROV. PARK
LORI LABATT

ABOVE/HUDSON BAY SHORELINE, POLAR BEAR PROV. PARK
LORI LABATT

Kesagami – Secure? or Sacrificed?

Janet Grand

Ah wilderness! After all these years, I think I've finally achieved it.

Not without effort. I have sampled many fine rivers. Inhaled their wilderness bouquet. Gently tested their flavour. Questing, always questing. But often disappointed.

Algonquin – stoplights at the portages. Mississagi – clearcuts visible through the trees. French River – beware the motorboats! Credit River – dams, weirs, and more dams. Mattawa – the portages of the voyageurs now drowned.

But here the ravages of humankind have not penetrated. The Kesagami, its lower reaches flowing through the flat Hudson Bay Lowland, has held little to attract abuse. Upstream it is too rocky, too undependable even for the natives who fished its headwater lake. Too small for hydro dams. A quiet thread dangling from the end of James Bay, the Kesagami was a river at peace.

We are the second to paddle the length of this river, or at least the second to leave a record. The first, some fifteen years ago, left little but platitudes to guide us along its treacherous chutes and rapids.

And treacherous they are. The swift, shallow, bouldery river sweeps us along willy-nilly – 34 km of nonstop white water. We become adept at "eddying out" into tiny patches of still waters behind rocks, catching our breath as we chart the course ahead. Now the river sweeps around a blind corner and we work our way oh-so-slowly down the edge. Now we glimpse, just in time, a hidden metre-wide ledge.

We are completely alone. There is no rescue if we should smash one of our two canoes. Nowhere to put down a plane for emergency rescue. No way to signal a disaster.

But for canoeists, what wilderness wine is more intoxicating? The challenge – the fear – of an unknown river. Time and time again we stop to scrutinize the tattered air photos for hints of major falls ahead, to make educated guesses on the "preliminary only" topographic maps. Occasionally we are swept along in a churning rapid, only the long experience of paddling together keeping us upright and more or less dry. What exhilaration!

And what hard work! There are no portages around the impossible parts. We get lucky now and again to find a game trail going our way. But often we have to hack our way through impenetrable stands of alder near the river. Or haul gear and canoes over the rocks. Some days, our labours take us 2 km, and we are exhausted.

We make camp where none have camped before. We eat, and talk, and dry out, and reflect on the day's simple pleasures. This is northern Shield country, in some ways much like the other rivers we have followed as they tumble from the ancient rocks down onto the Hudson Bay Lowland. But here the rapids, the thundering falls, have no names. So a part of the campfire lore each evening is debating the most fitting names for those we have passed – names to mark our progress, to leave our calling card for posterity.

But mostly the names seem silly, insignificant against the tremendous power of such wild country. The wildness catches at your soul, encourages reflection on the natural order of things. On the Kesagami, that order is very clear – we visitors are vulnerable, powerless, dwarfed by the uncaring kingdom of the rock, and the endless forest, and the river.

Yet in a way, we are here on behalf of the Crown. We have come at the request of the Ministry of Natural Resources, to help chart this land as "official wilderness". Kesagami River has been designated a Wilderness Park; its course is now a narrow band of green on Ontario's parks map.

We wanted to experience a wild untamed river, and others wish also to do so. But the way must first be made "safe". A canoe route map must be made, marking the river's dangers and its attractions for those who will follow. This is our task.

And herein lies our dilemma. By charting its nature, do we not in some way diminish this wild river? Do we take away the challenge of wilderness? Do we not somehow "tame" it? Is this what parks are meant to do?

When we agreed to map the river, we planned to include it as a chapter in our *Canoeing Ontario's Rivers* book. Now we are not so sure. Do we really wish to encourage people to come here? Will that not also diminish this wilderness, somehow take away its essence? Not to mention the indelible tracks of people—portage trails, campsites, garbage—that inevitably follow?

During Ontario's early days, wilderness was seen as an obstacle to be overcome, to be tamed to our wishes. We think we are more enlightened now. Faced with the loss of a large part of our original wilderness, we now see its value—as a resource, a scientific cornucopia, an ecological balance necessary for global survival. And yet, by drawing a line around this boisterous river, and officially designating it Wilderness, have we not continued that process of taming?

I can't argue with the need to set aside wilderness parks. For places like the Kesagami, the whine of chain saws and motorboats is simply too near. We cannot leave northern rivers without formal protection; that luxury is long gone. But for the Kesagami and rivers like it, Wilderness Park status seems more a painful necessity than a conservation victory.

For wilderness must have a constituency if it is to survive. Is it possible to support something you have never experienced? Can you effectively mount a battle against future dams or resource extraction, for instance, without knowing firsthand what the compromises will mean on the ground?

Reluctantly, we felt that the Kesagami too must have its constituency. It must be available to others to experience the awe, the joy, the overwhelming solitude that wilderness brings, even if it is a diminished wilderness. So dutifully we handed in our notes on the Kesagami, and included its description in our book.

For me, the Kesagami experience came as close to wilderness as I am ever likely to reach. But as much as I wish others to share my experience, I realize that our maps, our guide, mean they cannot. Like many others who strive to protect the best of our wild places, I am victim to that central irony—in saving wilderness, we cannot help but diminish it for all those who come after.

Polar Bear Park

Monte Hummel

North beyond the metropolitan tentacles of Toronto, north through the limestone ledges of rural central Ontario, north past the glorious hardwoods and granite outcrops of "cottage country", north into the highwayless Boreal forest flats, north onto vast spongy muskeg lowlands, and still further north to where the freshwater taiga abruptly gives way to the beach ridges and saltwater tides of Hudson and James Bay, there at the doorstep to the Arctic stands one of the largest protected areas in the world—Polar Bear Provincial Park.

A good story has it that in the late 1960s Premier John Robarts (the "Chairman of the Board") stood fishing for sea-run speckled trout at the mouth of the Sutton River, and uttered

something like "This area has just got to be a park!" Subsequently, in 1970, with one stroke of a political pen, about 24,000 km² were officially set aside for the main purpose of wilderness preservation, thereby protecting a major portion of the Hudson Bay Lowland, most of Ontario's tundra, and a third of the province's Arctic coastline.

To impart a specific idea of what this park represents in terms of natural values, it protects a number of features which are judged to be significant certainly on a North American scale and arguably on a world basis. These include distinct landscapes and coastlines, the southernmost limit of tundra environments and vegetation, sea-run brook trout, beluga whales, polar bears, waterfowl, and shorebirds. Testifying to its global significance, Polar Bear Park has been designated a "Wetland of International Importance" under the RAMSAR convention, administered from a headquarters in Switzerland.

Obviously, such features which are internationally significant are also supremely important on a provincial basis. In addition, however, Polar Bear's isolation and wilderness character, its hiking routes along beach ridges, its canoe routes along rivers such as the Winisk which end in a beluga estuary, its seals, walrus, caribou, and non-game birds are considered unique for all of Ontario. In short, Polar Bear represents a breathtaking array of wildlife and wild space.

But 1970 was not when this wilderness was first discovered or appreciated. Centuries before, the Cree of the Northern Hudson Bay Lowland inhabited the region. Today they concentrate in three river-mouth communities affected by the park: Attawapiskat on the coast of James Bay just outside the southern park limits, Peawanuck on the Winisk River on the south-central park border, and Fort Severn up the coast beyond the northwest corner. The community of Winisk, which was flooded in May 1986, has been largely abandoned in favour of the new site upstream at Peawanuck. Altogether, these communities account for about 1,500 people, approximately 1,000 of whom live in Attawapiskat, 300 or so in Fort Severn, and up to 200 in Peawanuck.

Therefore, the prehistoric archeology of the coastal Cree, the

communities' historic role in the fur trade (especially Fort Severn), the distinctive isolated "northernness" of the communities, and the culture of the area's first peoples are also provincially significant. Herein lies the central challenge presented by Polar Bear Provincial Park: *to preserve a unique wilderness environment, while respecting and benefiting the people who live there.* Promising this in the original objectives of the park was one thing; delivering on the promise has proven to be quite another. We can wax eloquent forever about the compelling natural beauty of the area, but the practical fact of the matter is that, even in Ontario's most remote park, nature's fate is directly tied to how well we can mesh protecting the environment with the interests of people.

Polar Bear presents considerable natural constraints on what people can do there, especially visitors. For example, even during the spring, summer, and fall seasons (May to October), temperatures are cool. There are likely to be about seventy days of rain, forty days of fog, seventy-five days with frost, and up to thirty days with snow during this period. Lakes freeze in the Fort Severn area around November 1 and don't clear until late June. For safety reasons, travel along the coast is advised only for people experienced with the weather, ice conditions, and tides. When walking beach ridges, especially in the area of Cape Henrietta Maria, hikers must know about precautions upon encountering polar bears. Even if park visitors are able to maintain radio contact with one of the nearest communities, it may be days before any outside help can be made available to people in trouble for one reason or another.

The fact that Polar Bear is formally classified as a Wilderness Park also brings some legal limitations. For example, facility development and commercial activities are generally not permitted, the only exception being two goose hunting camps at the mouths of the Sutton and Shagamu rivers. These are modest, native-owned camps with tents, which are only seasonally used (about three or four weeks a season). Both camps were in place before the park was established; therefore, it seemed only fair to allow them to continue. Motorized vehicles are not supposed to be employed in the park, except canoes with outboards used by native guides at the Sutton River and Winisk River access zones, and of course along

the coast. Aircraft may land only with a government permit at specified access zones, and private planes are severely limited by fuel availability. Overnight camping is not permitted in large zones within the park. Angling is limited to barbless hooks north of 54°, and hunting is restricted to waterfowl and small game sought by guests at the goose camps.

As desirable as some of these rules and regulations may sound to wilderness advocates, they can sit quite differently with local communities where wage employment occupies only a small part of the labour force, and where transfer payments and social assistance constitute the major source of income. On the other hand, this kind of economy also means that country food, animal hides, furs, and firewood are still very important to the Cree. These natural resources will only be available if the natural wellspring, wilderness, is also guaranteed and protected.

All of these concerns are being brought together in the form of a new park management plan for Polar Bear Park. In many respects, the future of the park is being redefined in light of changes that have occurred since the original park management plan was developed in the late 1970s. For example, the native communities there are trying to improve their economic self-sufficiency, and they now want to become more involved in co-managing the natural resources of the park. The projected level of recreational use by visitors has not materialized, nor has the facility development that would have been associated with it. New research has strengthened our knowledge about polar bears, geese, ducks, caribou, wetlands, habitat mapping, flora, and fisheries in the park. Studies have also been completed on tourism development, areas of scientific interest, and community flood plans. Now it's time to focus these new ingredients on a new park management plan.

Through a series of meetings involving residents of Fort Severn, Peawanuck, and Attawapiskat, as well as interest groups such as the Federation of Ontario Naturalists, NorthCare, the Northern Ontario Tourist Operators, the Ontario Federation of Anglers and Hunters, the Sierra Club, the Wildlands League, the Wilderness Canoe Association, and the World Wildlife Fund, a discussion paper identifying issues and options has been prepared for further public input. Although the process is far from over, this discussion paper certainly gives an idea of concerns that will need to be addressed:

1. The Weenusk and Muskegowuk tribal council are proposing revisions to the park goals to more clearly reflect the objectives of accommodating traditional hunting, fishing, trapping, and gathering activities, and to pursue economic development opportunities, including tourism, "without compromising the wilderness integrity of the park".

2. A co-management agreement is being considered which would recognize the bands' traditional dependence on park resources, ensure practical solutions to conservation problems, and involve the communities in stewarding the park's resources.

3. Local natives want to use all-terrain vehicles anywhere in the park, and for transporting guests at goose camps within access zones.

4. Residents want to continue to establish seasonal camps for personal use, especially in connection with trapping. These camps are small in number and often of the traditional *muskegan* or moss-house type.

5. Although more goose camps are not likely to be permitted in the park, the two existing camps may be upgraded and used for photography, fishing, birdwatching, canoeing, hiking, and research, as well as hunting.

6. The communities would like to see more native training and employment associated with the park.

7. A marketing strategy would promote more tourism and benefits to the communities through activities such as increased canoeing, more hiking and use of naturalist routes, package tours, coastal camping and sightseeing, and boat trips along the coast.

8. Local residents feel that low-flying aircraft disturb geese on feeding grounds and negatively affect native

POLAR BEAR
PAUL von BAICH

hunting activities. A number of specific measures have been suggested to address this concern.

9. There is need for detailed information on various uses of the park area, including seasonal hazards, safety, and transporting canoes.

10. The park boundaries and zoning might be changed: for example, to establish special areas to protect golden eagle nesting habitat and polar bear dens within the park; to protect polar bear dens outside the park; to include the rest of the Sutton River, which has significant recreational potential; to include the former townsite of Winisk, which was originally excluded from the park, and the new townsite at Peawanuck, which is at the south boundary of Polar Bear and the north boundary of Winisk River Provincial Park.

11. Should there be a road from Peawanuck to the old site of Winisk, providing the new community with access to the coast?

12. What kind of economic development, including a possible lodge and commercial fishing, is appropriate for the old area at Winisk?

To conclude on a personal note, all of this is close to my heart, because I served along with the band chiefs and government representatives on the technical committee overseeing the 1988 tourism development study, and now serve on the committee which is developing the new park management plan. This work has taken me out onto the tidal flats with the geese, along the beach ridges with the shore birds, into the park interior with the speckled trout, out to the Cape with the polar bears, and of course into the communities with the people who live there. It is truly a vast, quiet land, still wild. I have been indelibly impressed by the continuous rich ribbon of brown down the coast where wild geese bring a life-giving force each spring and fall. The skill and spirit of the Cree people are equally unforgettable. I remember a skiffle of early snow sifting through a willow thicket facing the Arctic bay, and asking myself, "What will happen to all of this?"

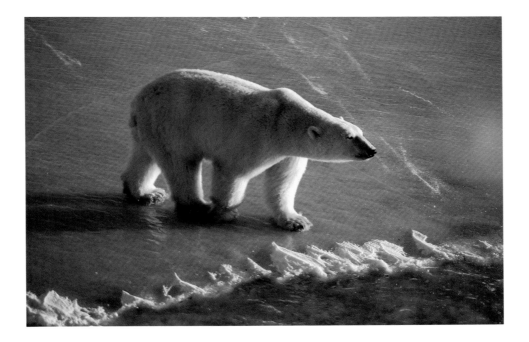

Mobilizing the Sense of Wonder

Janet Foster

As a young child growing up in Ottawa in the late 1940s and early '50s I was lucky, for nature and the wild world were never very far away. In those days, the city was more like a small town than the nation's capital, and our house was on a new street in the west end that had yet to be paved. There were still grassy fields surrounding the other new homes on our block. The beaches and marshes of the Ottawa River were a short bike ride away. The countryside was just around the corner, and always there were the Gatineau Hills visible across the river, their woods and vistas beckoning to us in every season of the year.

Springtime was pure magic! We could hardly wait for the second week in May to arrive. That was the time to take our nets and glass jars and collect toads' eggs and frog spawn from nearby ponds and ditches. What wonder there was for my sister and me in watching those small black dots cocooned in clear jelly turn into tadpoles! And we spent hours peering into the aquarium watching caddis flies encasing themselves in their mobile homes. Monarch butterflies emerging from the chrysalis held us spellbound, and we were equally enchanted by the io, cecropia, and luna moths.

We revelled in the world of the marshes, lakes, and rivers that were all within easy reach of our home. Our parents guided us into the natural world and they took as much interest in it as we did. Every Sunday we would pile into the old brown Chevrolet and go exploring. Later, we ventured forth by rowboat and then canoe, slipping into shallow bays along the Ottawa or the Rideau rivers and taking unparalleled delight in discovering turtles sunning themselves on logs and dragonflies skimming over the waters. I still remember the first night I heard whip-poor-wills, their voices seeming to wind up on springs and then calling for hours. Snakes were equally fascinating. So were mice and bats and fireflies. Every strange new creature we found sparked our curiosity and our growing sense of wonder.

Looking back over my childhood from the perspective of the 1990s, I sometimes feel privileged to have been young at a time when the world seemed young—a time when cities were towns, and towns were villages; a time when suburban development eating up the landscape was a problem of a distant future; a time when small children could still feel themselves dwarfed by a much larger natural environment. It was a time when experiencing a "sense of wonder" was as easy and as natural as breathing.

How different the world is today! Instead of being dwarfed by the natural world, we have come to dominate it—and to change it forever. The resulting crisis that faces our planet is overwhelming. There is the destruction of the rainforest, the depletion of the ozone, the pollution of our waterways, the poisoning of the soil and of the air we breathe. Species, habitats, and environments are disappearing faster than we can count them. Our national and provincial parks now strive to protect small portions of a steadily shrinking natural world that was once part of our daily lives. It was a world that we loved and perhaps took for granted, believing with a childlike faith that it would last forever. In southern Ontario, suburbs now connect many of our bigger cities where once there were forests and fields and ponds. Sometimes it seems that the kinds of special natural places I grew up with and treasured as a child are slowly slipping away, and increasingly I am reminded once again that wild places never grow, they only diminish. Must *this* be our legacy?

As a people, and as a society, we have been challenged as never before. If the natural world and wild places are to survive, the very fabric and meaning of our society must change. Values and

NEAR BASS LAKE PROV. PARK
FREEMAN PATTERSON, MASTERFILE

priorities must be altered, and so must our lifestyles. Perhaps never before in human history has the perspective been so clear, or the demands so imperative. And there is no certainty — no guarantee — that in the next ten years we will be able to "turn things around", to alter the unrelenting course of progress, to save our beautiful planet . . . and ourselves.

But change we must. And I like to think that this generation is better prepared to meet that challenge. True, marshlands are disappearing all over Ontario, but think for a moment how much more we know about them and about the vital role that all wetlands play in the ecosystem. We have become the beneficiaries of so much information about the natural world. Teachers, writers, scientists, naturalists, broadcasters, educators, guide and scouting groups — and caring parents — have all helped spread the knowledge. Students today are more informed and better educated about the environment than we ever were. When I was growing up, there were no courses on environmental studies. Recently, a little girl told me all about the chain of life, and how important it was that the links between mosquitoes and dragonflies and birds never be broken for then "we would lose our living things". She was in Grade 2.

Children are in a good position to fight for the kind of world they want. Already, their voices are finding expression. But now there is another hurdle. How can you fight for something you have never known? Thousands of young people, many of them coming to Canada as immigrants from distant lands and different cultures, are growing up in metropolitan centres where they have almost no contact with a wilder and more natural world. Zoos and well-manicured city parks can't do the job. They often give a sense of unreality to wild things. And for many working parents, weekends exploring in the country or summer holidays at a cottage are only dreams.

I began writing about nature for young readers more than fifteen years ago. Filming assignments have taken my husband, John, and me all across this land, and up into the High Arctic, and so I have been able to share our wildlife encounters with children through writing. But what gives me much greater pleasure is to take our images and true life stories into elementary school classrooms. I have talked about and shared a love for wild animals with countless children from kindergarten to Grade 8, from one end of Canada to the other. I have seen them become captivated and enthralled not just by stories of polar bears, whales, moose, and arctic caribou, but also by the deer mice that share our log cabin, the orphan porcupine who stayed in our fields all summer, the bluebirds that come back to our nesting boxes each spring, the garter snakes that live under the rocks — the chipmunks, praying mantids, flying squirrels, and foxes.

How naturally and inquisitively young children respond to the wild world! How positive and enthusiastic is their approach to nature! What a force to be reckoned with they will become as adults if we can just help them hang on to their curiosity and enthusiasm, if we can mobilize that sense of wonder!

Of the many things I learned as a child, nothing was so important, so valuable, or so lasting as that sense of wonder about wildlife. It has stayed with me down through the years, filling and enriching my life. All children are born with a natural curiosity. It's part of being human and something we share with all living creatures. How easy it is to fuel that curiosity, to see young eyes widen in wonder! Mud, worms, and "creepy crawlys" can be made just as interesting to youngsters as pretty birds, trees, and flowers. Perhaps even more so.

We have a neighbour in the country — a grown man — who is terrified of mice.

So was his mother . . . and his grandmother. Fear has been passed down three generations. And I remember the words from the musical *South Pacific*: "You've got to be taught to hate and fear, you've got to be taught from year to year . . ." But today, perhaps because of wise teachers, our neighbour's young children are slowly losing that fear. And perhaps some day their children will keep mice as pets.

In northern Alberta one year, I was showing slides and telling stories to a Grade 3 class. At the end of the hour, a small boy came up to me. He was wearing large, round, metal-rimmed glasses and he looked very, very serious. "Mrs Foster," he said, "I've had a big

SAUBLE BEACH PROV. PARK
PETER van RHIJN

problem. I've never known what I am going to do for the rest of my life." Then a look of pure triumph lit up his face. "But now I know! I'm going to write about animals!" And more recently, at a country school, another small boy (Grade 2) told me, "When I grow up, I'm going to do something *really* important for the environment!" Youngsters like these have to be the hope of the world.

The real challenge to us, as communicators and educators, is finding a way to make "nature" and the "environment" meaningful and relevant to young people wherever they live — in towns, cities, or the country. We must encourage them to care for a natural world that is their real home, and for the wild creatures with whom they share that world. And we must help them to find their own voices and expression. But what is even more important, we must try to instil in young minds that precious sense of wonder. For without it, there can be no hope that what we value most — parks, wilderness, wetlands, and special places — will survive to become the natural heritage of all children.

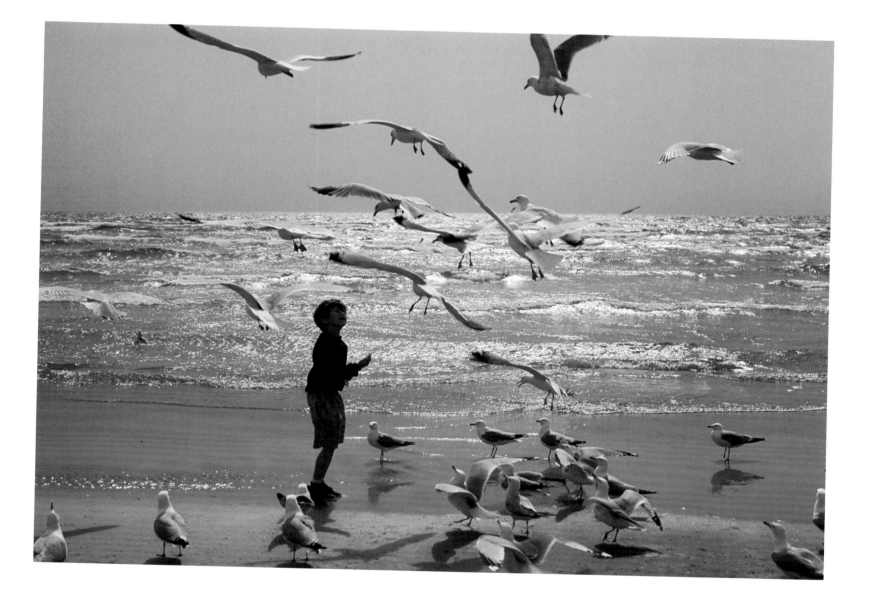

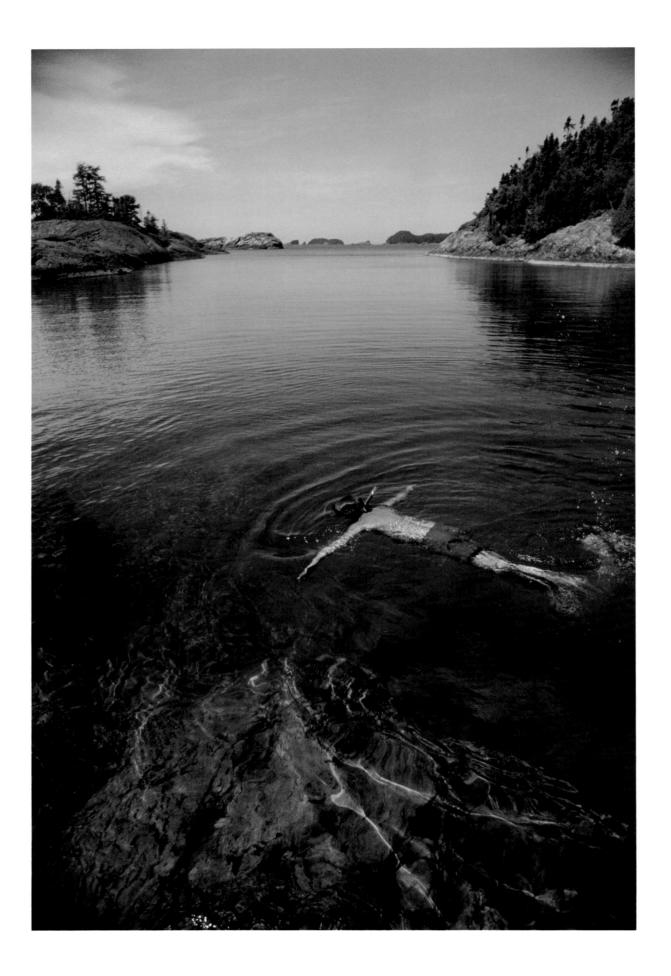

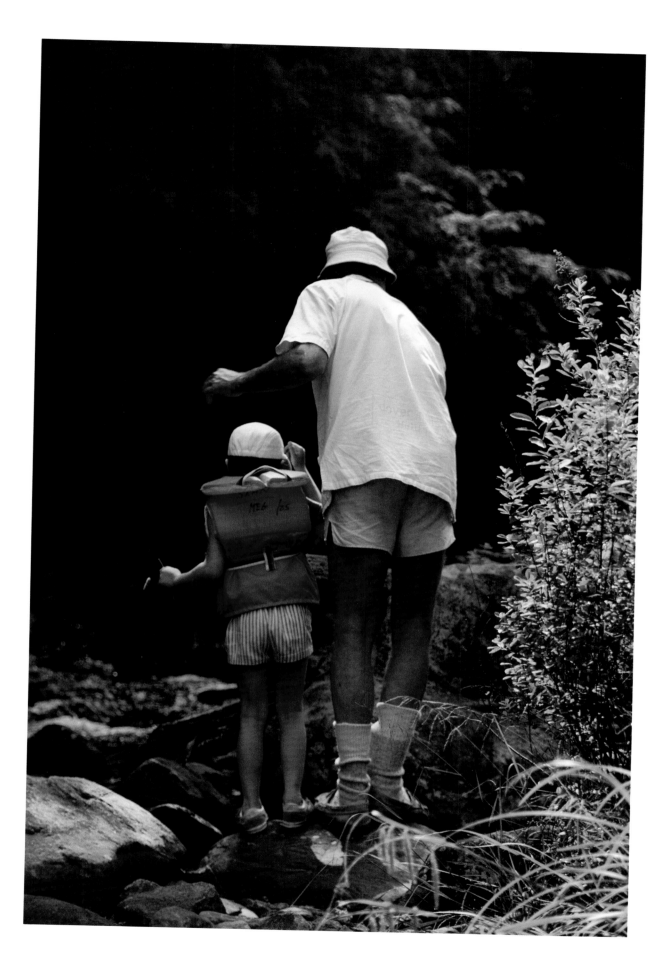

LEFT / LAKE SUPERIOR
PROV. PARK
BRENDA WALTON

RIGHT / ARROWHEAD
PROV. PARK
LORI LABATT

The World According to Mark

Lorraine Monk

From time to time, I am reminded by a small boy in my life that I too am a part of what he passionately refers to as "the world of nature".

Hearing me confide one weekend to a friend on a trip to Georgian Bay how much I feared and disliked snakes, Mark thrust his angry little face into mine.

"You don't like snakes?" he demanded.

"Not especially," I replied defensively.

"Then you don't like yourself," he announced, with all the vehemence he could muster. "Snakes are a part of nature. And you're part of nature. So you don't like yourself!"

His scorn and his logic hung in the air, creating a giant chasm between us.

This exchange took place three years ago when my young friend was four. He is now seven — an older and wiser champion of the philosophy that everything has a right to live and that we are all forever linked in the miraculous universe he calls "nature".

It is not easy having a youthful Albert Schweitzer constantly monitoring your actions. Mark saves ants from the ant traps he finds tucked under the sofa in the sunroom. Mark banishes fly swatters. Mark rescues nasty-looking spiders from the basement corners and releases them to the safety of the backyard, admonishing them to "run . . . run . . ." lest some less sympathetic human feel impelled to stamp out their tiny lives.

I have learned a lot contemplating Mark's youthful mission to save the world. His world. Our world.

I no longer recoil when I am presented with one of the little critters he has rooted out from under a rock in the backyard. I have learned to control my squeamishness when he proudly displays a wiggly beetle in his mud-stained hand, urging me to hurry and find a receptacle worthy of the strange-looking bug upon which he focuses all his rapt and wondrous delight.

I try never to use the forbidden word *disgusting*. Too often he has angrily reminded me, "In nature, there is no such thing as disgusting." I have come to respect this latter-day saint of creepy-crawlers. His childlike creed has the simplicity of a universal law. "Everything has a right to live. You are a part of the snakes you are afraid of. You die when a bug dies."

I am moved to a tenderness bordering on tears as I watch this wise, curious child return to his exploration of a small garden which is to his keen eyes as mysterious and thrilling as any scientific dig since the world began.

His reverence for life is awesome. Day by day, I find myself being drawn into Mark's world, Mark's perception not of the way things are but the way things ought to be. More than the television specials I have watched with their flaming spectacle of the rainforest disappearing at the rate of one hectare every two seconds, more than the newspaper articles with their grim statistics about the damage caused by acid rain and global warming, more than the illustrated books with their lovely photographs of endangered species and disappearing plant life, Mark has moved me to a new and deeper awareness of all of the life that is in danger on the tiny blue planet we call our home.

His message rings in my ears. We are the dinosaurs. We are the whales. We are the planet. It is not them. It is us. We are one.

Mark watches the film *Jaws* and falls painfully in love with the shark. He is transported to heights of ecstasy by their extraordinary beauty and power. He admires the renowned shark scientist, Dr. Eugenie Clark, who teaches him that sharks are the world's oldest living creatures. "They were alive when the dinosaurs were alive," he reminds me softly. His sense of wonder at so thrilling a fact is contagious. He weeps for sharks casually killed for sport.

I have learned to respect his preference for sharks and crocodiles in his evening bathtub rather than the more traditional ducks

and frogs. I have not yet conquered my fear, even revulsion, of snakes, which continues to mystify him. "How do you think you look to a snake?" he asks belligerently. This is a question I have never been faced with before and I find myself wrestling with yet another of Mark's challenges.

Mark's love of life—all of it—is as reverent and unconditional as that of Saint Francis. In the beginning I was moved by Mark's innocence. Mark's simplicity. But what moves me now is his passion. I am caught up in Mark's world.

Almost as a daily ritual, Mark presents me with drawings and paintings and plasticine sculptures of the things he loves. Sharks. Crocodiles. Bugs. Worms. Snakes. Each picture finds its allotted time and place on the fridge door. There is ample time for me to study each figure, and I observe each one intently. There is, I

discover, a lesson for me here. Mark has graphically demonstrated to me that everything that lives is important. Scarcely a day passes when he does not remind me, "When something dies, we die."

Of course, I recognize a larger reality at work here. Mark's dire warnings aside, I have not yet given up slapping mosquitoes who bite my limbs. But there is a bigger force here which his compassion has forced me to confront: every year more than a thousand different species of plants and animals become extinct. Mark has not learned this statistic yet. But in his compassion and caring, I sense he feels the danger.

Studying the shark on the fridge door, I make a fresh resolve to pay more heed to Mark's words. To do something. For I see now to ignore them would be to deny my own existence. And Mark's. And Mark's world.

Learning to Love Wilderness

Tija Luste

I cannot recall a time in my life when the gentle sway of a canoe and the "clink clink" sound of water against the side of its aluminum hull was not familiar. It is a soothing setting, one that never fails to relax me. An affinity with canoes can be developed at any age, but perhaps my twin brother and I had a head start, as my parents spent several weeks canoeing in Labrador just months before we were born.

While I do not remember the times and places of my first canoe trips, I have proof in the form of my father's journals and photographs that my parents took me and my brother to various provincial parks when we were three and four years old, still taking afternoon naps. Napping in the canoe must have been a supreme

experience, because to this day I find I can lean back and fall asleep in a canoe within minutes.

Since then, our family has made several trips to Algonquin, Killarney, Quetico, and Lake Superior provincial parks and Pukaskwa National Park, as well as trips along the Missinaibi and Ogoki–Albany rivers. More recently, owing to the time constraints associated with attending university and earning tuition in the summer, my canoe tripping has been confined to long weekends in Algonquin Park.

My first experience with the Ontario wilderness for an extended period of time was a five-week, 650-km trip on the Missinaibi from Hawk Junction to Moosonee in 1977, when I

was almost eight years old. Although my journal from that trip (my father, in his farsightedness, encouraged me to keep one and it has provided much family entertainment) is full of comments such as "I miss my bike, I miss movies" etc., with hindsight I can say that that trip marked the beginning of my love for Ontario's wilderness.

It all began weeks before the actual trip. We spent our days preparing, packaging food, and counting out hard candies. Then we planned the packing of the backpacks, while my father tried to distribute the weight among the children according to strength, and we tramped around the block, practising portages. Although we outwardly expressed embarrassment at being seen by our friends during these "dry run portages", inwardly we were basking under their envious glances as we prepared to head out into unknown territory. The adventure was delayed by a long and tortuous journey in our old Volkswagen van, and a brief trip on a train, but we finally arrived at Hawk Junction, where we loaded up the canoes and pushed off.

Developing an appreciation and affinity for the wilderness is not something that can be done instantly or in a few days. During those five weeks, my father often despaired that we would remain city slickers forever, as we complained about the monotonous scenery and whined about how bored we were. Our whole day revolved around mealtimes and candy breaks. Coming from a household where candy was available only on Halloween, we naturally focused on these usually forbidden treats. There were only a certain number of candies per day per person, because of weight restrictions, and by the end of the first week we lived for them. It became so that the most effective method of getting us to cooperate was the promise of, or withholding of, those beloved candies.

I was in a canoe with my sister, older brother, and father, and a typical exchange taking place several times an afternoon might go like this:

"Dad, I'm tired, and my arms hurt. When are we going to stop?"

"You girls have been whining all day. Paddling builds character, and I can't paddle the canoe all by myself. If you don't stop complaining, you'll lose a candy."

And we shut up. Of course, at that age we were not particularly interested in building character, and we failed to understand why anyone would become irritable after spending eight long hours in a canoe, day in and day out, with two chatty and sometimes whiny girls of seven and eight. Consequently, our journals were full of comments about "our father the dictator". I do not know if the experience built character, but gradually we began paddling full days without noticing the aches in our arms, and we developed an appreciation for the pleasant tiredness that comes after a day of physical labour in the outdoors. That has stayed with me today, along with a love of natural beauty.

Another wonderful use of those revered candies was as inducements to clean up the campsite. Upon landing each evening, my father would promise an extra candy to the person who found the most litter. While we were initially fuelled by a natural sweet tooth and simple sibling rivalry (there was a great feeling of power associated with savouring your extra candy while the others looked on enviously), these contests accustomed us to clean campsites and taught us how to pick up after ourselves.

Thus, while we fought over candies and argued about who got more dessert, we were living in the wilderness and learning an appreciation for nature and our ability to live in harmony with it. And the rest of our acclimatization to nature often passed us unnoticed, as well. Essentially, our parents set a daily routine, and we followed it unwaveringly: get up, have breakfast and break camp in less than an hour, paddle until the mid-morning candy break, paddle until lunch, eat lunch, paddle until the mid-afternoon candy break, and then paddle until we set up camp and eat dinner around 6:00 p.m. Bedtime was 8:00. Sometimes an event would interrupt the routine for a few minutes, such as a moose-spotting, or an exciting rapid, but we kept so much to our routine we almost stopped *noticing* the wilderness as we lived, in the fullest possible way, *in* nature. We became comfortable with getting up and going to bed with the sun, squatting in the bush, and cooking over fires.

However, there were two exceptions to this automatic and painless adjustment: mosquitoes and wet feet. On those early trips

we noticed *every* little mosquito, blackfly, and sand fly, and we were acutely aware of wet shoes and socks.

Personally, I preferred the "anticipate and prevent" approach. The Missinaibi was very low in the summer of 1977, and we would come to stretches only 6 or 7 cm deep. As we gradually came to shallower water, I would ask my father if we were going to have to get out and walk, to lighten the canoe. If he said yes, my next question was whether I could take off my shoes and socks. If the river bottom permitted it, he said yes again, and I quickly whipped them off, so that by the time we had to walk next to the canoe, I could go barefoot. On the occasions when the river bottom was sharp rocks, I would take off only my socks, and my sister and I would squish along until we were back in the canoe and we could lay out our shoes to dry.

For the bugs, my father had brought along head nets, and I believe he used his twice on that trip, while there were perhaps two days when I did not use mine. If one mosquito showed its face, my head net came out, while my father bemoaned my obsessive behaviour and wondered aloud if his children were ever going to become real lovers of the outdoors.

What made that trip special, and others taken around the same age, was our ignorance of maps and our location in terms of the rest of the province or country. We did not know where we were and truly felt that we were canoeing uncharted waters. This feeling was intensified as we paddled for days without seeing other people. The vastness of nature was overwhelming and indescribable. We always felt it was a little miracle when the trip finished and we rounded a bend in the river and saw civilization. Having learned to read maps, and now knowing where highways pass just kilometres from my campsite, I have

never been able to recapture that feeling of vastness and isolation.

The last "real" canoe trip (i.e., one over three days) I took was in the summer of 1983 when my father and I paddled along the north shore of Lake Superior from Grand Portage, Minnesota, to Sault Ste. Marie. Many aspects of that trip were new and different. First, because we did not anticipate any portages, we loaded the Grumman as full as possible, and took all kinds of extra clothes and snacks. Second, we never lost sight of civilization, as we passed four or five yachts a day and a major town at least every four days. This made the trip interesting, but I must admit that I prefer interior canoeing to "get away from it all".

However, other aspects of that trip were one hundred per cent improvements. First, I never got my feet wet, except for one day in a rainstorm and another day when I fell in while pushing off. Second, there were hardly any mosquitoes. And third, since I was the only other person on the trip with my father, I was consulted about what time to set up camp, get up in the morning, eat meals, and take breaks. We set our own routine each day. That was the first trip where I felt I was in control of the situation, and it relaxed me to the point where I was able to spend even more time enjoying my surroundings.

Today I go camping or canoeing every chance I have, purposely get my feet wet when running rapids or portaging, and rarely notice mosquitoes. It seems my childhood experiences have actually taught me something. I credit my love of the outdoors to my parents, who took me on long and frequently miserable trips. If that seems like a contradiction, think about it: if you have lived through and survived to tell about the worst, then everything else seems like fun.

LUNA MOTH
MARY W. FERGUSON

The Camp Experience

David Lang

I am following a deer trail deep in the bush. Stopping occasionally to judge the direction of the wind and the angle of the sun, I note the ambient sounds of the forest: the rustling of leaves, the creaking of limbs, the faint gurgle of a nearby stream. The brief sound of a breaking twig catches my attention and I remain still. Suddenly, from out of the shadows, a group of deer meet me face to face on the path. Their black-rimmed ears rise to attention. Their eyes grow wide in startled recognition. Then they are gone, surging past me on both sides, close enough to touch.

A doe and fawn trailing behind are alerted by the noise. They split up, with the young one moving into the dense brush below me to the left, and the mother going to the thickly treed higher ground to my right. I wait with a growing sense of wonder and contentment as I am observed carefully by the two of them. The fawn eyes me curiously from behind a log, seemingly convinced of its invisibility. The doe stands patiently with one leg poised for flight, keen to react to the slightest movement on my part. Our standoff finally ends several minutes later when the youngster loses interest and wanders off. Its mother leaves quickly to join it.

This encounter reminds me of my first trip to summer camp in Algonquin Park at the age of nine. As I boarded the camp train at Toronto's Union Station, I remember feeling nervous about leaving home for the first time, but somehow comforted to be among hundreds of other name-tag-bearing children making the same trip. Our arrival at camp was startling in its difference from the hot pavement, tall buildings, and traffic noise of the city that we had left behind. Certainly the scene was frantic with the sound of unpacking, staff greetings, and renewed friendships; but there was also a stillness about the place. I think it resulted from the collective hush that comes over us when we first encounter the beauty of a natural area. We breathe in deeply to taste the pine-scented air. Our ears become sensitive to the sounds of water

lapping on rocks, wind blowing through the trees, the buzzing of insects, and the songs of the birds. Often, those sensations only begin to register at the conscious level when we acquire the language to describe them. To a nine-year-old camper it just seemed tremendously new and exciting!

So much happened in those first few hours. After meeting our counsellor and cabin-mates we learned how to make up our bunks and do the other little things necessary to change a rustic log cabin into a summer home. Our section director outlined the huge array of daily activities available to us: from swimming, canoeing, and sailing to tennis, volleyball, archery, and baseball, drama, arts and crafts, and nature study. It was so noisy during our first meal in the huge dining hall that we couldn't hear our own nagging thoughts of homesickness. That evening we gathered around a campfire staring alternately into the flames, the glowing faces of the other campers, and the incredibly star-filled sky overhead. We learned songs that would stay with us for a lifetime, forever etching this moment in our minds.

> "Fire's burning, fire's burning
> Draw nearer, draw nearer
> In the gloaming, in the gloaming
> Come sing and be merry."

My most valuable camp lessons came from the first summer. They had to do with adapting to a new environment, meeting new people and accommodating their individual needs, and working together in a group for a common goal. There were children in my section from many different backgrounds. Some were worldly and widely travelled. Others, like myself, were uneasy about being away from their familiar support groups of family and neighbourhood for the first time. From the French-speaking kids we learned the

rudiments (beginning with the swear words) of communicating in a second language. At the same time we became aware of the trauma of adjusting to life in a culture with a different first tongue. A few of the campers came from wealthy and powerful families living in Spanish-speaking countries far to the south. They had led cosseted lives, with maids and servants to attend to their every need. The rough-and-tumble egalitarian experience of living with others in a camp setting seemed to benefit this group most of all.

It was clear from the first summer that my favourite activity was canoe tripping. While stumbling under a heavy pack, wading through a bog, or dragging our gear to shore and setting up camp at the end of a long day of paddling and portaging, I discovered a strength that I didn't know I possessed. It felt good to push my body to the limits of physical exhaustion. Besides, our most tiring moments were always rewarded by treasured glimpses of unspoiled beauty: a foraging moose, belly deep in a lily pond, raising his head amidst a cascade of water and grasses to observe our passing; the cathedral-like shafts of smoke-filled light arching across the campsite; the haunting cry of a solitary loon echoing over the still water just before sunrise.

Modern people's instinct seems to be to conquer or destroy the things that they don't understand; to subdue the remaining wild areas. At camp, our introduction to nature came in a supportive setting. Through understanding some of its vagaries we learned to view the wilderness without hostility. We became respectful of its fragility and concerned for its preservation. Above all, we gained an appreciation for the joys of a simple hike in the bush . . . and a chance encounter with a deer.

Hong Kong Viewpoint

Justin Tsang, aged 14

Canada is the second largest country in the world. It spans a huge area from Lake Erie to the Arctic Ocean and from the Atlantic to the Pacific Ocean. Internationally, Canada is envied by many other countries and is thought of as a place of vastness and open space where people can afford houses on big lots.

My whole family was born in Hong Kong, but eight or so years ago we immigrated to this country. Being an ignorant six-year-old I had never even heard of Canada and had never dreamt of such wide-open space. Today, having had a chance to compare this country with Hong Kong, I think that Canadians don't value enough the amazing amount of space they enjoy.

Hong Kong, even including the New Territories, is tiny — just over 1,000 km². Yet it has a permanent population of more than six million and about five million visitors each year. Some 92 per cent of the colony is urbanized. By contrast, Ontario, which is just a small part of Canada, is 1,068,580 km² in size, far more than a thousand times larger than Hong Kong and with far less than twice the population. Although the heavily urbanized parts of southern Ontario are fairly heavily populated, the province-wide population density is about nine persons per square kilometre. In Hong Kong, the population density is about 5,400 per square kilometre and is much heavier on Hong Kong Island, the centre of the colony. Here development expands upwards because of the lack of space. Only rich people can afford houses, which are mostly

found on mountainsides or around the Peak area on Hong Kong Island. All the lowland areas are used to build high-rise towers, some of them seventy storeys tall.

Space, to put it mildly, is in short supply. The average Hong Kongite might be familiar with the small urban parks of Kowloon, Victoria, and Hong Kong, but has no experience or impression of true wilderness. Compared to Ontario's provincial parks, Hong Kong has small and mostly cultivated recreational areas, plus some nature trails and a few campsites and beaches.

When we immigrated to Canada, I was overwhelmed by its vastness. Its sheer size and my unfamiliarity with the land made me feel very lonely and insignificant. There seemed to be too much nature, and it took time to get used to it.

My background in Hong Kong had not taught me to appreciate so much open country or the beauty of nature. In fact, with such little variety and opportunity, many Hong Kongites tend to think that there is not much for them to do out-of-doors. When many people think in such a way, the problem really becomes a cultural one. As my father says, "The kids in Hong Kong go to membership sports clubs for recreation. The kids in Canada go camping or go to family cottages." However, in Hong Kong this attitude is slowly changing. The government is allocating more land for parks and promoting environmental awareness. This task is difficult, given the shortage of resources and lack of available space. Even though more and more people in Hong Kong are trying to be closer to nature, the city parks are small and artificial in comparison to Canadian ones, the biking routes are often crammed, and camping grounds are hard to find.

Differences in lifestyle also affect recreation. Taxes are not very high in Hong Kong, and social services provided by the government are very basic compared to Ontario, where, for example, most medical expenses are covered by OHIP. With minimal social welfare, people have to work extra hard, so work often replaces the dream of weekends devoted to outdoor recreation. Asians, in general, have a lower standard of living than North Americans and simply do not have the leisure time or the money to take vacations in the out-of-doors.

It is different here. I have already spent eight years in Canada. It has always been a home away from home for me, and will continue to be. People often ask where I prefer living. When I was younger, I'd reply, "I like both places." As I grow older, my answer is, "I may spend some of my working life in Hong Kong in the future, but Canada is certainly more appealing as a place to live." I have grown to love the wide-open spaces that are so difficult to find where I was born.

I hope that Canadians who read this essay, and who have not lived in a crowded environment such as Hong Kong, realize how rich they are in terms of their natural environment. All over the world there are places, like Hong Kong, that are overdeveloped and crowded — places that never really planned ahead and suddenly realized that they'd forever lost their wild nature to urbanization and other human activities.

Canada, fortunately, still has wilderness areas left, but if they are not protected, they may rapidly disappear. Wilderness is a gift from nature, and can never be reproduced.

LEFT / PAINTED TURTLES
KARL SOMMERER

ABOVE / MARSH WREN
MICHAEL RUNTZ

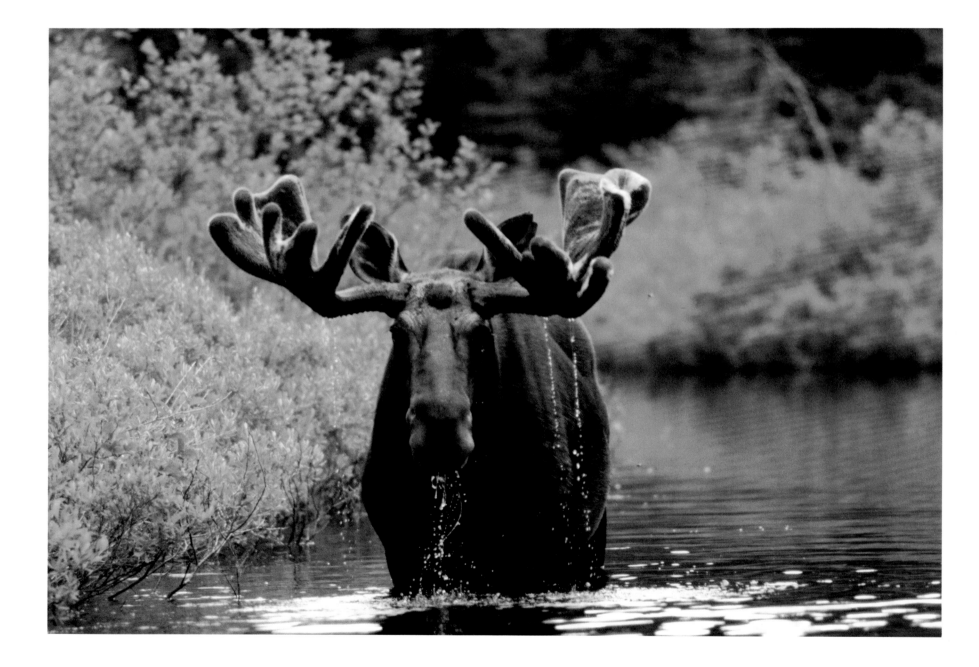

Wilderness

Brandy Stewart, aged 13

Wilderness is not something that can be pinpointed.
It is no one or single thing alone, but a combination of many.
It must be felt to be understood, understood to be appreciated.
It is not just a walk in a forest.
Nor is it a paddle down a river or a swim in a stream.
It is not the act of doing these things alone, but the feel that comes with it.
You can swim in a pool, paddle on a canal or walk down a sidewalk.
It is still the action but the wilderness is not present.
Wilderness is quiet.
Wilderness is animals.

Wilderness is land.
Wilderness is a place, one for quiet and peaceful times and one for great laughs and memories.
One's appreciation for this great gift grows with time and experience.
It can be nurtured in no other way.
Not with money, nor equipment, but with understanding and appreciation of nature and its values.
Wilderness is the feeling of enjoyment and peacefulness, once it is gone nothing artificial will ever replace it.
Wilderness is non-renewable.

Sunday Reflections

Derek Tse, aged 16

One day, I began to think. It was a cold Sunday, the type where you don't want to do a thing except stay inside in the comfort of your own home, with its artificial heat, artificial lighting, etc., etc.

Anyway, I was sitting there in my chair and a few thoughts somehow managed to sift through my clouded, early-morning brain. Thoughts like "Gee, it sure is cold today" and "Man, I wonder what's on TV today" and "My goodness, what is Canada all about?"

Well, it was that third question that stuck to me the most. Canada.

Spelled C-A-N-A-D-A.

A nation that's tacked to the United States and shares her ideals.

A country composed of provinces.

A, ahem, "world next door".

I began wondering how Canada got its name. It didn't sound French, or Indian, or English. It sounded unique.

You know, different. It stood out on its own. Make a list of countries like the United States, France, Britain, China, the Soviet Union and . . . Canada. Kind of sticks out, eh?

BULL MOOSE FEEDING
ROLF KRAIKER

Canadians are unique. We use mannerisms like "eh", we like sub-zero temperatures, we're a totally multicultural nation, we are bonded by words said and written hundreds of years ago, and we all love Wayne Gretzky. Most of us do, anyway.

Our country is unique. We've got a bunch of different, diverse provinces and each one, every single one, has some beautiful forests and natural environment within it.

Places totally untouched by human progress, places that are havens of green, leafy paradises. Places that are wonderlands of wildlife undaunted by nature's unintentional cruelties like the cold and snow. Places that are, well, magical.

Take a trip to one of these places (leave the Walkman behind) and you'll experience the . . . uh, "magic". A week, two weeks, three, four. You'll get a feeling of return, of going back. Of union with your country, of love.

I took one such trip a while ago and while I paddled my canoe, a moose grazed peacefully at the riverside. He looked at us, and we looked at him. He kept looking, munching the grass in his mouth, and eventually returned to his meal. We became, I suppose, a part of the wild, and we shared that wild with the moose.

"My goodness, what is Canada all about?" Yeah, that was the question I'd asked earlier.

I think I've just answered it myself.

Finding Our Feet

Jenifer Sutherland

One summer when I was about five my father made a joke about a pair of old shoes he was going to throw away. It was a public joke — he was welcoming a group of university students on a leadership retreat to an island in Muskoka. He held up the shoes so that everyone could see how the bottoms were worn right through, so that everyone could see, he said, that this island turned out holy souls. I knew what a soul was — I'd been told I had an eternal one — but I didn't have the faintest idea how it worked. The soles of my feet, though, now that was a different story. I knew the ins and outs of them, all right. All summer long on the island I ran barefoot, grazing my heels on the rock, stubbing my toes on roots of trees, stepping on nettles and sharp sticks and wasps. "Just look at the soles of your feet!" someone inevitably wailed around dinnertime,

and it was clear what I was expected to do. But my eternal soul was harder to get at. It wasn't enough to stand on one leg and twist. So while the students gathered in the dining hall broke into grateful laughter I gave a long hard stare at the shoes in my father's hands.

Soul. Even now the word makes my toes curl up inside whatever shoes I'm wearing. My feet itch to feel that tooth-chipping, knee-grating rock I crawled, then toddled on. Muskoka rock. Now I know it's a blend of black mica, white quartz, and fleshy pink feldspar from the Archeozoic period of geology. It's the oldest rock human beings have ever set foot on. Some of it dates back three thousand five hundred million years. Maybe it's not eternal but it's old. It's the earth's childhood raised to the surface and in my childhood it was the surface that began, sometimes

abruptly, where my body ended. Rough stuff it was, too—scaly with lichen, pokey with pine-needle tweezers, bearded with berry bushes and knotted roots. But it did have its gentle moments. In the woods your feet sank into soft black earth and green moss. In the woods, while mosquitoes swarmed to check out your blood type, you could recuperate from scratches and scrapes and tears by gathering acorn caps and bird feathers and loose scrolls of birch-bark. In the woods there were jack-in-the-pulpits and lady's slippers, mare's tails, and ferns—the last plants so ancient, you were told, they didn't know how to make seeds. In the woods there were spiders and beetles—new models each summer, it seemed—chipmunks and mice and garter snakes and toads both strange and familiar, like the knuckles on your hands. In the woods the rock never really disappeared. It shaped itself into furniture—chairs and stepping stools, arrow-proof crenellated towers (there were human beings in the woods, too, and some of them were sisters), and tables for sorting your treasure. In the woods—but sooner or later the mosquitoes forced you to flee to the island's edges, to where the coiling, breathing lake licked the bare rock clean, the way that first day of summer, after the boat had carried you here from the mainland, the lake had licked you clean of concrete and classroom.

Fall, winter, spring. What were these seasons but a footnote to summers spent on that outcrop of the earth's own long, long childhood? Then, when I was sixteen the island was sold. Getting an education and preparing for life, it turned out, were not footnotes after all, but the main text. It was like being told that now you have found your feet it was time to stand on your head. Over you go. The good news was you weren't going to wear out your soles. After a while you might even forget how they worked.

Dip dip and swing. I've talked a friend into driving me up to the old marina. We rent a canoe and head out on the lake, making a butterfly line for my island. On an ice rink my friend's high sticking would get him time in the box, but then my own form is nothing to sing about around the campfire. I'm pointing out islands—over there, that's Bigwin, and there's Gull, and that's Fairview. And here and there are ones I've made up my own names for—Blueberry, Flying Squirrel, Fortress. While I am nostalgic the canoe flirts with

ripples and the ripples get serious. Soon we're being pushed sideways and our dip dip and swinging turns earnest. At last my friend clings to a cedar handle on the shore of My Island and I disembark. I just want to stand for a few moments in the pink palm of this rock, to press my feet against the skin of my childhood. But it's someone else's private property now. Along the shore the aspens tremble. A yellow leaf bobs over the water and bumps up against the prow of our rented canoe. It sticks there, plastered against the green paint like an emblem of loss.

My childhood summers were isolated from the other seasons, an island cut off from the mainland not by water but by a kind of incongruity of genre. Summers were a poem and the rest was something prosy, like an instruction manual. It had meaning but not much. Later, an adult, I was a disappointed guest at other people's cottages. You got your lakefront footage, your boat, your slope of pine trees, your patio with the barbecue, and then over there through the trees you got their patio with the barbecue, their slope of pine trees, their boat and lakefront footage. The boat buzzed and the shifting colours of a television screen vied with the sunset. At the cottage summer was not isolated from the rest of the year. At the cottage the year was one long instruction manual. But what for?

For a long time I gave up going anywhere near North. You get used to stuff and I was getting pretty good at scraping my head across the concrete. I love the city, I keep telling people, and it's no fib, I do. I love the . . . you know the list. Then one evening at the first party I'd ventured out to since the birth of my daughter, I clicked crackers over the guacamole dip with a man who wanted to talk about crystals and their powers. This man was not mingling, he was proselytizing—I know chatter from chant. My toes started to curl under the tongues of my pink party boots. You can't buy a piece of soul, I thought, remembering my father's shoes. You've got to walk there.

I wanted to run. At home I have two rocks I took from the island before it was sold. One is mostly mica, the other, feldspar. To me they are the island's face by night and by rosy dawn. Whenever I move to a new place these two rocks are the last things I pack,

the first I unpack. They're weights I've attached to my ankles in the hope they'll gradually drag my feet back down around to the ground. There I stood beside the guacamole dip and all I could think of were those two rocks and my daughter asleep in her cradle. What if I put the rocks, one at her head, the other at her feet? I must go do this, now, I must go do it now!

"I wish we could go camping!"

My four-year-old son has hauled his sleeping bag out from behind the bags of summer clothes and is perched on the end of the tight roll. It's bedtime and he looks hard done by.

"We can," I say. "We will. As soon as the warm weather comes."

My daughter, aged seven now, leans down over the side of the top bunk. "Can we go back to our beach?"

"Which one is our beach?" I ask, curious. We visited four provincial parks last summer, all with more than one beach.

"You know," she says. "The one with the frogs."

"Oh, right!" She's talking about a small beach on a lake at Arrowhead where no motorboats are allowed.

On the far side of the swimming lines the sand went to weed and the weeds were popping with leopard frogs and green frogs. For eight full hours one day it was dog paddle to frog kick and I do believe bonding occurred.

"Yeah," my son concurs from the pinnacle of his rolled-up sleeping bag. "Frog Beach."

"Will they still be there?" my daughter wants to know.

"Oh, I think so."

Frogs, I know, are bio-indicators. That is, like other amphibians they are the first to signal when something goes wrong with our environment. Lately, frog populations of ponds and lakes and wetlands all around the planet have been suffering sickening declines. In some places the chortling and peeping and trilling of spring is altogether silent. But I don't feel like giving over tonight's bedtime story to this sad tale. The children's heads are already tight rolls of facts about the mess we're in. Ozone depletion, acid rain, destruction of the rainforests — they've got the basic vocabulary. They also know their three r's and can recite them like a pair of

Sesame Street puppets. There are times, when we set out on a walk along some trail, that I can almost see their little backs bent down under this heavy burden of words, and I wonder it is isn't the same old baggage — sin and guilt and redemption all done up in green. But on the whole I don't think so. On the whole I think the instruction manual has become something much more exciting — a user's manual, say.

"Don't worry," I assure the children later, in the darkness. "We'll go camping, soon."

At the park office just inside the main gate a girl with a bandage wrapped around her hand passes me a map of the camp-ground along with a schedule of special events and a recycling bag with instructions how to use it. "Hey!" I turn to the back seat. "See that, guys? They listened to us!"

The girl smiles as I explain that last year we dropped a card in the suggestion box asking why there weren't facilities for recycling. It was time, she agrees, and she explains how it works at Arrowhead. When the talk is over my daughter asks if they have a composter. The girl laughs. "Not yet!" She holds up her bandaged hand. "And watch yourself on the glass, eh!"

We drive to our campsite, put up our tent, and get organized. The kids are old hands this year and before long we set out into the woods. "Look at my legs!" my son commands as we walk down the trail.

"Longer and stronger," I respond. Longer and stronger — it's been his winter's refrain. By February he could almost reach the buttons on the Royal Ontario Museum's Build-A-Bird computer without standing on a stool. "Hey!" that reminds me. "What do you see that a bird might use to build a nest with?" The answers come so readily I decide we can afford some silence. I listen to the slip slap of our feet against the uneven earth. We're not barefoot — there's poison ivy in the underbrush, the girl with the bandaged hand has warned us — but the earth feels good even through running shoes. And to eyes tired from driving it looks pretty good, too. Look, I want to say. Look at this, look at that. But I bite my tongue. The kids' faces are relaxed. They're finding their feet. And then, a few metres off the trail, there it is — rock. I don't need to say

RED SQUIRREL
DIANE BIGGS

anything; they're already clambering onto the rough pink and white and black surface. I join them. "Let's take off our shoes," I say.

We stand there, our three pairs of naked feet side by side on that stuff made thousands of millions of years ago. Human beings have so many fewer days to put together their own blend of hardness and beauty. I miss My Island but I no longer feel I've lost the poem that it taught me. This is it. This is what the user's manual means. In such moments as these, our children are free of the old, worn-out hand-me-down shoes. In these moments our children join their soles to the earth's own childhood.

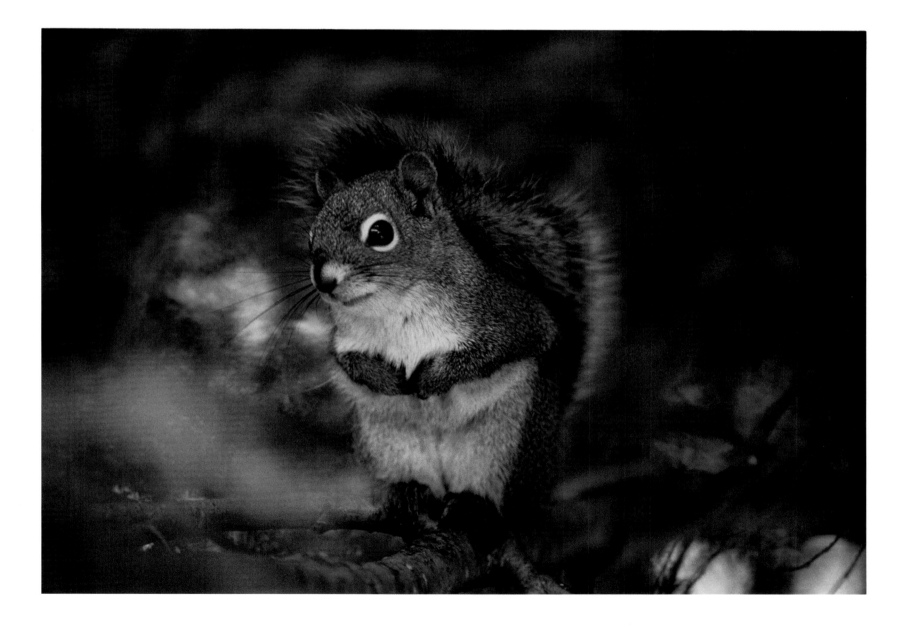

LEFT / CHILD IN MEADOW
PETER van RHIJN

ABOVE / OUTDOOR ART, MUSKOKA
BRUCE LITTELJOHN

Education and Understanding

Robert L. Mitton, Deputy Minister, Ministry of Education

Many of us who have travelled in Ontario's parks have had experiences that are brought to life in the pages of this book. Many of these experiences have stayed with us and may, in fact, have shaped our very lives. Some of these we remember as deeply moving spiritual experiences, such as the occasion when we first heard the plaintive call of a loon as, snuggled in a sleeping bag on the shore of a misty lake, we drifted off to sleep. Or we may have been kept awake by the howl of a distant wolf communicating with other members of the pack, or been awakened by the slap of a beaver tail close to our tent. It is in settings such as these, in which the land, the water, the air, the forest, and all the living things are in harmony, that we feel connected to all the other creatures in the natural environment. We, too, feel part of the harmony of nature.

It is these opportunities also that permit us to revitalize ourselves before returning to the arid, concrete environments of our cities and the hustle and bustle that we humans are subjected to in our daily lives. These moments of peace help us to understand the relationships between this planet Earth, this spaceship, and ourselves. We begin to understand the importance of the natural cycles of nature: birth, growth, decay, death, rebirth. We begin to understand the effects of the weather—of sun, wind, and rain—and of clean water and clean air on us, on our physical and emotional well-being. We begin to understand that the plants and animals have just as much right to live in peace in this land as we humans, their fellow animals, do.

Our parks system, built up over the past one hundred years, preserves many outstanding physical features and landforms and protects many varieties of plants and animals. It provides opportunities for humans to see the natural homes of other living things—but as respectful visitors only. We may visit and enjoy what we find, but we must show the same respect that we show when we visit our neighbour's home and we must eventually leave to return to *our* habitat.

How do we place a monetary value on the rivers, the lakes, the forests, and the resources that are hidden within the land? Most of our current economic indicators show that they are valueless until they are removed from their natural setting and manufactured into products for sale. It is imperative that we cease to view our resources as potential commodities. Our natural resources—of which our parks are such a glorious example—have intrinsic value as well as monetary value for us, the people of Ontario. We must learn to look upon them as a vital source of life, not as a source of profit.

Many environmentalists feel that we are at a crossroads with respect to our natural environment. Some say that we may never recover from the damage that has been done to planet Earth; that we do not have enough of our natural resources left to regenerate our world and make it into an environment that can sustain us. My vision is somewhat different. We are not at a crossroads; rather, we are in a canoe going down a turbulent river. Once we are in the current we will go with the river, willingly or unwillingly. We must read the water, and paddle our canoe with confidence, relying on the knowledge that we have built up with experience. We will have to make corrections, change direction, back-paddle, make stronger draws, stroke hard, and keep the centre of gravity low as we proceed on our environmental course. Science will be our eyes and ears on the journey, providing the information we will need to plot our route wisely through the rapids. And we must develop in our children the skills and confidence *they* will need to travel safely the length of the river. But ultimately we must be humble enough to recognize that Earth will keep rotating through space whether we survive in our current form or not.

MOOSE CALVES, OPASQUIA PROV. PARK
LORI LABATT

Our provincial parks will continue to provide opportunities for our children and our grandchildren to enjoy the same wonderful experiences that we have had. The writings of the children in this book demonstrate that they, too, share the sense of wonder at the connectedness of all living things and have an awareness of our place and role within this natural order. They already recognize the importance of the wilderness in our lives—of the "creepy crawleys", and of the tadpoles that grow from a clump of "yucky frog spawn". We must help them to see that these creatures make a very special contribution to our lives, that our experiences with them allow us to learn about ourselves and our place in the universe. We must also help them to assume responsibility for managing their precious inheritance with wisdom and foresight, so that the health and survival of all living things is assured. The school system can help young people to become sensitive to their environment, but it is only one of many agents in this process; all of us who read this book are challenged to help our young people exercise their natural curiosity and to ensure that they get the opportunities to have these very positive experiences with nature. We must find a way, in the words of Janet Foster, "to make nature and the environment meaningful and relevant to young people wherever they live—in towns, cities, or the country".

Some people have used the biblical promise "thou shalt have dominion over the fish of the sea and over the fowl of the air and over every living thing that moveth upon the earth" to exploit our natural resources for their own gain and convenience. They have chosen to believe that Earth has been created expressly for their use. They have forgotten that with this promise comes the responsibility of being the "steward" of all living things on this planet. Ontario's park system is an example of this stewardship at its best.

The authors have given us a wonderful overview of the land, the lakes, the rivers, the forests, the flowers, and the animals that live protected within the boundaries of our parks. They have reminded us of the incredible beauty of these natural features and of the importance of protecting our water, air, and land from further abuse. All of us share the responsibility for protecting and expanding our truly "wonder-ful" parks and for living with a conservation ethic that ensures that future generations will be able to live with the same dignity and comfort as we enjoy today.

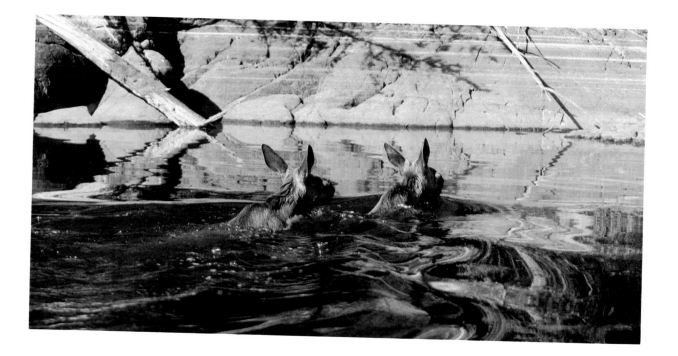

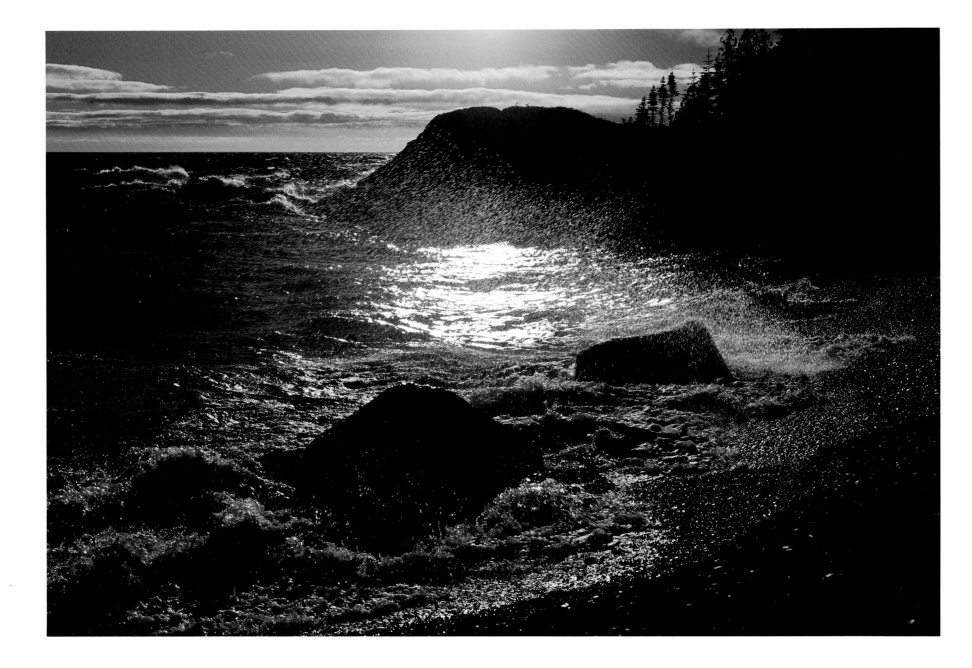

Attitudes to Nature

John A. Livingston

When I was approached for a contribution to this book, my first impulse was to respond somewhat churlishly. Not to the idea of the book itself, with which no one could conceivably find fault, but rather to the working title, which at that time was *Heritage*. While I was entirely willing to offer an essay dealing with our attitudes to nature, I was entirely unwilling to do so under a banner that explicitly identified nature as human property. To do so would have been to provide one more (however modest) item of legitimation to an attitude that is the very fundament of what all of us are striving *against*, and that consistently thwarts what we are striving *for*. That the title was changed was in no way, I am confident, merely a reponse to my intervention, but rather an affirmation of the editors' own positions. Working titles are just that. It must be recorded, however, that I did not commence this piece until after I had learned of the new title.

I entreat the reader to accept that this is no minor quibble. Those who give thought to the root causes of the historic and contemporary destruction of nature are agreed that ultimately it all boils down to matters of human attitudes: attitudes not perhaps so much to nature itself as to the human relationship with nature. No such attitude is more pervasive, more traditionally anointed, or more devastating, than that which causes us to see ourselves as the masters and proprietors, the heirs and owners, of all on Earth that is not human. From this received wisdom flow all of our problems and frustrations in the attempted defence of wild places against the human appetite.

Attitudes are not inherent in us; they are learned. Having been learned (by socio-cultural conditioning) they *predispose* us to respond to things, people, events, ideas, nature, in certain ways. Those predispositions are widely shared across society, and we tend thus to be quite consistent in our responses. Also, there is usually a strong emotional attachment to our attitudes. In a very real sense, we have become *bonded* to the sundry predispositions which have been inculcated in us. Or, just as accurately, to which we have been trained. They are part of us. Our attitudes are an integral part of our individual identities. We often hear a good deal of very glib (and, it must be said, somewhat naive) talk about "changing people's attitudes" toward, let us say, nature and natural areas. Although we utter such banalities with the greatest of ease and fluency, what we are in fact talking about is tantamount to the surgical severing of that which the patient holds very dear indeed—part of that person's identity. Such amputations are not undertaken lightly or without extreme care. Who knows what even more bizarre new growths might replace them?

Also, although we invest quite some time and energy talking about the necessity of changing public attitudes, we often tend to overlook the fact that a change in attitude (or expressed attitude) does not necessarily translate into a change in behaviour. Psychologists are by no means confident about any one-to-one causal relationship between attitudes and behaviour. We may (forcibly or otherwise) change someone's behaviour without in the slightest changing that person's attitudes. Or we may elicit a new statement of attitude from someone without in the slightest changing that person's behaviour.

Thus, it seems to me that we have little choice but to sharpen our thinking. Like all phenomena, attitudes have contexts. Attitudes have origins, evolutionary paths, and contemporary environments. As predispositions to respond to things in certain ways, attitudes are set in place by the system of beliefs in which we have been raised, tempered to some degree by individual experience. But since the human experience is almost exclusively rational, other modes of apprehending the world rarely influence our pre-packaged positions.

Attitudes, especially those most widely shared, may be seen

as fairly reliable clues to the nature of the ideological infrastructure that sustains and supports a human society. Field marks, if you like. Or, if you prefer, symptoms. It is symptomatic of our society's shared wisdom that nature is widely seen as (a) free "resource" inventory, and (b) free effluent sink. Not all human societies have seen nature in these ways, but ours has. And such is the moral authority of advanced industrial society that other modes of apprehending nature are widely seen, quite comfortably, as "primitive" and "uncivilized". It is interesting that in Canada extractive industries such as logging, commercial fishing, trapping, and recreational killing hold to themselves a disproportionate share of that moral authority. This position rests largely on tradition; it is of such industries that Canada was made. And vested interests in those enterprises are unremittingly aggressive about reminding us of that historical fact.

Ironically enough, raw extraction is the most primitive of industrial activities. Perhaps what I like to call *resourcismo* is no more than perfectly natural defensiveness. Perhaps the use of the term "harvest" by such enterprises to describe their pillage is a conscious attempt to condition public attitudes by the invocation of some of commercial agriculture's traditional self-righteousness. Whatever the reason for the vigorously offensive stance taken by the extractive industries, however, and no matter how logically vulnerable their usual defences may be, there is no doubt that they command the unfaltering obedience of their political servants.

The continuing debate over commerce in the skins of wild mammals is a case in point. During the hottest period in the harp seal controversy some years ago, the government of Canada saw fit to hire a public relations firm from Washington to discredit opponents of neonate seal clubbing and sent teams of flacks to Europe to lobby on behalf of the sealers. The harp seal pups were in that instance seen by the governments of both Canada and Newfoundland as economic dietary additives. Living, sensate, and sentient newborns as pogey supplements.

Wild non-human animals have long subsidized the social "safety net" in Canada. And over and over again they emerge as political bargaining chips. This is most vividly shown in the contemporary discussion of native land claims. Both the indigenous peoples and the sundry governments consistently focus on the "management" of wildlife "resources" as a critical agenda item. "Management" is the usual euphemism for deciding on what numbers of what species of living beings may be killed, where, when, by whom, and by what means. "Resources" means subhuman living entities.

So entrenched in our culture is the ideology of the human proprietorship over nature that even we, the naturalists and the nature defenders, in many of our postures and utterances unwittingly contribute to its continuing legitimation. At the simplest level, we speak of "our" diminishing hemlock stands and "our" endangered cougars. We speak of a natural "legacy" we have received, of a kind of inheritance or patrimony, and of our duty and obligation to "pass it on" to succeeding generations (of people). We even go on about "setting aside" natural areas. Oddly enough, we often neglect to say why we want to do so. We merely say, "That old red pine stand should be set aside." What that means is that the fate of the area is necessarily ours to decide, once we get around to deciding it.

This is the essence of old-line "conservation". Use now, but save some to use in future. Resource conservation is a wholly proprietary, human chauvinist concept. And so long as "parks are for people", and so long as we persist in "reserving" nature (or wilderness), we are perpetuating the resourcist myth of nature as the human fief. Indeed, the overwhelming thrust of contemporary environmentalism is planetary estate management. As the gurus keep telling us, who knows but what a cure for cancer may reside in some species of poison-arrow frog of the tropical rainforest, or an insecticidal miracle in some elusive orchid? Indeed, the Gaians instruct us that we can have our cake and eat it: we can live handsomely off our natural income and never touch our capital. It would be difficult to unearth a more unequivocal statement of the traditional cultural perception of the relationship between humankind and nature.

We thrash and flounder in a sea of ironies. Thomas H. Birch (*Environmental Ethics*, Spring 1990) has made the point that the

formal designation of "wilderness areas" behind fences is tantamount to the imprisonment of the quality of wildness. We like to say that wild nature has the "right" to continued existence in such places. Birch argues that the problem with granting rights to aspects of nature is that we (the grantors) must be in a position of power over Nature in order to do the granting. I have made the same point with respect to "animal rights" (*Osgoode Hall Law Journal*, Summer 1984). To confer rights upon wild animals is to draw them into the hierarchical human political apparatus, which was what necessitated the invention of rights in the first place. To convey rights to wild animals or to wilderness areas is the same thing as domesticating them. That is not, I think, what we nature defenders really have in mind.

Whatever happened to the concept of sanctuary? I may be wrong about this, but it seems to me that so overwhelming in recent times has been the bureau/technocratic or planning mode of approach to reserves, parks, and so on, that the element of sanctuary has quietly slipped from general usage. Granted, like the concept of rights, the idea of sanctuary has its origins in the defence of the individual within the social pathology that is human political organization; but unlike rights, sanctuary implies freedom from power structures, exemption from hierarchical governance, asylum from ideological captivity.

A sanctuary is a sacred place, a place of refuge, a place of immunity. Ontario parks are not nature sanctuaries, however. Even were the non-human inhabitants of all of the parks safe from persecution and defilement by guns, traps, motorboats, and chain saws (they are not), they can almost nowhere find refuge or asylum from the ubiquitous human recreational presence. There is no safe haven anywhere.

One wonders why we cannot begin to think in terms of the establishment of true sanctuaries, areas specifically off limits to exploitation either as "resource" inventories or as human playgrounds. Assuming for the moment that the will to do so may yet, at this late date, arise, we must again address the matter of our own role, including our posture, in their "creation". Clearly we are not "creating" such areas; we are creating human political

conditions for the safe and healthy continuance of remnant pieces of nature. Neither are we "granting status" to elements of nature. Status implies position in the political apparatus of the human power structure.

In the establishment of such places, we would not be "granting" or "conveying" anything. We are consciously *subtracting* from the human estate. Since we ourselves conveyed to ourselves our fancied proprietorship over nature, we would be consciously adjusting the terms and the content of that conveyance. We would not be "granting" or "awarding" anything to nature; we would simply be re-drawing the metes and bounds of the traditionally perceived human holdings.

Sanctuaries are not for us; they are for nature. They are places in which non-human beings and natural processes may flourish in their own ways and in their own time, in their own directions and to no purpose save their own. They would be off limits to humans, their machines, and their works.

This view implies a radical and fundamental shift in attitudes toward nature and our relationship with nature. It would be most agreeable to be able to say that such a shift is indeed possible, and then to provide hard evidence of that possibility. I am unable to do that, at least without recourse to a degree of self-delusion that has no proper place in these reflections. On the basis of the record, I can foresee little likelihood of conscious and deliberate change in our dominant cultural orientation toward nature and our relationship with it. Such a change would fly in the face of virtually every aspect of our received wisdom, our received humanistic ideology. It would be irrational.

The charge of irrationality is the most effective weapon in the entire defensive arsenal of the modern technoculture. (Most if not all aggression has defensive roots.) Adherents to any fundamentalist ideology are forever looking under their beds for heretics. Adherents to the ideology of nature as the appointed human hereditament have learned from experience to be ever vigilant against the possible emergence of cogent, rational arguments to the contrary. Lest they should be unable to refute such arguments, they pre-empt them by means of charges of irrationality. The quickest

and neatest way to deal with one's own weakness has always been to project it upon one's critics. To be so described places the critic beyond the fringe, unworthy of serious hearing. The technoculture is engaged in "matters of conseqence", as the Little Prince's businessman put it. To be irrational is to be inconsequential.

Nature is irrational. Or, as I prefer, non-rational. Those who would see sanctuaries created not in the human interest but in the sole and exclusive interest of nature are thus themselves perceived as bereft of reason. How could an entity lacking rationality — nature, for example — have an interest, in any case? The pat answer is that in our society infants, the senile, and the mentally incompetent all have legal interests. And although they do not have legal "standing", some domesticated and captive non-human animals, on paper at least, have nominal protection from "unnecessary" cruelty. That is because both human and non-human "incompetents" are our wards, having been taken into our custodianship.

One would not think that many naturalists or other nature defenders would be able to rest easy with the image of nature as an incompetent in our benign charge. But that is the point to which we are brought, unavoidably, if we allow our case for nature to be made on the basis of, for example, human "stewardship". Anyone who advocates stewardship (all "resource" conservationists do) is confirming in the same breath (a) human proprietorship and (b) nature's incompetence. There are some among us who, while fully aware of the burden of what they are saying, continue to resort to the language of resourcism in order to defend their "credibility". They seem to fear that not to do so would impair their effectiveness. They would be laughed out of court — or so they believe. So they remain (rationally and pragmatically, they insist) within the ironclad conceptual framework of human chauvinist imperialism. Those who knowingly and consciously argue for nature in resourcist terms, in full awareness of the implications of what they are doing, are practising self-censorship. Self-censorship is never admirable, always demeaning, inevitably destructive. I think it is strategically and tactically, as well as in some ultimate moral sense, wrong. To argue the case for a red-shouldered hawk or a beluga as a "resource" is not only to underscore, one more time, the human chauvinist position, but it is also to accept the quite impossible onus of showing what the hawk or the whale is "good for". And in rational terms.

There is no rational argument for raptors or cetaceans or even sanctuaries. The invocation of ecological principles takes us nowhere, because ecology simply describes the way in which the human fief "works". It tells us how the hawk and the whale may be seen (if one wishes to see them that way) as "system components" within their specific environments, and how the "mechanisms" (if you like that sort of language) within a community may be understood to function, but it can tell us nothing whatever about what those phenomena *really are*, and even less about why they should even *be*. Ecology provides a theoretical cost/benefit model of production and consumption in the global human empire, but has nothing to say about the rightness of buteos and toothed whales, or the wrongness of their exposure to the self-interested whim of a single species. Ecology cannot cope with matters of transcendent worth.

But it need not; it is not meant to. Science is a human construct for human purposes. Like the rest of our institutions, science is dedicated to the advancement of the human enterprise. We should not expect science to be any better at rising above human chauvinism than moral philosophy and ethics or arts and crafts. Such institutions are not about to turn on their creator, even were they able to. Their creator is anointed. The human right over nature finds sanctuary in the sacred place of the human endeavour on Earth.

Now, I may be utterly wrong in the foregoing diagnosis, but I am persuaded that I am not. In any case, I trust the reader is not expecting anything in the way of a "solution". I fully realize that solutions are the coin of the technoculture. In spite of that, I have no remedy, no "fix" for a problem that is metaphysical, cosmological, ontological. The problem is in the essence of "civilized" human being. No doubt there are more people around nowadays who share this understanding of nature's predicament than there used to be. Perhaps there are more than I think. Arne Naess once asked, "Will the defenders of nature please rise?" Let's stop worrying about "attitudes" and start counting heads.

LOOKOUT TRAIL, ALGONQUIN PROV. PARK
LORI LABATT

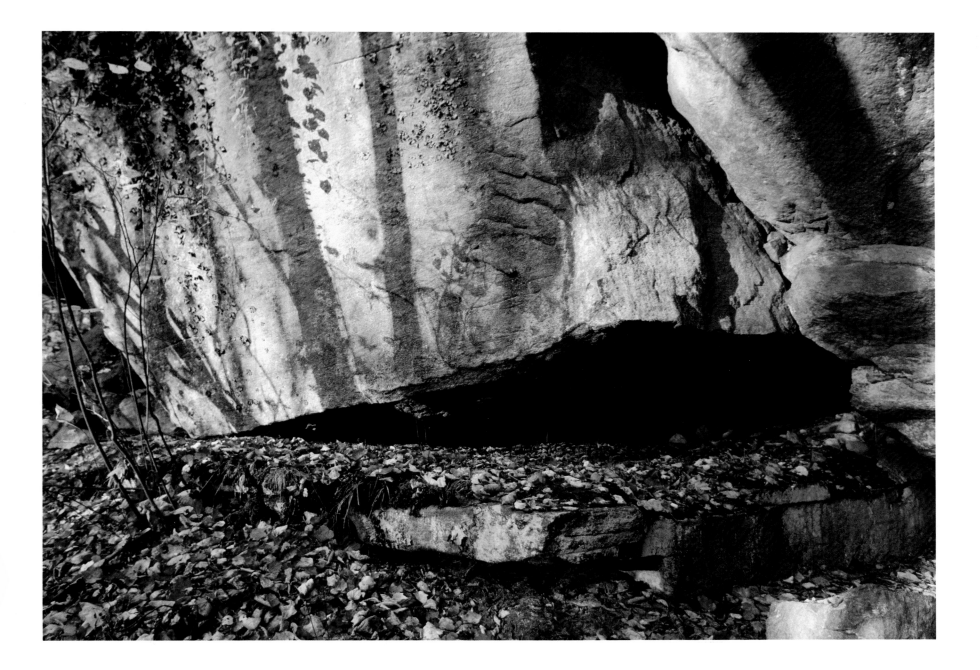

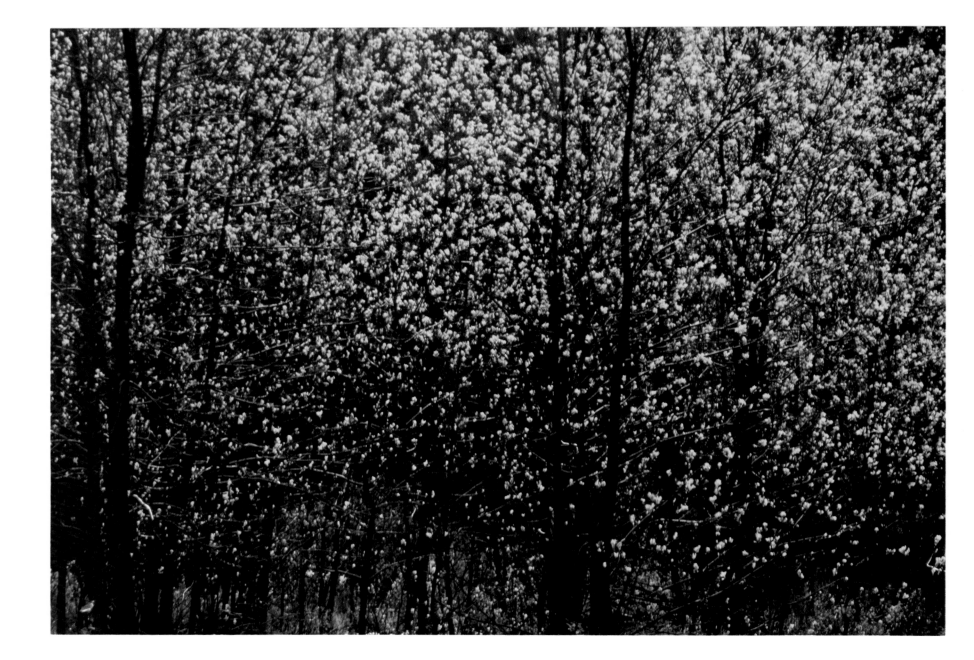

RIGHT / SCARECROW CUT, TEMAGAMI
MARK MOLDAVER

ABOVE / RED ASH, MANITOULIN ISLAND
CHRIS MOTHERWELL

LEFT / SWAMP MILKWEED AND RED OSIER DOGWOOD
ROBERT McCAW

ABOVE / CRAIGLEITH PROV. PARK
LORI LABATT

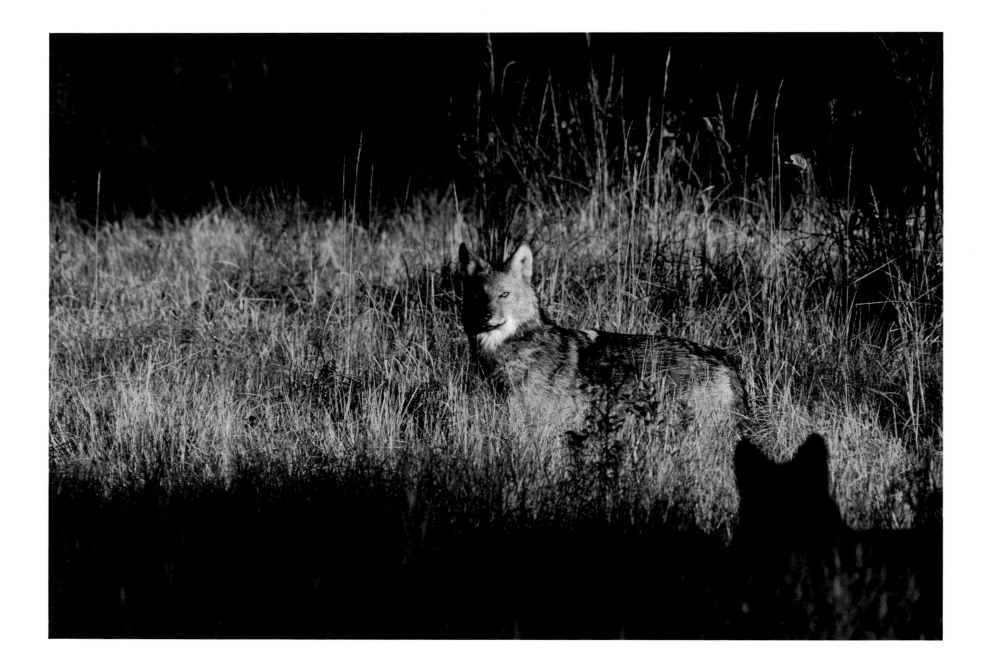

Wolves, Algonquin Park, and the Hierarchy of Ecology

John B. Theberge

Algonquin morning. Sun reflected off rippling lake water. Loon a black speck away out there. A few warblers in the pines overhead. Whitethroat notes filtered through the trees behind camp. Wolves nearby: they had howled the night before, filling the darkness with their wild music. Evidence of wolves, too, was the radio signal— 151.373 megahertz — Foys Lake female. She was there at the rendezvous site 2 km away, with her pups.

Pine-filtered sunlight. Lake-freshened breeze. We lay half awake in our sleeping bags enjoying one of the pleasures of wolf research. After tracking wolves all night, each day we awake to summer mornings in full swing. A red-breasted nuthatch yanks its way up a pine trunk: a Swainson's thrush pipes its ascending spiral of notes from somewhere in the distance. A wolf howls? Or was it just the wind?

Algonquin Park wolves have bestowed more pleasure on my wife, Mary, and me than possibly anyone else in the history of the park. Twenty-seven years ago we first glimpsed them, up on a rock ledge above our canoe in the early-morning mist-weakened sunlight. Off and on we have studied them ever since, each discovery posing new but more insightful questions, each set of observations either fitting or failing to fit the ecological patterns described in the literature, every year's field work full of surprises.

Over the years our fascination with wolves has grown beyond the various individuals we have been privileged to know, like Foys Lake female 151.373 who was on the air for almost nineteen months. Her suspected mate, 151.773, we had tracked for two years: these two wolves had travelled together much of the previous winter. But wolves are part of a web of ecological relationships— they represent the strand that binds soils and snowstorms and fir trees and moose all together. They are the ecosystem's glue. And ecosystems themselves, as they shift in response to landforms and climate across a landscape, as they collect sunlight and distribute nutrients and provide homes to living things, collectively represent

the biosphere of planet Earth—that delicate membrane of life wrapped around the globe.

In this way, wolves are just one part of an ecological hierarchy: species, ecosystems, biosphere. Each part has meaning and significance. Each is under threat. In terms of geological ages, none may survive much longer. The ecological hierarchy with its uncertain future and its need for allies gives meaning to our work.

Predators like the wolf, together with coyotes, grizzlies, cougars, and polar bears, lie at the top of the hierarchy not as much for biological reasons but because, at the species level, they represent the next major ethical hurdle for humans to jump. These species dare to compete with us. They defy our dominance. They challenge our supremacy. They take what we want. They cause us trouble.

In contrast, species which are either benign or irrelevant to human welfare are candidates for human concern. We have gradually come to care about whooping cranes, garner blue butterflies, Furbish's louseworts, and Henslow's sparrows. We have even taken up the cause of bald eagles, which mainly scavenge fish, and ospreys, which kill fish but rarely congregate in significant numbers, and peregrine falcons, whose predatory impacts are diffused across many species of small birds. Very recently, we have even extended our concern to fur-bearers, trapped and snared for luxury furs. But can we ever accept a large carnivore like the wolf, who practises such a maladaptive evolutionary trait as killing deer, moose, and caribou that evolved for thousands of years just to provide food and recreation for us, as some people seem to think?

The evidence on this question is split. Against it are facts such as those our own research is producing: more than 60 per cent of the deaths of all wolves we have radio-collared in Algonquin Park over the last four years have been from guns, snares, or traps,

TIMBER WOLVES, ALGONQUIN PROV. PARK
MICHAEL RUNTZ

all but one occurring outside the park. Only a few wolves that have trespassed onto private land, to our knowledge, have ever returned alive. A lot of hate appears to reside in the peaceful-looking towns and farmhouses and logging mills around Algonquin Park. From our interviews we have found that characteristic of persons who kill these wolves is a sense of having provided a valued social service. Deer good. Wolves bad. The killings are not motivated by livestock losses. They are motivated by an underlying and deep-seated belief that wolves are evil creatures. Even Algonquin Park, the largest place where wolves are protected in Ontario, is not large enough to fully protect a wolf population. That fact is one we had not hoped to discover.

And yet, in response to a TV science program on the wolf aired by the CBC late in 1990, the almost 1,000 letters received contained only four that objected to the program's solidly pro-wolf stance. Hammered by the program was the insensitivity of government-sponsored wolf killing. The letters were overwhelming in expressions of anger at the senseless slaughter of such a magnificent and highly social animal as a wolf.

Sound of an airplane overhead. We emerged from our sleeping bags and turned on our air-to-ground radio receiver. Volunteer pilot Hank Halliday flew in a couple of circles over us while Ph.D. student Graham Forbes read off the map coordinates of the radio-collared wolves they had found from the air. 151.373 and her mate 151.773 were out hunting 3 km behind the den now, down beside Bog Lake, beyond the range of our ground receiver. Other pack members were scattered over the pack's 200-km^2 range. The plane droned off in the distance, heading back to the Pembroke airfield.

By then little wavelets were washing the shore. A moose — 350 kg of prepackaged wolf food — was uprooting water lilies in a backwater across the way. We sat on a log to watch, and our conversation drifted, as it so often does, to various aspects of the marvellous complexity and beauty of the northern hardwood-Boreal transition forests — the next step up the ecological hierarchy. Scent of pines and sweet fern. Music of winter wrens. Feeling of wilderness — that undefinable, intangible high.

Wolves, moose, deer, beaver — the immediate predator/prey system. Hemlocks, maples, balsam firs, birches, aspens, hobblebush, and hazel — the forage extension of the predator/prey system. Red fox, grey jay, raven, pine marten, scavenger beetle, blow fly —

benefactors of the system. Spruce budworm, forest tent caterpillar, winter tick, brainworm — the invertebrate agitators of the system. Bedrock, soil, topography, climate — the abiotic variants of the system. And a lot more: bay-breasted warblers that benefit from an outbreak of larval spruce budworm; red-breasted nuthatches that benefit later from budworm-killed trees; snowshoe hares that benefit from the cover of balsam firs clipped low by browsing moose . . . On top of all that are human influences, even in a park: logging with its profound effect on the forest community; moose and deer hunting by Indians; climate change with its possible chain of consequences. For example, nearly a decade of below-average snowfall has increased the survival of deer, which in turn may have increased the infection rate in snails of immature brainworm, which in turn may cause an increase in moose mortality. Relatively minor climatic influences like that may be only the beginning of what lies ahead.

To say that the system is of staggering complexity is an understatement. To think humans can "manage" it is an illusion. Management must be based upon understanding. How do you even begin to understand anything as complex as an ecosystem?

A literature is developing on the science of ecosystem preservation. Although seemingly a contradiction, preservation in a human-dominated biosphere does indeed require management. Drawing a boundary around a natural area is not sufficient. Topics that make up this literature include such subjects as minimum viable population size, minimum area, critical habitat, catastrophe theory, and ecosystem health. Whole courses are given at universities on these things. Techniques of landscape analysis include high-tech applications: satellite imagery and computer-driven Geographic Information Systems.

The moose in the backwater was still concentrating on the water lilies. Every few seconds his head would emerge. He was alert; less watchful moose had been pruned from population gene pools by the care and attention of wolves. If he sensed us across the lake, he recognized nothing to fear from that distance. Despite his grey shroud of flies, he looked healthy; at least he was fat and functioning. But was the ecosystem around him healthy?

NORTH CHANNEL, GEORGIAN BAY
SONIA LABATT

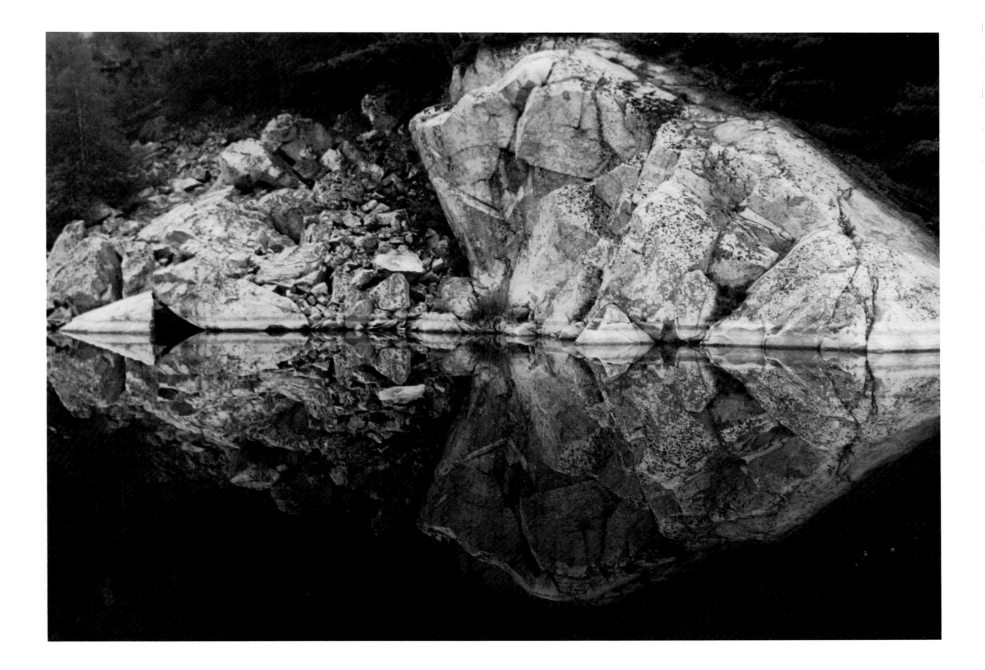

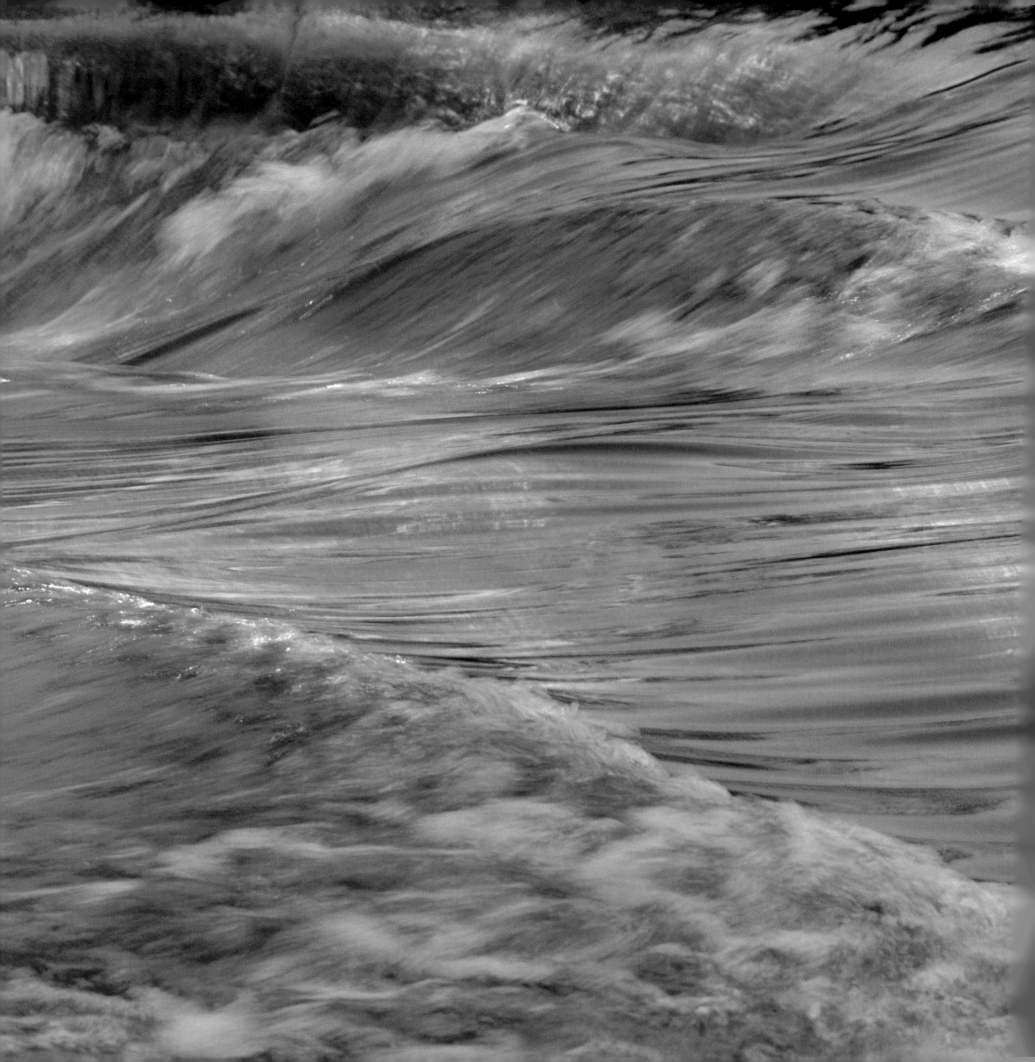

It has been said that a land that can grow a wolf is a "healthy land". The wolf may indicate that all pieces of the ecosystem are present and functioning normally—normal rates of productivity, population sizes of the normal complement of species interacting in normal ways. The ideal of normality, however, must include natural catastrophes such as fire and insect outbreak, which profoundly change all these things. Normality, in fact, is an illusive concept, not easy to define.

Nor can healthy simply be equated to "pristine". No ecosystem on Earth is pristine if that means unaffected by humans. Molecules of synthetic chemical are in all living things, and then there is climate change, acid precipitation, toxicants bound to the hydrological cycle and travelling worldwide . . . Where do you go to find one square kilometre of virgin hardwood forest—tolerant hardwood stands with their scattered pines still there—old growth? A few pitifully small "nature reserves" in Algonquin, perhaps, although even most of them have at some time felt axe or chain saw too. Only to the ecologically myopic do these places represent the expansive ecosystem of which they were once a part. Nor is there any expanse of virgin northern hardwood forest in Lake Superior Park, nor in any park, nor indeed in any place in Canada! It is gone. A memory.

Difficult to rationalize with the notion of ecosystem health, too, is the reality that most of Algonquin Park is open to logging. Roads, trucks, bulldozers, skidders, chain saws: they are all there and they profoundly influence the system. A freshly logged-over area is an aesthetic disaster with treetops and limbs and stumps scattered all over the place. And yet the moose and deer move right in. They feed on the downed treetops, and on the new browse the following years. The wolves move in too. In fact, both ungulate and wolf numbers may be artificially high because of logging. Is this situation unhealthy? To a struggling cedar seedling, too many deer are disabling; to balsam fir seedlings, moose are a definitive hazard to health.

Just as illusive as the concept of ecosystem health is the concept of "minimum population size". Most research on this topic has focused on summit predators, usually the most wide-ranging non-migratory species in ecosystems. Generally accepted is the rule that no population should experience more than I per cent inbreeding per generation. To do so severely restricts genetic variability and hence ability to adapt. In genetics theory, this rule translates into a minimum population size of fifty free-breeding adult animals, plus sub-adults and non-breeders. The percentage of non-breeders in a wolf population increases with intensity of exploitation, as breeding attempts to compensate for losses. This situation ironically seems to mean that the minimum viable population size is smaller for an exploited than an unexploited population. But from the standpoint of letting nature impose selective pressure on gene pools, rather than humans, exploitation is hardly a management tool to increase adaptability. Adding confusion, too, are new computer-driven models of minimum viable population size, based upon population demography rather than genetics, which indicate that much larger numbers are needed than do models based upon genetic arguments. The subject, like ecosystem health, begins to lose precision.

Algonquin Park, although below the theoretical minimum size to support such a wolf population, fortunately is not an ecological island, or its wolf population might not persist. Immigration into the park may be important. The park, then, is only healthy with the support of adjacent semi-wild lands. This situation is true of every park in Canada, and it is one reason why preservation implies management, at least of adjacent lands.

What has the science of preservation taught us? Some tough lessons. It has emphasized that normality is practically undefinable; that complete systems have some indeterminate boundaries away out there somewhere if they have any boundaries at all; that ecosystem complexity, climate change, and human interference around parks, or anywhere, make prediction of ecological futures impossible.

However, only to the "we must manage it all for human betterment" mentality should these problems be problems. Why should we think that the human brain, even with computer assistance, should be grand enough to understand an ecosystem? To

MISSINAIBI RIVER WATERWAY PARK
BRUCE LITTELJOHN

think so may well represent the height of human arrogance. It might just prove to be the ultimate folly of our species. Humility, not practicality, is the true lesson taught by ecology.

A couple of days later Mary and I flew with Graham and Hank on one of the telemetry surveys. The noonday air was calm, as it rarely is, and we wanted to observe the habitat at the interface between the Foys Lake and Basin Depot packs where for some reason the Foys wolves had been spending much of their time. Once, the Foys wolves were at the same bog only hours after a radio-collared Basin wolf was there. We speculated on the relationship between these adjacent packs. Indeed once, back when she was captured, 151.373 was a member of the Basin pack, possibly the dominant female. She had joined the Foys pack the year before in December, when it invaded the Basin pack's territory. A different social order. Different rules honed to perfection in the time-mill of evolution. We only guess at how they operate. Our different senses and different perceptions of the environment keep us forever apart.

After circling all over the sky to find the wolves we headed back in level flight to the Bonnechere airfield. The warm sun streamed through the cockpit windows. In the sky, detached from the ground, human endeavour sometimes can be glimpsed in biospheric perspective — the highest level in the ecological hierarchy. Flying over a park, even that invention of many may be viewed in a broader context.

Definition of a park: a place where nature is protected? What a noble idea, part of our grab-bag of environmental bandaids. But parks must be established with the utmost care not to impede growth. If they might do so, like Algonquin, we exploit them. The principal objective of Algonquin Park, according to its master plan: "to provide continuing opportunities for a diversity of low intensity recreational experiences *within the constraint of the contribution of the Park to the economic life of the region*". Emphasis added.

How thoughtful we are of the other species that co-inhabit the earth! How generous we are! In full knowledge of our species' utter dependence upon a stable biosphere, and with plenty of evidence of the reliance of the biosphere on its component ecosystems, we designate a small bit, less than 4 per cent in Canada, to remain beyond the scythe of economic development.

Perhaps we are consoled by the 40 per cent or so of Canada that is still relatively natural. If so, it is a delusion. Much of the

northwest is gridded with seismic lines, there for the next few generations of people to see. When you fly over the rest of northern Canada and look down on vast forests and tundra, you cannot see the multitude of lines that would clutter a land use map: mineral leases, oil and gas leases, logging leases, trapping rights, big game outfitting rights, proposed pipeline routes, engineering lands for dams and diversions on any river of suitable size that has not already been harnessed to capacity. You cannot perceive the pressures exacted by human population growth and overconsumption that make trivial the preservation of wild lands, or any environmental action in any geologic or evolution time perspective. We are in the process of transforming it all. The brown haze that obscured even the relatively remote Bonnechere airfield from 15 km out made that apparent.

Approximately six human births a second. Two deaths. Net increase of four per second, 240 every minute, a quarter million every day. Unchecked consumption. Unchecked economic growth: every community in Canada wants more. The inevitable consequence. Pillage of wilderness. Chain saws even in Algonquin Park. Rifles, traps even in Algonquin Park. Is our species totally without soul?

And so, at all three levels of the biological hierarchy there is a lot of bad news: the wolf, symbol of persecution; the ecosystem, complex beyond the hope of any science to do more than elucidate the most obvious relationships; the biosphere, under deadly assault by a species seemingly bereft of any sense of environmental propriety. And yet, as a direct result of all our years out in the Algonquin bush, Mary and I have made our peace with all three levels of the ecological hierarchy. That we have achieved this peace perhaps speaks to the restorative catharsis of nature. It can do the same for anyone.

At the species level, the wolf: we study its marvellous adaptations, its integral essence of the wild, its capacity to survive, its ease of travel, its howls floating up from some bog in the darkness of a summer night, its skill in pursuit and capture, its home life, its social life, the mysteries of predator/prey relationships with their fascinating forefronts of scientific inquiry. There is a

HORSETAIL AND SEDGES,
FRENCH RIVER WATERWAY PARK
BRUCE LITTELJOHN

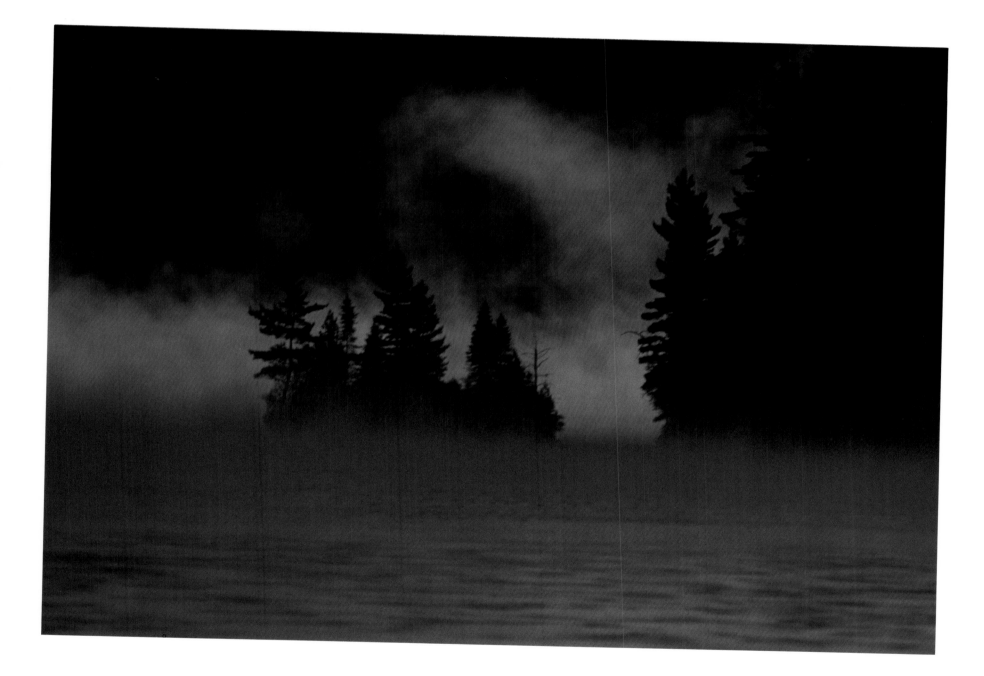

LEFT / NORTH FOWL LAKE,
LA VERENDRYE WATERWAY PARK
P.S.G. KOR

ABOVE / SMOKE LAKE, ALGONQUIN PROV. PARK
LORI LABATT

great peace in studying nature. It is studying god (with a small g) — the forces that made the planet and all its living things. Research is exciting — the greatest game on earth. And it never ends. Ecosystem complexity assures us of that. I know other naturalists who quite likely have found the same peace and excitement in the Algonquin forests studying grey jays and snapping turtles and white-throated sparrows and even blackflies. I read of other naturalists whose studies of ravens, grizzlies, fossil invertebrates, and the meaning of "ecosystem health" enrich their lives. If the results of ecological research, amateur or professional, do no more than portray that excitement of understanding how various species of nature function in relation to others, and thereby hook more people on nature, make them preservation advocates, make them defenders of the wild, then it has served a high social purpose.

The second level — the Algonquin ecosystems — has taught us how to wonder. They have shown us firsthand that the more you learn about an ecosystem, the better and more significant and fundamental your questions become. Where, then, is the need for an abstract idol as a springboard for speculation beyond science? If people can revere something as totally abstract as a God, surely there is hope that we can revere something as immediate and profoundly beautiful as an ecosystem complete with all its marvellous, interacting species — a small urban park, an Algonquin. If a reverence for nature ever overwhelmed our society, many of our environmental problems would simply melt away.

Thirdly, the biosphere. Its salvation rests on no profound science. It rests only on the values of society. It depends on an extension of ethics by the single species in which the very notion of ethics has evolved. The idea is not new:

"The land ethic simply enlarges the boundaries of the community to include soils, waters, plants, and animals, or collectively, land . . . But just what and whom do we love? Certainly not the soil, which we are sending helter-skelter downriver. Certainly not the waters, which we assume have no function except to turn turbines, float barges, and carry off sewage. Certainly not the plants, of which we exterminate whole commu-

nities without batting an eye. Certainly not the animals, of which we have already extirpated many of the largest and most beautiful species. A land ethic of course cannot prevent the alteration, management, and use of these 'resources', but it does affirm their right to continued existence, and, at least in spots, their continuance in a natural state." (Aldo Leopold, 1949)

That Leopold's perception of the problem is so relevant forty-three years later suggest that not much has changed. If anything, we know in more scientific detail why he was right.

But paleontologists have demonstrated that extinction has been the rule for the vast majority of species inhabiting the Earth, even for those such as trilobites and dinosaurs that dominated for more than 100 million years. What is the tragedy in human extinction? There is a perverse kind of peace in realizing that even this event, when sooner or later it happens, fits the evolutionary norm.

Foys female 151.373 howled that evening, out hunting by herself, or possibly with a pack member that carried no transmitter. She was near us, across the little lake where we had hiked before dark. Moonlight washed the shore. The spruces were in ragged silhouette. Her pups answered away to the north, at home in the rendezvous site. If science teaches us nothing else, it puts human endeavour into an ecological and evolutionary perspective. We are only one species. This is their world too.

Postscript: On February 19, 1991, Foys Lake female 151.373 was shot through the heart with a single bullet. She had made the fatal mistake of crossing out of the park in search of prey, following the deer down to Round Lake Centre. About 4:30 in the afternoon, a farmer, cutting wood, heard her and her pack mates howl. His rifle was stashed behind the seat of his pickup. 151.373, unaware of danger, walked up a forest trail only 100 m from his log pile. He killed her with one shot.

Her pack mates mourned — we were sure they did. Don't dogs? They stayed near her for two days, then headed back towards the sanctuary of the park. We radio-tracked them, staying well back as they made their way slowly over pine and hardwood ridges. One wolf howled repeatedly — long, low, mournful sounds. Her mate? One of her pups?

What is the future for a world not safe for a wolf?

Temagami – Both Sides from the Middle: A Native Perspective

Vicki Grant

It is March, mid-afternoon. The sun is shining and the sky is a brilliant blue. A light breeze whispers around the rock where we sit looking down the south arm of Lake Temagami. It is quiet and peaceful, and we are alone at this most incredible time of the year – the best that Temagami has to offer.

As I soak up the sun and tranquillity, my mind turns to all the confusion and debate about the area. Who owns the land? Are parks the answer? What about logging? It is hard to answer these questions, especially when your livelihood depends on the economic health of the area. It is even more difficult when you like to canoe trip, and to hunt and eat fish. And if that isn't confusing enough, I am a member of the Teme-Augama Anishnabai, which has a claim to the surrounding land. I sometimes think I am fated to see both sides from the middle, and that has a lot to do with my native ancestry and the way I was brought up, and the fact that I now live in a largely non-native community.

Growing up in the 1950s and '60s at Bear Island on Lake Temagami was very different from what it is now. The community was isolated because of the lack of modern conveniences such as indoor plumbing, electricity, and transportation. There was more work to everyday living. Generally the families were larger and the houses were smaller, and as children we spent much of the time outdoors entertaining ourselves.

As a child I was not aware of what a special place Temagami is. The trees and water were there to play in and to use for whatever was needed. To think of your backyard as enchanting or special was absurd; it was just there – a part of everyday life. Whatever nature threw at you, you adjusted your life to accommodate. The only time I vividly remember as exciting and looked forward to with anticipation was break-up and freeze-up. They truly marked the end of one season and the beginning of the next. The first fall I went away to high school, I remember having felt cheated because I was not on the island during freeze-up.

As I grew older I became more and more aware of what a special place Temagami is and how much it is a part of me. I was sure I would never want to live anywhere else.

My husband, who is non-native, and I were married on Bear Island and lived on Lake Temagami year round until 1985. We own an island in the south arm of the lake about 10 km away from Bear Island. We moved into New Liskeard, a community about 60 km north of Temagami, in 1985, so that our children would have the benefits of living in town; but we are down at the island on weekends from break-up in early May through until November.

Because my immediate family all reside on Bear Island and also many of the people I grew up with still live there, I still maintain a strong connection with the community. I feel that it is important to share my background with my children. My brothers continue to hunt, trap, and fish, not because they need food for their families but because it is a link to their past and who they are as native people – their *identity*.

Over the years I have watched my brothers take their non-native friends out on the trapline and listened to their conversations. They are quite proud of what they have to share with their non-native friends. This really is a part of who they are.

As I try to examine my conscience and sort out my feelings regarding the issues in the area, I find I mostly have very mixed feelings. The reaction I have to certain questions will depend on who is asking. I find that what matters is not whether that person is native or non-native, but how hard that person is trying to understand both sides of the issue.

One such issue is that of hunting and fishing. They are an essential part of native life and culture. Some people feel that they are not necessary anymore because most native people do not depend on them as a means to live. It is true for the most part that native people do not need to hunt and fish to meet physical needs, but I believe that they still must for psychological and spiritual needs.

When it comes to such issues of identity, I believe I have a good sense of who I am because of my parents and our strong sense of family. My parents did not teach us to speak Indian in our home because they felt it would be of no use to us as we got older and, if anything, would only cause anguish in our lives. At the time, children who had been sent away to residential schools had been severely punished for speaking their language. Our family was separated in the winter months as soon as my brothers started school. My father continued to go into the bush to trap with his family. Someone always stayed back to help my mom with the children and chores of everyday life. Had the school-age children continued to go to the bush, they would have been taken away. Over a few winters my family boarded the oldest children of another family so that the rest of that family could still move to the bush.

Our diet consisted of wild meat and fish until I was quite old. We were kind of in transition from one way of life to quite another. Many of the things my grandfather taught my father as a means to look after a family were no longer applicable. However, my father taught us the ways of the bush — how to hunt, fish, and trap — not as a means of survival but only as a part of life. My parents felt that what was important now was an education for their children, education being the Ontario school system.

The lives of my grandparents and parents changed drastically over the last sixty years, and such rapid change came at a cost. In our family, we have had to deal with some of the social problems, such as alcoholism and low self-esteem, which I am sure have been caused by these changes. Many of our people have suffered from serious social and educational problems and still do as a result of such major changes.

I do not say this to make anyone feel guilty, but only to create an understanding that it has taken some time to get into this mess and it will take some time to get out of it.

The problems we face are much greater now than they were in the days of my grandfather. He felt that non-native society would live up to the promises that were made to his people. But every time a letter was written asking where the reserve would be or suggesting a reserve, the government at the time would have some reason not to complete the transaction. Now, with natives' access to the justice system and with native people not so inclined to believe that the non-native way of life is the better, an agreement will be much harder to work out.

Before an agreement can be reached with the native people, there has to be a healing in the communities. I think that fishing, hunting, and trapping can play a part in the healing process. I know for myself that whether I am out canoeing, in at a hunt camp, or just out in the bush, I am much more at peace with myself.

To address the issue of the abuse of the hunting and fishing rights that some people fear, I can assure you that where I grew up, people used what they killed. If someone in the community killed an animal and did not deal with it responsibly, respect for him within the community would be lost. Most native people would agree that hunting and fishing irresponsibly is a crime.

I also feel that if the native communities had some input into and responsibility for the laws which govern them, including those related to hunting and fishing, they would have more respect for them. Native people have been made dependent on the government. Now native people understand what has happened to them and want independence. I think with patience, understanding, and time, an agreement will be reached which will be acceptable to all concerned parties.

As I explained at the beginning, I have had a hard time organizing my thoughts with regard to all of the issues that affect Temagami and my people, and sometimes I feel my life is a contradiction. Still, I believe with time and the right people we will be able to sort this mess out.

As for the Temagami area, I believe there will be changes, and that at the same time I will always be able to obtain the sense of peace and tranquillity from it that I always have.

No-name River

Anne Champagne

This is any-river, a wild river you may have paddled yourself. It has the same frothing rapids and tranquil pools, brutal portages and voracious blackflies. But it is all rivers too. So it has no name.

It is, however, crowded with the ghosts of names. Millennia of leaves become skeletal and then liquid as they break apart in fast water. Herons that are as much river as wings. Muskrat and river otters, moose in quiet tributaries, lobelia and orchids, tribal camps, canoes. Sometimes their voices grow loud and sleep is impossible.

This river is north; it must be. Southern rivers are human now, as docile and stupefied as cattle. We slip our canoes into river-water with currents as alive as any running animal.

The usual band of paddlers has come on this trip, rejoining one another every year for the love of such rivers. We come in hope that the river will take us into itself. Here we become worshippers of this green land, and advocates.

We enter the river when it's calm, loving the sun on our arms and on this effusion of shifting colour. Aromatic earth and leaves brush against our skin. The road in is dustier, wider than last year, and we quench ourselves in clear water.

Canoes weighted with packs, we drift off with the current. Warm water envelops each boat, and we soon relax into the rhythm of paddling. Thick conifer woods rise up from these hills and press upon us on sharp turns. Mosses gleam emerald on half-submerged rocks. The songs of unseen birds fill us and we gradually let all sounds and images flow into and over our starved bodies.

There could be no gentler craft than this. The paddle blade nudging against riffles so that the bow shades slightly in or away from shore is like wind through feathers turning minutely for a perfect curve in space. When the blade takes you into the river, there is no longer reason to fight currents and wind. We let them lead.

The river negotiates boulders and drowned trees. We follow. The history of rock slides and uprooted pines draws us, and we learn by reading the water and shore. This is a spillway, glacial memory of larger patterns carved by deeper rivers. Its boulders could have been carried millennia in melting ice, the sharper slices of rock are sheared off from cliffs lining the shore here. Cedars and ferns hold fast to the rock face. All will eventually merge with the river, their bones its future conversation.

Later the river softens into marshes thick with pickerelweed, arrowhead, and cattails. We feel moose in the neighbourhood and paddle quietly, intent. The bank has its own history, in hoof prints, raccoon tracks, and split shells. Animal trails push through thick shrubs everywhere. We take a detour up a small tributary barely wider than a canoe. Cross-bow rudder and draw, pole and draw again. Branches catch the bows, wildflowers crowd in among us, fragrance reminiscent of something just out of mind.

Huge moose prints press into the mud and we feel surround-ed. We rest the canoes on a beaver dam and walk into thick grasses and shrubs, exposing ourselves to this private place, cautious and respectful. We are close to so strong a presence, and hope for con-tact, but there is a sense of resistance. We are conscious of trespass, and return to the river.

But we are ready. Deep into the trip days later, we abandon anticipation of moose and see one, water belly-high around her, feeding slowly on tender plants. We drift closer, in awe. In slow motion she lifts her lumbering weight out onto shore and fades into the bush. We are suspended, silent, happy.

The river widens and quickens here. Riffles, then rapids. We paddle into the V's and slip through, feeling the energy of fast water fill and strengthen us. The river banks pour past, green and purple, black with shade. Surges of fear are a reminder that human control is illusion.

We camp on a long rock point jutting into the wide river, wind blowing insects across and away from grateful skin. We each

nestle into a pocket or ledge of rock, alone but close, and lose ourselves in the smell and feel of a thousand lives around this bay, scuffling and swimming and tasting whatever's been washed up by the water.

As sun makes a rose blanket of the soothed river, a fox appears on the next point. Her eyes are quick, muscles alert to remote sounds. How different from the animals caged in zoos till they're stripped of all agility and deftness, all acuity and capacity to respond! She is no simple clone of all foxes. Her eyes catch every flicker of light, she chooses each action. Without warning our eyes meet and for a moment we cross over into each other's lives, there is a brief companionship. After she vanishes into the shrubs, a lingering loneliness.

The rhythm of paddling stays with us on shore, takes us out of time. A loon surfaces off the point and calls to another somewhere on a neighbouring lake. Their piercing echoes make a cathedral of the bay, and something in us falls gently in place. Trees lean against water, reflected sky brought to earth. Water slides down the loon's neck as it cranes upward calling and calling until there is nothing left but this rent in the universe, an opening into a time so ancient that loons were young and humans still embedded in the body of the land like any cub or sapling. The song carries into the lakes and firs beyond the river, meshes us with the furthest wheeling gull. There is no division between our bodies and this seamless river, water and wings. There is nothing but soaring release and a strange painful joy singing through us, making us whole again.

We relinquish any claim that our skin is the proper border of our selves. Somewhere deeper in our bones, we learn that a loon is as much a part of us as our own lungs, and if it were to be lost forever we would grieve as for the loss of power to feel spring air. The glimmering bay is deep within us, perhaps we are even part of its experience. As we gather together in a circle, one carrying kindling, another larger wood, to build the evening fire, words for what has just happened emerge, tentatively, rising with sparks from the fire. This presence that comes so near when a loon breaks apart the night, or when mist rises off the river at dawn, is something in common to loons and rivers and humans, one

among us proposes. This loon and every living being on these lakes and shores took billions of years to evolve into what they are now. There can be no human right to intervene. Against such certainty, attempts to manage wilderness seem such extraordinary arrogance, since we can never understand enough of these intricate beings or their home.

Our small group agrees there is no truly healthy land on Earth but wilderness. Most human cultures are now so out of synchrony with life, so incapable of living at peace with other life forms, that we will destroy it all unless we can re-learn humility and again hear the voices of Earth. For such distorted cultures all that is not human is a machine, each animal a stimulus/response automaton. Perhaps if more of us could meet the clear gaze of a fox we would know otherwise, and be at least partly healed.

But that would be complicating. How else could we massacre whole forest ecosystems unless we dismiss all resident wildlife as expendable ciphers? If animals are subhuman, vacuous things, they are unimportant and manipulable. Always there is a need to question further our motivations.

On a river trip such as this, convictions can emerge that all forests, loons, rivers, and foxes have lives to live as important to them as ours are to us, and as much right to live them. Our interference in their lives is an act of lunatic egoism.

One among us recalls the thoughts of a teacher, that only when we deeply experience wilderness do we fully experience the wounds we inflict on the Earth. When we finally beach our canoes at the end of our trip, we must portage past an abandoned logging camp. All trees around it are cleared, a sudden vacuum in the land. Soon we can see that the last part of the river we've paddled is edged not with deep woods but a thin strip of trees backed by huge clearcuts. We react with anguish and rage.

We know there are cutting machines that snap a tree off its roots like so much asparagus, then strip off branches like dried herbs. We have discussed before the notion that these machines are products of a male culture in love with domination and power, looking for proof of some demented mastery of nature mythed as female. A recalcitrant mother nature that after all cannot give

COCOS LAKE, OPASQUIA PROV. PARK
BRUCE LITTELJOHN

endlessly. This culture wills nature to be ruthless so it can say "That is the way of the world" and justify its own continual violence against all that is untamed.

Always, though, on a northern river trip, there are momentary raptures to counterbalance the trauma of split trees and mined earth. These are motivation enough for permanent devotion to the preservation of wildness and the pursuit of further brushes with wild nature.

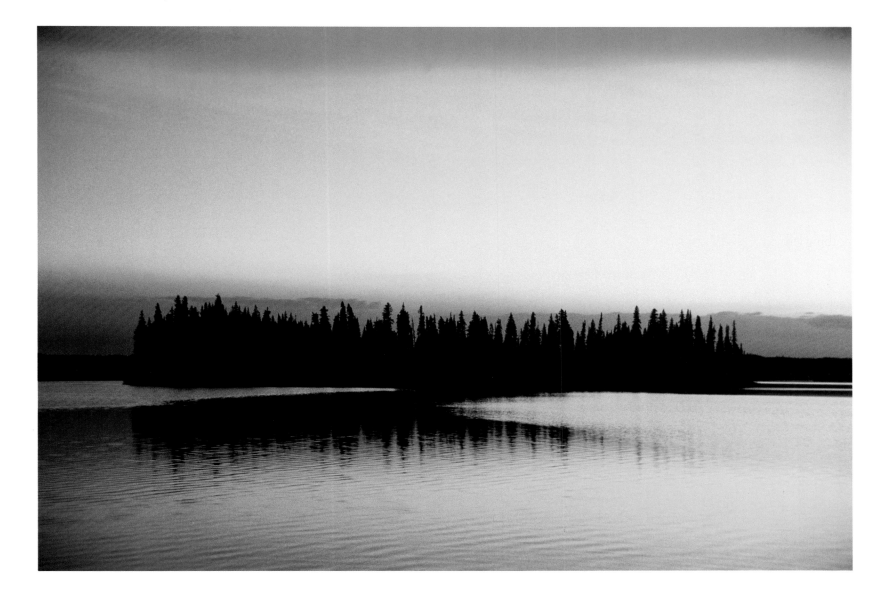

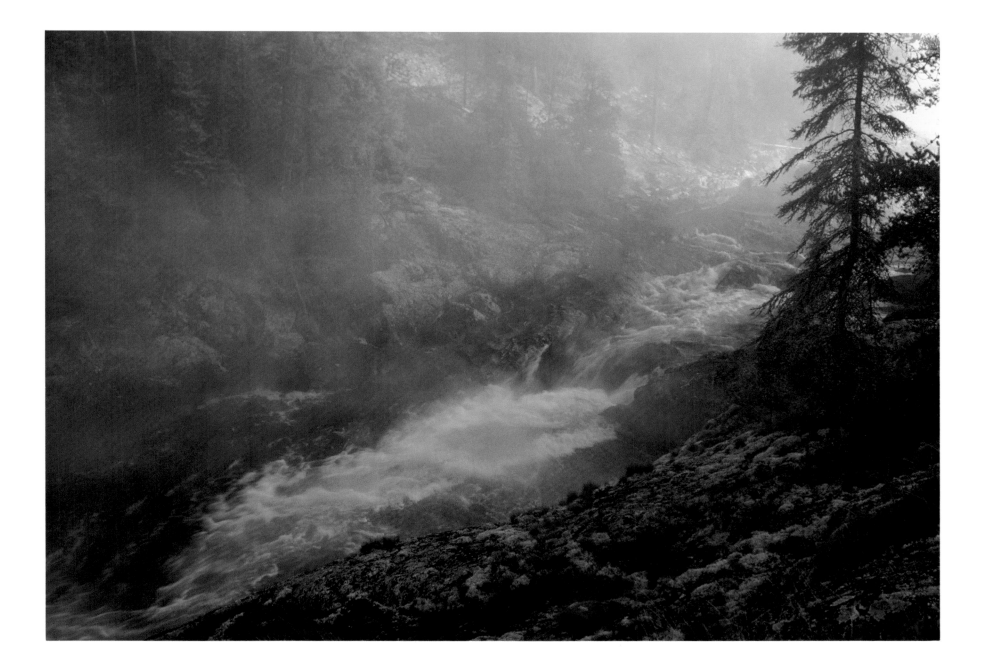

LEFT/NIPIGON BAY, LAKE SUPERIOR
BRUCE LITTELJOHN

ABOVE/HELLGATE RAPIDS,
MISSISSAGI RIVER WATERWAY PARK
LORI LABATT

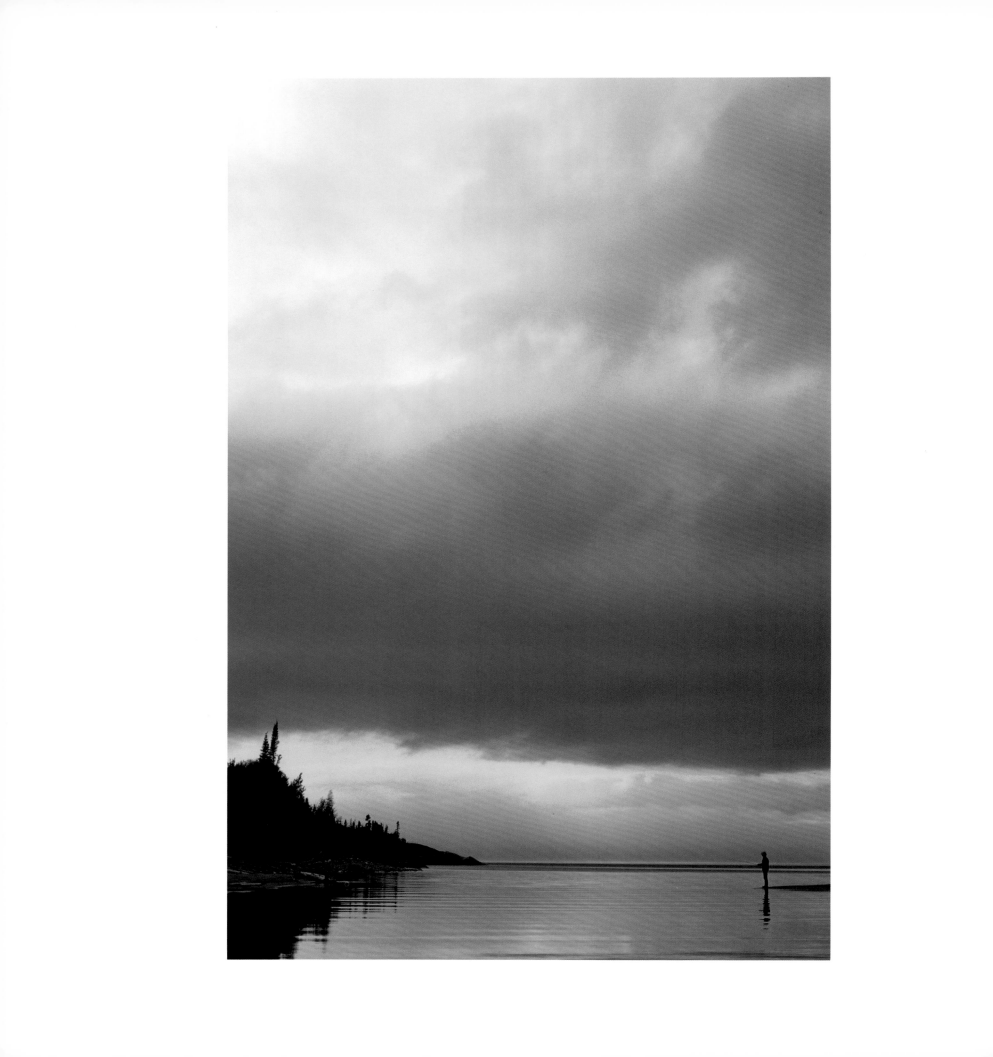

A Small Boy's Real Log Cabin

Bruce Hyer

One archetype of this century is the white American urban male, with career and house, who throws it all over to move to the wilderness of Alaska or Canada. I don't know how well I fit the mould, but it may be of interest to some to hear one perspective of how the Boreal forests of northern Ontario match Yankee urban fantasies of the Canadian wilds.

From the time I was a very small boy in New England, I had always wanted to grow up to build, and live in, a real log cabin in "The North". Most of my allowance when I was little went for flashlight batteries to read under the covers after curfew. I exhausted all the librarians and library shelves within bicycle distance looking for books with titles like *We Went to the Woods, Cache Lake Country, Wilderness Survival, Building a Wilderness Log Cabin*, and *Feasting on Wild Edibles*.

My father loves canoes and canoeing, and I paddled whitewater rivers throughout New England with him, but he associated camping with living in foxholes in the South Pacific while being shot at, so I had to join Boy Scouts to escape on weekends to go backpacking and tenting. It was fun, but I knew that it wasn't the "real" wilderness that I sought.

In 1965, while in university, I was walking past a classroom when my ears caught the words "height of land", "portage", and "maybe runnable". I backed up, eavesdropped, and inveigled my way in. The professor, a former consul to Ottawa, was planning a northern Quebec excursion with students and Canadian friends. Alas, there were no openings, but I made hopeful noises, and left my address and phone numbers. Fate took over. One student went to Vietnam, and I went to Clova, P.Q.

The train from Ottawa changed at La Tuque, and became a time machine, dropping us at 2:00 a.m. at a siding along the CN tracks, somewhere in the eighteenth century. Two weeks and 320 km later, my life was forever altered. Everyone revelled in the fresh air, the fishing, the white water, the camaraderie. For me, it was total, albeit pleasant, shock. It was as if I had been there before. Nothing was strange. No adaptation was required. Was it genetic imprinting? Was it reincarnation? I was reborn. I was home.

For the next decade, I was in my glory. Each summer, I could look forward to a new adventure, ever more north, ever more remote and beautiful. I had the best of both worlds. I could pursue my chosen career of environmental management, enjoy urban toys, symphonies, family and friends. Every summer I could ride those magical time machines: the rails, the floatplane, and the canoe. Labrador. Yukon. Northwest Territories. I could do this forever. I became smug with the knowledge that all that wilderness would be there: summertime tonic and wintertime fond memory. I would help save civilization from pollution. Wilderness would remain. Maybe I would retire to that log cabin. There was no hurry.

1973. My first repeated trip. Back to central Quebec, perhaps the finest wilderness canoeing anywhere. Up the Mégiscane, up the Rivière St-Cyr, up to Barry Lake, where the river flows both north and south, in a portage-free divide. Barry Lake, where at the centuries-old natural campsite on the point I had previously found both an arrowhead and a fur-trade-era coin in the sand. We paddled all day, upstream, heads bent against the north wind and rain. I wouldn't hear of stopping; I had a date with the voyageurs at Barry Lake. The rain slackened. One more riffle to wade, one last point to round. Again Boreal Quebec offered a shock. The Jet Ranger helicopter lifted off, rocketing toward us just below the ceiling of grey scudding clouds.

"Hey, Bruce. I thought you said this river was wild." No answer. I paddled numbly to the old campsite, now bulldozed flat to make room for helicopters, tents for dozens of men, barrels of Jet B, and mounds of trash. We were a hit. We all, especially the women, had lots of attention from the Québécois pilots,

engineers, and labourers. Ice cream, steaks, and helicopter rides bought quick friends among the rest, while I hovered, chopperlike, somewhere between shock, depression, and rage. The head engineer showed me maps of how the Eastmain, the LaGrande, the Mistassini, and other old/new friends would be buried under monuments to progress, Robert Bourassa, and Québécois autonomy. In an afternoon, my world changed. I had long known that civilization was progressing, but my sense of that progression had been arithmetic. The good people of the Sierra Club were supposed to halt, or at least slow, that civilized advance; I had preferred to believe. In an afternoon, my smugness evaporated like the mist over Barry Lake. The maps told of a 1,600-km leap by roads, dams, and the biggest high-tension towers in the world. I returned to a U.S. where nobody knew, nobody understood, and nobody cared.

My comfortable assumptions were in tatters. My downtown office chair was no longer padded with cosy memories of my inviolable wilderness. I wouldn't wait for the gold watch and the log cabin. I would experience wilderness now, and help show it to others who could help to save it. After two years, and a lot of homework, I selected a spot just off the good old CN line, west of Armstrong, Ontario. This time, there would be protection. The Ministry of Natural Resources district forester assured me that "there will never be any logging around there; the wood's too small, and the sites are too fragile. There are too many rivers and lakes, and it's too far from the mill." The district lands' supervisor reaffirmed: "We know of no plans for any kind of development, probably for decades, if ever." These were the guys who should know. I returned home, infected my wife with my zeal, quit my job, sold most possessions, hugged friends and family goodbye, and left to start a wilderness canoe outfitting business.

May 26, 1976. All our earthly possessions were unloaded from the old suburban and piled on the CN platform in Armstrong. Six canoes, five tents, lots of log-building tools and books, and about 50 kg of rice were loaded onto the midnight train, filled with trappers, schoolteachers, missionaries, Indians, and tourists. We didn't know a soul in northwestern Ontario, and were brimming with equal amounts of apprehension and excitement. A German tourist bought me a cold Molson's in the dining car, and I reflected on my wisdom in moving to a province that had committed to good rail travel, returnable stubby beer bottles, and land use planning with voluminous rules (unlike Quebec, where anyone could put up a *patates frites* stand or dam wherever she or he chose).

Approval for a cabin took longer than I suspected, and I had to call a tepee home for over a year, while Harriet did substitute teaching in Thunder Bay to keep up the cash flow. It was frustrating that the bureaucracy moved so slowly, but I took solace in the thought that MNR staff were so slow and careful with their wilderness management. Indeed, one day an MNR "yellow bird" landed; an official measured the distance from my tepee to the lake and informed me that I was almost 3 m short of the 30-m requirement.

I wanted to see my environs, so I headed north to Hudson Bay with a fishing rod and a .22 rifle, to Fort Hope, Attawapiskat, Webequi, and Winisk, on a six-week solo trip that left me about as skinny and happy as I've ever been. I found that given enough hunger, one could eat entire walleyes . . . bones, skin, and all! That winter, I made friends with several Indian neighbours who taught me how to trap. One wonderful discovery was that among my other neighbours were several hundred secretive woodland caribou, as sure an indicator of "real" wilderness as there ever was.

Book in one hand, axe in the other, I tackled the cabin that was to become home for another year. Selecting each straight black spruce with care, I agonized about cutting them, and about the tracks that I made in the deep feather mosses. I selected a site a few hundred metres back in the forest, as I felt guilty about civilizing this wild lake. An Indian neighbour assured me, "Never before has any man lived at Shawanabis Lake." Indian neighbours who had been open and friendly when I had lived in the tepee became distant and almost hostile as the obviously more permanent cabin rose on their ancestral lands.

The next summer, on my excursions to town, I began to hear rumours of a proposed logging road and cutting. The MNR said they knew nothing of such plans. I went directly to Thunder Bay, to talk to a mill woodlands division executive. "It's none of your business. We hold the timber licence, and we'll do what we want.

Besides, you outfitters are all crooks and bandits. Your customers are all goddam Yankees, and the sooner you all go out of business, the better." I left the steaming, odoriferous pulp mill in a rage, which simmered into a firm resolve. The Ogoki–Albany wilderness was too fragile and valuable to become "one week trees", in their dizzying ride from Armstrong to Thunder Bay, where only the pollution remained while newsprint cellulose would live forever in a Chicago landfill.

Lobbying from a log cabin 40 km from the nearest road is somewhat ineffective, so I headed for Thunder Bay, for "six months, or possibly a year". School bus driver. College teacher. Log cabin instructor (well, I had built one . . .). Contract moose biologist, racing the wolves and ravens to be up to my elbows in ripe gut piles. My MNR supervisor got wind of my conflicts with his timber branch. "Bruce, you've got to remember that MNR bureaucrats are like elephants; they're long lived, they've got long memories, and someday you're going to need something from them. When that time comes, do you want to get stepped on?"

I went to see members of the Parks Branch, many of whom reminded me of furtive lemurs emerging from the shadows, with big eyes watching for predaceous foresters. Finally, one lowly parks planner arranged a clandestine meeting in a little-visited beer parlour. When I launched into my usual speech about the fragility, beauty, and recreational potential of the Ogoki area, he pulled out a map, onto which was drawn the Whitewater Lake Candidate Wilderness Area, or just "Whitewater". "We don't want the company to find out about this yet, or it will be killed before it ever gets into the draft plan." What plan? "SLUP." What in heavens name is that, a new kind of slurpy frozen drink? "Strategic Land Use Plan for northwestern Ontario." He need never have been so secretive. The plan, together with a memo from an MNR forester worried about the threat from his Parks Branch, had already gone to the company in question: "I advise you to quickly get a plan in place for roads and cutting, to preempt our pinko parks people. Kill it before it multiplies."

The problem was that given the distance from the mill, the predominance of bedrock, and lack of road-building gravel, the area didn't appear to be economic to harvest. Never fear, the feds would come to the rescue. A secret subsidy request went to DREE (Department of Regional Economic Expansion). A brown manila copy came to us. I showed it to a friend, a fly-in lodge owner who had always been, like most outfitters, somewhat nervous of my talk of parks. "It's time to fish or cut bait, Don. Do you outfitters want a park that may cramp your style, or massive clearcuts and roads, which will surely put you out of business? If you support the park, I'll do my best to get grandfather status for the local and traditional users."

Don organized an Armstrong Wilderness Outfitters' Association, with a handsome caribou logo on the letterhead, on which he wrote powerful and articulate letters to bureaucrats and MPs. I commuted endlessly to Toronto, the source of all northern political and economic power, wondering all the while if I would ever get to live peacefully in that wilderness cabin . . . and if there would even *be* a wilderness around it. I had given up a rather lucrative environmental career in one city to take on an unpaid environmental career in one of the biggest and busiest cities in the world. I wasn't getting anywhere very fast, and my life savings were rapidly being transferred to the current accounts of those two "Canada's", Air and Bell.

I showed slides to ministers. I showed slides to politicians. I showed slides to the Parks Council. I showed slides of bedrock, moss, caribou, and waterfalls to the FON and the Sierra Club. Eureka! Ron Reid and Rick Simms gathered kindred spirits Janet Grand and George Luste, and showed up at my Shawanabis Lake cabin for a two-week trip. There really was an undiscovered wilderness gem northwest of Armstrong! They gained the interest of the likes of World Wildlife Fund's Monte Hummel and the Algonquin Wildlands League's Arlin Hackman. They connected me with Thunder Bay's indomitable Bill Addison and Dave Bates, and the quietly effective naturalists Mike and Sue Bryan. The network was building, and into the mélange was thrown a new minister, Alan Pope. Where many ministers are led around by the nose by their deputies, Pope was different. He trampled bureaucrats mercilessly, and connected directly and privately not just with multinational companies but with trappers, and outfitters, and parks advocates. He played his cards close to his chest, but when the

smoke cleared in 1984, Ontario had dozens of new parks, including a couple of new wilderness areas. It was a quantum leap, but all the news wasn't entirely good. Some site regions were represented inadequately or not at all.

Of particular disappointment was Ogoki–Albany/Whitewater, which was only 1,215 km² compared to the over 4,050 km² recommended by the park planners and the Parks Council. Alan Pope held a press conference in Thunder Bay, accompanied by a beautiful map of the new parks in northern Ontario. Graphic artists had skilfully drawn in all of the parks except for one. Now called Wabakimi (which ironically means "white water" in Ojibwe), the new park northwest of Armstrong had shrunk to the smallest of three concentric circles, the outer two having been crudely obliterated with ordinary steno whiteout. Clearly, the battle between the Timber Branch and the Parks Branch had continued literally until the eleventh hour . . . and the Parks Branch had not won.

We gathered for a beery postmortem. Anger at the Wabakimi decision was swallowed in the pleasure of the other new parks, and in the relief that the alphabet soup of MNR land-use-planning acronyms was history.

Years later, parks supporters are beginning to recover from the the old war wounds. There are new stirrings. World Wildlife Fund is leading the charge this time, with their Endangered Spaces program. New MNR planners are talking of the need to expand Wabakimi: virtually all the natural features that were the *raison d'être* are outside the park, along with some of its caribou and their habitat.

For a few more years, perhaps a decade, plus or minus, some options for wildlands remain. A Wabakimi we can be proud of. Lake Superior Islands. Amazing Lake Nipigon, the only Great Lake that belongs entirely to Canada. Unrepresented natural site regions.

All we set aside soon for nature is all we will ever have. Can old parks warriors with new grey hairs rouse themselves to vigorous initiatives? Do we need to find and groom new young urban males, and females, to protect and help nourish their fantasies of wilderness waterways, loons and wolves calling under yellow moons . . . wild Boreal landscapes to show their children, and their children's children? Maybe they're under their covers tonight, devouring their wilderness tales in the yellow glow of their flashlights, and thinking of a real log cabin in "the North".

WINTER IMPRESSIONS
W.D. ADDISON

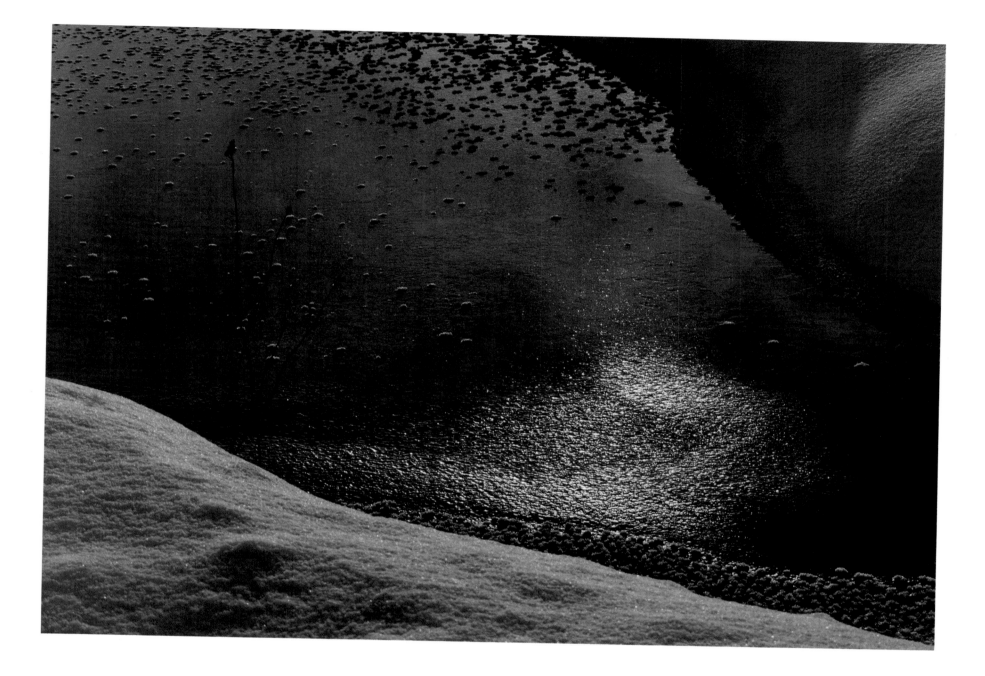

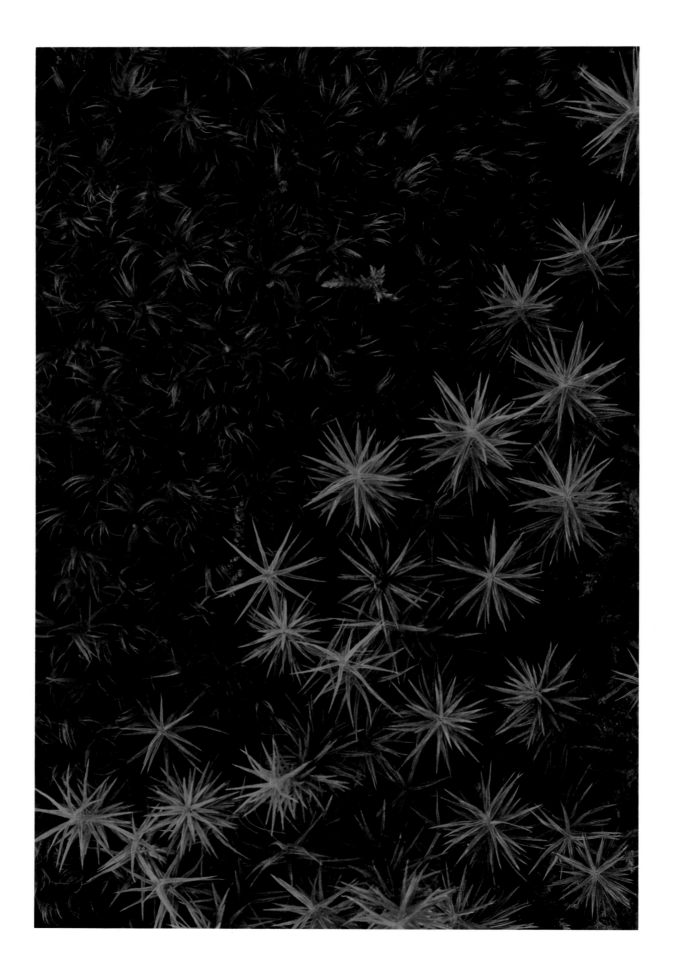

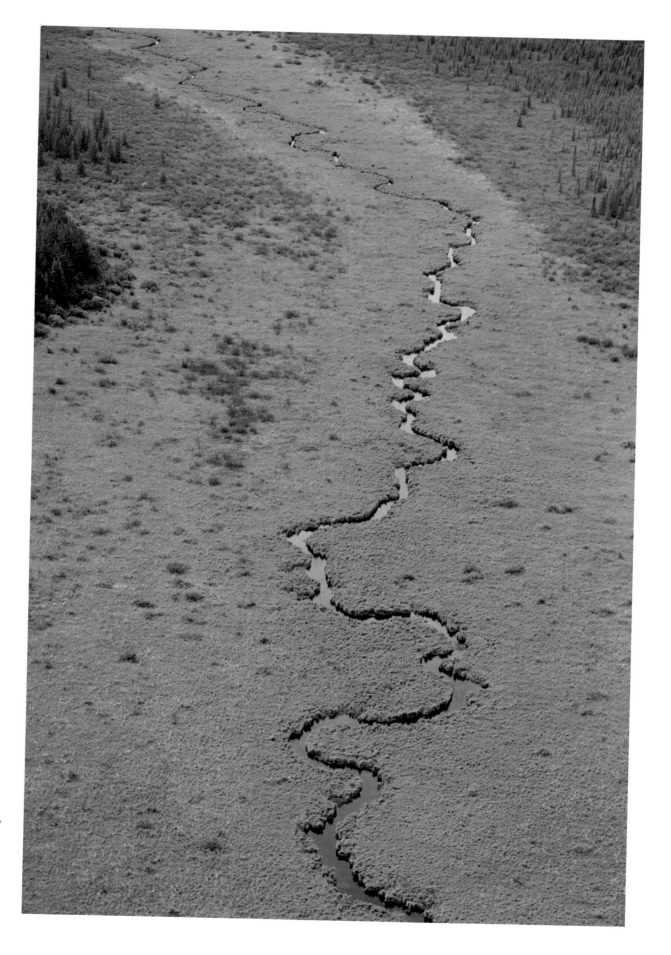

LEFT / MOSSES,
AWENDA PROV. PARK
RICHARD MATTHEW SIMPSON

RIGHT / BARASS CREEK,
LAKE OF THE WOODS
PROV. PARK
LEO HEYENS

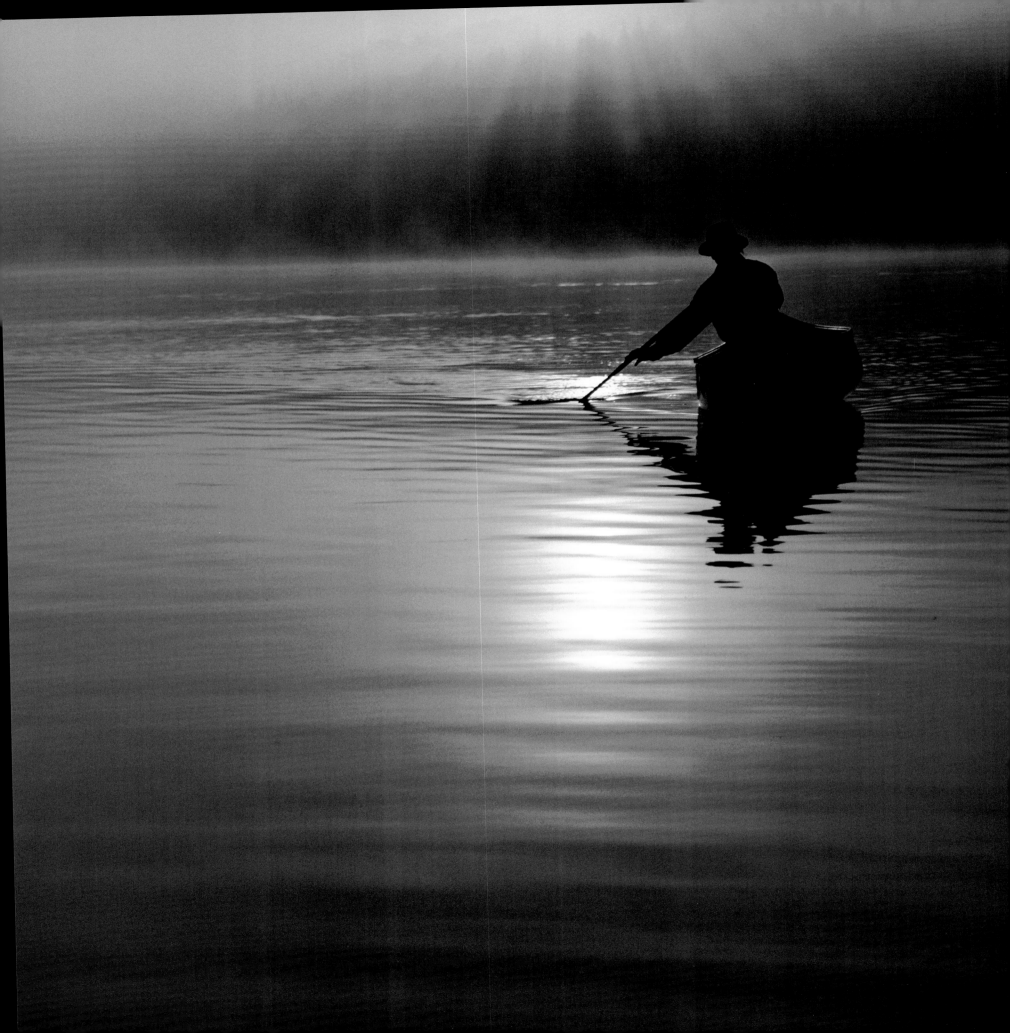

Parks, Protection, and People

Norm Richards, Director
Provincial Parks and Natural Heritage Policy Branch
Ontario Ministry of Natural Resources

It often seems that Ontario has two provincial park systems. One is the administrative system that people like to argue about. The other system seems to exist as a collection of fond memories dating back to the days when we rode in the back seat chanting "Are we there yet?" It's a system made up of our favourite parks where the bacon smells mingle with pine on the morning breeze, where people—complete strangers—call out "good morning" from campsite to campsite, where the campfire smoke drifts up into the stars at night and sunburned kids fall asleep in their parents' laps. It's the system that serves all Ontarians and is loved in return.

It's nice to know that system still exists, and that it's bigger and better than ever.

Compared with many jurisdictions, Ontario has provided a century of great parks and great park experiences. A cast of thousands created those parks: avid campers, naturalists, anglers and hunters, conservationists, politicians of every stripe—they all played a part.

But a lot of the credit, too, must go to the old-timers in the Department of Lands and Forests. In the 1950s and '60s, when the public was clamouring for campsites, some of the early park superintendents were hurriedly diagramming park road systems on the backs of envelopes while the bulldozers were being unloaded. And because these were practical people, those designs were pretty good. Later came the park managers, planners, and ecologists, community college and university educated, many of whom still serve in the Ministry of Natural Resources. The old-timers and the MNR staff may not have pleased everyone all the time, but generally, they knew what Ontarians wanted and they provided it.

What they provided was one of the largest and most highly regarded park systems in the world. Work just one shift at the provincial parks booth at any camping or outdoors show and you will realize that our parks are one of the province's best-loved institutions. People from every walk of life come strolling up to the counter for the new parks guide or brochures, and also to talk about their favourite park. Invariably, their parting comment is: "We just love provincial parks." Ontario's parks have a huge fan club. And it's international. Every year, foreign delegations come to Ontario to study our park system.

There's so much to study. The parks are scattered across a landscape that is rich in natural diversity. In Ontario, you can visit a park on southern farmland, on Great Lakes shoreline, on rocky outcrops by wild northern rivers, or on the tundra.

Parks offer a diversity of visitors, too. It's not hard to find campers from Alabama parked next to a group of touring Germans. On a Sunday afternoon in some southern Ontario parks near Toronto, you can hear different languages being spoken and smell the food aromas of the world from hundreds of cooking fires.

The diversity is also reflected in the policies governing Ontario's provincial parks system. Ontario parks serve many purposes. They exist to protect natural resources, stimulate heritage appreciation, provide outdoor recreation, and support tourism.

These objectives have remained relevant, and parks managers

RAGGED LAKE, ALGONQUIN PROV. PARK
BRUCE LITTELJOHN

have always attempted to be sensitive to the balance that must be maintained. They have to protect the forests, scenic vistas, nesting areas, and rare plants. But they must also provide enough parking spaces, clean campsites, good beaches, and trails.

Park managers maintain these traditions: wise environment management, excellence in services and facilities, and quality staffing. At the same time, parks staff have always tried to be progressive and open to change.

But it's not change for the sake of change. Revitalized facilities have been gradually introduced in many parks; but if you want a place for a wilderness experience or an old-fashioned family picnic, provincial parks can provide the facilities.

Park managers know how important good customer service can be. In a way, it has become their obsession. The MNR still runs intensive staff training programs and carries out annual park-visitor surveys to find out what people want. Several years ago, visitors to Algonquin thought the park should have a world-class visitor centre. It will open in 1992.

What are the plans for the next 100 years? Generally speaking, be prepared for more of the same. The basic traditions that have served Ontario so well for so long will be maintained. At the same time, parks staff will continue to plan for elements of change.

Ontario parks staff pride themselves on being leaders in park management. It goes back to the days following the Second World War. When new roads and an increase in the standard of living and leisure time created a mass desire to visit special outdoor recreation areas, the province responded.

The increase began in the 1950s. Then the new parks began coming in batches. In 1963, for example, there were more new parks created that one year than in the preceding seventy-year period that began with the creation of Algonquin, the province's first park, in 1893.

The post-war development boom in the province amazed, astounded, and then made Ontarians a little uneasy. In the 1970s, growing awareness of the environmental consequences of this development brought calls for more wilderness and nature reserve parks, while recreation enthusiasts, afraid development would swallow every available green space, demanded more accessible

parkland. In response, the province created another 155 new parks in the 1980s.

The public has also indicated a growing concern about environmental management within provincial parks. Certain types of land uses and activities such as timber harvesting, mineral exploration and mining, hydro development, trapping, hunting, and tourism development have received increased scrutiny as to their appropriateness in our parks. Accordingly, parks management policies have become more protection-oriented.

In the coming years, parks staff will continue working on the Ontario share of the Endangered Spaces campaign, an effort to set aside an appropriate amount of natural area in the province. The Endangered Spaces campaign is a ten-year effort, initiated by World Wildlife Fund Canada and supported by many conservation groups, to conserve Canada's natural diversity by protecting a representative sample of each of Canada's roughly 350 natural regions. The recommended target is to represent Ontario's thirteen natural site regions and sixty-five site districts with protected provincially significant areas by the year 2000. Ontario's network of protected areas is incomplete. Our parks cover 6 per cent of the area of Ontario, but we need approximately another 2 per cent to achieve all the earth science, life science, and cultural feature targets as well as recreation targets.

Ontario will also be double-checking to ensure that the process used to manage parks is environmentally friendly. Parks staff will be involved in a class environmental assessment of park management. The planning process currently used to manage provincial parks will be examined to ensure that it complies with Ontario's Environmental Assessment Act. The act provides for the protection, conservation, and wise management of the environment through good planning and informed decision-making.

The emphasis on training and developing parks staff will continue so that park managers will remain sensitive to societal trends and visitor concerns. Aside from regular park-user surveys, there will be increased "environmental scanning", the gathering of information about trends from a wide variety of sources, including daily media reports.

Parks staff have remained sensitive to public opinion. In 1990, in response to the public's concerns about the environment and the introduction of new waste handling ideas in many cities and towns, parks staff introduced a recycling program in twenty-six provincial parks. In 1991, the program was expanded to sixty-five parks and will continue to grow until most parks have a recycling program.

Parks staff have been improving park facilities for persons with disabilities, too. Today, eighty of the 125 operating parks in Ontario's 261-park system offer facilities for campers and nature enthusiasts with disabilities.

Parks managers are also preparing to wrestle with fiscal challenges for the next decade. In 1983, parks staff adopted twenty-three efficiency strategies that stretched budget dollars by, for example, streamlined administrative procedures and cost-effective maintenance standards.

The Ontario public today wants to be involved in decisions affecting institutions in which they have an interest. As a result, parks managers have sought out partnerships. Volunteer associations such as the Friends of Algonquin Park and Presqu'ile Park have been established, and many of these groups are helping fund park projects that could not be afforded otherwise.

In the 1990s, the MNR will be especially interested in partnerships with private landowners to protect significant natural features. Under a growing number of stewardship programs, many landowners have agreed to protect such features on their own properties. Extending these programs is especially important, for Ontario's provincial park system alone can never be expected to represent all of the province's significant landscapes. In addition, some of the most significant natural features in Ontario are on private land.

Whatever the future brings, the Ontario provincial parks system will always remain committed to the broad cross-section of the population that helped create it.

In recent years, that family has grown. The people whose families have used parks for years and the visitors from outside the province have been joined by an increasing number of senior citizens, by persons with disabilities, and by more new Canadians.

They visit parks to lie on white sand, to fish, to enjoy a campfire, to observe marsh life, to study the geology of areas like the Ouimet Canyon, and to look at the mysterious rock carvings at Petroglyphs Provincial Park . . . for all kinds of reasons.

Our parks are also home to the researchers, interpreters, and educators who, like the late Shan Walshe of Quetico Provincial Park, spent most of their lifetimes studying every aspect of the natural life of an area.

Ontario's aboriginal people will likely play an important role in the future of provincial parks. Park managers in the future will be supporting the rights and interests of First Nations people, while at the same time ensuring that the provincial parks system continues in its role of protecting the province's natural heritage. It is the newest challenge for park managers and the parks family — and the newest opportunity.

The parks family also embraces the legion of people whose lives, to varying degrees, revolve around the management and protection of the parks. They are the MNR staff drafting policy in Queen's Park and implementing park programs in field offices, as well as the volunteer groups selling publications and helping out in park visitor centres. Then there are the individual volunteers who devote hours of their own time to lead groups on nature walks and canoe trips. The long arms of the parks system also reach out to embrace the taxpayers of Ontario, who are investors in the park system.

Beyond the taxpayers, are another group of Ontarians who play a very under-publicized role in our park system. They are people who have never once visited a park. They are the vicarious users who want to know that there is a system out there protecting the whitest sand beaches; the best representative examples of landforms, flora, and fauna; and the precious artifacts of our past. They sleep better knowing it's all out there, the wild things that help define the special character of the province and contribute to its environmental health.

The future of Ontario's provincial parks will depend on all these people, who will contribute to the protection, management, appreciation and enjoyment of provincial parks as we move into the second century of provincial parks in Ontario.

The Job to Be Done

Arlin Hackman

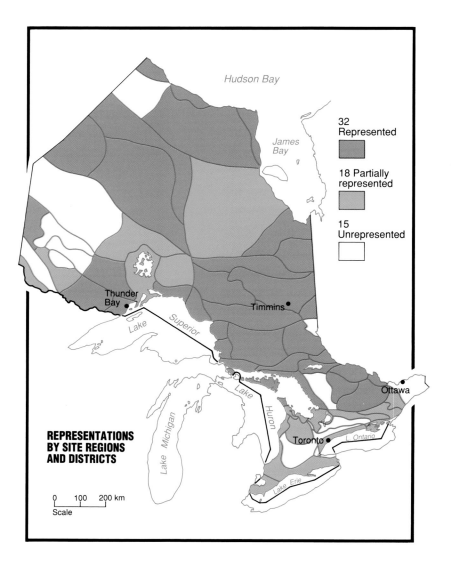

REPRESENTATIONS BY SITE REGIONS AND DISTRICTS

32 Represented

18 Partially represented

15 Unrepresented

Hudson Bay

James Bay

Thunder Bay

Lake Superior

Timmins

Lake Michigan

Lake Huron

Ottawa

Toronto

L. Ontario

Lake Erie

0 100 200 km
Scale

The second century of Ontario parks begins not only with a celebration of past achievement but with a sobering reality. As we toast one hundred years of conservation achievement, the sun is quickly setting on a much longer period of human history—a millennium in which our quest for earthly dominion is replacing the last uncharted frontiers with a landscape of human geometry at exponential speed. Whatever gains we have made in officially designating wild areas as parks over the past one hundred years are relative, occurring against a backdrop of steady losses of de facto wilderness and wildlife species. And at some point in time the two trend lines will meet across the province, as they already have in most of southern Ontario, where wild country is virtually extinct and the options for new parks are all but gone.

Though our actions and timescales were once of little consequence in predicting changes in the natural order of things, the forces determining the future of the planet are now largely those of humankind, organized according to our clock. It is therefore not pure fancy when conservation experts, observing the accelerating pace of development around the world, conclude that the opportunity to add more wild places to the global network of parks and protected areas will effectively disappear by the year 2000. How do we address this challenge which has faced no other generation? How do we decide if we need more parkland in Ontario and, if we do, where it should be?

MISSING PIECES

According to the Ontario government's own policy and targets, the provincial system of parks and protected areas is still incomplete. You can't tell this by looking at a list of existing parks or checking out an Ontario highways map, because the park system is not based on reaching a certain number of sites or spacing them at convenient intervals along major highways like so many gas sta-

tions. That's because the fundamental conservation goal of our parks system is to protect examples of Ontario's natural history, ranging from prickly pear cactus on Pelee Island to polar bear roaming the subarctic tundra along Hudson Bay. To gauge new park needs according to this yardstick, we must consider the distinct ecological zones of the province called "site districts". Each of these geographic units contains a distinct assembly of natural habitats and species, conditioned by climate, soil, and physiography. When existing parks are overlaid on such a jigsaw puzzle map of Ontario, we find that in at least thirty-three of the sixty-five site districts more lands and waters need to be protected. (See map page 276.) This assessment is generous and warrants future refinement. However, enough field work has now been done that we have a good idea which site districts need more protected space, and in most cases candidate areas to do the job are also well known. These areas include, for example, the Aulneau Peninsula in Lake of the Woods, a large undisturbed wilderness area now proposed for logging; a large number of peatland habitats identified as candidate nature reserves in the James Bay lowlands, some of which lie in the path of proposed hydroelectric development; the Madawaska highlands, a rugged and thinly settled tract of Shield country within reach of Ottawa; the deep-water habitat of Lake Superior; and a host of remnant wetlands and woodlands scattered across southern Ontario, including Walpole Island and the Lake St. Clair marshes. Such places are not ecological curios; they are vital to the overall environmental health of the province.

THE MANDATE FOR ACTION

Ontarians want to see their natural heritage protected, and parks are seen as a key strategy for doing this. Six out of ten Canadians surveyed by Angus Reid in 1990 favoured at least doubling the amount of protected wilderness. And in two years following the launch of the Endangered Spaces campaign in 1989, more than 200,000 Ontarians signed the Canadian Wilderness Charter, calling for completion of a nationwide network of parks and other protected areas by the year 2000. Such places are seen as distinct from the surrounding industrial landscape by a wide majority of Ontarians, who have stated in other surveys by Gallup (1981) and Decima (1987) that logging, mining, and hydroelectric development are harmful and inappropriate in parks and wilderness.

These are not idle armchair sentiments: Ontarians and visitors to the province turn out in vast numbers to explore our parks year after year (almost eight and a half million in 1991), and back-country usage continues to grow faster than total visitation. Far from being a drain on an already shaky resource-based economy, these encounters have been shown to generate a greater return per hectare than logging.

It's not that people want more parks per se, but that they fear the loss of a dwindling heritage. Parks, along with other techniques for reserving public or private lands for nature, are simply the way to hold the line. From the outpouring of public support for protecting Toronto's Rouge Valley and other prime Carolinian habitat at Backus Woods, the unease of Sioux Narrows residents about losing the wildness of the Aulneau Peninsula, and concern among the Cree about Ontario Hydro's plans for the Moose River basin, the sense of loss runs deeper than a romantic urge to save a mythical frontier playground. Ontarians are feeling the loss of their homeplace.

Politicians are beginning to recognize this mandate. Ontario's New Democratic government took office in 1990 having endorsed the goals of the Canadian Wilderness Charter. In January 1992, the Minister of Natural Resources outlined steps to meet these goals in Ontario, including the short-term target of protecting representative natural areas in five site districts by the end of 1993.

Fortunately, the bureaucratic machinery and scientific tools are largely available to make these goals possible. Ontario led the country in planning for protected areas through the 1970s and '80s based on the 1978 Cabinet-approved *Provincial Parks Policy* and the manual *Ontario Provincial Parks Planning and Management Policies* (the so-called "blue book"). Both are widely admired documents. More recently, *Wildlife Strategy for Ontario* presented far-reaching recommendations which would broaden the scope of wildlife policy well beyond the tradition of game management to encom-

pass a network of protected habitats and conservation-sensitive practices on the rest of the landscape. And the Natural Heritage League already provides a forum in which a wide range of public- and private-sector conservation agencies are working together with an overarching concern for the biological diversity of Ontario.

CHALLENGES TO BE FACED

With a measurable goal, a geographic agenda, and so many signs of hope, it seems as though the story should end happily right here. But since 1988 there has been no significant increase in protected areas within the province. This situation is partly due to plain old bureaucratic inertia, but there are also other forces at work restricting the designation of new preserves.

First, as we reach the limits of a rural economy fuelled by exploiting our natural resources, efforts to set aside remaining pockets of wild country are meeting an increasingly hostile local public. Motivated by a potent combination of fear for their future and a sense of powerlessness, local residents see wilderness preservation as a threat. Convinced that "wise use" or resource development of the entire landscape is needed to preserve the status quo for their communities, they are organizing under the appealing banner of "sharing" the land and its resources. Precious energy is then spent fighting against parks rather than searching for a way out of an economic predicament that resulted not from parks but from outdated provincial resource policies as well as global market forces. This backlash is unfortunate not only because it frustrates conservation but because its objective is illusory: the status quo for so many resource-based communities is not stability; it is an economic free fall with no parachute.

The high-profile fight over Temagami added Ontario's chapter to this nationwide story, depicting an apparently irreconcilable conflict between the urban-based pressure to preserve wilderness and the desperate need for jobs and healthy communities in the hinterland. A similar storyline continues to unfold in southern Ontario around the long-running tug-of-war over development restrictions in the Niagara Escarpment Plan.

Regrettably, politicians in Ontario and elsewhere have tended to reinforce, not resolve, wildland skirmishes. Instead of demonstrating the political will to preserve wilderness *and* work, and then developing the necessary policies, they have tended to look for short-term, valley-by-valley compromises. This solution usually means shrinking the protected-area proposal and prolonging the agony of declining industries for a year or two with scarce tax dollars — a lose/lose scenario. Without government leadership, the ill will generating in issues such as Temagami and entrenching in rural/urban, local/provincial rifts will prove a major obstacle to parks and wilderness proposals.

There's no argument here to impose protected areas on people against their will. Nor should reserves for nature be advertised on the basis that they will perform economic miracles. The reasons are simple. Wilderness and wildlife will not survive when surrounded by hostile residents or rape-and-pillage development or when overrun by tourists. But neither can we succumb to misplaced fears and resentment and abandon efforts to dedicate wilderness preserves now. After all, protected areas and improved resource practices on the rest of the landscape are essential steps in the transition to a stable future and sustainable resource economy which we *all* want for Ontario.

A second challenge, which could turn into an opportunity, is the resolution of land claims and the treaty rights of First Nations. Across Canada, aboriginal people are strongly asserting their desire to maintain sufficient wild country and wildlife for cultural survival and economic independence. Though the practical means for achieving these aims are still emerging, and cannot be generalized for all aboriginal communities, there is no *inherent* reason why lands owned and managed by First Nations cannot contribute to Ontario's protected areas goals. On the contrary, we should start from the assumption that there is a potential mutual interest in keeping certain parts of the landscape in a wild state and then initiate practical discussions to identify these places.

The agreement-in-principle for Nunavut, the eastern Arctic homeland of the Inuit, bears out this approach. It provides for some conservation areas which the Inuit will fully control as part of their entitlement, as well as for some new national parks. Though remaining in public ownership, these parks will involve some form of co-management and contribute to the

goals of the Inuit by expanding the territory secured from industrial disturbance. These parks and other special conservation sites thereby help to ensure that there is at least a fighting chance for some communities to sustain a way of life based on wildlife harvesting.

Unfortunately, negotiations between First Nations and the provincial government in Ontario started down a different track, largely because the NDP government has shown little appreciation for conservation issues. No strategic plan was devised to serve the government's dual mandates of achieving justice for native people and completing a protected areas system. Instead, in its haste to implement its native affairs agenda, the Cabinet took decisions in Algonquin, Quetico, and Rondeau which were seen by many Ontarians as a betrayal of long-held conservation principles. A wedge was thereby driven between First Nations and conservationists, suggesting that their interests are incompatible. It remains to be seen if a cooperative approach to establishing new protected areas can be found, one based on a shared commitment to maintaining certain ecological conditions in these areas regardless of who owns or manages them. Consultations being set up as I write (in January 1992) to implement the government's commitment to the Endangered Spaces campaign goals will be an important testing ground.

There is a third challenge. In the midst of a recession and a constitutional crisis, when communities are hemorrhaging jobs and hospital beds and Canada's founding nations are threatening divorce, the fact that no one dies waiting in line to enter a park leads many politicians to believe that protecting our natural heritage is a luxury, not a priority. That's wrong. It so happens that forty-six other species *are* officially facing extinction in Ontario, waiting in line for their habitat to be secured and oblivious to whether or not we have a recession. And just like canaries in a mine, their trauma is a warning that *our* security is threatened too. As noted by the Premier's Council on Health, Well-being and Social Justice (July 1991):

"The preservation of natural ecosystems has important implications for human health. Plant species as well as marine and terrestrial animals, contribute to the development of medicines. There is still much to learn from screening plants for medicinal purposes. Ecological diversity contributes to food production (i.e. natural pest control, food diversity, genetic enrichment of domestic crops). Natural ecosystems contribute to water purification and flood control. Opportunities for wilderness recreation and the maintenance of traditional cultures is also important for individual and community health."

Protected areas are not a mere amenity we can do without; today they are an essential means for conserving the biological capital on which a healthy society and resource-based economy depend. But because the loss of wild places is incremental, rarely catastrophic, our leaders can get away with passing on the associated costs to future generations. In fact, during 1990–91 the provincial government invested only $1 per capita in setting aside new protected areas — barely an afterthought compared to the $1500 per capita for health care. Yet we have already lost the option of protecting anything close to a minimum wilderness area of 50,000 hectares in almost half of Ontario's sixty-five ecological zones. Not surprisingly, these are the very same areas where most of our endangered species are struggling to survive.

THE CRITICAL PATH

If Ontarians are serious about meeting the year 2000 deadline for new parks and reserves, let alone reversing the tragic depletion of natural diversity all around us, an immediate and determined response to these challenges is needed. First, the rhetoric of sustainable development, spouted by government and industry alike, must be infused with commitment to the major changes which are required in the way we do business on the land, no matter who owns or manages it. A two-pronged approach is called for: on the one hand, completing a network of protected areas representing the diversity of Ontario's ecosystems; and on the other, applying strict conservation practices to the rest of the landscape.

Not all our leaders are finding it easy to swallow this simple

prescription, for it does mean living more gently on the land, making more efficient use of its remaining bounty. Fortunately, the global marketplace is already signalling loud and clear that we can't compete by simply extracting more raw materials from the wilderness. Rather, we have to invest more in our human resources so that we can depend on ingenuity to turn the "interest" on "natural capital" into high-value products for international trade. Further, as wilderness becomes more scarce worldwide, Canada's conservation record will come under increasing scrutiny by people around the world who rightly consider biological diversity to be a matter of global interest and universal entitlement. Rumoured boycotts are already challenging our self-image if not our pocketbooks. So we can consciously choose — or be forced — to do the right thing.

Second, the provincial government needs to move on its year 2000 protected-areas commitment in concert with other government objectives, especially regarding the wildlife strategy, sustainable forestry, and aboriginal land claims. There are many potentially complementary aspects among these objectives that, if pursued together, afford the basic ingredients in a conservation strategy for sustainable development in Ontario. And there's little doubt that an ad hoc approach will accelerate conflict, political heartburn, and inefficient use of the public treasury. It's high time to bring protected areas in from the cold, from the edge to the centre of government policy, and recognize that safeguarding our natural heritage is an inseparable part of a progressive agenda for development and social justice.

Third, bounded by a schedule and criteria for what's needed to adequately represent natural regions, local residents and other stakeholders should have a major role in the siting and securement strategies for new protected areas. While decisions about province-wide goals are properly taken at Queen's Park, the means to achieve them are best confirmed closer to the ground by people whose support is vital to ensure that protected areas fulfil their mission. Just as there are a wide range of habitats at stake, with varying protection requirements, there are also many ways to secure land in accordance with both ecological and social conditions. These range from private nature trusts to land use zones in municipal plans to national marine parks and so forth. Provincial parks should not be seen as the only way to protect wild places.

Of course, this flexible approach needs to be governed by a conservation bottom line: any protection strategy for a site must preclude industrial activity, have legal status, and clearly assign someone the responsibility for ongoing management according to a management plan. Areas of Natural and Scientific Interest (ANSIs), for example, currently fail this test principally because ANSIs allow industrial activity. Yet if their protection were strengthened, the roughly 600 ANSIs already identified would go a long way to completing Ontario's protected-areas system.

Furthermore, to encourage a positive local response and to share more of the protected areas workload with the private sector, the government needs to ensure that its other policies and programs are not working against protected areas. Subsidies for draining wetlands are a glaring example of this problem: simply they must cease.

Fourth, to maintain the ecological integrity of existing and future parklands we must strengthen the scientific content of their management plans. Where they exist, these plans are usually guided by vague statements of intent without measurable objectives or performance indicators, and thus fail to keep pace with recent advances in conservation biology. Management staff are also short of scientific expertise and resources for monitoring the condition of park environments. Yet external and internal stresses on these natural ecosystems are growing as human activity spreads across the land.

Ecological integrity is such an important long-term issue that it demands a larger and growing share of government conservation budgets even as other programs are cut and greater responsibility falls on the private sector. It also demands that Ontario follow the federal government's lead by amending the Provincial Parks Act to entrench "ecological integrity" as the guiding principle for parklands. At the same time this outdated piece of legislation should mandate the government to adhere to its own park policies stated in the "blue book", and so give legal force to park boundaries, management plans, and public participation. Our first

SWAN LAKE, ALGONQUIN PROV. PARK
LORI LABATT

parks centennial is an ideal time for Ontarians to demand action by provincial legislators to meet the second century's challenge of keeping our natural assets in a healthy condition.

Finally, in many southern Ontario site districts where wilderness is virtually extinct, our challenge is to actually recover lost ground through a combination of measures. These include securing small habitat fragments immediately, limiting adjacent development to provide buffer zones, establishing connecting corridors to enable wildlife to migrate and maintain a healthy genetic variation, and undertaking longer-term restoration projects to bring back natural conditions to important sites which have been degraded by human impacts. A good starting point would be a pilot project in the Carolinian zone, already home to innovative partnerships as well as a high concentration of endangered species. One way or another, government leadership remains the key to steady progress on the ground, during the 1993 centennial and every year after

until 2000, in designating new protected lands and waters. Whether we get such leadership depends fundamentally on each and every one of us raising our voice to say that wild places are not a postcard dream we live outside normal business hours.

Rather, wild places are the anchor for a moral universe which must extend to all the lands and waters we inhabit. Wildness is the reference point for how we reconcile nature and human nature, caring for the Earth so as to care for people, both living and unborn. Simply put, we will only be as healthy as our environment.

Ontario's park system has kept alive this realization for one hundred years, with or without our conscious knowledge. Now that we are coming to understand it, our generation, in the '90s, has the responsibility to ensure that we not only hang on to remnants of wilderness but also adopt a humbler view of creation so that we pause and reflect before disturbing or trying to improve it.

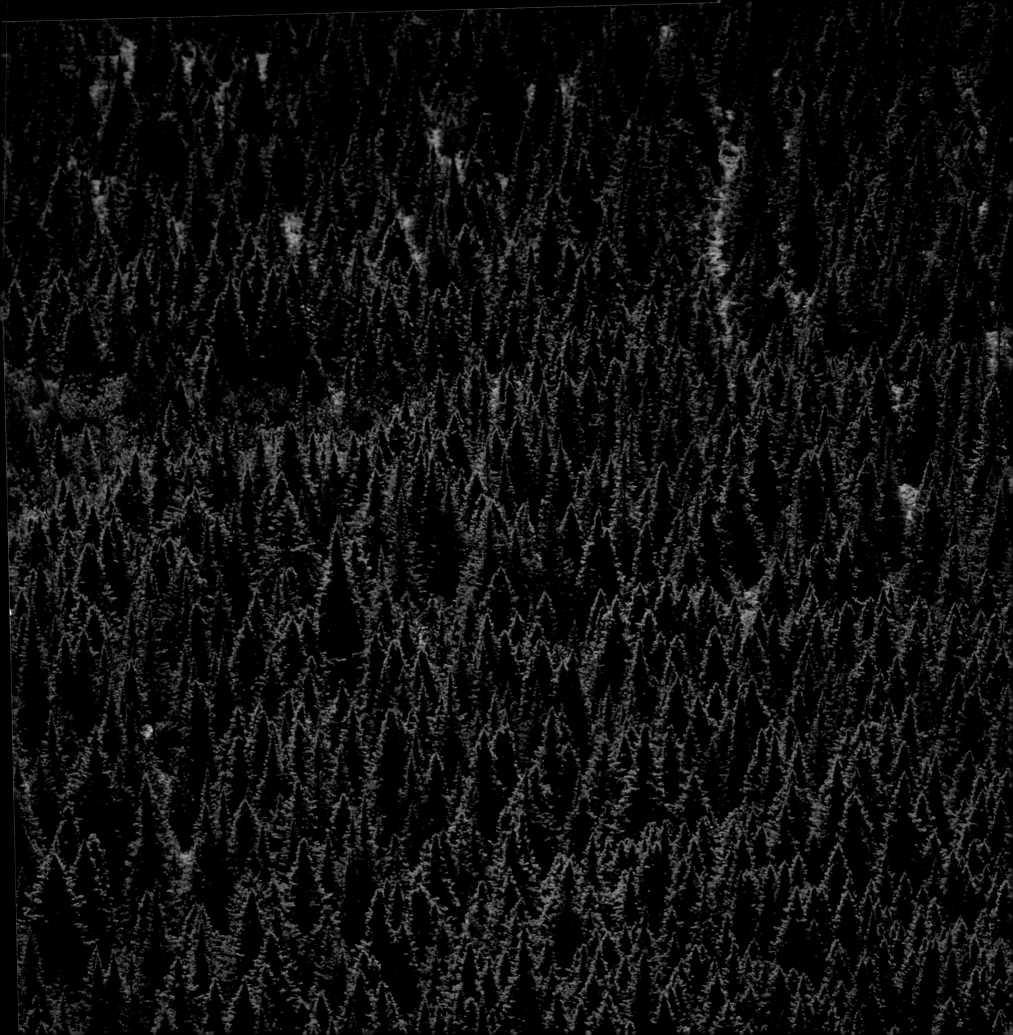

Canadian Wilderness Charter

1. Whereas humankind is but one of millions of species sharing planet Earth and whereas the future of the Earth is severely threatened by the activities of this single species,

2. Whereas our planet has already lost much of its former wilderness character, thereby endangering many species and ecosystems,

3. Whereas Canadians still have the opportunity to complete a network of protected areas representing the biological diversity of our country,

4. Whereas Canada's remaining wild places, be they land or water, merit protection for their inherent value,

5. Whereas the protection of wilderness also meets an intrinsic human need for spiritual rekindling and artistic inspiration,

6. Whereas Canada's once vast wilderness has deeply shaped the national identity and continues to profoundly influence how we view ourselves as Canadians,

7. Whereas Canada's aboriginal peoples hold deep and direct ties to wilderness areas throughout Canada and seek to maintain options for traditional wilderness use,

8. Whereas protected areas can serve a variety of purposes including:

 a) preserving a genetic reservoir of wild plants and animals for future use and appreciation by citizens of Canada and the world,

 b) producing economic benefits from environmentally sensitive tourism,

 c) offering opportunities for research and environmental education,

9. Whereas the opportunity to complete a national network of protected areas must be grasped and acted upon during the next ten years, or be lost,

We the undersigned agree and urge:

1. That governments, industries, environmental groups and individual Canadians commit themselves to a national effort to establish at least one representative protected area in each of the natural regions of Canada by the year 2000,

2. That the total area thereby protected comprise at least 12 per cent of the lands and waters of Canada as recommended in the World Commission on Environment and Development's report *Our Common Future*,

3. That public and private agencies at international, national, provincial, territorial and local levels rigorously monitor progress toward meeting these goals in Canada and ensure that they are fully achieved, and

4. That federal, provincial and territorial government conservation agencies on behalf of all Canadians develop action plans by 1990 for achieving these goals by the year 2000.

*CRAIG'S PIT NATURE RESERVE,
LAKE SUPERIOR
BRUCE LITTELJOHN*

283

How can you make a difference?

The editors of *Islands of Hope* want it to be more than a book. We hope it has instilled in our readers a desire to see a completed wilderness network in Ontario representing examples of all of this province's outstanding natural diversity. To accomplish this goal, however, we urgently need a network of people who share our concerns.

Please join us. Having read our book, you can start by adding your name as a supporter of the Canadian Wilderness Charter. This document is the mission statement for the national Endangered Spaces campaign, a cooperative effort among more than 250 Canadian organizations. Hundreds of thousands of Canadians, in all parts of the country, are doing the same thing, indicating their concern and willingness to lend a hand. To sign on, please contact one of the offices listed below.

If you're not already aboard, please consider joining the Canadian Parks and Wilderness Society (CPAWS). This national grassroots organization, with chapters across the country, is working to protect wilderness in your region of Canada. CPAWS will welcome your help, and by working together we will make a difference.

CPAWS **National Office:**
Canadian Parks and Wilderness Society
160 Bloor Street East, Suite 1335
Toronto, Ontario M4W 1B9
Tel. (416) 972-0868

Chapters:
CPAWS B.C.
3328 West 15th Avenue
Vancouver, British Columbia V6R 2Y8

CPAWS Manitoba
414 Place Cabana
Winnipeg, Manitoba R2H 0K4

CPAWS Yukon
Site 16, Comp. 62,
R.R. #1
Whitehorse, Yukon Y1A 4Z6

CPAWS Wildlands League
160 Bloor Street East, Suite 1335
Toronto, Ontario M4W 1B9

CPAWS Calgary/Banff
P.O. Box 608 (Sub P.O. Box 91)
University of Calgary
Calgary, Alberta T2N 1N4

CPAWS Ottawa/Hull
P.O. Box 3072, Station D
Ottawa, Ontario K1P 6H6

CPAWS Edmonton
11759 Groat Road
Edmonton, Alberta T5M 3K6

CPAWS Nova Scotia
73 Chadwick Street
Dartmouth, Nova Scotia B2Y 2M2

CPAWS Saskatchewan
P.O. Box 914
Saskatoon, Saskatchewan S7K 3M4

Biographies

Margaret Atwood has achieved international fame as a poet, novelist, and literary critic. She has received the Governor General's Award on several occasions as well as other honours far too numerous to mention. As a child she spent much time in the wilderness with her entomologist father, who was also active in conservation work.

Gregor Gilpin Beck obtained an M.Sc. from McGill University where he specialized in the study of marine mammals. A former director of the Norval Outdoor School of Upper Canada College, he has long been associated with World Wildlife Canada and the Quebec Labrador Foundation's Atlantic Centre for the Environment. Mr. Beck is a keen field naturalist, photographer, and writer.

T.J. (Tom) Beechey completed postgraduate studies in biology and conservation in 1970. Since that time he has worked in the field of conservation, primarily on parks and protected areas. He is currently Senior Conservation Biologist in the Provincial Parks and Natural Heritage Policy Branch of the Ministry of Natural Resources and is involved with many provincial and national conservation organizations, including the Canadian Council on Ecological Areas.

Dan Brunton is a widely published field naturalist and life sciences specialist. He has done a great deal of consulting work with organizations such as Ontario's Ministry of Natural Resources and the National Capital Commission. In addition to his natural environment planning and inventory work, he is active with a number of conservation groups.

Anne Champagne is a graduate in Environmental Studies from York University. She has written and edited extensively for environmental journals and has worked in both volunteer and professional capacities for many environmental groups, including the Canadian Parks and Wilderness Society, the Federation of Ontario Naturalists, and the Wildlands League.

Robert J. Davidson graduated from the Department of Earth Science at the University of Waterloo in 1973. Since graduation, he has worked within the Ministry of Natural Resources to establish a program to protect Ontario's significant geological features. This work has included contributions to provincial parks and other conservation initiatives.

Wayland Drew received the Lieutenant-Governor's Conservation Award for 1991 and holds an honorary Doctor of Letters degree from Trent University. A secondary school teacher in Bracebridge, he is also a prolific writer, a concerned environmentalist, and an avid wilderness camper. Mr. Drew has published twelve books, both fiction and non-fiction, the most recent being *Halfway Man* (1989). He is currently writing the script for a film on Ontario's parks.

Janet (Green) Foster holds a doctorate in Canadian history from York University and is the author of a pioneering conservation history entitled *Working for Wildlife* as well as a number of books for children. A fine still photographer, she is perhaps best known as co-host, with her husband, John, on the CBC television series *To the Wild Country*, *This Land*, and *Wild Canada*. The Fosters are currently making films for TVOntario.

Janet Grand has spent more than fifteen years in conservation and environmental work. A director of the Canadian Nature Federation, she has been widely published in nature and conservation journals and is co-author of *Paddling Ontario's Rivers* with her husband, Ron Reid. Her experience of wilderness travel is extensive and includes challenging areas in the north of Ontario.

Victoria McKenzie Grant is of Ojibwe heritage and spent her childhood at Bear Island on Lake Temagami. Following her schooling on the island and in North Bay, she worked for seven years in the Temagami Indian Band office. She now lives with her husband and children in New Liskeard, where she is actively involved in educational and community affairs. She retains a strong link with family and friends at Bear Island.

Arlin Hackman was raised in rural Alberta. After earning a Master of Environmental Studies degree from York University, he went on to gain extremely broad experience as an environmentalist with both public and private agencies. An acknowledged authority on Ontario's parks, Mr. Hackman was an outstanding executive director of the Wildlands League (1978 to 1983). Since 1987 he has been with World Wildlife Fund Canada, where he is deeply involved with the Endangered Spaces campaign.

David Harding holds a B.Sc. in Fisheries and Wildlife Biology from the University of Guelph. He has worked for the Fish and Wildlife Branch of the Ministry of Natural Resources and for about twenty-five summers as Park Naturalist at Samuel de Champlain Provincial Park. Mr. Harding lives in the Caledon Hills, where he pursues his interests in trout fishing, cross-country skiing, and bird carving.

Monte Hummel is president of World Wildlife Fund Canada and one of the nation's most effective environmentalists. A former director of the Wildlands League, he was also chairman and co-founder of Pollution Probe. Mr. Hummel, raised at Whitedog Falls, north of Kenora, has taught at the University of Toronto, has served with a wide range of conservation and environmental organizations, and has well over a hundred publications to his credit, including *Endangered Spaces, The Future for Canada's Wilderness* (1989).

Bruce Hyer was born in the United States, where he became Senior Environmental Analyst for the State of Connecticut. At age twenty-nine he moved to Canada and now lives near Thunder Bay. Mr. Hyer is a bush pilot and wilderness outfitter who is also doing graduate research at Lakehead University. An active environmentalist and past president of Environment North, he has a strong interest in the Lake Superior ecosystem.

Kevin Kavanagh was born and raised in rural Quebec. He holds a B.Sc. (McGill) and M.Sc. (York), both in biogeography. He is currently working on a doctorate in botany and forest ecology at the University of Toronto. Since 1989, Mr. Kavanagh has served as the highly effective president of the Wildlands League. He is also Manager of Research and Special Projects for the Endangered Spaces program of World Wildlife Fund Canada.

Michael Keating is one of Canada's leading environmental writers, who for many years wrote extensively for the *Globe and Mail* on environmental subjects. The author of major reports for the federal Ministry of the Environment, his books include *To the Last Drop: Canada and the World's Water Crisis*. He is the founder and co-director of a new environmental journalism course at the University of Western Ontario.

Gerald Killan is Professor of History at King's College, University of Western Ontario. A member of the original Provincial Parks Council (1974–80), he is president of the Champlain Society and past president of the Ontario Historical Society. Dr. Killan's publications include the award-winning *David Boyle: From Artisan to Archaeologist*. His latest book is *Protected Spaces: A History of Ontario's Provincial Parks System*.

Phil Kor graduated from the University of Manitoba with an M.Sc. in Geology. Currently a parks geologist with the Ministry of Natural Resources, he has also worked with the Ontario Geological Survey. A highly accomplished photographer, Mr. Kor is also a member of CPAWS. He enjoys hiking, kayaking, and wilderness camping.

Lori Labatt is a Toronto-based photographer, writer, and traveller whose journeys have taken her from the High Arctic to Antarctica, from the Galápagos to East Africa, to document the world's wild places. These images and impressions form the basis for her photographic workshops, lectures, and published articles. A director of the Wildlands League, she will tour the province in 1993 with "Visions of Wilderness", a sound/slide presentation based on this book.

David Lang is a director of the Wildlands League who has taught at Upper Canada College and currently works with public school students. An accomplished ocean sailor, he was for many years one of Canada's leading cattle breeders. He has published widely on agricultural subjects and has worked as a camp counsellor and wilderness guide in Algonquin Park.

Bruce Litteljohn has been associated with Upper Canada College as a teacher, administrator, or consultant since 1965. For almost twenty-five years he has been a director of the Wildlands League and was

particulary active in the struggle to get Quetico Provincial Park classified as a Wilderness Park. His photographs and writings have been widely published and he is co-author or co-editor of several books.

John A. Livingston is a distinguished environmental educator in the broadest sense of the term. The author of nine influential books on nature and conservation, he was also the first executive producer of CBC's *The Nature of Things*. A past president of the Federation of Ontario Naturalists, Professor Livingston now teaches in the graduate Faculty of Environmental Studies at York University.

George J. Luste is a physics professor at the University of Toronto. He has made many extended canoe trips and winter treks in remote wilderness areas, including Baffin and Ellesmere islands and Labrador. A member of numerous conservation organizations, he has served on the board of the Sierra Club of eastern Canada and has worked for protection of the Missinaibi River for twenty years.

Tija Luste has combined seasonal work with the Ministry of Natural Resources with studies that have recently led to a degree in Economics and Environmental Management from the University of Toronto. Her early canoe travels with her parents have instilled a continuing interest in canoe tripping.

Kevin McNamee, a geographer by training, has had a broad and influential experience in conservation and environmental work at both the provincial and national levels. He lives in Ottawa, where he is Natural Areas Coordinator with the Canadian Nature Federation and is heavily involved with the Endangered Spaces program. For recreation, he particularly enjoys sea kayaking and canoe camping.

Robert L. Mitton became supervisor of long-range and park systems planning with the Ontario Ministry of Natural Resources in 1973. In this capacity, he played a key role in developing a comprehensive provincial parks policy for Ontario. Following a decade of public service work in western Canada he returned to the province and became Deputy Minister of Education in 1990.

Lorraine Monk is an Officer of the Order of Canada and the doyenne of Canadian still photography. Formerly executive producer of the Still Photography Division of the National Film Board of Canada, she is also the creator of many acclaimed photographic books, including *Canada, A Year of the Land* and, most recently, *Photographs That Changed the World* (1989).

James Raffan is an avid wilderness traveller who has been published extensively. A Fellow of the Royal Canadian Geographical Society, he is an Assistant Professor of Education at Queen's University and is currently doing research on cross-cultural perceptions of the Thelon Game Sanctuary in the Northwest Territories. His most recent book is *Summer North of Sixty*.

Ron Reid is an environmental consultant and writer living in Washago. As a former staff member with the Federation of Ontario Naturalists, he

has a long history of involvement with parks issues. He is co-author of *Canoeing Ontario's Rivers* with his wife, Janet Grand, and has visited parks in many parts of Canada and the world.

Norm Richards is a senior administrator with the Ontario Ministry of Natural Resources. Since 1981 he has been director of the Provincial Parks and Natural Heritage Policy Branch. During this period the number of parks has increased greatly and there have been significant changes in policy. Mr. Richards is a keen outdoorsman and is actively involved with the YMCA and other community service groups.

Alec Ross is a Kingston-based writer and erstwhile journalist with the Kingston *Whig Standard*. He has been published in journals such as *Equinox* and the *Canadian Geographic* and is currently finishing a book on his solo canoe journey from Montreal to Vancouver. Mr. Ross is a director of the Friends of Frontenac Park and is active with the Cataraqui Conservation Authority.

Hugh Stewart is a former director of the Wildlands League, and was among the first conservationists to lobby for the preservation of the Temagami wilderness area. An avid wilderness traveller for thirty-five years, he was owner and director of Headwaters, a wilderness camping business, for a decade. Today he works as a canoe builder and carpenter.

Brandy Stewart had an early introduction to wilderness experiences. Living with her parents on an island in Lake Temagami, she travelled to and from school at Bear Island by boat and snowmobile. Her first canoe trip was at the age of eight, and since then she has canoed frequently in Algonquin and Temagami. An enthusiastic ski racer, Brandy is now fourteen years old and lives in Ottawa.

Dan Strickland has been Chief Naturalist in Algonquin Park for more than twenty-five years. With degrees in biochemistry and ornithology, he has become a world authority on the grey jay. He is widely published, and is currently working on the new Algonquin Park museum. Mr. Strickland takes particular pleasure in scouring the province for promising young naturalists and helping them to advance in their careers.

Jenifer Sutherland is a Toronto writer and broadcaster and a city woman born and bred. In the warmer season she makes brief excursions into the bush, usually accompanied by her two young children. She claims to know the difference between a lost weekend and a weekend spent finding her feet, but confesses that she still can't identify poison ivy.

John B. Theberge is an ecologist and prolific writer. In addition to many articles and scientific papers, he has written or edited three books, including *Legacy, A Natural History of Ontario* (1990). Widely recognized as an authority on wolves, he has also done much work for a variety of conservation groups and is Professor of Ecology in the Faculty of Environmental Studies, University of Waterloo.

Warner Troyer died on September 15, 1991, shortly after completing his essay on Algonquin Park. One of Canada's most respected investigative journalists, he was an author, newspaper reporter, filmaker, and journalism teacher who was well known as a broadcaster on CBC and CTV television news programs. His 1975 book *No Safe Place* reflected his strong concern for the environment.

Justin Tsang immigrated to Canada with his parents in 1983, at the age of six. He was fourteen years old and a student at Upper Canada College when he wrote his essay comparing Hong Kong with Ontario. Active in both athletics and the arts, he is also very concerned with environmental issues.

Derek Tse is a Grade 12 student in Cochrane, Ontario. He was sixteen years old when he wrote "Sunday Reflections". Born in Canada, his parents came here from China and Hong Kong in 1972. He hopes to study journalism following his graduation from secondary school.

George Warecki has taught Canadian history at McMaster University, the University of Western Ontario, and King's College (UWO) in London, Ontario. His 1989 doctoral dissertation examined wilderness conservation in Ontario from 1927 to 1973. With Dr. Gerald Killan he has written a history of conservation in the Quetico–Superior region. Both historians are currently writing a history of Algonquin Park.

Acknowledgments

For permission to reprint copyright materials, acknowledgment is made to:

The *Paris Review* for "Lichens" by Margaret Atwood.

The Harmony Foundation for "Laughter in the Labyrinth: Wilderness and Soul" by Wayland Drew.

We are grateful for the contributions of many people.

- Thanks for continuing support from our colleagues at both the Wildlands League (Kevin Kavanagh, President) and CPAWS (Angus Scott, Executive Director).
- Thanks to our copy editor, Catherine Cragg, and readers Lorna Green, Alec Ross, Pat Hardy, and John Bell.
- Thank you, Deby Smith, for excellent word-processing services.
- For advice and useful insights, thanks to Doug Brown, Gary Forma, Mike Barker, and Joe C.W. Armstrong.

- A special thank you to Greg Stott, Paul Berger, David Gibson, Wendy Lyttle, and Beverley Daniker for assistance in fund-raising.
- We appreciate the assistance in field work given by the Ministry of Natural Resources, Provincial Parks and Natural Heritage Policy Branch.
- For creative contributions, we thank Chris Selley, Amish Morrell, Jonathan Bordo, Mike Walton, Nancy Scott, Gerry O'Reilly, Richard F. Grant, Marion Taylor, Mike Jones, Lloyd Walton, Bruce Hodgins, Leo Heyens, Sherman Hines, and Gerard Williams.
- Thanks to Kevin Seymour, Treasurer, Wildlands League, for bookkeeping assistance.
- We thank Dan Gibson for the use of his compact disk " *The Algonquin Suite.*"
- Lionel Koffler of Firefly Books shares our concern for a healthy environment. We thank him and his staff for making *Islands of Hope* part of the parks centenary celebration.

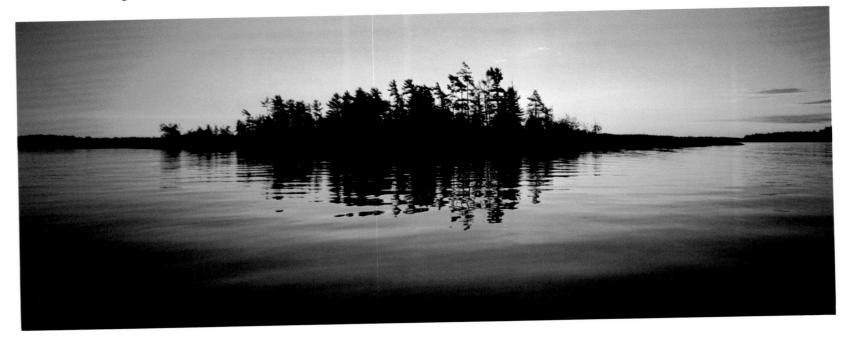